ART

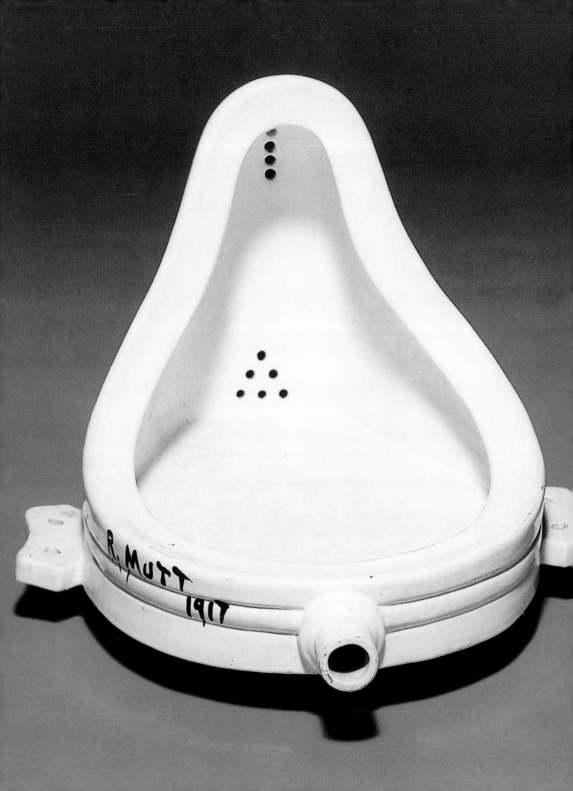

Flaminio Gualdoni

ART

The Twentieth Century

SKIRA

facing title page
Marcel Duchamp
Fountain, 1917
Original lost; replica
Ready-made: white porcelain
urinal, 62.5 cm (height)
Arturo Schwarz Collection, Milan

Skira editore

Editor
Eileen Romano

Design
Marcello Francone

Layout
Anna Cattaneo

Editorial Coordination
Giovanna Rocchi

Editing
Maria Conconi

Iconographical Research
Alice Spadacini

Translations
Christopher "Shanti" Evans
(except for *Post-Impressionism*,
translated by Robert Burns)
for Language Consulting
Congressi, Milan

First published in Italy in 2008
by Skira Editore S.p.A.
Palazzo Casati Stampa
via Torino 61
20123 Milano
Italy
www.skira.net

© 2008 by Skira editore

Printed and bound in Italy.
First edition

ISBN 978-88-6130-801-5

Distributed in North America by
Rizzoli International Publications,
Inc., 300 Park Avenue South,
New York, NY 10010.
Distributed elsewhere in the world
by Thames and Hudson Ltd.,
181a High Holborn, London
WC1V 7QX, United Kingdom.

Contents

Foreword

A book on 20th-century art, now that almost a decade has gone by since the end of that "short century" (although as far as the arts are concerned it has proved to be anything but short), has the nature of a stocktaking, a summing up, a reassessment.

A necessary reassessment, given that the 20th century was not just the time of avant-gardes, of artistic hothouses, movements and theories, but also that of the media, of museums, of the history of art: paradoxically, it can even be claimed that from Post-Impressionism onwards—if we wanted to set a date, from the momentous exhibitions of van Gogh and Cézanne at Ambroise Vollard's gallery in Paris, in 1895—the very process of the emergence of new artistic experiences has been indissolubly linked to the project of historicization, official validation and mediation in taste, of the bourgeois market and "high" art, and at the same time of a continual contamination by "low" culture, culminating in the current, inextricable, visual melting pot.

This has led to the establishment of some stubborn myths, commencing with the mystical madness of van Gogh and continuing with the insidious one of the new at any cost, and of formulations that started out life as simple and succinct definitions but then turned into stereotypes. It has also meant that the centrality of the work of art, in all its ambiguous, fervent force, has been obsessively harnessed and defused in a tangle of words, schemes and rhetorical oversimplifications, almost as if it existed only to occupy the place that it has been officially assigned in the history of art and on the wall of the museum.

On this occasion we have chosen to take a different and humbler approach, one less preoccupied with schemes and classificatory impulses, and base ourselves precisely on the centrality of the work. We have set ourselves the task of placing a large number of works in sequence, in order to find out whether it is possible to squeeze information, ideas, doubts and curiosities out of the "matter" of art itself, without letting the critical discourse gain the upper hand, as all too often happens.

We have scanned the decades that run

from the end of the 19th century to the present day, adopting problematical and not stringent divisions, treating the names of movements and situations as doubtful territories and not as rigid and self-explanatory pigeon-holes, suggesting affinities and differences, continuities and divergences, mutual points of contact between areas and implacable oppositions.

Giving pre-eminence, in a book on art, to the gaze rather than to discourse, to the eyes rather than to the ears, is not something as obvious as it might appear at first sight.

Even a summary glance at the existing range of publications provides confirmation of this.

Nor is it as easy a task as it seems: just ask Eileen Romano, Marcello Francone, Alice Spadacini, Giovanna Rocchi and Anna Cattaneo, who have shared with me in some truly gruelling—but also, it must be said, gratifying—sessions of selection and sorting.

As a consequence of this overriding decision came the one to tell the story of the century's art rather than explain it, and to render it clear rather than theoretically well-defined. Telling readers, in essential terms but without borrowed schemes, the salient facts, conceptual as well as historical, that have made the course taken by art in that century so crucial. Giving the right weight to the geniuses, but also to the variegated milieu from which they sprang; highlighting fundamental connections—in a time of integration of the arts—with the culture of literature, music, drama, cinema, etc.; paying due attention to the system of exhibitions, criticism, dealers and the media within which developments took place and people acted, but also not underrating the unique role played by some individual, glowing personalities. Choosing, moreover, to let the artists themselves and their direct associates speak wherever possible, and not relying on subsequent critical interpretations. Building a history out of history seemed to us much less fruitful, and certainly less enjoyable, than capturing the intellectual climate, the thought processes, the outbursts of controversy and the flashes of inspiration in a way that could only be done through the words of protagonists and firsthand witnesses: well aware on the one hand that, as Barnett Newman put it, "aesthetics is for artists what ornithology is for birds", but also that in a century in which art took on a militant character in the forms of the avant-garde, speaking, publishing and making declarations have been an essential part of the work itself, and not an optional accessory.

We have, to be sure, almost always preferred the words of the artists to those of the intellectuals who supported

8

and worked alongside them, because while it is true that, in the words of the elderly Annibale Carracci, "we Painters have to speak with our hands", the 20th century also produced art through theory, through thinking about art, through the search for conceptual foundations and not just effects; because, again, it was a century of true creators, lucid and conscious, which only recently seems to have given way to a time of bland, and far less critical, creators; because, finally, the fact that far more people spent the century talking and writing about art than practicing it, in a sort of cultural saprophytism that has been irksome in many cases, has generated more than one false perspective of interpretation, which it is now possible and opportune to redress. In fact people were already aware of these pernicious propensities back in the heroic days of the early avant-gardes, as is clear from the lucid and farsighted words of authors like Jean Cocteau and Tristan Tzara.

The *peintre philosophe*, the theoretical artist, is a figure that cannot be escaped in any balanced view of the 20th century. With the proviso, of course, that it must never be forgotten that even the most cerebral conceptual approach has always culminated in the work itself: perhaps redefined with respect to the aims of completeness, between perfection and the sublime, that held sway in the past, perhaps self-doubting rather than affirmative: but, in any case, a work.

So we have preferred to tell a story rather than to explain. To construct a narrative out of images for which the text will serve as a sort of simple Ariadne's thread, but a strong and taut one. Which does not signify, of course, a renunciation of clear choices, of a reasoned and well thought-out effort of criticism, i.e. of inclusion and exclusion, of emphasis and depreciation. Rather, that such choices and considerations have been made with a due measure of understatement, getting down from the pedestal of the critic in an attempt to hold a conversation with readers and not lecture them dogmatically.

There is a great difference between seriousness and intellectual dogmatism, and it is one that grows more and more evident as time passes. Let us leave the terrorism of thought to the 20th century that produced it, and enjoy, in this new one, the culture of beauty.

Post-Impressionism

On May 3, 1888, Vincent van Gogh wrote to his brother Theo, who was involved in the Parisian art market, about his ideas on the painter of the future. This painter would have to be a colourist unlike any who had ever existed. He said that Manet had laid the groundwork, but the Impressionists had already used colours that were much more vivid than his. He continued, "I can't imagine the painter of the future living in small restaurants, setting to work with a lot of false teeth, and going to the Zouaves' brothels as I do. But I'm sure I'm right to think that will come in a later generation, and it is up to us to do all we can to encourage it, without question or complaint."

It is usually said that the term "Post-Impressionism" was coined by the art scholar Roger Fry in 1910 on the occasion of the *Manet and the Post-Impressionists* exhibition at London's Grafton Galleries. This is true. But the impulse to move beyond Impressionism was already crystal clear in van Gogh's words twelve years earlier, at a time when he was not yet sure of his talents but not lacking a clear orientation.

And it was generally clear to the entire generation of artists coming of age in Paris in the shadow of the Impressionist revolution.

It was a composite generation operating within the anti-academic viewpoints emerging from Impressionism. It encompassed orientations that differed greatly, but that were often closely intertwined. The main site of this meshing was the Salon des Artistes Indépendants, which opened its doors on December 1, 1884 at the Polychrome Pavilion, just a stone's throw from the Palais de l'Industrie. Like the 1863 Salon des Refusés, which had witnessed the scandal of Manet's *Déjeuner sur l'herbe*, the exhibitors at the Indépendants were strongly opposed to the selective, jury-mediated admissions process to the official Salon, the pre-eminent public exhibition in Paris. They favoured a free exchange of artistic expression in which the artists themselves, and not some institution, are in charge. The founders included, among others, Albert Dubois-Pillet, Odilon Redon, Georges Seurat and Paul Signac, who also exhibited their works at the event.

When the exhibition opened, Seurat had already been working for several months on his masterpiece *Un dimanche après-midi à l'Île de la Grande Jatte* (A *Sunday on La Grande Jatte*). Seurat admired the noble and composed painting style of Pierre Puvis de Chavannes, but sought to reconstruct Classical perfection, which he saw as the model to be pursued, but on a new, scientific basis. Seurat was fascinated with the optical theories of Eugène Chevreul, author of the 1939 work *De la loi du contraste simultané des couleurs* (*The Principles of Harmony*

and Contrast of Colours) in which Chevreul demonstrated that when colour A is juxtaposed with colour B, the latter changes its appearance by the seeming addition of the complement of colour A. If colours A and B are complementary, they tend to cause the other to appear lighter, otherwise, impure tones are generated. Chevreul later wrote prophetically in his 1864 essay *De l'abstraction considérée relativement aux Beaux-Arts* (*Abstraction considered in its relationship to the Fine Arts*) that the fine arts offer us only abstractions, even when they present us with a work that apparently reproduces a concrete image. Seurat began to construct his scenes of life simplifying his figures into static geometric solids with clear edges defined by a change in colour. He applied his paint in small, tightly spaced dots in a technique termed at the time "Pointillisme". In 1886, on the occasion of the public unveiling of the painting, the art critic Félix Fénéon would refer to the technique as "Neo-Impressionism", choosing that term over "Divisionism". The latter term however was preferred by Seurat and immediately adopted by Italian admirers of the Frenchman's work

Georges Seurat
The Circus (detail), 1891
Oil on canvas, 185 × 152 cm
Musée d'Orsay, Paris

such as Segantini, Previati, Pellizza da Volpedo and Morbelli. "We have, therefore," wrote Fénéon, "not a mixture of material colours (pigments), but a mixture of differently coloured rays of light."

Accompanying and carrying on Seurat's new venture—Seurat died at the age of 31 in 1891—we have Armand Guillaumin and his teacher Camille Pissarro, a great impressionist who was swayed by the ideas of his younger colleagues. More importantly, however, we have Paul Signac, who continued the development of the theory with a stronger conception of the relations between colours and greater attention to the proportion of the coloured dots in relation to the dimensions of the overall composition.

It would be Signac, in his essay *D'Eugène Delacroix au Néo-Impressionnisme* (*From Eugène Delacroix to Neo-Impressionism*), published in 1899, to sum up the rules of the movement: "The Neo-Impressionist does not *stipple*, he *divides*. And dividing involves (…) guaranteeing all benefits of light, coloration and harmony by: i. An optical mixture of pigments which are pure (all the tints of the prism and all their tones); ii. The separation of different elements (locally applied colour, lighting colours, their reactions, etc.); iii. The balance of these elements and their proportion

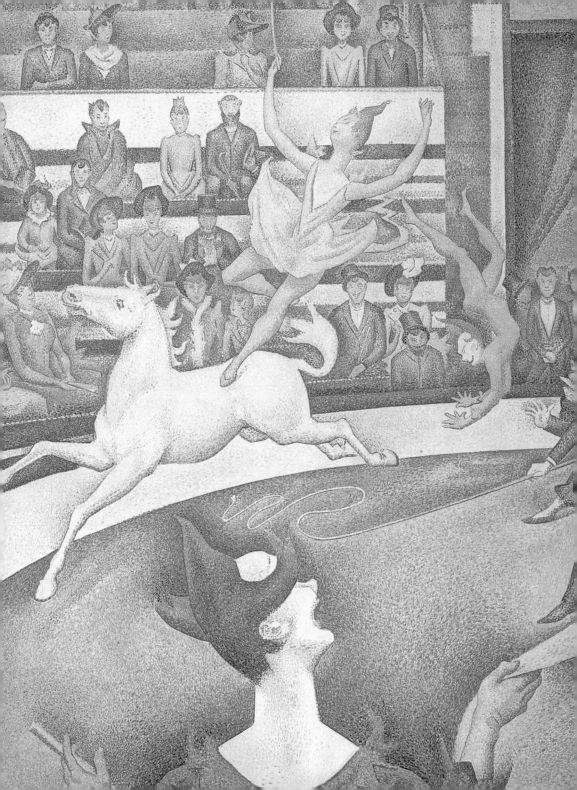

"… I can't imagine the painter
of the future living in small
restaurants, setting to work
with a lot of false teeth, and going
to the Zouaves' brothels as I do.
But I'm sure I'm right to think
that will come in a later generation,
and it is up to us to do all
we can to encourage it,
without question or complaint."

Vincent van Gogh

(following laws of contrast, deterioration, and irradiation); iv. Choosing a touch that is proportionate to the size of the painting." He explains that the separated brush-touch is only one of an infinitude of coloured elements which together compose the painting. It is an element that has the same importance as a note in a symphony. Sad or joyful sensations, calm or active effects are not achieved via the virtuosity of the brush work, but through the combination of tints, tones and lines. Many of these principles will form the basis of the Fauve paintings of Henri Matisse, André Derain and Georges Braque, and contribute to the initial abstractionist intuitions of Wassily Kandinsky.

Alongside the Seurats and Signacs, the "Indépendants" exhibition of 1884 included works by Redon, leader of another important current, Symbolism. Initially a movement that was prevalently literary, Symbolism was brought to the public's attention that same year by Verlaine's piece on the "accursed poets" Mallarmé, Corbière and Rimbaud. Two years later, when Rimbaud's *Illuminations* was published, Jean Moréas would sum it up perfectly as "dressing the Idea in a sensible form".

Verlaine explained that the poetry lay in the creating. What is necessary is to identify states of absolute purity in the human soul that can be distilled down to the very essence of humanity.

The symbol is here, creation is here, and the term poetry here means something. In sum, he claims, poetry is the only possible human creation. Redon and the more mature Gustave Moreau and Pierre Puvis de Chavannes were the spearheads in France of an attitude that would soon spread abroad, especially into the German-speaking areas, where it was expressed by authors such as Ferdinand Hodler, Arnold Böcklin, Fernand Khnopff and especially Gustav Klimt. In Vienna in 1897, Klimt, together with Joseph Olbrich and Koloman Moser, would found the Viennese Secession and the magazine *Ver Sacrum*. He would also be the teacher of Egon Schiele.

While the art of the Viennese Secession is characterised by its strong allegorical images and the use of gold to indicate a metaphysical world, along the lines of the Byzantine tradition, the trend toward adopting esoteric and inspired attitudes in painting was manifested in France with Les Nabis, who developed the primary Symbolist attitude.

"Nabis" is a term deriving from the Hebrew for prophet, one whose expressions are mediated by the direct agency of divine inspiration. Restoring a sacred value to art and re-establishing painting based exclusively on the highest spiritual aspirations and a sense of truth

that transcends all considerations of style or technique were the obscure aspirations that motivated artists like van Gogh and Paul Gauguin, who met in Paris in 1887, and the Nabis group, who would coalesce three years later around Gauguin, Émile Bernard and Paul Sérusier in Pont-Aven in Brittany. Les Nabis would represent a veritable fraternity that included, among others, Édouard Vuillard, Pierre Bonnard, Maurice Denis, Ker-Xavier Roussel, Félix Vallotton and Paul-Élie Ranson.

It was within this group that the predilection ripened for emblematic subjects and hieratic, simplified painting in the manner of ancient Egypt and Rome, with strong, flat colours and pronounced, sinuous borders, which would progressively gain stature as a new pictorial style above and beyond its symbolic intent.

When the man of letters Georges-Albert Aurier published the definition of pictorial Symbolism in *Mercure de France*, he wrote that: "The work of art has to be first of all *ideist*, because its one aim will be the expression of an idea; secondly, symbolist, as it will express this idea with forms; thirdly, synthetic, as it will put down these signs and forms in a generally understandable manner; fourthly, subjective, because the object will never be considered merely as an object, but as the expression of an idea perceived by the subject; fifthly,

decorative, because decorative painting, such as the Egyptians and also probably the Greeks and Primitives conceived it, is no other than a manifestation of art which is at one and the same time subjective, synthetic, symbolist and *ideist*."

While artists still in the blush of youth such as Bonnard and Vuillard would not fully develop their personalities until years later and become models of a painting based on a poetic intimism accomplished through the mastery of light colours, at this time the two most complex personalities and greatest geniuses were Gauguin and van Gogh. Recently back from his first trip to Martinique, in late 1888 Gauguin worked for two months together with van Gogh in Arles in the south of France. Vincent wrote to his brother Theo in January 1889: "Old Gauguin and I understand each other basically, and if we are a bit mad, what of it? Aren't we also thoroughly artists enough to contradict suspicions on that score by what we say with our brush? Perhaps someday everyone will have neurosis, St. Vitus's dance, or something else. But doesn't the antidote exist? In Delacroix, in Berlioz, and Wagner? And really, as for the artist's madness of all the rest of us, I do not say that I especially am not infected through and through, but I say

and will maintain that our antidotes and consolations may, with a little good will, be considered ample compensation." Above and beyond the perhaps overly fervid anecdotage accumulating around such an irregular figure as Vincent van Gogh, whose brief years were punctuated with episodes of mental derangement and ended with his suicide on July 29, 1890 in Auvers-sur-Oise, the painting styles of the two artists are actually quite different. Van Gogh matured irregularly, pursuing a multitude of cues ranging from the use of pure colours to the decorative flat colours typical of the Japanese woodcuts that were greatly in vogue in a Paris caught up in an Orientalist rage, and from his simple, almost genre iconography, which allowed him to concentrate into his painting all the emotional charge that a given situation aroused in him, to his use of fluid and intense brushwork, with his urgent onrush of pictorial gestures capable of deforming the normal mode of visual perception. His painting is irregular, deviating not only from an effete academism, but also from the new contemporary trends, which were increasingly oriented toward seeking justification in a solid intellectual and

Following pages
Amedeo Modigliani
Red Nude (detail), 1917
Oil on canvas, 60 × 92 cm
Private collection

theoretical background. It was this irregularity, combined with a brief and searing biography that reads like a romance novel, to exalt him to the ranks of legend immediately upon his death, to make him immediate fodder for mythmaking.

Gauguin's is a completely different story. First of all, he did not fully grasp van Gogh's spontaneous and anomalous innovativeness. Nurtured on Symbolist culture and, like Seurat, in competition with the noble forefather Puvis de Chavannes, Gauguin was always concerned with providing a conceptual basis for his work. Gauguin explained: "Puvis explains his idea, yes, but he does not paint it. He is a Greek while I am a savage, a wolf in the woods without a collar. Puvis would call a painting "Purity", and to explain it he would paint a young virgin holding a lily in her hand—a familiar symbol; consequently one understands it. Gauguin, for the title "Purity", would paint a landscape with limpid waters; no stain of the civilized human being, perhaps a figure. Without entering into details there is a wide world between Puvis and myself. As a painter Puvis is a lettered man but he is not a man of letters, while I am not a lettered man but perhaps a man of letters."
And again, in his brief *Notes* of 1884-85: "Painting is the most beautiful of all arts. In it, all sensations are condensed; contemplating it, everyone can create a

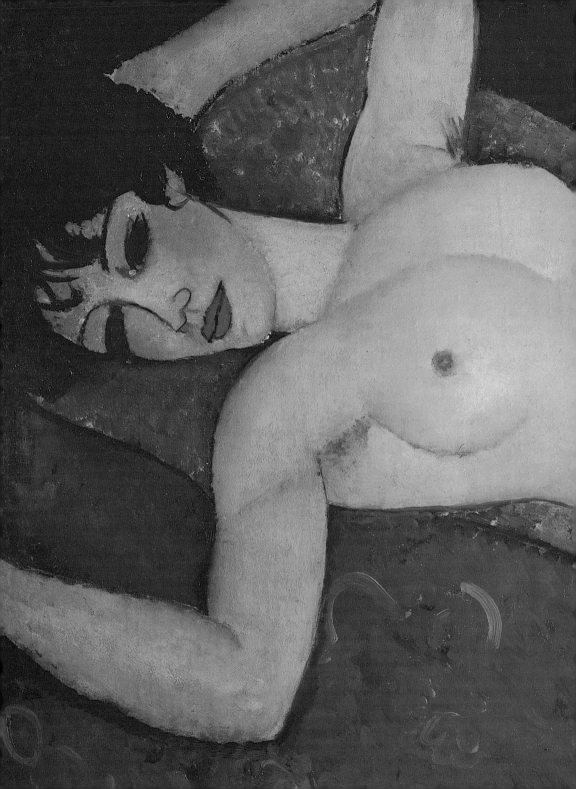

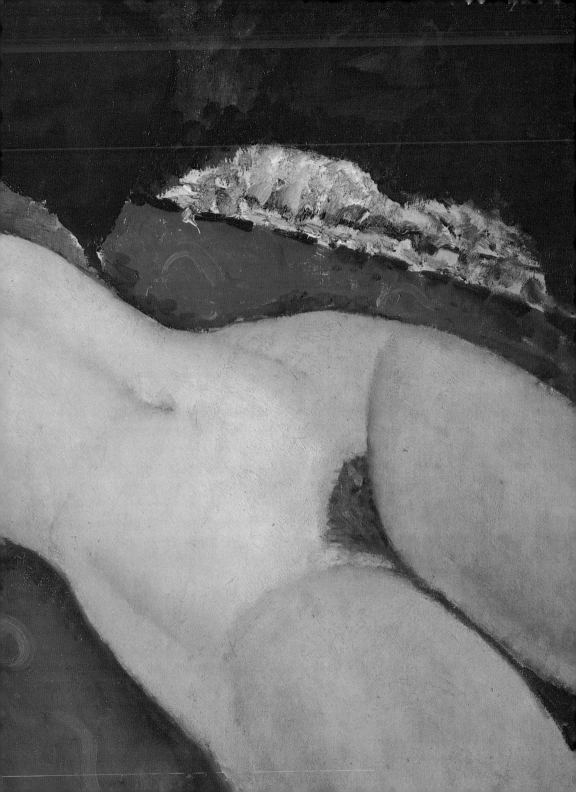

"Art for art's sake? Why not.
Art for life's sake? Why not.
Art for pleasure's sake? Why not.
What does it matter so long
as it is art."

Paul Gauguin

story at the will of his imagination and—with a single glance—have his soul invaded by the most profound recollections; no effort of memory, everything is summed up in one instant. A complete art which sums up all the others and completes them. Like music, it acts on the soul through the intermediary of the senses: harmonious colours correspond to the harmonies of sounds. But in painting a unity is obtained which is not possible in music (…)."

In 1891, the year after van Gogh's suicide, Gauguin embarked for Tahiti, later going to the village of Atuona on the southern coast of Hiva Oa, in the Marquesas Islands, where he would spend the rest of his life. He believed it was necessary to return to a condition of primitive purity in order to develop a newly sacred style of painting free of the filters that European culture lays over the original truth. His synthetic style is animated by strong, warm tones, and the hieraticity that Les Nabis sought in Egypt or Byzantium was replaced by that of the indigenous statuary that was to became one of his favourite subjects. His book *Noa-Noa*, published in 1897 in the *Revue Blanche*, the cultural bible of the times, was a sensation.

While Gauguin needed to escape "civilisation" on his quest for original purity, a master from the early generation of Impressionists such as Paul Cézanne preferred the total isolation of his native land, Provence. Cézanne's position with respect to Impressionism was problematic right from the start. While he too believed in the importance of working *en plein air* and in the primacy of visual perception over academic rules of composition and contrived lighting, he was immediately convinced that this experience could only be a transition toward an ulterior synthesis, in which the inner geometries and physical sensation of nature become one and the same; he wanted to make Impressionism into something solid and durable.

"Everything we see falls apart, vanishes. Nature is always the same, but nothing in her that appears to us, lasts. Our art must render the thrill of her permanence along with her elements, the appearance of all her changes. It must give us the taste of her eternity", wrote Cézanne. The thrill of duration united with the solidity of the form underlying the appearance is what allows painting to transcend sensation in favour of a classical measure. And instead of being imposed by the artist upon our vision as it was in the past, this measure is brought to the surface by the artist who analyses what is seen, it being the germ of truth that reality contains within itself. "Couture used to say to his pupils: 'keep good company, that is: go to the Louvre.

But after having seen the great masters who repose there, we must hasten out and by contact with nature revive within ourselves the instincts, the artistic sensations which live in us". Cézanne once again, here signifying that painting outdoors and working on the motif are not in contradiction with tradition, but serve to help us recognise in the fullness of our lives that which only the intellect had previously grasped. In the years 1882-90, when he chose as his favourite subject Mount Sainte Victoire—to which he would return in the final years of his life, after the turn of the twentieth century—he began a process of meticulous simplification, sharpening the visual elements into essential colour zones, purifying the image of all accessory detail, and adopting a sober, raw colour as a sort of building block for the essence, the solid and permanent essence, of the image. Isolated from everyone, Cézanne was also absent during the large Parisian exhibition of his works staged by the noted art merchant Vollard. The exhibition nevertheless succeeded in influencing the new generation because it confirmed that a synthetic simplification of the image is one of the main approaches to adopt. It was held in 1895, the same year that the art merchant Samuel Bing founded the gallery L'Art Nouveau – La Maison Bing, a place not only for the dissemination of the established fashion of *japonisme*, but also for the affirmation of great masters and the incubation of the young international generation. Exhibitors included Edvard Munch, Auguste Rodin, Henri de Toulouse-Lautrec, Camille Claudel, Fernand Khnopff, Constantin Meunier, Félix Vallotton, Henri van de Velde, Théo van Rysselberghe and Édouard Vuillard.

At that time, Rodin, an artist who was prying sculpture away from the bonds of academic rhetoric, was involved in two extraordinary projects. In 1895 *The Burghers of Calais* was inaugurated in memory of the six burghers who were willing to sacrifice themselves to save their city. However, Rodin was not satisfied. He wanted to place his statues, he wrote, one behind another, in front of the town hall, right in the paved part of the square as a sort of living procession of suffering and sacrifice. The inhabitants of Calais would have almost brushed against them in passing and strongly felt the ancient solidarity binding them to these heroes. Rodin felt that this would have brought out the full power of his work. However, the authorities rejected this plan and forced him to place his statues on a pedestal that was

Constantin Brancusi
Mademoiselle Pogany, 1913
Bronze with black patina
on limestone base,
cm 43,8 × 21,5 × 31,7
The Museum of Modern
Art, New York
Acquired through
the Lillie P. Bliss Bequest

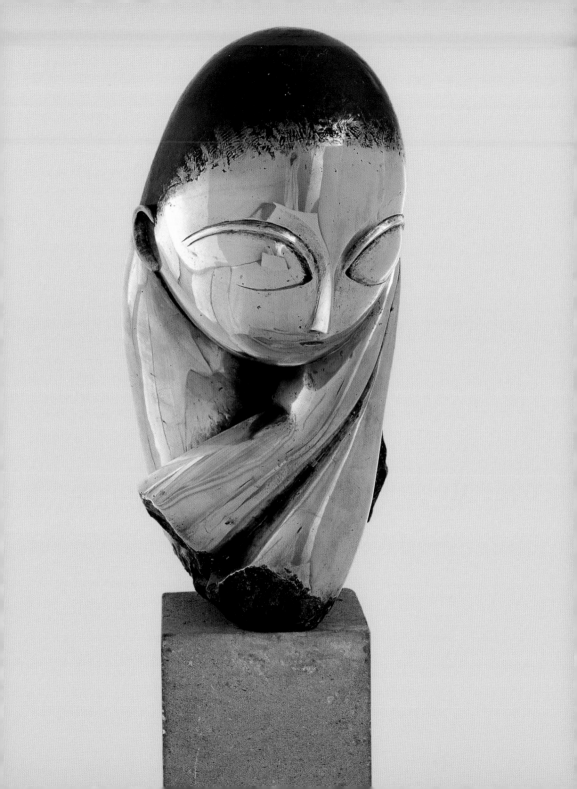

both inappropriate and ugly: a great mistake in the artist's eye. Other disappointments lay in store regarding the monument to Honoré de Balzac that Émile Zola commissioned him to do for the Société des Gens de Lettres. Much loved by Medardo Rosso, who was in Paris right at that time and found some time to spend with his colleague, and also by intellectuals such as Monet, Debussy, Signac and Clemenceau, the sculpture was attacked by those who felt that a monument must be celebratory and saw Rodin's as merely a rough rendition. It was not until 1939 that it was finally given a public location. Rodin sought to create sculpture that was intimately classical and as energetic and potent as ancient sculpture, a reinvention and not an imitation. After this momentary setback he would go on to be considered in the twentieth century the father of modern sculpture.

Among the artists hosted by Bing there was also the American Louis Comfort Tiffany, founder of a factory that produced coloured glass using historical techniques in line with the ideals predicated by the Arts & Crafts movement of William Morris. Tiffany was a pioneer of that which would be dubbed, by none other than the Bing gallery, Art Nouveau. At the 1895 Salon, Tiffany exhibited stained glass windows based on cartoons by Vuillard, Bonnard, Toulouse-Lautrec, Sérusier and Vallotton.

Henri de Toulouse-Lautrec gained success in 1891 as an *affichiste*, creating a poster for the Moulin Rouge, a famous nightspot that opened its doors in 1889. He later specialised in theatre bills and colour lithographs, a widely used technique since it was associated with the burgeoning market for cultural magazines. A prolific painter and graphic artist, he created a strong synthetic style, as well as an iconography dominated by the *demi-monde* that gravitated around the stage, the *café-concert* and the circus. These are the themes, along with the abrupt, lively colours of Toulouse-Lautrec's painting, that would influence the young Pablo Picasso. After having debuted at the Els 4 Gats cabaret in Barcelona, in 1900 Picasso took his first trip to Paris, setting up shop in the Montmartre district, where he would settle in 1904.

Max Jacob, Guillaume Apollinaire, André Salmon, Pierre Mac Orlan, Francis Carco and Roland Dorgelès are the young emerging intellectuals in the Montmartre circles, which orbited around several symbolic locations. Nightspots such as the Moulin Rouge, Le Chat Noir and Le Divan Japonais—where Yvette Guilbert debuted and was eternalised by Toulouse-Lautrec and also by Rosso—but especially Le Lapin Agile, all became, in a perfectly bohemian climate, the stomping grounds of writers and

artists such as Picasso and his fellow countrymen Juan Gris and Julio González, as well as Maurice Utrillo, Théodore Steinlen and Amedeo Modigliani. The Bateau-Lavoir was a bizarre building housing the studios of numerous artists. It was there in 1908, thanks to the initiative of Picasso, that a memorable soirée was held in honour of Henri Rousseau, nicknamed "Le Douanier" (the customs agent) because of his means of making a living. In spite of the fact that Rousseau had debuted in 1886 at the exhibition of the Indépendants, it was only thanks to the appreciation of his work by young artists like Picasso, Matisse, Derain and Delaunay—as well as by a writer no less irregular than he, Alfred Jarry, the author of *Ubu Roi* in 1894—that his style steeped in all its naïveté and exoticism, so wildly visionary as to make him a forerunner of the Surrealists, began to be seen as an authentic artistic position and not as mere uncultivated eccentricity.

Born in Livorno, Modigliani arrived in Paris in 1906 and became acquainted with Constantin Brancusi, in addition to the bohemia of Montmartre and then of Montparnasse. Brancusi arrived in Paris from Romania in 1904. Two years later he was noted by Rodin, Rosso, Maillol, Bourdelle and Despiau, and accepted into the Salon d'Automne, establishing in the meantime relations with the artistic colony of Montmartre. Brancusi worked within a primitive, essential idea of sculpture marked by extremely simplified forms in which the geometric interplay of the volumes and surfaces prevails over any idea of representation. Modigliani would follow him along this primitivist path, at first trying his hand at sculpture and then dedicating himself to a painting style whose hieratic simplifications evoke a feeling of primitive art, from Pre-Colombian to ancient Egyptian art, balanced by a strong and spare colour scheme, even at the expense of colouristic harmony. It would be Modigliani's painting that influenced many young artists arriving in Paris in the early 1910s from other countries: Chaïm Soutine, Michel Kikoine, Marc Chagall and Moïse Kisling.

In the meantime, other crucial events occurred. At the 1905 Salon d'Automne, Matisse, Vlaminck, Derain and Marquet earned the appellative *fauves*, or "ferocious beasts", for the disruptive force of their colours and the expressionist power of their works. In his Bateau-Lavoir studio, Picasso worked long on a large format painting, finally unveiling it to his friends one evening in 1907. The innovativeness of the work was so great that even his closest cohorts were left dumbstruck.

It was *Les Demoiselles d'Avignon*.

Vincent van Gogh
1. *Self-portrait*

Vincent van Gogh
2. *Wheatfield with Crows*

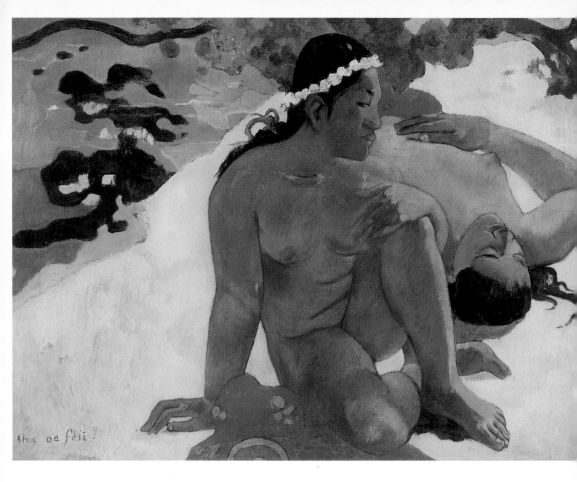

Paul Gauguin
3. Aha oe feii?
(What! Are you jealous?)

Paul Gauguin
4. Self-Portrait with Palette

Following pages
Georges Seurat
5. Un dimanche après-midi
à l'Île de la Grande-Jatte
(A Sunday on La Grande Jatte)

28

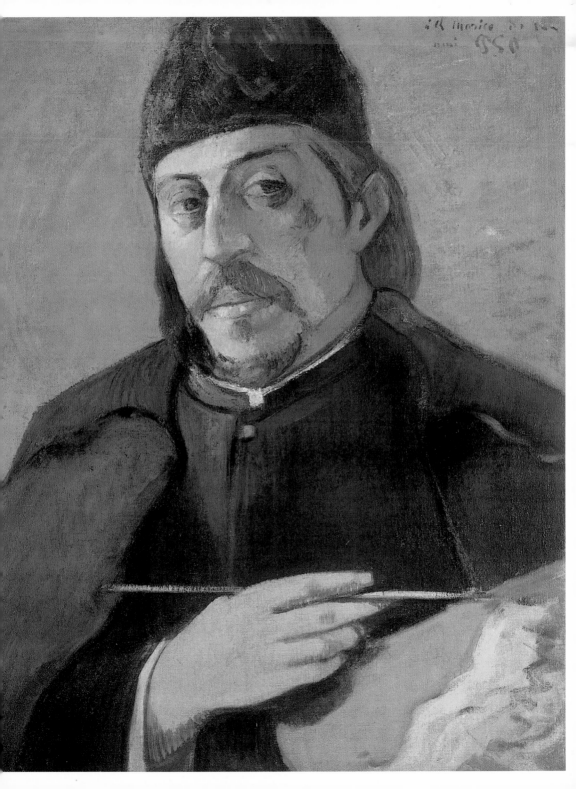

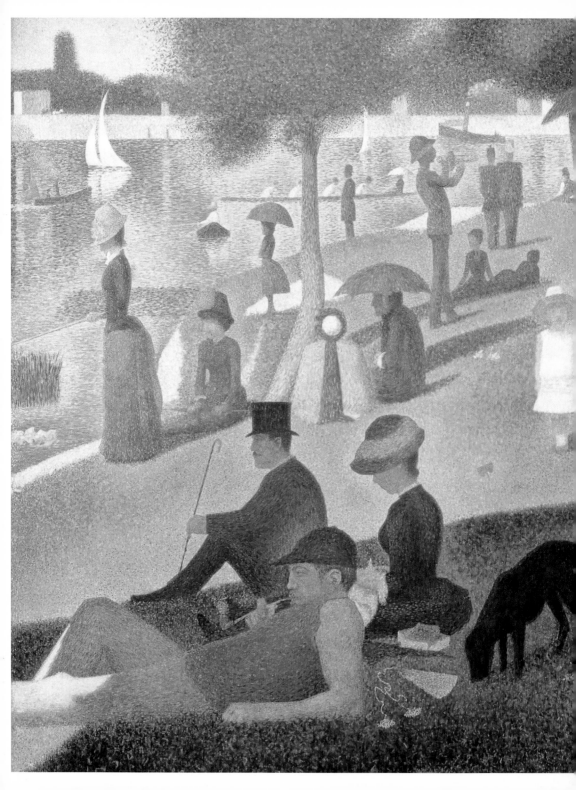

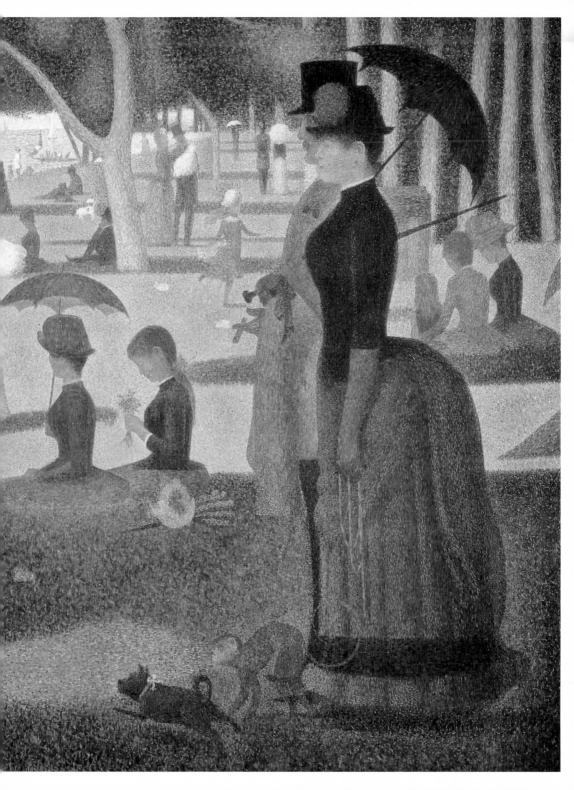

Paul Signac
6. *Opus 217. Against
the Enamel of a Background
Rhythmic with Beats and
Angles, Tones, and Tints,
Portrait of M. Félix Fénéon
in 1890*

32

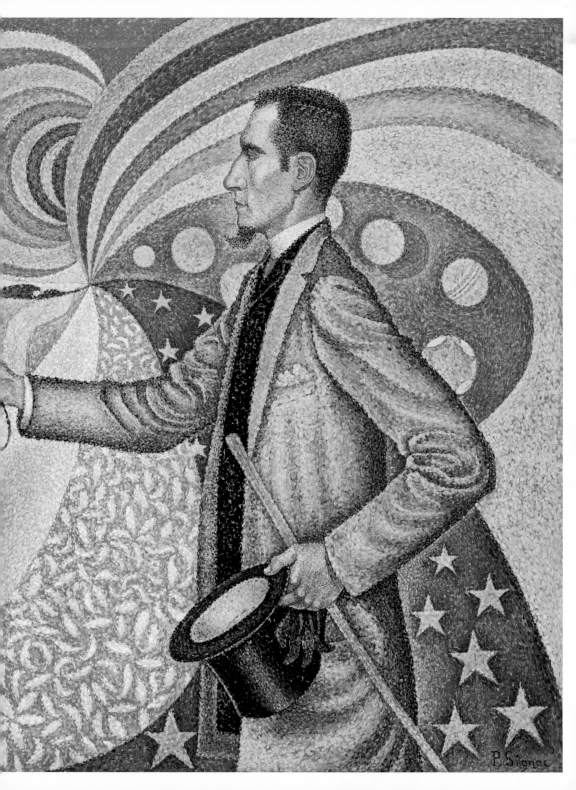

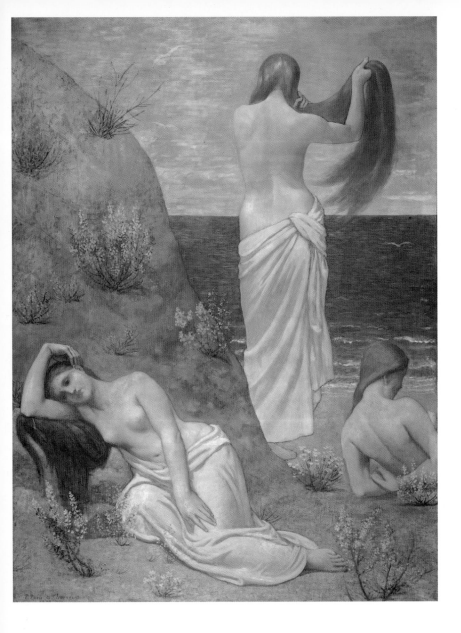

Pierre Puvis de Chavannes
7. *Young Girls at the Seaside*

Maurice Denis
8. *The Muses*

34

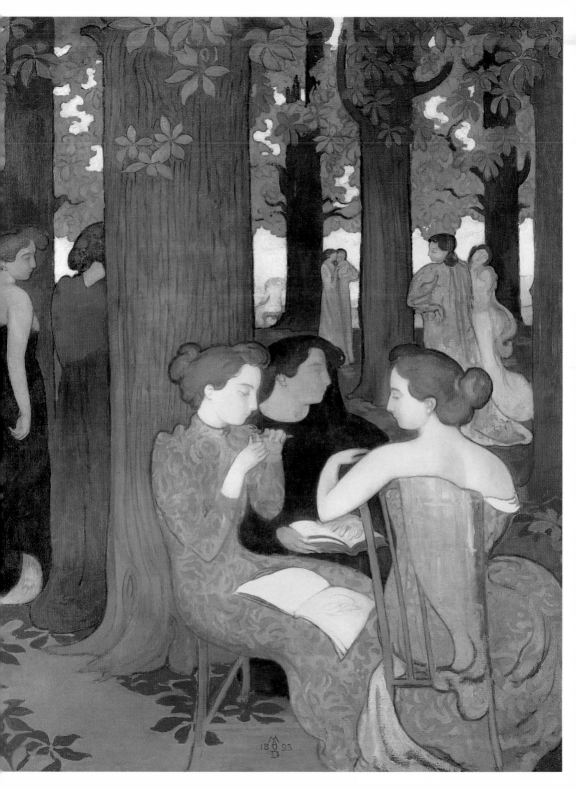

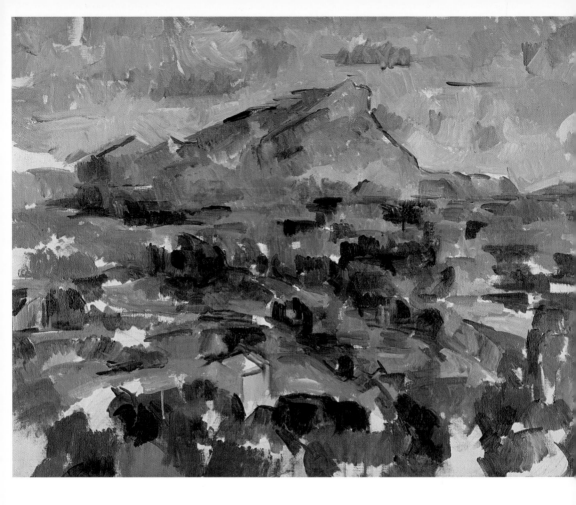

Paul Cézanne
9. *Mount Sainte Victoire*

Paul Cézanne
10. *Woman in Blue*

36

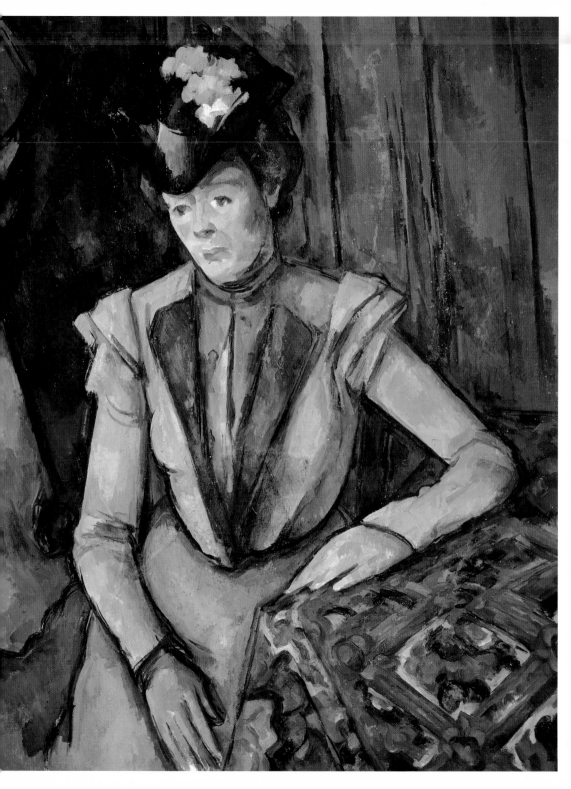

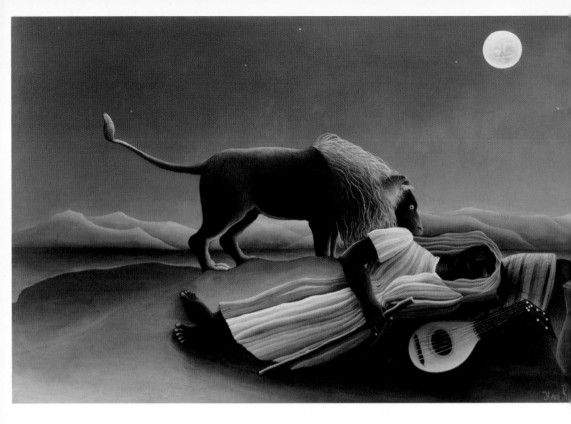

**Henri Rousseau
("Le Douanier")**
11. *The Sleeping Gypsy*

**Henri Rousseau
("Le Douanier")**
12. *The Snake Charmer*

38

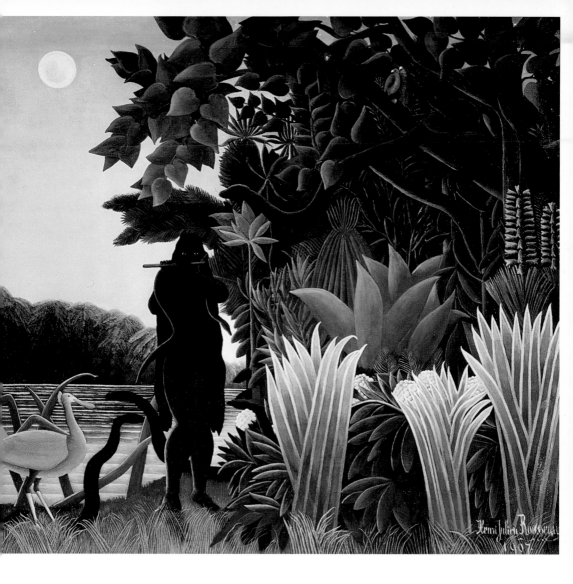

39

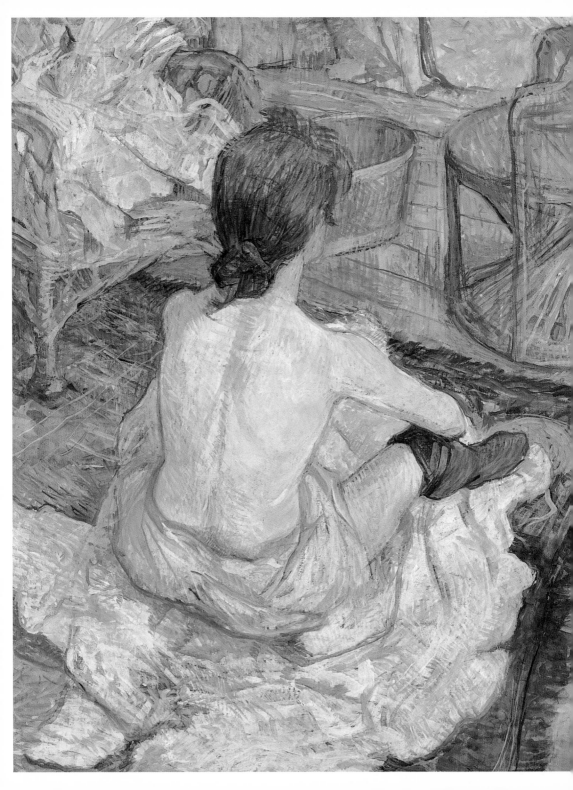

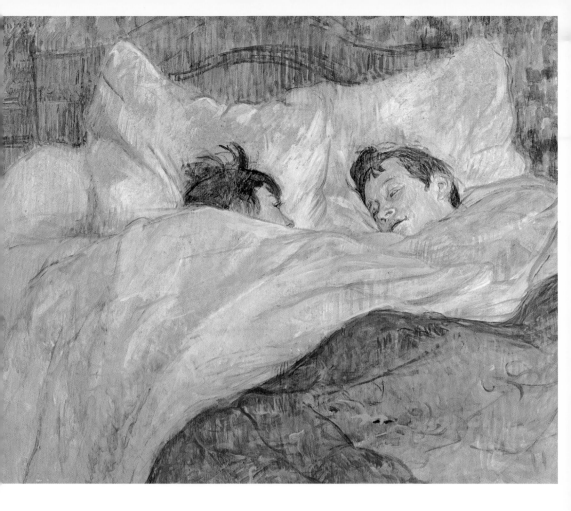

Henri de Toulouse-Lautrec
13. *La toilette*

Henri de Toulouse-Lautrec
14. *The bed*

Henri Matisse
15. *Luxe, Calme et Volupté*

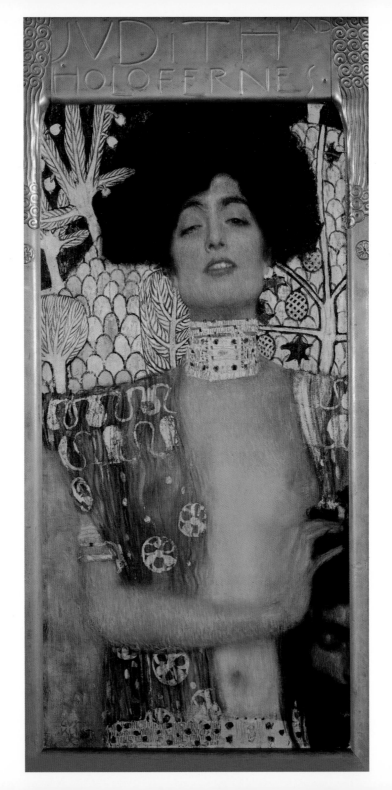

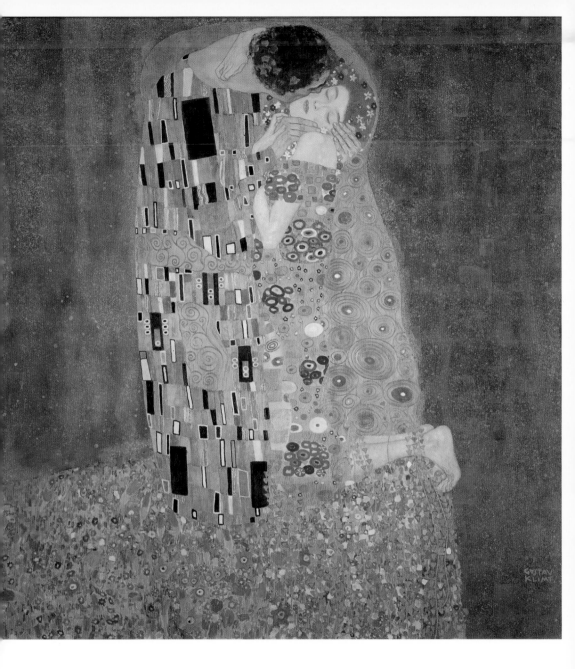

Gustav Klimt
16. *Judith with the Head
of Holofernes*

Gustav Klimt
17. *The Kiss*

45

Expressionism

"To paint an autumn landscape I will not try to remember what colours suit this season, I will be inspired only by the sensation that the season gives me." These are the succinct and effective words with which Henri Matisse explained his painting of the Fauve years, and with it the whole sense of Expressionist art, which released drawing and colour from the obligation of fidelity to the visible world and turned them into vehicles for pure streams of emotion. In the space of just a few years the Post-Impressionist milieu found one of its main directions, influencing many of the avant-garde movements in the process. The beginning of the century had seen a number of apparently unconnected events. In 1900 Antoni Gaudí, an exponent of Catalan Modernism, created the flamboyant decorations of the Parco Güell in Barcelona, reinventing nature in a visionary fashion that answered only to the artist's emotional needs, and in 1905 started work on the House Milá. In the same year of 1900 Wassily Kandinsky, Franz Marc and Paul Klee enrolled in the Munich Academy: just two years later, Kandinsky was to become president of the avant-garde group Phalanx and the *Frieze of Life*, a work of Symbolist derivation by the tormented Norwegian artist Edvard Munch, would be shown at the Berlin Secession. In the meantime, in a Paris in the grip of the myth of van Gogh, with a major exhibition of his work staged by Bernheim-Jeune in 1901, and of Gauguin, the dominant figure at Vollard's and the Salon d'Automne in 1903, a group of young painters was emerging who felt that they would be able to develop a completely new kind of painting from those models, as well as from the Neo-Impressionist lesson of Signac: their names were Henri Matisse, André Derain, Maurice de Vlaminck, Georges Braque, Albert Marquet, Othon Friesz, Raoul Dufy, Henri Manguin, Jean Puy, Kees van Dongen, Louis Valtat and Charles Camoin.

They worked largely *sur le motif*, "from life", but not with the aim of faithfully reproducing its visual appearance. What interested them, rather, was to focus on the immediate and emotionally direct sensation that the vision stirred in the artist's mind, and its transposition in a rapid and flowing style of painting, in which the drawing underwent anti-naturalistic syntheses and the colour was laid on in strong and jarring tones, with abrupt juxtapositions and impure blends. It was a lyrical attitude in which what mattered was the poetic shock, even though the subjects which they painted were those of the typical genres of the historical tradition: the landscape, portrait and still life. The handling of paint, however, was the central point,

along with a sense of synthesis in which the reference was no longer the new Impressionist and Post-Impressionist tradition, but a completely different range of stylistic references.

In those years a knowledge of and familiarity with folk arts and those of primitive peoples, especially from Oceania and Black Africa, which could be studied at the Musée de l'Homme in Paris and were keenly sought after by private collectors, showed that art was not necessarily based on harmonious compositions, perspective, chiaroscuro and accuracy of representation. Figuration could be brutally terse and colours perform a function that was not descriptive but ranged from the symbolic to the evocative, and therefore be conceived and perceived as autonomous values and not attributes of the image.

It was considerations of a similar nature that would shortly lead Picasso, a friend of Matisse, Vlaminck and Braque, to experiment with what would come to be generically known as *art nègre*, and to paint the picture *Les Demoiselles d'Avignon*.

The moment when this climate jelled

Franz Marc
Horses and Eagle
(detail), 1912
Oil on canvas, 74 × 98 cm
Sprengel Museum,
Hanover

was the Salon d'Automne of 1905, at which Vlaminck, Derain, Matisse, Manguin, Marquet, van Dongen, Puy and Valtat showed together (Rouault, although working along similar lines, preferred to show separately), presenting an island of violently coloured and extraneous paintings in the middle of the exhibition. Reacting polemically to such abnormality, the critic Louis Vauxcelles described the room of works by the young painters as a cage of *fauves*, of "wild beasts", providing the group with its first official name. Only years later, in 1911, did the term Expressionism begin to be used in explicit contrast to that of Impressionism: applied to the group of new French artists present at the exhibition of the Berlin Secession and to the young German painters who worked in a similar manner, the term would be used by Paul Ferdinand Schmidt in an article entitled "Über Expressionisten" published in the *Rheinlande* review. However, the definition came to indicate a much broader horizon of research than that of the small group of Matisse and his companions, and their German and Austrian colleagues, and would continue to do so for a long time. The tendency towards a new art freed from the shackles of tradition—the art of the century that had just started in which, to use the words of Franz Marc, the aim of artists was to create "symbols for their

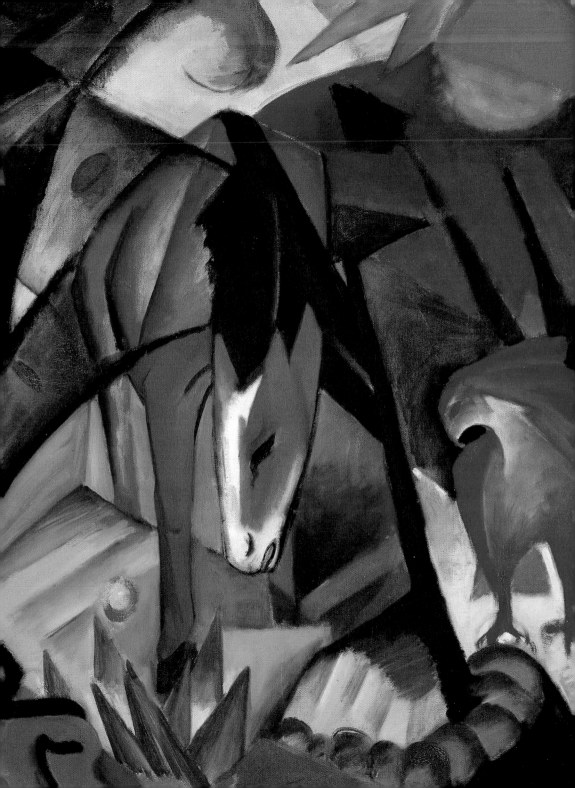

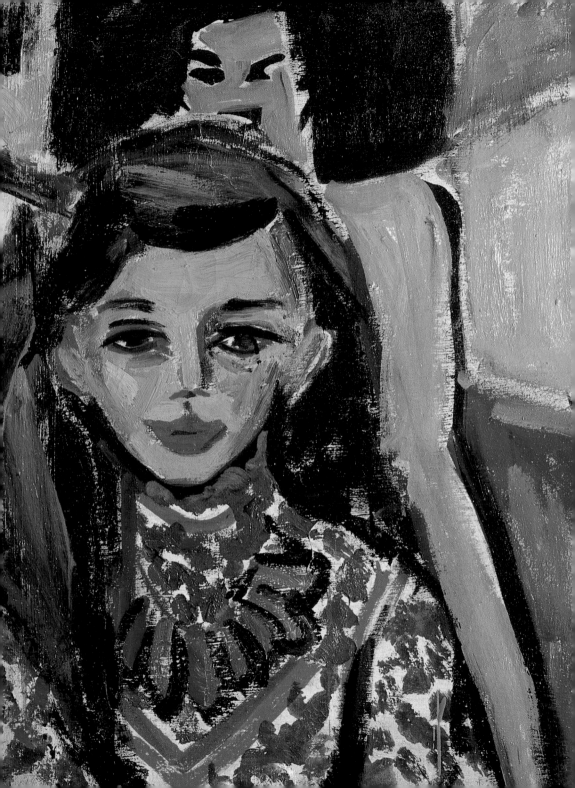

own time, symbols that belong on the altars of a future spiritual religion"—was a very widespread and ramified one, but unified by the domination of the emotionally individual element and by a lack of inhibition with respect to the technical and stylistic heritage of the past.

The mythology surrounding van Gogh's short life and tragic death had led people to see his work as reflecting a wholly psychological conflict between the artist and a society that did not understand him and that considered him, for this very reason, mad. He seemed to embody, for the minority who spurned bourgeois respectability and considered social rules to be a prison of individual freedom, the role that had belonged in history to the prophets and to the figure of the fool, that of being possessed by a burning truth which society rejected and strove to keep at its margins.

In Belgium James Ensor was producing a fiercely anti-conformist painting of acerbic symbolic value. In his monumentally agitated picture of the *Christ's Entry into Brussels in 1889* the artist is compared to Jesus Christ himself, the bearer of a revolutionary truth that society is unable to comprehend. Edvard Munch, who spent his time shuttling between France and Germany before withdrawing into isolation in his native Norway, developed a schematic and fluent style of painting in livid and brutal colours that made him a Nordic and introverted Gauguin, reflecting bitterly and sorrowfully on life and its meaning, on key values like the sacred, love, death and solitude.

A similar course, treading a fine line between symbolic research and a natural and ecstatic religiosity, was taken by the German Emil Nolde: "For wherever I turned my eyes nature, the sky, the clouds were alive, in each stone and in the branches of each tree, everywhere, my figures stirred and lived their still or wildly animated life, and they aroused my enthusiasm as well as tormented me with demands that I paint them."

At the beginning of the century there was even talk in Vienna of *Nervenkunst*, "nerve art", in a reference to the emotionally excited state in which painters were operating. Against this background the position of the French Fauves appears less moralistic and more focused on questions of style. Simplifying and expressively distorting forms, treating colour as an independent poetic force, doing away with all conventions of

Ernst Ludwig Kirchner
Fränzi in front of a Carved Chair (detail), 1910
Oil on canvas, 75 × 49 cm
Museo Thyssen-Bornemisza, Madrid

perspective, making no attempt to hide the imperfections and rapidity of the execution, rejecting any compromise with the technical etiquette of painting: these were the watchwords of the new tendency in art. In practice, the individual artists took very different approaches to Fauve painting, which was shortly going to have to contend with the Cubist revolution that was brewing in the studios of Picasso and Braque and with the ideas that were emerging from no less aggressive avant-garde movements like Futurism. While Picasso, who was moving in a direction all of his own that eventually led him to reflect on the possibilities of unshackling colour from the fetters of representation, did not yet feel ready to abandon the requirements of verisimilitude, among the Fauves artists like van Dongen and Vlaminck thoroughly explored the potential of a drawing deformed to the point of the grotesque and a range of harsh and acid colours, oscillating between a deliberate vulgarity and explicitly sensual values. Still others, like Marquet and above all Matisse, set out to distil such possibilities and use them to construct a new stylistic order.

By far the most influential personality in this area was Matisse. In his work the expressive deformation of the subject took on sumptuously decorative, exotic and sensual implications, rather than those of emotional upheaval. He chose genre subjects, from the landscape to the portrait to the interior scene, and reworked them into luxuriant symphonies of colour in which the line carved seductive intarsias. In 1908 he wrote explicitly that he was dreaming of "an art of balance, of purity and serenity devoid of troubling or depressing subject matter, an art which might be for every mental worker, be he businessman or writer, like an appeasing influence, like a mental balm, something like a good armchair in which to rest from physical fatigue".

Over the space of a few years his painting grew more structured and came to be rooted in a highly simplified iconography, reminiscent of the primitive arts, that was capable of creating abstraction out of the natural through the pure, lush interplay of colours in sonorous tones. Derain, another great Fauve painter who a few years later was to play a leading role in the return to order, also immediately played down the movement's excesses of gesture and colour in favour of more stable balances of forces and harmonies of tone.

The models of Cézanne, Gauguin and van Gogh were also crucial for the German artistic world. In 1905 a group of fifty works by van Gogh was shown at the Arnold gallery in Dresden and the same year saw the birth of the group called Die Brücke,

"I had little thought for houses
and trees, drawing coloured lines
and blobs on the canvas
with my palette knife, and making
them sing just as powerfully as
I knew how. In my ears resounded
that fatal hour in Moscow,
in my eyes I saw again the strong
and intense colours of
the atmosphere of Munich and
the deep thunder of its shadows."

Wassily Kandinsky

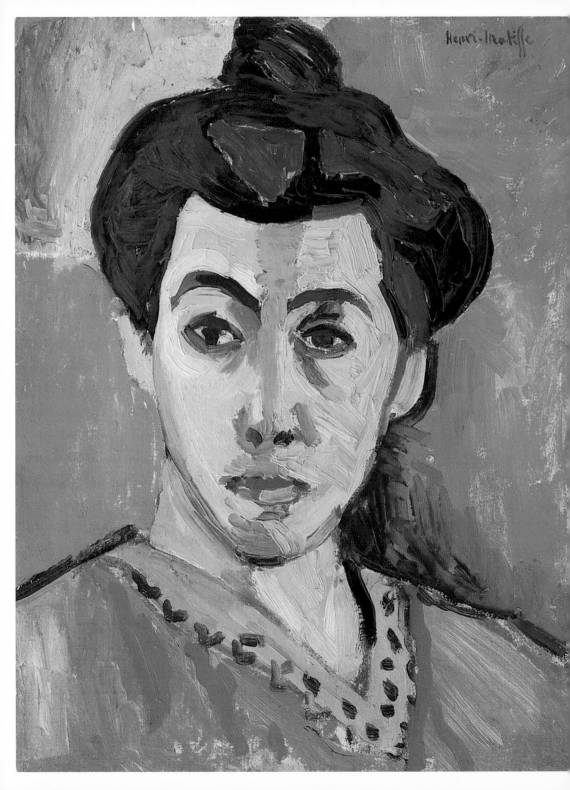

literally "The Bridge", a bridge built into the future. It was founded by the architectural students Ernst Ludwig Kirchner, Fritz Bleyl, Erich Heckel and Karl Schmidt-Rottluff. The French models were combined, in the German group's aggressive pursuit of innovation, with other references: the painting of Munch, who held an exhibition at the Sächsischer Kunstverein in 1906, and that of the already mature Nolde, whose at once mystical and agitated naturalism induced the members of Die Brücke to ask him to join their group. In contrast to their French colleagues, the young artists of Dresden declared their explicitly ethical intentions, making their opposition to official culture a genuine element of revolt.

Henri Matisse
Green Stripe (Portrait of Madame Matisse), 1905
Oil on canvas, 40 × 32 cm
Statens Museum
for Kunst, Copenhagen

Whence their predilection for subjects like city life, presented as empty and superficial in images that verged on the grotesque—Kirchner caused a scandal with his elegant, livid streetwalkers—contrasted with a nature seen as the source of a fresh purity. Whence, too, the overt choice to draw on the primitive arts, whose inelegant schematism was opposed to the simpering ways of academic painting: the colours were taken to extremes of jarring dissonance and given an impurity of tone that stopped them from being pleasing to the eye. All this stemmed from a precise system of working, which Kirchner summed up as follows: "First of all I needed to invent a technique of grasping everything while it was in motion, and here I took suggestions from Rembrandt's drawings in the collection of engravings in Munich. I practised seizing things quickly in bold strokes, wherever I was, while walking or standing still, and at home I made larger drawings; and in this way I learned how to depict movement itself, and I found new forms in the ecstasy and haste of this work, which, without being naturalistic, yet represented everything I saw and wanted to represent in a larger and clearer way. And to this form was added pure colour, as pure as the sun generates it.

An exhibition of French Neo-Impressionists caught my attention: I found the drawings rather weak, but studied the theory of colour based on optics only to come to the opposite conclusion, that of making the eye produce non-complementary colours and complementary ones, in accordance with Goethe's theory. This makes the pictures much more colourful."

The group carried out an active programme of proselytizing and propaganda, leading to the co-opting in 1906 of Cuno Amiet, Max Pechstein

"Nature is everywhere, in us and outside us; there is only one thing that is not altogether nature, but rather the overcoming and interpreting of nature: art. Art always has been and is in its very essence the boldest departure from nature and 'naturalness'. It is the bridge into the spirit world, the necromancy of the human race (…)."

Franz Marc

and the Finnish artist Axel Gallén-Kallela, in addition to Nolde; in 1910 it would be the turn of Otto Müller, whose obsession with the theme of the nude represented in a natural setting and in forms that verged on the iconography of naïve art became almost a symbol of the natural mysticism they were all pursuing. Müller was, like the other members of the group, a skilled engraver and lithographer as well as painter. For the artists of Die Brücke the decision to practise graphic art systematically, and even to revive and give new lifeblood to the technique of xylography, the art of engraving on blocks of wood, represented a reclamation of an expression of popular culture that was considered inferior and a tradition that dated back to the incendiary times of the Protestant Reformation. It was a rejection of bourgeois values, but a move that was also made on the basis of precise stylistic choices.

As Kirchner put it: "The desire that leads the artist to work with graphics is perhaps in part an effort to fix the unique and indefinite character of the drawing in a definitive and solid form. The mysterious fascination that surrounded the invention of printing in the Middle Ages is still felt today by anyone who devotes himself seriously to graphic art, supervising every detail of its execution by hand."

Like the Fauve movement, Die Brücke has to be considered a period of transition in the evolution of the individual artistic personalities. The group broke up not long afterwards, in 1913. At the same time the spirit of collaboration in a key of opposition to official culture that characterized the young generation also found expression in Munich, which vied with Berlin for the role of Germany's cultural capital.

In January 1909 a group of artists was formed with the intention of "organizing exhibitions of art in Germany and abroad and supporting them with lectures, publications and other initiatives" in a key of affirmation of the new. The founding members of the group, which took the name of Neue Künstlervereinigung München, "New Artists' Association of Munich", were Alexey von Jawlensky, Alexander Kanoldt, Adolf Erbslöh, Marianne von Werefkin, Wassily Kandinsky and Gabriele Münter. The programme was very explicit: "We start from the idea that the artist, besides the impressions he receives from the outer world, from nature, is constantly gathering experiences in an inner world. The search for artistic forms to express the interpenetration of all these experiences, forms that must be free of all unessential aspects so as to emphasize only the essential—in brief, the striving for an artistic

synthesis—seems to us a motto that is now once again spiritually uniting more and more artists."

The group's first exhibition opened in December 1909 at the Moderne Galerie Thannhauser in Munich and then travelled to many German cities. The poster was designed by Kandinsky. At the second exhibition, which was held at Thannhauser's gallery again in September 1910, Braque, Picasso, Rouault, Derain, Vlaminck and van Dongen were among the artists invited to take part. The catalogue contains several prefaces, from which Kandinsky's stands out: "At an indeterminable hour and from a source that is mysterious to us today, but inevitably, the Work came into the world. Cold calculation, splashes of colour that shoot at random, mathematically exact construction (clear or hidden), silent or noisy drawing, scrupulous execution; colours played with a fanfare or pianissimo with the violin, large, serene, balanced, shattered surfaces. Is this not the form? Is this not the medium? Souls that suffer, that seek, that agonize, with a profound anguish provoked by the clash of the spiritual with the material. The rediscovered. The life of living nature

Antoni Gaudí
Casa Milá (*La Pedrera*)
(detail of the chimneys),
1905-10
Barcelona

and dead nature. Consolation in the phenomena of the world: outer, inner. Presage of joy. The calling. Speaking of mystery through mystery. Is this not the content? Is it not the conscious or unconscious goal of the urgent creative impetus? Woe betide anyone who has the power to put the necessary words in the mouth of art and does not do so. Woe betide anyone who turns the ear of his soul away from the mouth of art. Man speaks to the man of the superhuman—the tongue of art."

This spiritual vehemence, and the quarrelsomeness typical of the avant-garde groupings of the time, soon led Kandinsky, Jawlensky and Münter, who were joined by August Macke and Franz Marc, to set up Der Blaue Reiter, "The Blue Rider". The group's first show, held at the Moderne Galerie Thannhauser in 1911, included works by artists like Le Douanier Rousseau and Heinrich Campendonk as well as, in the guise of a painter, the composer Arnold Schoenberg.

Kandinsky and Marc, leaders of the group, worked untiringly to gather as many artistic innovators around them as possible. At the second exhibition of Der Blaue Reiter, held at the Goltz gallery in the spring of 1912, the decision was taken to show only graphic works, but the artists of the Blaue Reiter were joined

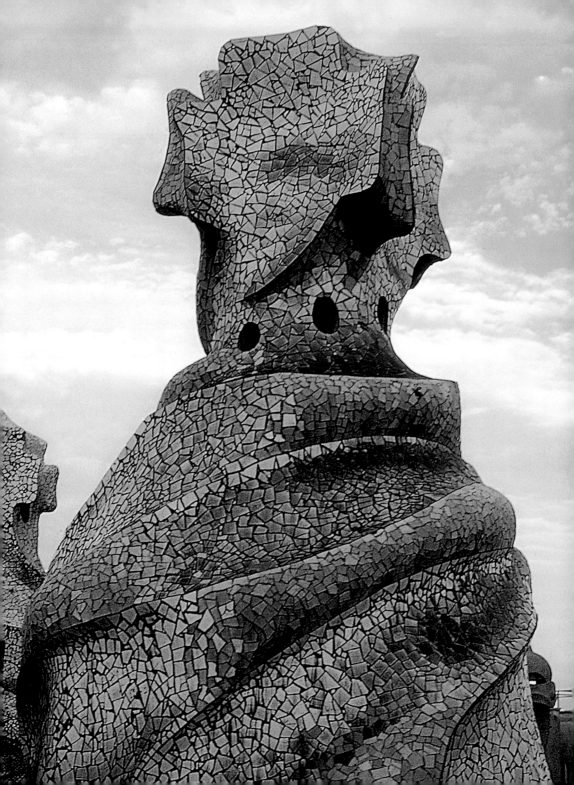

by those of Die Brücke as well as Braque, Derain, Picasso, Vlaminck, Arp, Klee, Kubin and Malevich. Expressionist and Cubists painters exhibiting side by side should not surprise us if we consider that, at that moment, it was far more important for the aggressive young generation to mark out the boundaries of what was acceptable as avant-garde art by contrasting it *in toto* with the official, late-academic, aestheticizing kind.

It is no coincidence that, even on the pictorial plane, the tension that Kandinsky and Jawlensky manifested in their paintings mixed elements of traditional Russian sentimentalism with van Dongen's Fauve emphasis on colour and the Neo-Impressionist style of painting in short strokes or dots, while Münter took his inspiration explicitly from Matisse and Marc explored a formulation of geometric schematizations that were influenced by the new Cubist and Futurist painting.

Kandinsky wrote of those years: "I had little thought for houses and trees, drawing coloured lines and blobs on the canvas with my palette knife, and making them sing just as powerfully as I knew how. In my ears resounded that fatal hour in Moscow, in my eyes I saw again the strong and intense colours of the atmosphere of Munich and the deep thunder of its

shadows." And Marc: "I am trying to intensify my feeling for the organic rhythm of all things, to achieve pantheistic empathy with the throbbing and flowing of nature's bloodstream in trees, in animals, in the air. I am trying make a picture out of it with new movements and with colours that make a mockery of our old easel painting." And again: "Nature is everywhere, in us and outside us; there is only one thing that is not altogether nature, but rather the overcoming and interpreting of nature: art. Art always has been and is in its very essence the boldest departure from nature and 'naturalness'. It is the bridge into the spirit world, the necromancy of the human race. We no longer depend on the image of nature. We destroy it to show the great laws that hold sway behind its beautiful appearance." We already get a sense in the words of Marc, who was destined to meet an untimely death in the First World War, of what Kandinsky was shortly to realize in full, the setting aside of any tangible reference in favour of an abstract art filled with a sense of the spiritual, of the magic of nature, independently of its forms. In 1911 Marc also wrote an article entitled "Die Wilden in Deutschland" ("The Fauves in Germany"), in which he tried to take preliminary stock of the achievements of German Expressionism. The centre of the movement was, in his view, not

Dresden or Munich but the cosmopolitan Berlin, home to the New Secession, the grouping set up in 1898 to bring together all the artists opposed to the policy on art favoured by Emperor Wilhelm II.

As early as 1901 an exhibition of van Gogh's work at the Secession and one of Cézanne at the associated Cassirer gallery had attracted criticism from the emperor: the following year the same thing had happened with Munch at the Secession and Alfred Kubin at Cassirer.

The Secession comprised German and foreign artists like Barlach, Beckmann, Feininger, Kandinsky, Käthe Kollwitz, Munch, Nolde, Amiet, Bonnard, Denis, Matisse and Rohlfs, and showed works by Die Brücke and the Munich group as well as by Braque, Dufy and Picasso. Its activities were flanked by that of the weekly *Der Sturm*, which soon also began to organize exhibitions of artists like the Austrian Oskar Kokoschka, main exponent of the new generation of Viennese artists along with Egon Schiele, Klimt's tormented pupil whose paintings caused a scandal with their brutal flaunting of the human body in all its wretched physicality. Here, in 1912, an exhibition of the Futurist movement was held. It was in this milieu, stimulated a few years later by the contribution of the Dada experience, reflecting a politicization that the Great War was to render more and more overt, that artists like George Grosz and Otto Dix, Max Beckmann and Christian Schad matured: protagonists in the years to come of other avant-garde movements, they took from the Expressionist lesson the sense of an art with a high spiritual content, one that did not accept reality as it was but challenged it with its own polemical passion. In 1918 the legacy of Expressionism gave rise to the Novembergruppe, and this was followed in 1924 by the Rote Gruppe, the "Red Group". Both were politically revolutionary in their outlook, and it was under their umbrella that artists like Grosz, Dix and Beckmann operated. Their fiercely visionary attitude, which in an artist like Schad turned into gelid and deathly imagery and which was translated into cinematographic language in Fritz Lang's memorable *Metropolis*, was to influence art for a long time to come. Its echoes can be found in such close heirs as the American Ben Shahn and in the Italian Transavanguardia and the German Neue Wilden, "New Fauves", of the 1980s.

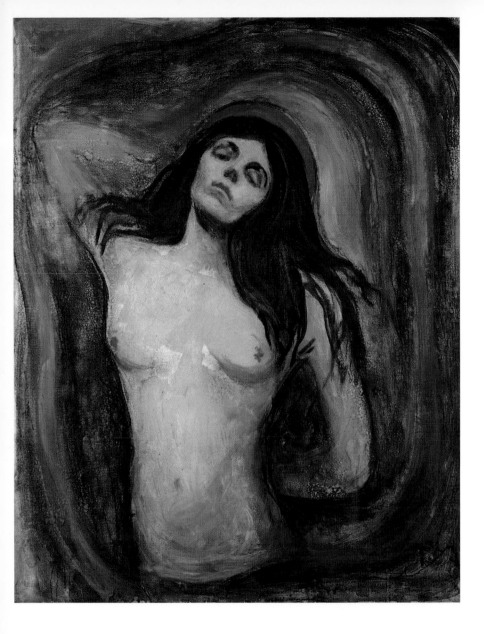

Edvard Munch
1. *Madonna*

Edvard Munch
2. *The Scream*

Following pages
James Ensor
3. *Christ's Entry
into Brussels in 1889*

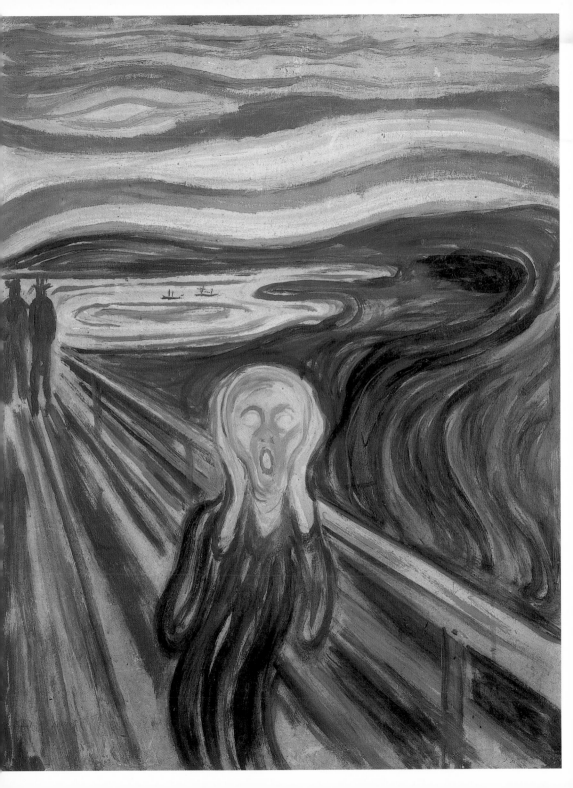

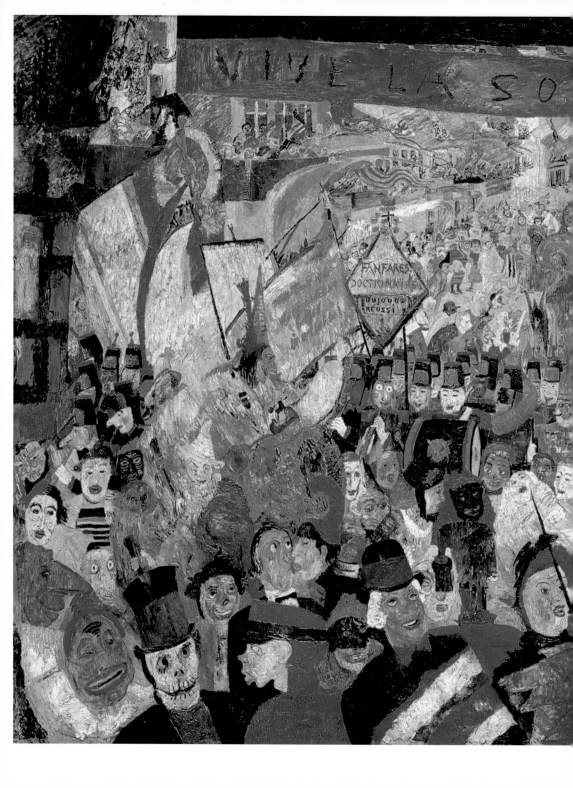

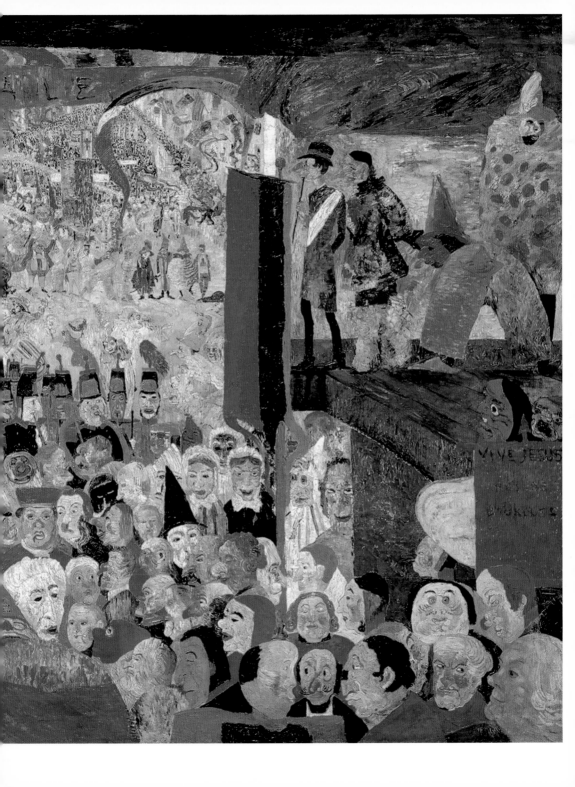

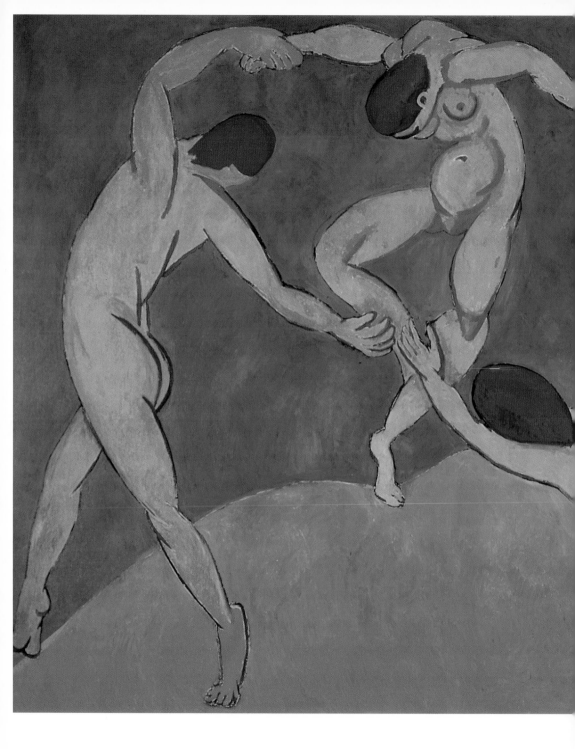

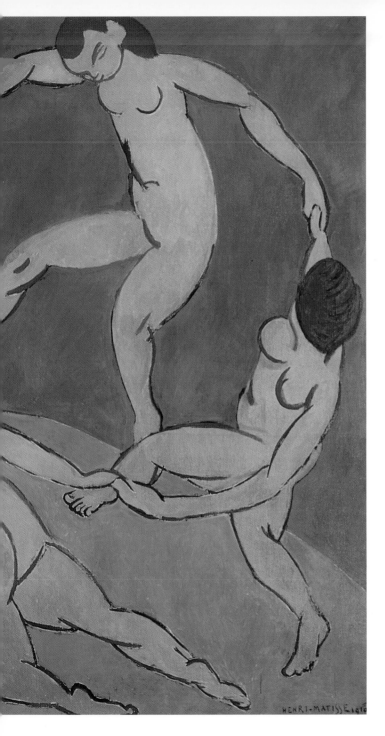

Henri Matisse
4. *The Dance*

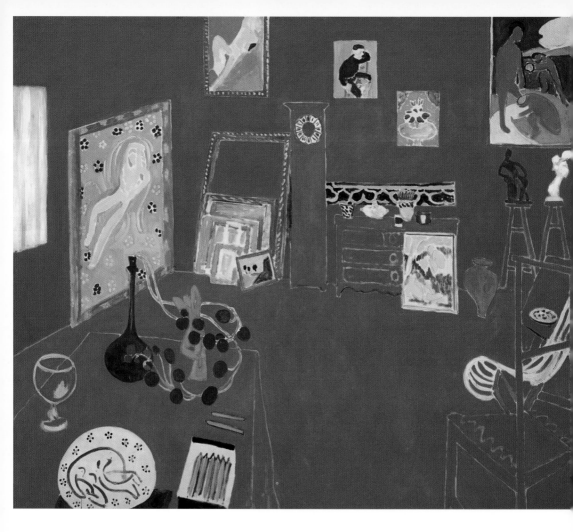

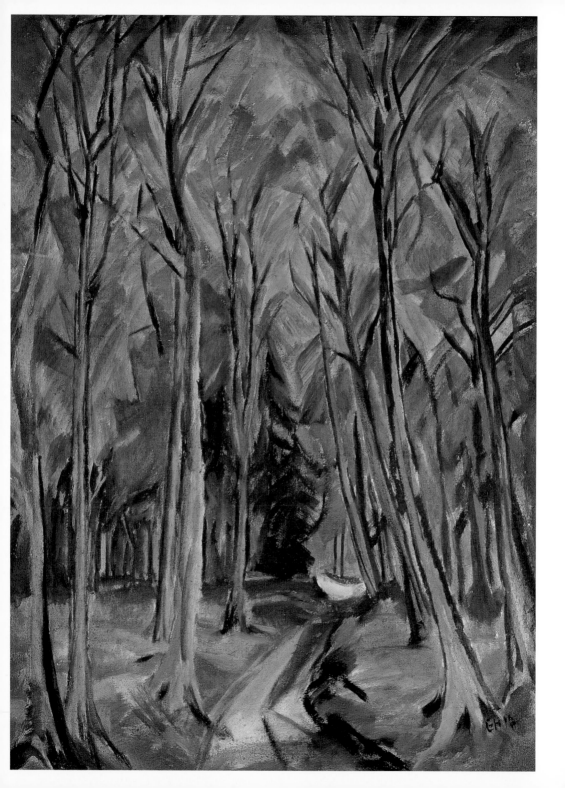

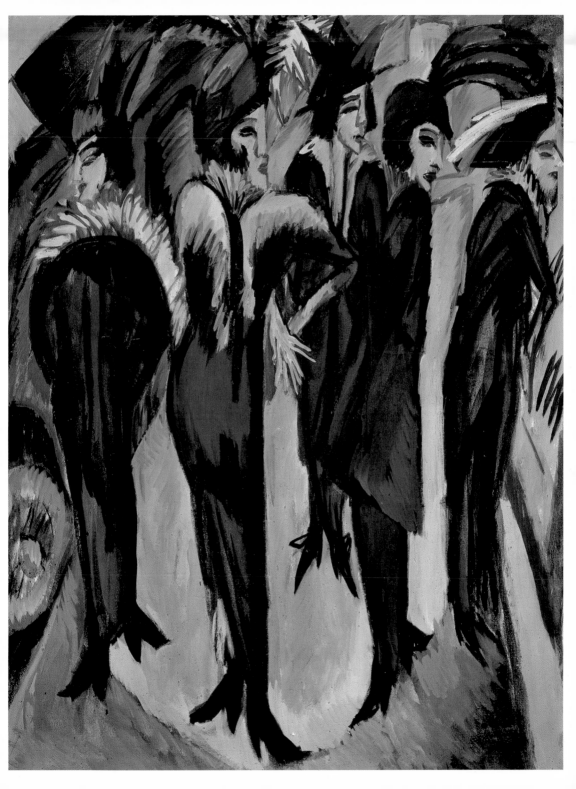

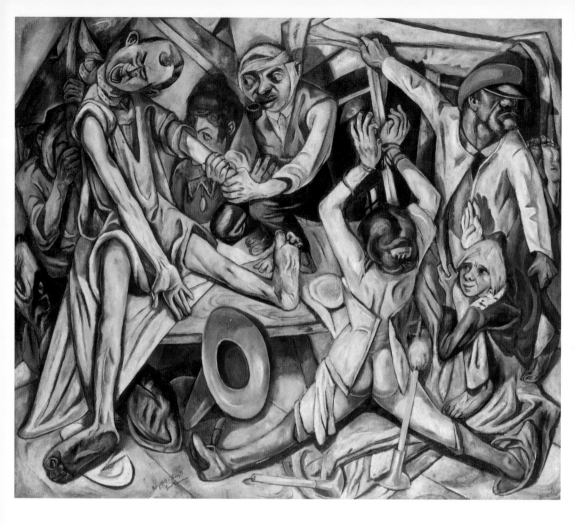

Max Beckmann
13. *The Night*

Christian Schad
14. *Self-portrait with Model*

Futurism

aris, 20 February 1909. An article by the young Italian poet Filippo Tommaso Marinetti, until that moment known as the author of poems in the Symbolist style that are moreover considered much inferior to those of the far more famous Gabriele d'Annunzio, appears on the front page of the newspaper *Le Figaro*. It is the text of the "Manifesto of Futurism", the movement with which Marinetti intends to challenge the Parisian avant-gardes by proposing not a new kind of literature and art, but a new way of living, and one that expresses the new collective myth of modernity through and through.

The key passages of the "Manifesto" run as follows: "We want to sing the love of danger, the habit of energy and rashness. The essential elements of our poetry will be courage, audacity and revolt. Literature has up to now magnified pensive immobility, ecstasy and slumber. We want to exalt movements of aggression, feverish sleeplessness, the double march, the perilous leap, the slap and the blow with the fist. We declare that the splendour of the world has been enriched by a new beauty: the beauty of speed. A racing automobile with its bonnet adorned with great tubes like serpents with explosive breath... a roaring motor car which seems to run on machine-gun fire, is more beautiful than the Victory of Samothrace.

We want to glorify war—the only cure for the world—militarism, patriotism, the destructive gesture of the anarchists, the beautiful ideas which kill, and contempt for woman. We want to demolish museums, libraries and academies of all kinds, fight morality, feminism and all opportunist and utilitarian cowardice. We will sing of the great crowds agitated by work, pleasure and revolt; the multi-coloured and polyphonic surf of revolutions in modern capitals: the nocturnal vibration of the arsenals and the workshops beneath their violent electric moons: the gluttonous railway stations devouring smoking serpents; factories suspended from the clouds by the thread of their smoke; bridges with the leap of gymnasts flung across the diabolic cutlery of sunny rivers: adventurous steamers sniffing the horizon; great-breasted locomotives, puffing on the rails like enormous steel horses with long tubes for bridle, and the gliding flight of aeroplanes whose propeller sounds like the flapping of a flag and the applause of enthusiastic crowds. "It is from Italy that we are issuing this manifesto of ruinous and incendiary violence, by which we today are founding FUTURISM, because we want to deliver Italy from its gangrene of professors, archaeologists, tourist guides and antiquaries. Italy has been too long the great second-hand market. We want to get rid of the innumerable museums which cover it with innumerable cemeteries."

This was, it is plain, an attitude deeply imbued with political ideas, exalting speed, machinery, movement, violence and the myth of the revolutionary individual and demiurge who imposes his own will on history, typical of a historical climate that was to give birth, following different paths, to fascism.

In the world of culture it was an extreme position. If the term avant-garde itself had been transferred from military jargon to that of the arts, Marinetti proposed an avant-garde to which politics and acts of war were not extraneous. And he did so in a world that was seeing a mounting tide of different forms of revolution, from anarchism to socialism and various kinds of nationalism, and in which the approach of war was in the air.

Marinetti published the "Manifesto" in Paris because that was where the most lively avant-garde debate was taking place, but he worked in Milan, where since 1905 he had edited and funded the review *Poesia*. Up until 1909 this had focused largely on Symbolism, publishing authors like Kahn, Mendès, Pascoli, d'Annunzio and Gozzano. In Paris moreover, again in 1909, he had published his first Futurist novel, which came out in Italian the following year under the title *Mafarka il futurista*.

The hero of the story, set in Africa against a classical colonial background, is a superman who asserts that it is necessary to "believe in the absolute and definitive power of the will, which has to be cultivated, intensified, by following a cruel discipline" up until the "violent death that crowns youth". Only this makes men real men and not "wretched slaves of the vulva": not love, but heroism and the sensual pleasure of a glorious death are the supreme values. Put on trial for obscenity, as the book was filled with rapes and orgies and pervaded by a sort of bleak eroticism, *Mafarka il futurista* perfectly fulfilled, along with the "Manifesto", the polemical goal which the author had set himself, that of becoming the point of reference for a group of young men who intended to make an aggressive impact on the cultural scene, largely by getting it to reject them. Marinetti knew that bohemianism was a form of marginalization of the artist that society tolerated and cultivated: what was needed, now, were actions that would irritate the orthodox world, and authors whose very lack of success (or, as in the case of *Mafarka*, legal persecution) could be interpreted as a self-evident sign of the mediocrity of official culture. Marinetti preached the "delight of being heckled", and with his first followers, the painters Umberto Boccioni, Carlo Carrà and Luigi Russolo, and poets like Aldo Palazzeschi

Giacomo Balla
Numbers in Love
(detail), *circa* 1924
Oil on canvas, 77 × 55 cm
MART – Museo d'Arte
Moderna e Contemporanea
di Trento e Rovereto,
Rovereto

80

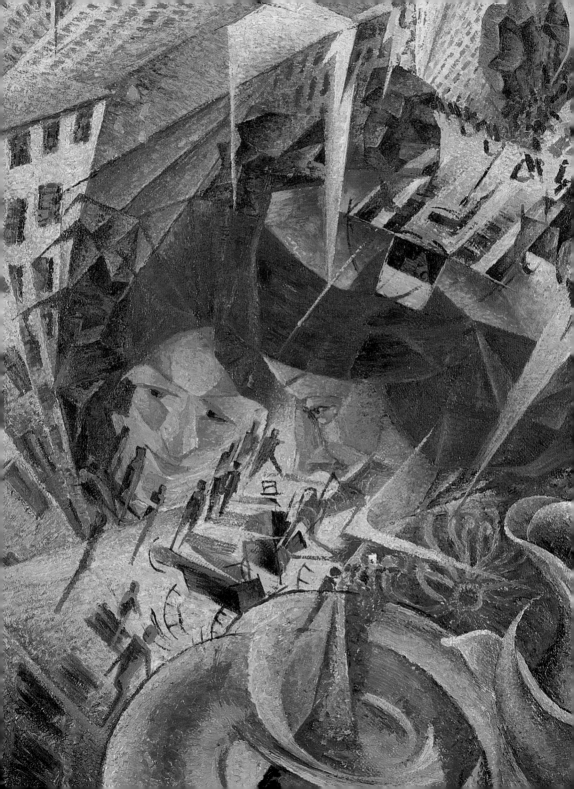

and Corrado Govoni, launched the series of "Futurist evenings". These were duly publicized events somewhere between theatre and cabaret at which the Futurists declaimed derisory and violent texts ment to provoke the audience into making riotous protests, in a game of play-acting in which the artists could win kudos by getting themselves talked about in the newspapers and scandalizing the respectable world. These initiatives also spilled out of the theatres, taking on the character of genuine happenings: the most famous would be the dropping of leaflets from the campanile of St. Marks onto the crowd beneath: entitled "Against Past-Loving Venice", they called for the canals to be filled with the rubble from the old palaces in order to "prepare for the birth of an industrial and militarized Venice", capable of dominating the Adriatic. Marinetti continued along this course, focusing more and more on an indefatigable work of propaganda and proselytizing and establishing an international network of artists with Futurist sympathies that extended from Russia to Portugal.

Umberto Boccioni
Simultaneous Visions
(detail), 1911
Oil on canvas, 60.5 × 69.5 cm
Von der Heydt-Museum,
Wuppertal

On the plane of expressive activities he theorized in 1912, in the *Technical* "Manifesto" of *Futurist Literature*, about what he called *parolibere*, "words-in-freedom", since "we must destroy syntax by scattering nouns at random, as they are born", also bringing in the possibilities offered by the art of typography. Exemplary of this, in 1914, was *Zang Tumb Tumb*, an account of a battle in the war lacking any punctuation and syntax and with the words arranged on the page in such a way as to create a powerful visual effect. Literary experiments like these, although of brief duration, earned Marinetti the support of other authors, like Ardengo Soffici and Giovanni Papini, and magazines like *Lacerba*.

But it was on the front of the visual arts that Futurism was at its best. Boccioni, Carrà and Russolo were joined by Giacomo Balla and Gino Severini, each of whom followed his own remarkable course of development.

Among other things, the "Manifesto of Futurist Painters", published in 1910, declares: "We will fight with all our might the fanatical, senseless and snobbish religion of the past, a religion encouraged by the vicious existence of museums. We rebel against that spineless worshipping of old canvases, old statues and old bric-a-brac, against everything which is filthy and worm-ridden and corroded by time. We consider the habitual contempt for everything which is young, new and burning with life to be unjust and even criminal."

The artistic culture of Italy at the beginning of the 20th century was oppressively academic. The spearheads of innovation were represented by the bohemian rebelliousness of the Scapigliati, with their languid and tormented subjects, and, at its best, the Divisionist art of Giovanni Segantini, Pellizza da Volpedo and Gaetano Previati. These last, in a manner similar to the French movement of the same name, also known as Pointillism, constructed their images out of a subtle mesh of divided filaments of distinct colours, bestowing a new solidity and luminosity on the work. From the viewpoint of their subjects, these paintings varied from moments of explicit allegory to others in which what predominated was the reflection of a new social engagement that chose to represent the world of the humble, of the marginalized, of labour.

"Everywhere bad taste and pretentious ignorance mixed up with a sort of mania for a painting of stews and pickles": this was Carrà's pitiless verdict. Futurism countered the stews and pickles with an evolution of the Divisionist technique, intensifying it to the point of turning it into an agitated mosaic of pure colours traced with dynamic lines, in which diagonals and curves predominated: while Pellizza da Volpedo, a fellow student of Balla's, and Previati,

who Boccioni regarded as an older brother, still constructed the picture according to strict rules of composition and set themselves the goal of a clear and static vision, for the Futurists everything changed: "For us the gesture will no longer be an *arrested* moment of universal dynamism: it will clearly be the *dynamic sensation* itself made eternal. All things move, all things run, all things are rapidly changing. A figure is never motionless before our eyes, but constantly appears and disappears. On account of the persistency of an image upon the retina, moving objects constantly multiply themselves; their form changes like rapid vibrations, in their mad career. Thus a running horse has not four legs, but twenty, and their movements are triangular." This is what Boccioni, Carrà, Russolo, Balla and Severini wrote in the "Technical Manifesto of Futurist Painting", signed on 11 April 1910. The first Futurist exhibition with the five signatories of the manifesto was held in 1912 at the Galerie Bernheim-Jeune in Paris, before moving on to London and Berlin. It was in this period that Ferruccio Busoni, a composer who in his theoretical text *Sketch of a New Aesthetic of Music*, 1906, had called for renewal in terms not dissimilar from those of the Futurists, bought Boccioni's *The City Rises*: one of the last pictures painted by Boccioni, in 1916, would be a portrait of his friend Busoni.
Boccioni was, in any case, the greatest

"We want to glorify war—the only cure for the world—militarism, patriotism, the destructive gesture of the anarchists, the beautiful ideas which kill and contempt for woman. We want to demolish museums, libraries and academies of all kinds, fight morality, feminism and all opportunist and utilitarian cowardice."

Filippo Tommaso Marinetti

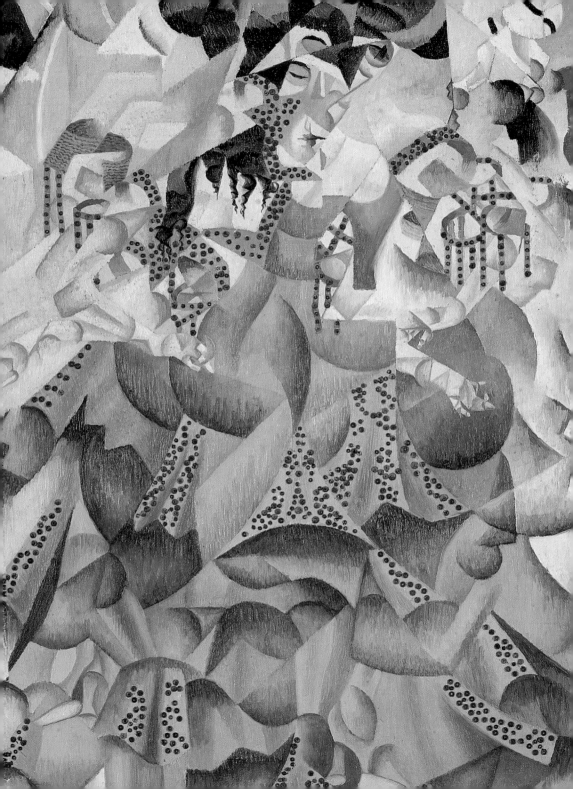

exponent of Futurism. His origins, not far from Divisionism and Symbolism, made him careful in his use of colour, which in the Cubist manner was never bright, more constructive in effect than intended to satisfy the eye. At the height of the Futurist period his pictures were an explicit response to Cubism, which was openly challenged by the young Italian artists at the exhibition in Paris: while Picasso and company set out to construct a static, plastically and geometrically solid reality in painting, which they rendered modern by purifying it of the Renaissance utopia of representing every aspect of the object depicted in a single, complete image, Boccioni understood Futurism as a visual communication of the inner vitality of the physical material, whether animate or inanimate: a vitality that time, light and the relative movements between beings and things always convey as movement in space; not the form of bodies, but their life. It was in order to explore the expression of the dynamic energy that rendered figures continually mutable in space that Boccioni devoted himself to sculpture as well, theorizing about it in the "Technical Manifesto of Futurist Sculpture", 1912.

Gino Severini
Blue Dancer (detail), 1912
Oil on canvas, 61 × 46 cm
Peggy Guggenheim
Museum, Venice
Gianni Mattioli Collection,
temporary loan

In his preface to the catalogue of the first exhibition of his Futurist sculpture at the Galerie La Boétie in Paris he wrote: "Traditional sculptors made their statues revolve in front of the spectator, or the spectator around the statues. Thus every visual angle of the observer embraces one side of the statue or the group and this does nothing but increase the immobility of the work of sculpture. My spiral, architectural construction, on the other hand, creates before the spectator a continuity of forms which permit him to follow ideally (through the force forms sprung from the real form) a new, abstract contour which expresses the body in its material movements." Balla too had come to his insight into the pictorial expression of movement through Divisionism. Present at the Salon of Automne in Paris ever since the momentous time of the publication of Marinetti's manifesto in 1909, he sought a vision that, unlike Boccioni's, was based less on rotations of the volumes that made up the form and more on chromatic and linear shifts. His series of *Iridescent Interpenetrations*, commenced in 1912 and considered one of the foundations of geometric abstraction (it was from Futurist ideas that Alberto Magnelli would also evolve toward abstractionism), indicates his attention to the dynamic effects of the perception of colour: in 1918, moreover, he wrote the "Manifesto of Colour". The perception of movement

"We will fight with all our might the fanatical, senseless and snobbish religion of the past, a religion encouraged by the vicious existence of museums. We rebel against that spineless worshipping of old canvases, old statues and old bric-à-brac, against everything which is filthy and worm-ridden and corroded by time."

from the "Manifesto of Futurist Painters"

was also at the base of emblematic works like *Dynamism of a Dog on a Leash*, 1912, which brought into painting what Muybridge and Marey had already explored in photography. Carrà was the most politically extreme of the early group of Futurists, nursing anarchist ideas, but from the viewpoint of his painting the most careful not to get bogged down in a controversy with Cubism and with the lesson of Cézanne out of which it had sprung, aiming instead to go beyond them in a higher synthesis. His adherence to Futurism was a stage in a process of maturation that within a few years would lead to his becoming a protagonist of Metaphysical painting and the movement known as the Novecento Italiano.

At the opposite pole stood the figure of Russolo, who combined a limited activity as a painter with music, drawing up the manifesto *The Art of Noise* in 1913. Noise placed on the same footing as sound as a protagonist of modernity and of the new mechanical way of life, the breakdown of every principle of harmony and composition and the use of non-traditional instruments (he even invented a specific device, the *Intonarumori* or "Noise Maker", and went on to carry out pioneering experiments in electronic music) were the key elements of his theory, which was to inspire composers like Edgar Varèse in Dada circles. Gino Severini was the "Paris-based" member of the first Futurist group,

a friend of Picasso and the Cubists. A strong colourist, he tried to bridge the two positions in a painting in which the images were structured kaleidoscopically in juxtaposed chromatic tesserae. Like Carrà, Severini would soon leave Futurism behind, devoting himself to a revival of the classical clarity of form.

If Carrà and Severini quickly moved away from Futurist principles, and if Boccioni was heading, before his untimely death in 1916, towards a calmer reflection on Cézanne, it was Balla who was to play a leading role in the development of the movement. Many young artists were fascinated by the new ideas and their aggressive proselytizing: they included Cangiullo, Depero, Prampolini, Rosai, Morandi, Licini, Sironi and Martini. It was with one of these young disciples, Fortunato Depero, that Balla signed the *Futurist Reconstruction of the Universe* manifesto on 11 March 1915. In it they declared: "We Futurists, Balla and Depero, seek to realize this total fusion in order to reconstruct the universe, making it more joyful, in other words by a complete re-creation. We will give skeleton and flesh to the invisible, the impalpable, the imponderable and the imperceptible. We will find abstract equivalents for every form and element in the universe, and then we will combine them according to the caprice of our inspiration, creating plastic complexes

which we will set in motion."

This was a project not just for the creation of a "total work of art", of the kind people had been dreaming of since Wagner's time, but also and above all for the creative and inventive contamination of all aspects of life. Painting and sculpture, but also architecture, fashion, photography, theatre, poetry, graphic design, advertising, interior decoration, dance and even cooking: there was a "Futurist method" that could and should be applied to every aspect of creativity and life in order to bring into existence a truly Futurist world.

Gerardo Dottori
Agriculture (detail), 1934
Oil on canvas, 151 × 203 cm
Galleria Nazionale d'Arte
Moderna – Arte
Contemporanea, Rome

In 1914 Antonio Sant'Elia, another victim of the First World War in 1916, had published the manifesto *Futurist Architecture*, in which he argued that it was "a question of tending the healthy growth of the Futurist house, of constructing it with all the resources of technology and science, satisfying magisterially all the demands of our habits and our spirit, trampling down all that is grotesque and antithetical (tradition, style, aesthetics, proportion), determining new forms, new lines, a new harmony of profiles and volumes, an architecture whose reason for existence can be found solely in the unique conditions of modern life (…)": the

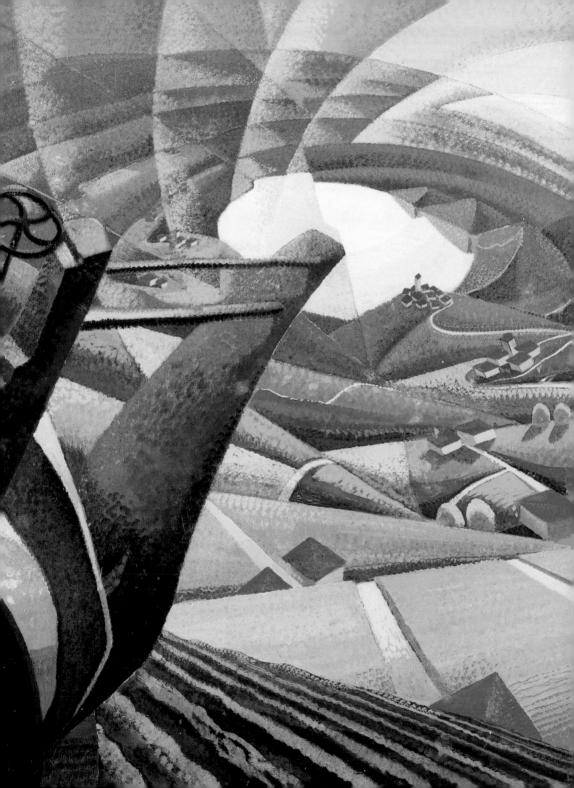

rejection of decoration and of heavy volumes, the "taste for the light, the practical, the ephemeral and the swift" and the inventive use of materials like reinforced concrete, steel, glass and cardboard were the watchwords of the new architecture, and of the Futurist style in general.

Balla devoted himself to the design of furniture and clothing, to an expansion of the Futurist spirit in a distinctly decorative direction. Going even further, Depero ventured into the world of theatre, staging the *Balli plastici* ("Plastic Dances") with his friend the poet Gilbert Clavel in Rome in 1918, a ballet in which puppets took the place of actors and dancers. He went on to design hangings, furniture, stage sets and events, making their author one of the international pioneers of industrial and graphic design. In 1927 he and the publisher Fedele Azari invented the book *Depero futurista 1913-1927*: the use of different kinds of paper, texts in various formats and type that ran in all directions and above all the binding, with two massive bolts running through the pages, made it a masterpiece of modern publishing. Balla also explored the youngest medium of expression of all, the cinema, whose innovative linguistic potential and ability to fascinate the public did not escape the great experimenter. As early as 11 September 1916 he had

been one of the signatories of the "Manifesto of Futurist Cinema", along with Marinetti, Corra, Settimelli, Ginna and Chiti. The cinema was *par excellence* the art of transparency, velocity and movement. However, it was necessary to free the new art from the temptation to limit itself by transposing the structure of the "old" book into images. "Therefore all the immense *artistic* possibilities of the cinema still rest entirely in the future", they wrote prophetically, going on to say: "The most varied elements will enter into the Futurist film as expressive means: from the slice of life to the streak of colour, from the conventional line to words-in-freedom, from chromatic and plastic music to the music of objects. In other words it will be painting, architecture, sculpture, words-in-freedom, music of colours, lines and forms, a jumble of objects and reality thrown together at random. We shall offer new inspirations for the researches of painters, which will tend to break out of the limits of the frame. We shall set in motion the words-in-freedom that smash the boundaries of literature as they march towards painting, music, noise-art, and throw a marvellous bridge between the word and the real object." Along with Balla and Depero there was Enrico Prampolini, like his two friends engaged in multiple activities, from architecture to theory (among other things, he signed, with Pannaggi and Paladini, the "Manifesto of Futurist

Mechanical Art" in 1920) and from graphics and painting to theatre. His international relations with the major European movements, from the Bauhaus to Abstraction-Création, were fundamental. While the second generation of Futurists was encouraged by Marinetti to adhere explicitly to the heroic rhetoric of Fascism and to take a nationalistic stand of rejection of all things foreign, Prampolini wanted to move in the direction of the avant-garde cosmopolitanism of the thirties. It was from this perspective that, adopting positions not far from those of Schwitters, that he developed the concept of the use of different materials, combining the traditional materials of painting with others taken from reality. He tried this out in numerous works of art and described it in a fundamental text published in 1944: it was this text and the example of the aging but indefatigable master, who in 1948 still gave his backing to the Movimento Arte Concreta of Dorazio, Dorfles, Fontana, Garau, Guerrini, Mazzon, Monnet, Munari, Perilli, Soldati, Sottsass and Veronesi, that formed the basis for experiences like that of Alberto Burri.

Although his position was distant from the nationalistic outlook of Futurism, Prampolini was one of the signatories of the last of the movement's major manifestos, that of *Futurist Aeropainting*, drawn up in 1929 with Marinetti, Balla, Depero and the young artists Benedetta, Dottori, Fillia, Somenzi and Tato.

After the myth of the automobile, Marinetti attempted to revive the flagging fortunes of the artistic movement by focusing on that of the aeroplane, the epitome of the modern machine: "The aeroplane, which glides, dives, zooms, etc., creates an ideal hypersensitive observatory hanging everywhere in the infinite, rendered dynamic moreover by the very awareness of the motion that changes the value and the rhythm of the minutes and the seconds of vision-sensation. Time and space are pulverized by the instantaneous realization that the earth is rushing past at high speed under the motionless aeroplane." Thus, "every aeropainting simultaneously contains the dual movement of the aeroplane and of the painter's hand which moves pencil, brush or airbrush". From the artistic point of view, while advanced experiments like those of Prampolini, which in fact went considerably beyond the presuppositions of the movement, and of Balla and Depero, who were increasingly drawn to the world of the applied arts in line with—and often in advance of—developments in international culture, aeropainting did not produce works of any qualitative significance, never overcoming the limits of an art that was essentially rhetorical in character.

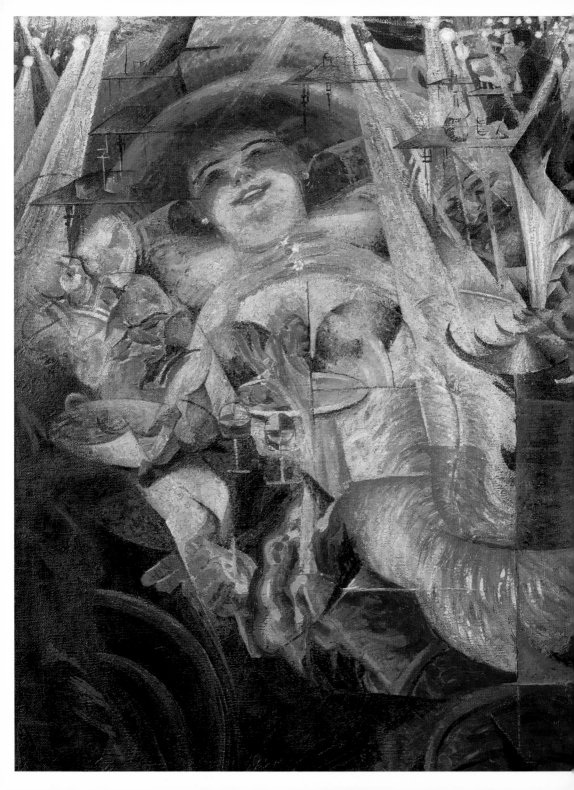

Umberto Boccioni
1. *The Laugh*

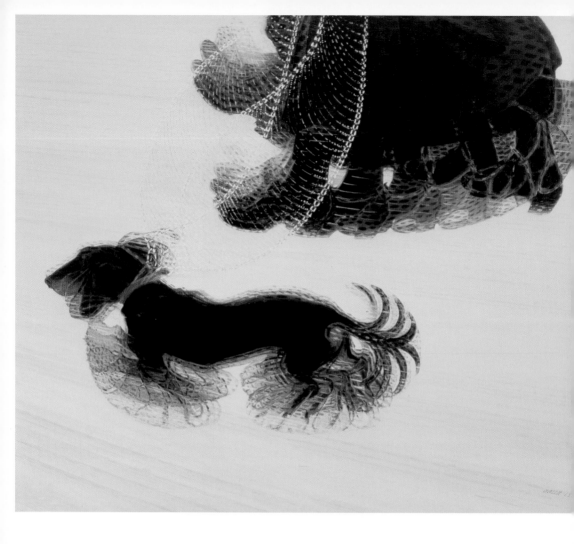

Giacomo Balla
2. *Dynamism of a Dog
on a Leash*

Giacomo Balla
3. *Little Girl Running
on the Balcony*

96

97

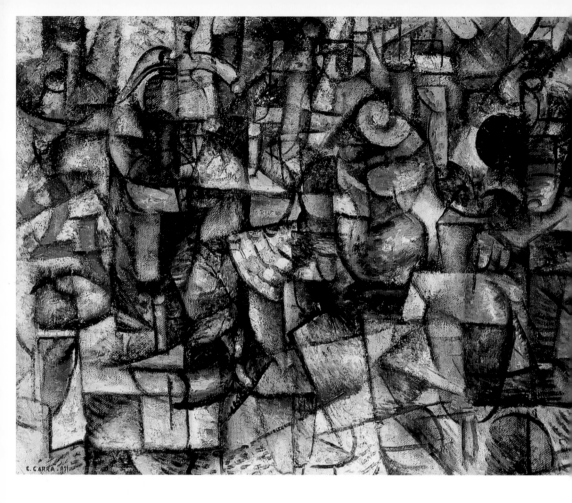

Carlo Carrà
4. *Rhythms of Objects*

Luigi Russolo
5. *Music*

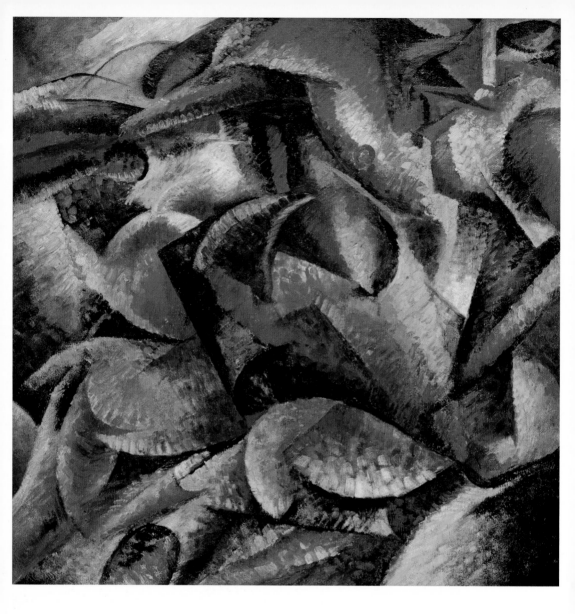

Umberto Boccioni
6. *Dynamism
of a Human Body*

Gino Severini
7. *Sea=Dancer*

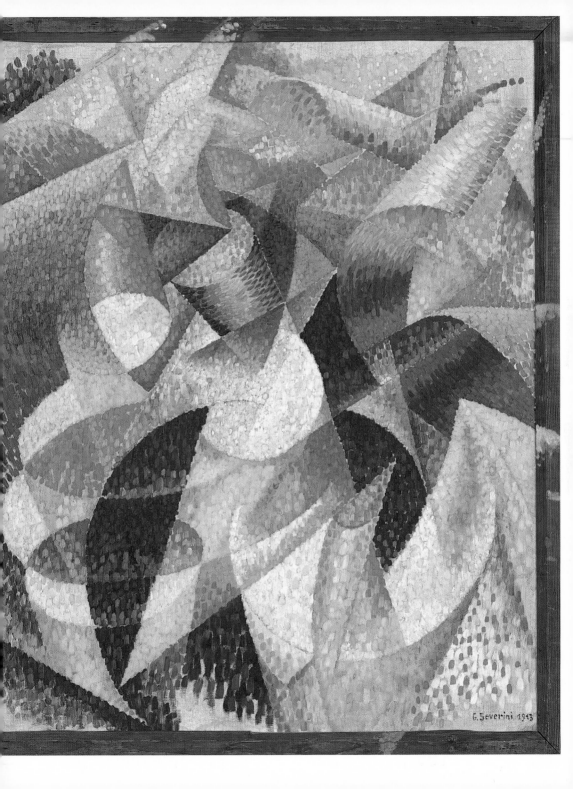

Umberto Boccioni
8. *Development of a Bottle*
in Space

Umberto Boccioni
9. *Unique Forms*
of Continuity in Space

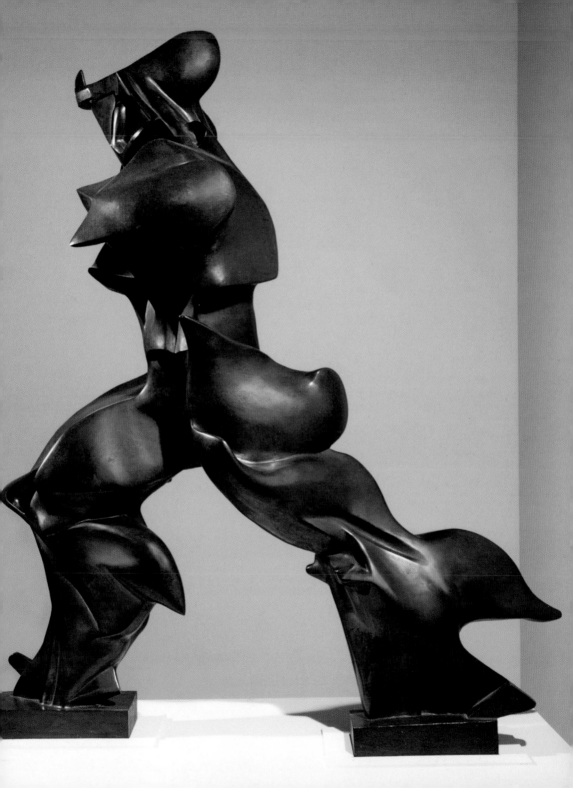

Fortunato Depero
10. *Figure Seated at a Café Table (Portrait of Gilbert Clavel)*

Enrico Prampolini
11. *F. T. Marinetti, Free-word Poet*

104

Cubism

Two events marked, in 1907, the beginning of the extraordinary story of Cubism. The first was the major retrospective of Paul Cézanne, who had died the previous year, at the Salon d'Automne in Paris, comprising fifty-six of his works. The revelation of his painting was the result of the interest shown by a group of young artists, who had not failed to grasp the profound way in which Cézanne had moved beyond the limits of Impressionism: in particular Émile Bernard, who had spent time with him towards the end of his life and who in 1905 had published his "Souvenirs sur Paul Cézanne" in the *Mercure de France*. And it was to his young friend that Cézanne, in search of a vision that would not betray the reality of nature but purify it and transcend it by selecting only the essential data, the internal geometry of the form, in the process of painting, had written shortly before his death that "time and reflection, moreover, modify little by little our vision, and at last comprehension comes to us".

The second event was the painting of *Les Demoiselles d'Avignon* by Pablo Picasso in his studio at the Bateau-Lavoir in Montmartre. In 1906, having just emerged from his "Blue Period" in which several paintings already displayed a plastic, architectural sense of composition, and moved permanently to Paris in 1904, Picasso and his mistress Fernande Olivier were introduced to Henri Matisse by Gertrude Stein, the American intellectual and patron of whom he painted a portrait dominated by the abstraction, sense of monumentality and primitive synthesis that were shortly to find full expression in the *Demoiselles*. As Stein recounts in her fundamental *Autobiography of Alice B. Toklas*: "And now once more to return to the return from all their travels and to Picasso becoming the head of a movement that was later to be known as the Cubists. Who called it Cubist first I do not know but very likely it was Apollinaire. At any rate he wrote the first little pamphlet about them all and illustrated it with their paintings. I can so well remember the first time Gertrude Stein took me to see Guillaume Apollinaire. It was a tiny bachelor's apartment on the rue des Martyrs. The room was crowded with a great many small young gentlemen. Who, I asked Fernande, are all these little men. They are poets, answered Fernande. I was overcome. I had never seen poets before, one poet yes but not poets (…). Derain and Braque became followers of Picasso about six months after Picasso had, through Gertrude Stein and her brother, met Matisse. Matisse had in the meantime introduced Picasso to negro sculpture." Whether it really was Matisse who had

got his friend interested in *art nègre* is a controversial question, but fundamentally an irrelevant one, given the out-and-out craze for African art that gripped collectors, artists and dealers alike in that period. What matters is that those models were grafted onto his very recent reflections about the geometric synthesis of primitive Spanish art and the non-perspective relationship between figure and space defined by geometric intarsias: the subject of the painting, the interior of a brothel in the Carrer d'Avinyó at Barcelona, is completely irrelevant. It would not be exhibited until 1916, but many artists who saw it in his studio, above all Georges Braque, were immediately influenced by the work, which put the implications of the intellectual approach proposed by Cézanne into abrupt and daring effect.

In November 1908 Braque staged a show at Daniel-Henry Kahnweiler's new Parisian gallery that was presented by the poet and pioneer of art criticism Guillaume Apollinaire: "He has become a creator by drawing from within himself the elements of the synthetic motifs that he represents. He no longer owes a debt to anything that surrounds him.

Marcel Duchamp
Nude Descending a Staircase (No. 2), 1912
Oil on canvas, 146 × 89.2 cm
Philadelphia Museum of Art, Philadelphia
The Louise and Walter Arensberg Collection

His spirit has voluntarily provoked the twilight of reality and so it is that a rebirth of the universe is taking place visually within him and outside him. He expresses a beauty full of tenderness, and the pearly sheens of his paintings play on our intellect like a rainbow." The large nudes and above all the landscapes of L'Estaque, painted between 1907 and 1908, were geometric simplifications based as much on the example of Cézanne as on the recent example of Picasso. The simple geometries, deforming visible reality, the short and intense strokes of paint, the brusque compression of the logic of perspective and the reduction of the palette to a few austere tones all indicated that a new conception of painting was incubating.

It was Louis Vauxcelles, the same critic who had coined the provocative term of *fauves* for Matisse and his companions in 1905, who suggested the name of the movement in his review of the exhibition in *Gil Blas*: Braque, he wrote on 14 November 1908, "reduces everything, places and figures and houses, to geometric schemes, to cubes". As Braque himself put it later: "What really drew me—and this was the main direction of Cubism—was the materialisation of this new space I could feel. (…) The first Cubist painting was all about the search for space. As for colour, the light was all that interested

NU DESCENDANT UN ESCALIER

"(…) Cézanne makes a cylinder
from a bottle; I start from the cylinder
(…) to make a bottle, a certain bottle.
Cézanne moves toward architecture;
I start from architecture, which
is why I compose with abstractions
(colours) and compose when
those colours have become objects.
(…) This painting is to
the other as poetry is to prose."

Juan Gris

us. Light and space are two things that are connected (…). I used fragmentation to establish space and the movement of the space and I could only introduce the object once I had created the space. (…) For Fauves, it was about light, for Cubists it was space." From that moment on, all the way through 1909 and up until the beginning of 1910, the shift to more and more geometric forms of representation, reducing the vision to a dense structure of intersecting planes that were intended to convey not the appearance of things but the totality of their presence in the dimensions of space and in that of time, took place in the work of many other artists.

In the summer of that year Picasso painted a series of landscapes and portraits at Horta de Ebro, in Spain, in which he in turn started out from the model of Cézanne in an effort to find accords of outline and geometric volumes in a harsh painting couched in essential shades of earth and grey: he also created a sculptural portrait of Fernande in which the physical three-dimensionality added further complexity to the vision.
At the same time other artists were moving, along different routes, towards a geometricization of the motifs of the representation. This was the case with Juan Gris, a young Spaniard fascinated by Picasso who grasped straightaway that the crux of the new painting was not stylistic, but conceptual: it was not, in short, a new way of painting, but of seeing. We can thank Gris for one of the clearest explanations of Cubist ideas, which would be published in *Cahiers d'Art* in 1927: "I attempt to make concrete what is abstract, I go from general to particular, which means that I start from an abstraction to arrive at a real fact. My art is an art of synthesis, a deductive art. I want to reach a new qualification, I want to succeed in producing special individuals starting from the general type. I consider that the architectural side of painting is mathematics, the abstract side; I want to humanize it: Cézanne makes a cylinder from a bottle; I start from the cylinder (…) to make a bottle, a certain bottle. Cézanne moves toward architecture; I start from architecture, which is why I compose with abstractions (colours) and compose when those colours have become objects. For example, I make a composition with a white and a black and I adjust the white so that it becomes a piece of paper and the black so that it becomes a shadow. This painting is to the other as poetry is to prose." Outside the circle of Picasso and Braque other groups were formed that developed different versions of Cubism. In 1909, the same year in which Kahnweiler held an exhibition with works by Picasso,

Braque, Derain and van Dongen, the painters Fernand Léger and Robert Delaunay, the sculptors Alexander Archipenko and Henri Laurens and the poet Blaise Cendrars, who were also supported by Apollinaire, came together at the studios in the Ruche de Montparnasse.

For their part, working in isolation, Albert Gleizes and Jean Metzinger commenced a series of experiments and theoretical reflections that in 1912 were to find expression in the essay *Du Cubisme*: "Cubism, in fact, goes beyond the external object to envelop it and get a better hold on it. Looking at the model is no longer enough, it is necessary for the painter to represent it to himself. He transports it into a space that is at once spiritual and plastic, a space for which it is not at all out of place to speak of the fourth dimension. Here proportions become qualities, sensations are no longer linked to a rigid system of equilibrium and it is solely their expressive value that determines the order of their transcription. The location of the different parts of a figure, of a still life, of a landscape, is no longer linked to that of the other parts; it depends on their arrangement in the artist's mind, on their 'true' situation."
The reference to the fourth dimension is important. The studies of the mathematician, physicist and philosopher Henri Poincaré on the aesthetics of science and relativity (the same relativity on which Albert Einstein was building his theory), those of Hermann Minkowski on space-time and the philosophical ideas of Henri Bergson on time as duration of consciousness were just a few of the cultural influences that were leading in that period to the breakdown of the idea of rigid spatial three-dimensionality on which perspective was based, as well as of the historically accepted discontinuity between space and time. For the Cubists the image was an artifice that did not delude the senses into believing it was a reality, but re-created it visually with the signs of painting as an independent reality, fruit of the artist's intellectual and emotional reworking. "I couldn't portray a woman in all her natural loveliness... I haven't the skill. No one has. I must, therefore, create a new sort of beauty, the beauty that appears to me in terms of volume, of line, of mass, of weight, and through that beauty interpret my subjective impression", Braque was to declare. The concept of painting as a system of signs like writing cropped up constantly in the statements of the time and in later summaries. In the book *Les Peintres Cubistes* published in 1913, Apollinaire used this example when discussing the question of the

"Cubism, in fact, goes beyond
the external object to envelop it and
get a better hold on it.
Looking at the model is no longer
enough, it is necessary for the painter
to represent it to himself. He transports
it into a space that is at once spiritual
and plastic, a space for which
it is not at all out of place to speak
of the fourth dimension (…)."

Albert Gleizes and Jean Metzinger

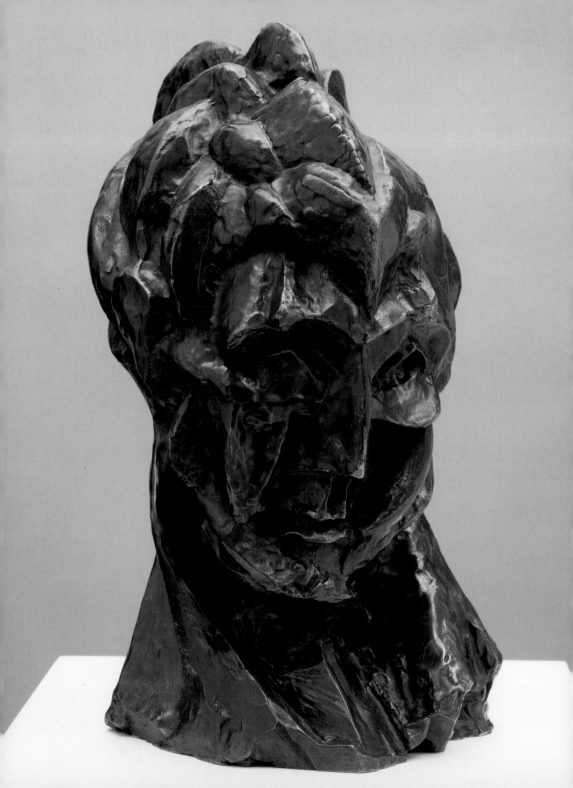

overcoming of the three Euclidean dimensions: "The new painters have been severely criticized for being obsessed with geometry. Yet geometric shapes are the most important part of drawing. Geometry, a science whose subject is dimension, its measurement and the study of its relations, has always been the rule *par excellence* of painting. Until now, the three dimensions of Euclid's geometry were sufficient to the restiveness felt by great artists yearning for the infinite. The new painters do not propose, any more than did their predecessors, to be geometers. But it may be said that geometry is to the plastic arts what grammar is to the art of the writer. Today, scholars no longer limit themselves to the three dimensions of Euclid. The painters have been led quite naturally, one may say by intuition, to preoccupy themselves with the new possibilities of spatial measurement which, in the language of modern studies, are designated by the term fourth dimension. The fourth dimension presents itself to the mind, from the plastic point of view, as generated by the three known measurements: it represents the immensity of space that, at a determinate moment, reaches out towards the infinite in all directions."

Pablo Picasso
Woman's Head (Fernande), 1909
Bronze,
41.3 × 24.7 × 26.6 cm
The Museum of Modern Art, New York
Purchase

For his part, Kahnweiler, the owner of the gallery where the group showed its work, would explain years later: "One fact that in my view is absolutely essential to an understanding of Cubism and of what to my eyes is true modern art should not be forgotten: painting is a form of writing; it is a script that creates signs. A figure of a woman painted on canvas is not a woman; she is a group of signs that I read as 'woman'. If I write 'w-o-m-a-n' on a sheet of paper, someone who knows the language and can read will not just read the word, but will have as it were before his eyes the complete image of a woman. The same thing happens, without the slightest difference, with painting, which fundamentally has never been a mirror of the external world, nor has it been similar to photography; it has been a creation of signs which were always read correctly by contemporaries, after a certain apprenticeship." On Kandinsky's initiative, Picasso and Braque showed together in 1910 at the second exhibition of the Neue Künstlervereinigung München, the "New Artists' Association of Munich", held at the Moderne Galerie Thannhauser, becoming the points of reference for the international avant-garde. At this

"(…) The use of dissociated elements, even of the human figure, regardless of any narrative intent, for their plastic, formal, coloristic or linear qualities is not new: the Mycenaeans, the Orientals and the Blacks have always made use of them in this way. Cubism has done nothing but bring back into fashion in painting a very ancient system, the oldest of all, that of ornamental aesthetics."

Amédée Ozenfant and Le Corbusier

moment their painting, despite being rooted in the typical genres of tradition (landscape, portrait and still life) attained the height of its essentiality of form: the colour was reduced to a subtle interplay of brown and grey tones, the form fragmented and powerfully reassembled into an articulation of abbreviated portions of planes arranged around a vertical axis, like a hermetic formal script. The two artists carried out their research in seclusion, in a sort of monastic rigour that isolated them from one another—from 1912 onwards they increasingly headed in different directions—and that above all kept them apart from the wave of Cubist experiments that spread out all over Europe from Paris.

The initiative of establishing a true movement was taken instead by the artists of the Ruche, who were joined by yet another aggregation that had formed around the brothers Marcel Duchamp, Raymond Duchamp-Villon and Jacques Villon. The group was born in Villon's studio at Puteaux and named the Section d'Or, in explicit reference to the "golden section" or divine rule of proportion of the Renaissance tradition. In addition to the Duchamp brothers, the members of the group were Robert Delaunay, Albert Gleizes, František Kupka, Henri Le Fauconnier, Fernand Léger and Jean Metzinger. Their motto, coined by Villon, was plainly an attempt to downplay to some extent the intellectual extremism of Picasso and Braque: "Where Cubism uproots, the Section d'Or roots"; in other words it took up the thread from the highest point at which geometry and rational and non-imitative thought had left their mark on the history of European art. While Picasso and Braque refused to take part in the Salons, preferring separate exhibitions like Picasso's one-man show in the spring of 1911 at Alfred Stieglitz's gallery 291 in New York, it was the Cubists of the Ruche and Puteaux who turned themselves into a movement and took on the task of competing with the aggressiveness of the Italian Futurists. In October 1912, just a few months after the Futurist exhibition at the Galerie Bernheim-Jeune, the Cubists organized an exhibition at the Galerie La Boétie: the members of the Section d'Or were joined by Alexander Archipenko, André Lhote, a Roger de La Fresnaye strongly influenced by the pre-Cubist Picasso, Louis Marcoussis and Francis Picabia, whose work in reality was not so remote from Futurist ideas. Only Delaunay, afraid like Picasso and Braque of being confused with his fellow-travellers, did not show: however, his work on colour dynamism and the simultaneous perception of coloured forms, which had the most direct links

117

with Futurist research, was at this moment a direction at which many were looking.

As well as getting into an argument with Delaunay over precedence in the use of the concept of simultaneity, Umberto Boccioni expressed the considerable reservations of the Futurists about Cubist poetics in *Pittura, Scultura futuriste*, 1914: "Thus the Cubists do not offer a completely new interpretation of matter, conceiving it in other words not only in its overall dimensions but also in the determinism of the organic qualities of its forces. They stop at how to construct the picture, how to compose it, how to distribute the masses and colours in it. They disrupt the elements of the traditional picture and find new rhythms for the new combination of a straight line with a curve... But that is not all. We are still at a new arrangement of the surface, not at a new and abstract interpretation of depth."

The scandal caused by the presence of the Cubists at the Salons was great, for the innovative character of their work, and sufficient to elicit a parliamentary debate that anticipated the many clumsy attempts to reconcile institutional activity

Paul Cézanne
The Large Bathers
(detail), 1906
Oil on canvas,
210.5 × 250.8 cm
Philadelphia Museum
of Art, Philadelphia

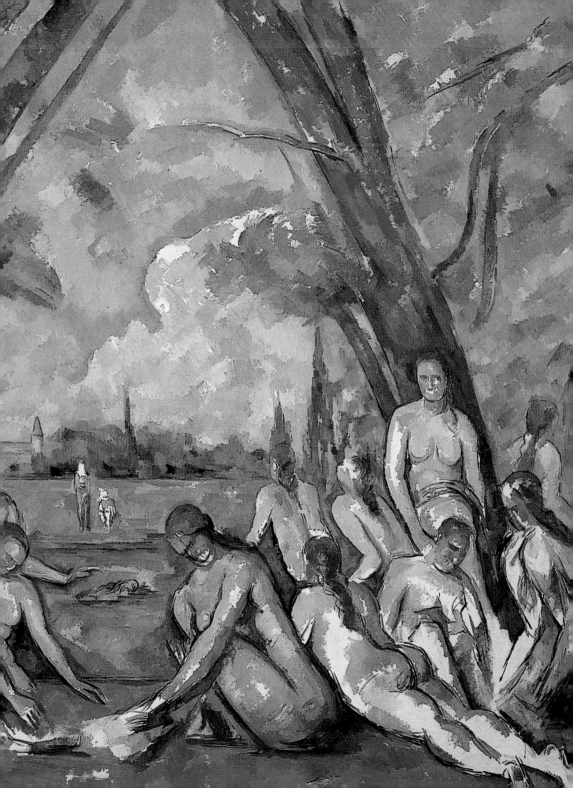

and avant-garde that were to be made throughout the century.

During the sitting of the Chamber of Deputies in Paris on 3 December 1912 the following debate took place: "Monsieur Jules-Louis Breton: (…) so I shall confine myself to asking the Under-secretary of State what steps he intends to take to avoid a repetition of the artistic scandal to which the last Salon d'Automne gave rise (…). For several years, under the pretext of a renewal of art, some exploiters of the public's credulity have lapsed into the craziest expressions of weirdness and eccentricity. I do not have the slightest intention of challenging their sad right to do so, but I cannot accept that our Administration of Fine Arts should lend itself to this buffoonery of abominable taste and graciously allow public buildings to be used for events that run the risk of compromising our marvellous artistic heritage ("hear hear!" from many seats). All the more so in that they are for the most part foreigners who have come here, to our national exhibition venues, to wittingly or unwittingly bring discredit on French art. In fact, out of around seven hundred exhibitors at the last Salon d'Automne, I have been able to identify, from the official catalogue, over three hundred foreigners (…). Despite this, I am not asking the Under-secretary of State to deny the rooms of the Grand Palais to the Societé du Salon d'Automne in the future, for I consider it only proper on my part to acknowledge that, alongside the self-styled artistic monstrosities on display there, I found an enchanting, delightful exhibition of decorative art (…). Monsieur Charles Beauquier: Don't encourage filth! There is excrement in art as elsewhere. Monsieur Marcel Sembat: To hear that you too have views of this kind does not annoy me at all. I don't believe that even the Cubists will take offence (…). It is indeed curious: there are no protests when the State permits the use of public buildings by unscrupulous businessmen and merchants, and yet there are protests when they are used by artists to exhibit paintings that are regarded as ugly. (Addressed to Monsieur Jules-Louis Breton): My dear friend, when you find a picture ugly, you have an incontrovertible right: that of not looking at it, of going away to look at others; but it is not a good reason to call the police!"
At the very moment in which even Picasso and Braque's work began to explore more distended geometries, opening up to inserts of written words and pieces of collage in a vision that clearly appeared to be evolving; at the very moment, 1913, in which the two artists were, along with Duchamp and his *Nu descendant un escalier (Nude*

Descending a Staircase), the most admired artists at the Armory Show, which marked the success of the European avant-garde in New York, it was artists like Léger, Delaunay and his wife Sonia who indicated that the line of most fruitful development of Cubism was towards an abstraction of an articulately geometric type, not suspicious of colour like that of its founders: elements of geometricization, handled in his typically decorative fashion, can even be found in Matisse's work during the second decade of the century.

In 1914 the First World War threw the Parisian art scene into disarray: Braque, Léger, Gleizes, Metzinger and Villon set off for the front; Duchamp and Picabia moved to the United States; Picasso withdrew into a line of research that would lead him, in 1917, to a renewed classicism and the beginning of what Jean Cocteau was to call the "rappel à l'ordre". The Cubist lesson germinated in different areas of expression, from the early experiments of the young Giorgio Morandi to those of Marc Chagall, who in 1914 returned to his Vitebsk from Paris; from Kasimir Malevich to Franz Marc; from Piet Mondrian to Vladimir Tatlin. After the war two young companions of Léger's, increasingly drawn by a figuration somewhere between the schematic and the monumental, would try to take the route of a supersession of Cubism in a Purist key, pursuing a classical geometric order not exempt from the influence of de Chirico. In *Après le Cubisme*, published in 1918, Amédée Ozenfant and Charles-Édouard Jeanneret-Gris, later better known as Le Corbusier, declared: "Despite their theories the Cubists have simply painted pictures composed like rugs, with elements drawn from nature and dissociated. This is a thing that has always been done. The use of dissociated elements, even of the human figure, regardless of any narrative intent, for their plastic, formal, coloristic or linear qualities is not new: the Mycenaeans, the Orientals and the Blacks have always made use of them in this way. Cubism has done nothing but bring back into fashion in painting a very ancient system, the oldest of all, that of ornamental aesthetics." But the fortunes of Cubist art would not be revived by the large-scale public images of Léger, nor by the integration of painting with architecture attempted in the thirties by Robert and Sonia Delaunay. Rather, it was Picasso once again, who with his 1937 picture *Guernica*, inspired by the tragedy of the Spanish Civil War, gave rise to the Neo-Cubism of the period following the Second World War.

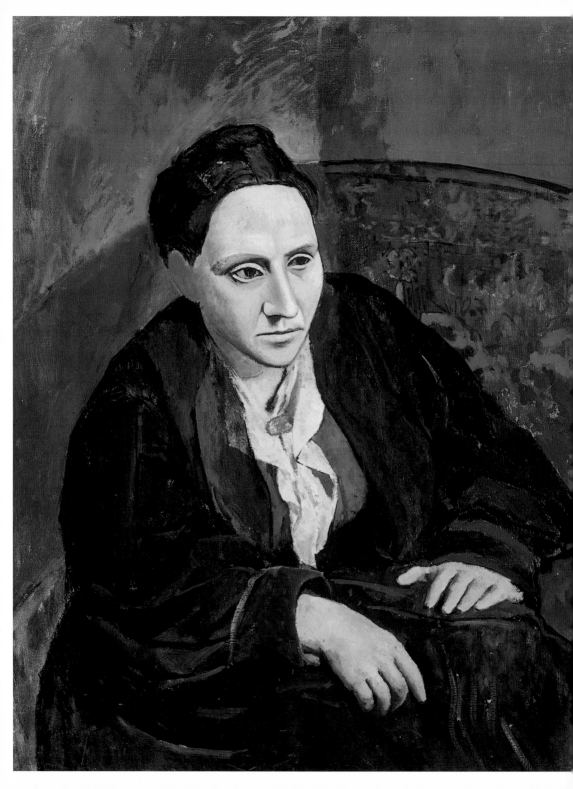

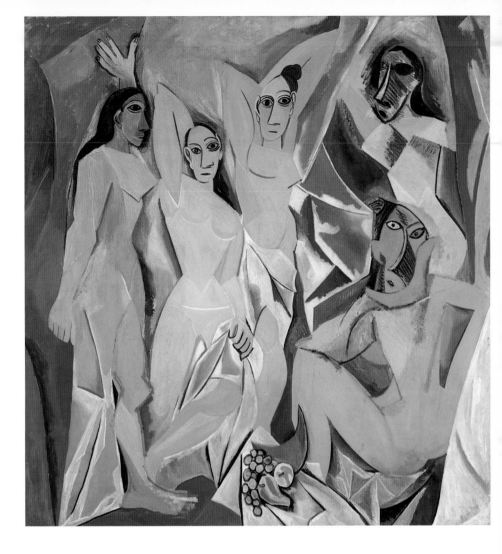

Pablo Picasso
1. *Gertrude Stein*

Pablo Picasso
2. *Les Demoiselles d'Avignon*

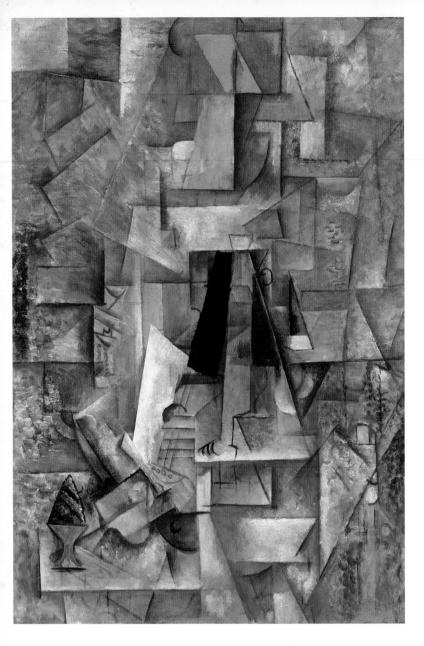

Pablo Picasso
3. *Man with a Guitar*

Georges Braque
4. *Viaduct at L'Estaque*

Following pages
Robert Delaunay
5. *The City No. 2*

Georges Braque
6. *Man with a Guitar*

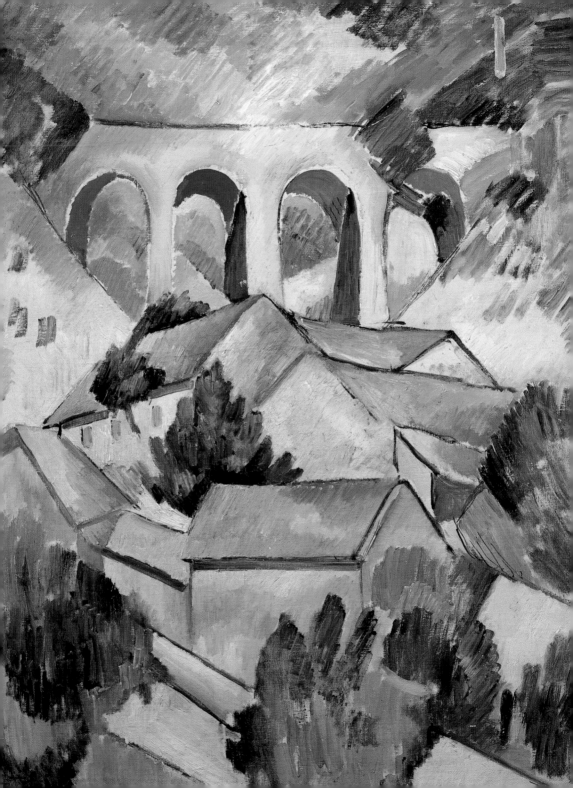

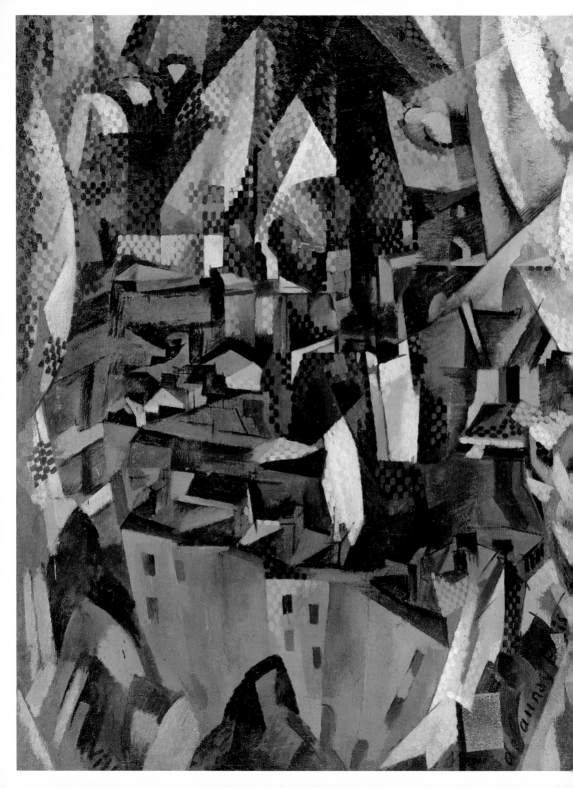

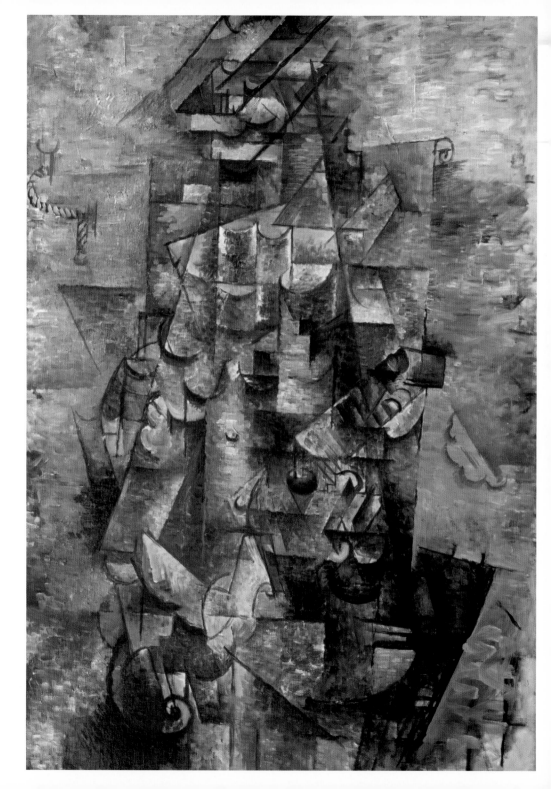

Sonia Delaunay
7. *Electric Prisms*

Fernand Léger
8. *Mechanical Elements*

128

Francis Picabia
9. *Impétuosité Française*

130

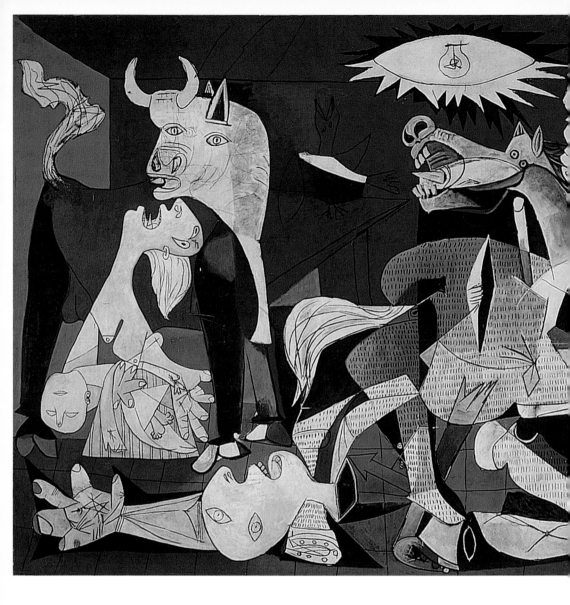

Pablo Picasso
10. *Guernica*

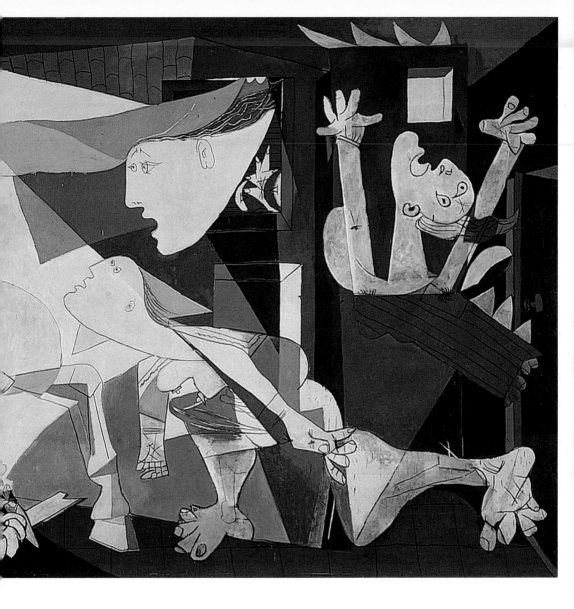

Art of the
Revolutions

On 22 January 1905 the police of Tsar Nicholas II fired on a peaceful crowd demanding reforms, led by the priest Georgy Gapon. The massacre, which has gone down in history as "Bloody Sunday", triggered other insurrections in St. Petersburg and Moscow, where the first soviets were set up and units of the army mutinied, as did navy squadrons at Kronstadt and Odessa: Sergei Eisenstein's 1925 film *The Battleship Potemkin* would celebrate one of these events. These were the first stirrings of the revolution that, on 25 October 1917, would bring Lenin and Trotsky's Bolshevik government to power, a few months after the tsar's empire had collapsed in the face of new revolts. The violence of the revolutions that followed one another in those years was actively accompanied, and nowhere was this so true as in Russia, by a profound renewal of culture and the visual arts, which ever since the end of the 19th century had been showing signs of impatience with the oppressive climate of the tsarist regime. Indeed, it can be said that the artistic revolutions anticipated the political ones, achieving far less controversial and more lasting results.

The magazine *Mir iskusstva*, "The World of Art", was founded in St. Petersburg as early as 1898 by Alexandre Benois, Léon Bakst and Sergey Diaghilev, who were all destined to play important roles in European musical theatre. Diaghilev's Ballets Russes, a company that made its debut in Paris in 1909 with Borodin's *Prince Igor* and whose scenery and costumes were often designed by Bakst, would become a point of connection for many exponents of the avant-garde, from composers like Stravinsky, Rimsky-Korsakov, Ravel, Debussy and Satie to dancers like Pavlova, Nijinsky and Balanchine and artists like Picasso, Matisse, Braque, Derain and de Chirico.

Typical of *Mir iskusstva* was the quest for an art that would be at once authentically Russian, i.e. linked to the fabulous soul, with hints of the exotic, of its traditional folk culture, and international, in other words set free from the autarkic and academic climate that held sway under the tsarist regime. The magazine organized annual exhibitions on the model of the Parisian Salons and the Secessions, showing the work of both already established artists like Mikhail Vrubel, Isaac Levitan and Valentin Serov and younger ones like Boris Kustodiyev and Vladimir Tatlin, as well, above all, as that of Europeans like Degas, Monet and Puvis de Chavannes. The Symbolist climate, personified by artists like Serov and Vrubel, and that of Art Nouveau, which was also influenced by some of the ideas of the Fauves, were predominant in the research of the

young artists. Outstanding among them was the isolated figure of the Lithuanian Mikalojus Čiurlionis, whose early Symbolism evolved independently into a visionary proto-abstraction: active in St. Petersburg from 1909, he died prematurely in 1911 and a year later was celebrated by *Mir iskusstva* with a retrospective.

In Moscow a fundamental role was played by another group, Golubaya Roza, "Blue Rose", linked to Symbolist poets like Aleksandr Blok and Andrey Bely. Its members included Pavel Kuznetsov and Martiros Saryan, and above all Mikhail Larionov and Natalya Goncharova, who had met Kazimir Malevich the year before at an exhibition of the Union of Artists. The exhibition organized by the group in 1908 showed the work of these authors alongside the cream of European art, with Cézanne, van Gogh, Gauguin, Matisse, Derain and van Dongen. Their painting was, in this period, primitivist in character, highly synthetic and with a strong emphasis on colour, patterned on the then predominant model of Gauguin and the essentiality of traditional folk arts. Information on what was going on in the rest of Europe arrived continually

Vladimir Stenberg and Georgy Stenberg
Man with the Movie Camera, directed by Dziga Vertov, 1929
Chromolithograph,
100.8 × 71 cm
Russian State Library, Moscow

and promptly: in addition to the exhibitions, there were the Muscovite collections of Sergei Shchukin and Ivan Morozov, who bought from Parisian galleries like Durand-Ruel and Bernheim-Jeune, to show the Russians the best products of the Paris art scene.

Highly active as an organizer too, Larionov founded in 1909 the group Bubnovy Valet, "Jack of Diamonds", which the flowing year staged an exhibition with the abstract incunabula of Kandinsky and Cubist works by Albert Gleizes, André Lhote and Henri Le Fauconnier. In 1912, his new group, Osliny Chvost, "Donkey's Tail", which Malevich and Tatlin joined as well, openly adopted positions close to Futurism and Delaunay's research. This marked the beginning of a complex period that, for the multiplicity of the forms it took in painting and its dense web of cultural references, is referred to as Cubo-Futurism.

There was a Marinettian spirit to the pamphlet *A Slap in the Face of Public Taste* published in 1912, with literary and theoretical contributions from David Burlyuk, co-founder of the Jack of Diamonds, and from Khlebnikov, Livshits, Kandinsky and Mayakovsky in which they proclaimed their liking for scandal and lack of success and invoked the "new, primordial, unexpected" and the "self-sufficient

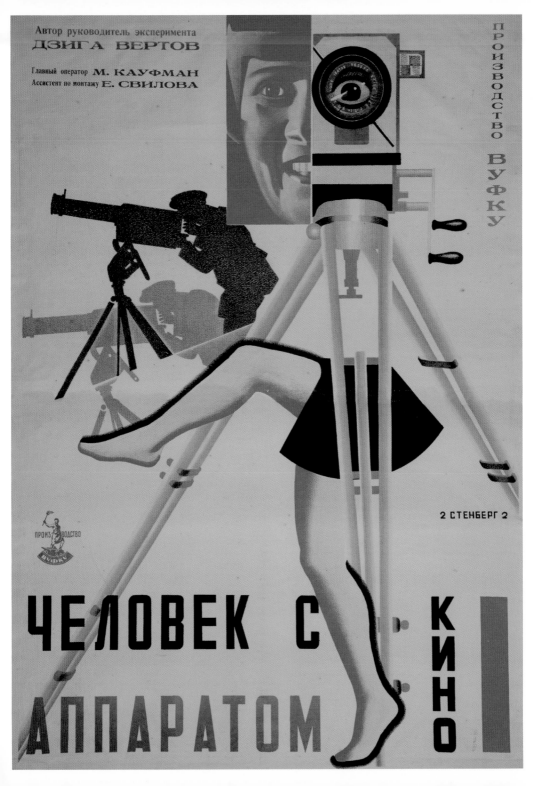

"We know that everything has its own essential image; chair, table, lamp, telephone, book, house, man…
They are all entire worlds with their own rhythms, their own orbits.
That is why we in creating things take away from them the labels of their owners… all accidental and local, leaving only the reality of the constant rhythm of the forces in them."

from the "Realist Manifesto"

word". Larionov went on to describe Futurism as "a dynamic style that dilates the picture, places the painter at the centre of things, examines the object from every point of view, envisages its transparency, envisages even what only the painter knows exists and what in reality is not seen", while Malevich would say that it "has laid bare the forms of the dynamic movement of the new world of iron". It should be pointed out that not long afterwards, in 1914, Marinetti himself would be fiercely challenged and accused of being outdated by these young artists when he came to give a series of lectures in Moscow and St. Petersburg.

In 1913, on the occasion of an exhibition that was entitled *The Target* in homage to Delaunay, Larionov and Goncharova published the "Manifesto of Rayonism".

"The style of Rayonist painting that we advance signifies spatial forms which are obtained arising from the intersection of the reflected rays of various objects, and forms chosen by the artist's will. The ray is depicted provisionally on the surface by a coloured line. That which is valuable for the lover of painting finds its maximum expression in a Rayonist picture. The objects that we see in life play no role here, but that which is the essence of painting itself can be shown here best of all—the combination of colour, its saturation, the relation of coloured masses, depth, texture. (…) We perceive a sum of rays proceeding from a source of light; these are reflected from the object and enter our field of vision. Consequently, if we wish to paint literally what we see, then we must paint the sum of rays reflected from the object. (…) Rayonism erases the barriers that exist between the picture's surface and nature." There is a clear echo here of French Post-Impressionism and the Futurist lesson, mediated by the ideas of an exponent of the older generation, Vrubel, who argued: "The contours with which artists normally delineate the confines of a form in actual fact do not exist—they are merely an optical illusion that occurs from the interaction of rays falling onto the object and reflected from its surface at different angles. In fact, at this point you get a 'complementary colour'—complementary to the basic, local colour."

I f Larionov and Goncharova's research was oriented more in a Futurist direction, in the same years the example of Cubism, with its small portions of plane linked together to convey a geometrically reduced plastic sense of the volume of the object, had an influence on the development of other artists. An early translation of Gleizes and Metzinger's *Du Cubisme*

was made by the poet, painter and composer Mikhail Matyushin, among other things the author in 1910 along with Burlyuk, Khlebnikov and others of *Sadok Sudei*, "A Trap for Judges", a collection of poems in a Futurist spirit. The Cubism to which the Russian avant-garde was exposed was not the uncompromising and monastic version of Picasso and Braque. It was a more stylized but brilliantly coloured one, less distant from the elementary recognizability of the subjects.

From both movements, then, came the practice of inserting verbal elements into the compositions, although the influence of Futurism seems to have been prevalent in those years. The use of wordplays, neologisms and onomatopoeias in the Futurist manner was characteristic of the fundamental theatrical production *Pobeda nad solncem*, "Victory over the Sun", by Alexei Kruchenykh, staged in December 1913 at St. Petersburg with music by Matyushin and scenery, costumes and lighting in an already Suprematist flavour by Malevich. In the same year Kruchenykh was the author of theoretical texts on the abstract autonomy of the word, which matched meaningless phonemes with arbitrary verbal associations (the poet called them *Zaum*, transrational language) and verbal/visual publications in the manner of the Futurist *parolibere* compositions

with titles like *Vzorval*, "Explodity", illustrated by artists like Malevich and Olga Rozanova.

After the outbreak of war, in 1914, Lyubov Popova, Ivan Puni, Nathan Altman and Marc Chagall returned home from Paris, while El Lissitzky arrived from architectural school in Darmstadt, Wassily Kandinsky from Munich and Alexandra Exter from Italy, where she had made frequent visits and been in contact with the Futurists. Larionov and Goncharova, on the other hand, left the country. While in the rest of Europe the avant-garde groups broke up, Moscow and Petrograd (the new name just assumed by St. Petersburg) saw a concentration of different experiences, all of the highest order. It was in this climate that the exhibition *0.10* was organized in Petrograd in 1915 by Puni, presenting the two cornerstones of the new Russian art, Malevich's Suprematism and Tatlin's Constructivism. Malevich's contribution was a room in which pure geometric shapes were set against absolute backdrops: the pictures were arranged on several levels, and the *Black Square* in particular was placed in a corner high up between the walls, as if it were an icon. At the same time, in his manifesto *From Cubism to Suprematism. The New Realism in Painting*, the artist proclaimed: "Only with the

"Only with the disappearance of a habit of mind which sees in pictures little corners of nature, Madonnas and shameless Venuses, shall we witness a work of pure, living art."

Kazimir Malevich

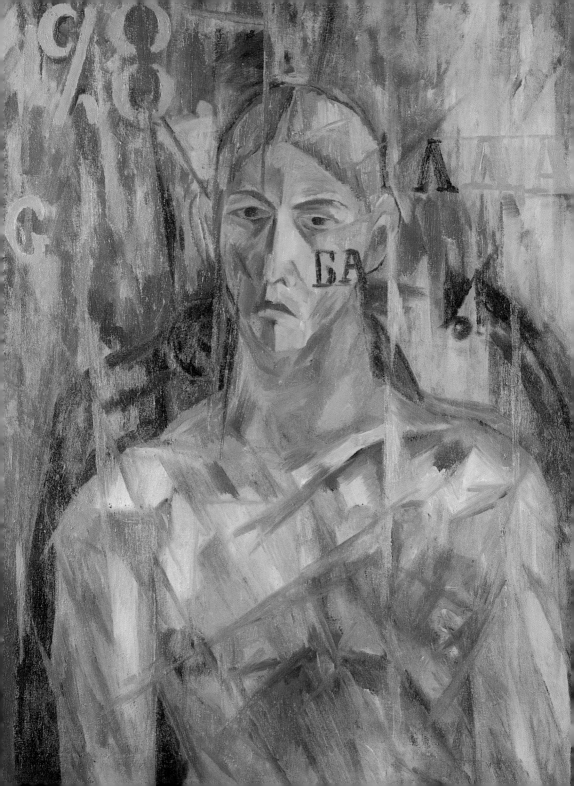

disappearance of a habit of mind which sees in pictures little corners of nature, Madonnas and shameless Venuses, shall we witness a work of pure, living art." The sense of his radically non-objective operation indicated a metaphysical view, with mystical accents, of painting, whose independence of our sensible experience had to be total to permit an absolutely authentic intellectual and emotional experience. Malevich went on to say: "The world as representation, as intellect, as will, will vanish like mist. To all the actions of human knowledge, to its objective type of thought, is contrasted the principle of non-objectivity, a principle extraneous to any limit or boundary, in the future an objective base in which to place any objective hope. In the solemnity of broad cosmic space I found the white world of Suprematist non-objectivity, as a manifestation of the nothing set free", for "burning emotion is the highest force, the white force that troubles thought".

Over the following decades many artists, from Ad Reinhardt to Robert Ryman, would take Malevich's work as their starting point.

Mikhail Larionov
Portrait of Vladimir Tatlin
(detail), 1913
Oil on canvas, 89 × 72 cm
Musée national d'Art
moderne – Centre Georges
Pompidou, Paris

At the same exhibition Tatlin presented his *Reliefs and Counter-reliefs*, three-dimensional geometric structures in which he focused on the process of their realization and on the disparate materials utilized: the sense of doing by constructing, instead of expressing, was at the base of his Constructivism, as well as that of all the multi-material experiments, from Schwitters to Prampolini, that were to follow over the century. He would apply the same principles in 1917 to the decoration of the Café Picturesque in Moscow, on which Georgy Yakulov and Alexander Rodchenko also worked, in which constructions of wood and metal rendered the space dynamic with the help of the lighting and prefigured the integration with architecture and the expansion of the work of art into its surroundings.

In 1917 the artistic debate took an unexpected direction. The revolution of languages and consciousnesses dreamt of by artists became a historical reality, and many protagonists of the art world played a direct part. In the months following the fall of the tsar a Commission for the Preservation of Artistic Treasures was formed in Petrograd. Its members included Mayakovsky, Puni and Blok, who had the backing of figures like Altman, Meyerhold, Prokofiev, Malevich and Tatlin.

143

"In creating a concrete object for everyday use with particular functions, the artist who draws on material culture takes account of all the properties of the suitable materials and their interactions, of the organic form of the human being for which the object in question is created and, finally, of the social moment: this man works and will use the object in the framework of a productive life."

Vladimir Tatlin

On 24 October Lenin installed himself in the Smolny Institute in Petrograd and launched the armed insurrection: a celebrated painting by Isaac Brodsky shows him in the austere setting of the Smolny in those crucial days.

In his position of commissar for education Anatoly Lunacharsky, an intellectual and great friend of Maksim Gorky, recruited numerous artists, from Kandinsky to Chagall and from Malevich to Rodchenko, with the aim of "creating new, free and popular forms of artistic life", as "art belongs to the people". Kandinsky set up thirteen museums of pictorial culture in the same number of cities, the Petrograd Academy was transformed into the State Academy of Artistic Studies, with the acronym GAChN, while the schools of art in Moscow were turned into the Higher Art and Technical Studios, VkhuTeMas.

Right from the start two divergent tendencies emerged among the artists who supported the revolution. On the one hand there were those, like Aleksandr Malinouski (called Bogdanov), scientist and founder of the movement called Proletkult (from *proletarskaya kultura*, proletarian culture), who wanted to promote workers' art and science as an alternative to those of the bourgeoisie and proposed the compilation of a new Proletarian Encyclopaedia; on the other were those who argued, like Osip Brik, that "those who see proletarian art as 'an art for proletarians' will respond at once that this art, like any other, will be created by artists, by people with talent. According to them talent is universal and it costs it nothing to adapt itself to any consumer. Today the bourgeoisie, tomorrow the proletariat, what difference does it make? They do not know how free themselves from the viewpoint of the bourgeois consumer and strive to place the proletariat in a situation that does not suit it at all, that of mass patron, magnanimously disposed to let itself be amused by funny ideas. Whence the continual preoccupation with 'accessibility', as if this were the heart of the matter".

Art as an experience in itself revolutionary, or art as propaganda in the service of the political revolution: this was the dilemma that emerged here in dramatic fashion, and that was to resurface again many times in the decades to come (from the arguments among the Surrealists to those of the Italian Communist Party, after the Second World War, against abstract art). During the early twenties the constructive aspects prevailed and opposition to them remained muted though smouldering. Working on his tower celebrating the Third International,

whose model he exhibited in 1920, Tatlin proposed Constructivism as total art, applicable to every aspect of life, and as experience of design and collective skill: he also became involved in the design of overalls for workers and functional objects. At the same time Rodchenko promoted the conceptual fusion of painting, sculpture and architecture in an approach based on design, on method, on a total rational command of the process, with creative as well as utilitarian functions.

In this perspective he devoted himself to the development of disciplines like photography, interior design and graphic design, experiences in which his wife Varvara Stepanova, another talented artist, was often involved as well.

For his part El Lissitzky, a teacher at the school of painting in Vitebsk run by Chagall and a brilliant graphic designer, developed the concept of the *Proun* (*Proekty Utverzdeniya Novogo*, "Project for the Affirmation of the New"): "The *Proun*," he wrote "is the station where one changes from painting to architecture", i.e. at which painting abandons its own limited dimensions to become a constructive adventure

Vladimir Tatlin
Monument to the Third International, 1920

Construction of the Model.
The collective of Tatlin's studio in front of the model

Monument to the Third International, 1919

The Second Model at the International Exhibition in Paris, 1925

in space. Lissitzky wrote about the *Proun* in the June 1922 issue of the magazine *De Stijl*: "The forms with which the *Proun* makes its assault on space are constructed not from aesthetics, but from material. In the initial stations of the *Prouns* this material is colour. It is taken as the purest aspect of the energetic state of matter in its material embodiment. (…) From the rich range of colours we choose the ones that appear most free of subjective characteristics. At the height of its perfection Suprematism has freed itself from the individualism of orange, green, blue, *etcetera*, and has arrived at black and white. In these two colours we have seen the purity of the energetic force. The force of the contrast or the harmony of two shades of black, white or grey can convey the harmony or the contrast of two technological materials, such as aluminium and granite, or concrete and iron."

Returning to Germany in 1922, Lissitzky collaborated with Hans Arp on the book *Die Kunstismen* ("The Isms of Art") and designed the first *Proun* settings, from which Schwitters would get the idea for his *Merzbau*. Just as Malevich saw Suprematism as the highest form of Realism, the brothers Anton Pevsner and Naum Gabo indicated the new Constructivist theories as Realism, and their "Realist Manifesto", posted in the streets of Moscow in 1920, is

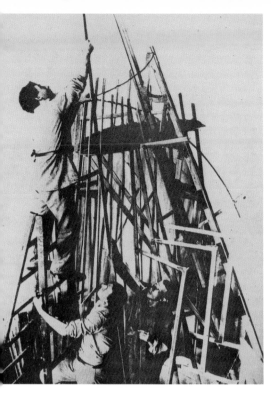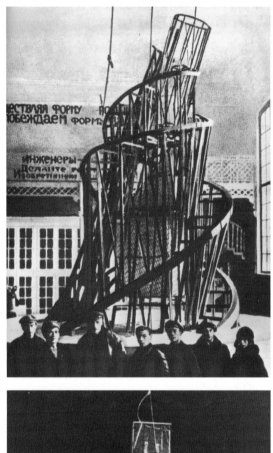

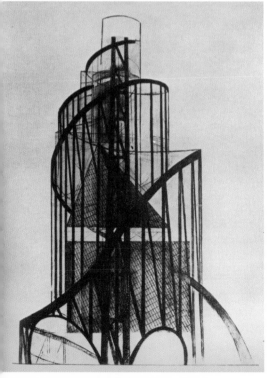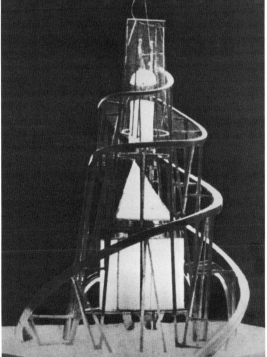

considered the most lucid summary of the movement: "We know that everything has its own essential image; chair, table, lamp, telephone, book, house, man… They are all entire worlds with their own rhythms, their own orbits. That is why we in creating things take away from them the labels of their owners… all accidental and local, leaving only the reality of the constant rhythm of the forces in them.

1. In painting, we repudiate colour as a pictorial element. (…) We proclaim that the tone of bodies, that is, their material substance absorbing the light, is their sole pictorial reality.

2. We deny the line its graphic value. (…) We acknowledge the line only as the direction of static forces that are hidden in the objects, and of their rhythms.

3. We disown volume as a plastic form of space. One cannot measure a liquid in inches. Look at our real space: What is it if not a continuous depth? We proclaim depth as the unique plastic form of space.

4. We disown, in sculpture, mass as a sculptural element. Every engineer knows that the static forces of solids, their material resistance, are not a function of their mass. For example: the rail, the buttress, the beam… (…) We thus restore to sculpture the line as direction, which prejudice had stolen from it. This way, we affirm in sculpture depth, the unique form of space.

5. We repudiate the millennial error inherited from Egyptian art: static rhythms seen as the sole elements of plastic creation. We proclaim a new element in plastic arts: the kinetic rhythms, which are essential forms of our perception of real time.

These are the five fundamental principles of our work and our technique of construction.

Art is called upon to accompany man everywhere where his tireless life takes place and acts: at the workbench, at the office, at work, at rest, and at leisure; work days and holidays, at home and on the road, so that the flame of life does not go out in man.

We leave the past behind like a corpse. We leave the future to prophets. For ourselves we take today."

The link with the applied arts became predominant. Rodchenko, Stepanova, Lissitzky, Malevich and Popova designed furniture, fabrics, pottery, advertisements and typographic fonts, bringing into existence a proletarian art that was supposed to be the image of a new way of being and living.

It was one of the crucial moments in the incubation of the discipline of design, which reached its culmination in the German Bauhaus. "In creating", wrote Tatlin in 1930, "a concrete object

for everyday use with particular functions, the artist who draws on material culture takes account of all the properties of the suitable materials and their interactions, of the organic form of the human being for which the object in question is created and, finally, of the social moment: this man works and will use the object in the framework of a productive life."

Alongside these artists, those of more direct Realist origins, who had been celebrating the glories of the Revolution with heroic images ever since 1917, were the most zealous in falling into line with the positions of the Proletkult: one of these was Boris Kustodiyev, who adapted his late 19th-century style to revolutionary themes. In 1922 the Association of Artists of Revolutionary Russia, AChRR, was set up with explicit aims: "We will represent daily life, the Red Army of the workers, the peasants, the heroes of the revolution and labour. We will give events their true image in place of the fantastic abstractions that discredit our revolution."

Following Lenin's death in January 1924, Stalin began to exercise ever more strict control over intellectual activity: on 16 June 1925 a resolution of the Party called for a "comprehensible" art, close to the workers. The foundation in 1930 of the Federation of Soviet Associations of Workers in the Spatial Arts, FOChS,

followed the year afterwards by the Russian Association of Proletarian Artists, RAPCh, was aimed at unifying all the artistic organizations under a single umbrella, depriving them of any space of independence and debate and reducing their goal to that of pure propaganda for the process of collectivization and industrialization launched by Stalin with the Five Year Plan of 1928.

In 1932 Andrey Aleksandrovich Zhdanov, a rising star in the culture of the regime, coined the term "Socialist Realism" at the very moment when a resolution of the central committee of the Party decreed the "reorganization of literary and artistic associations", *de facto* unifying them under its own control and stripping them of any margin of creative freedom and autonomy. Just two years later the same Zhdanov, at the General Congress of Soviet Writers, affirmed Socialist Realism as the only form of art possible in the name of the "party spirit" and the "revolutionary viewpoint", i.e. of the rhetorical and stereotyped celebration of a regime that now showed its totalitarian colours openly.

149

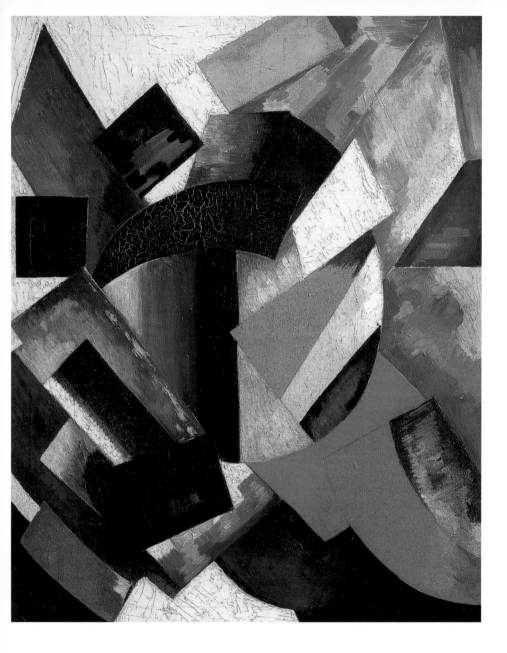

Alexandra Exter
1. *Abstract Composition*

Lyubov Popova
2. *Still-Life*

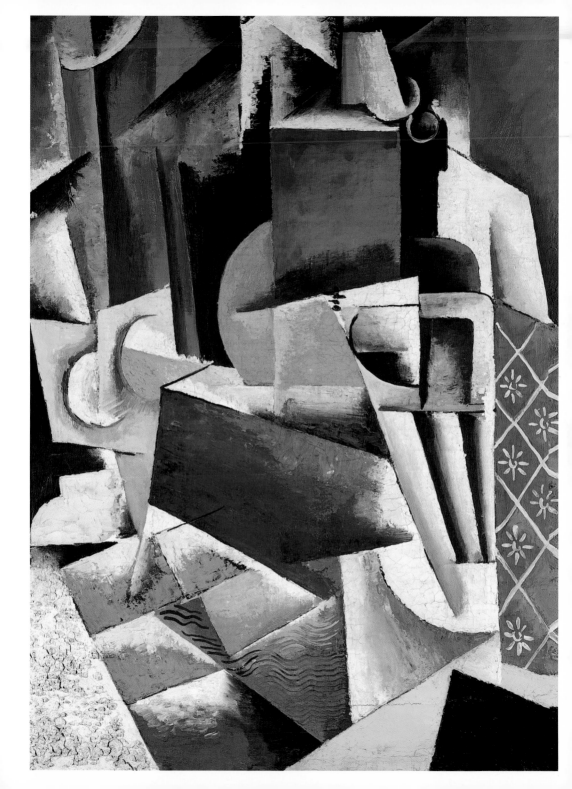

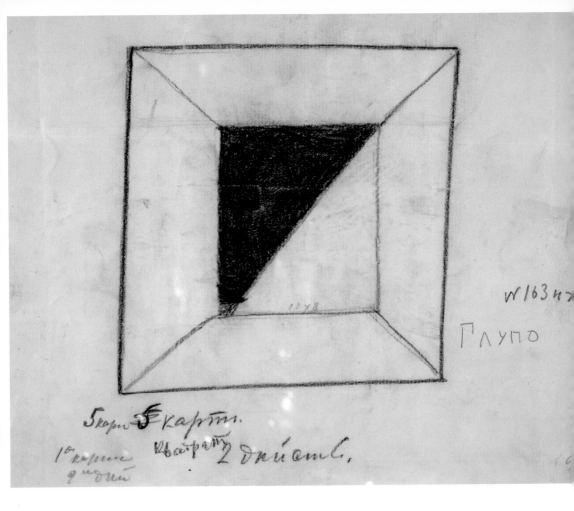

Kazimir Malevich
3. *Drawing for the Opera*
Victory over the Sun
by M. Matyushin
and A.E. Kruchenykh

Kazimir Malevich
4. *[Black] Cross*

152

Kazimir Malevich
5. *Suprematist Composition:*
Airplane Flying

Kazimir Malevich
6. *Suprematism*

155

**Lazar Markovich Lisitsky
(El Lissitzky)**
7. *Proun 1 D*

Alexander Rodchenko
8. *Yellow Composition*

157

Alexander Rodchenko
9. *Poster for the Propaganda
of the Book*

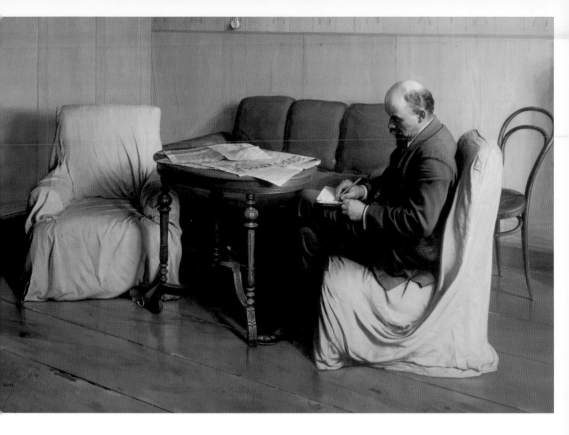

Alexander Gerasimov
10. *Lenin on the Tribune*

Isaac Brodsky
11. *Lenin at the Smolny*

161

Dada

"The word Dada was accidentally discovered by Hugo Ball and myself in a German-French dictionary, as we were looking for a name for Madame le Roy, the chanteuse at our cabaret. Dada is French for wooden horse." This is how Richard Huelsenbeck, one of the founders of the most radically revolutionary movement of the century, recalled how even the choice of its name had been the product of chance and an act devoid of logical purpose, perfectly embodying the crucial traits of Dadaist practice. All this happened in Zurich, a city on which many intellectuals of diverse origin converged, seeking shelter from the hardships of the First World War in neutral Switzerland.

Hugo Ball and his partner Emmy Hennings had come there in 1915, and were joined shortly afterwards by Huelsenbeck, Marcel Janco, Hans Arp, Tristan Tzara and many others. Their background was varied, in literature, art, music: Sophie Taeuber and Mary Wigman, for example, were choreographers and dancers of some fame.

Their meeting as exiles and common resentment over a war that threatened to destroy Europe civilization in the name of boorish nationalistic demands led them to conclude that only an art totally devoid of logic and any sense of destiny would be suited to an age in which there was such an eclipse of reason. If bourgeois culture, so full of common sense, had spawned the war, only an art that mocked sense and all propriety could provide an answer. As Arp would explain later: "We were seeking an art based on fundamentals, to cure the madness of the age. We aspired to a new order that might restore the balance between heaven and hell."

Their reaction was to take up the model of the Futurist events that held official culture up to ridicule in a mixture of literature, theatre, the visual arts and the variety show, and then use it in an even more provocative manner.

Out of this, on 1 February 1916, was born the Cabaret Voltaire, at which Ball, Huelsenbeck, Janco, Taeuber, Wigman, Arp and Hans Richter staged meaningless sketches, recitals of improvised onomatopoeic poems, strange dances and paradoxical musical performances. The effect on the public was naturally one of extreme provocation: the rejection of any aesthetics and any technique was presented, here, as the sole possibility of artistic expression. The world of art was equally pilloried for its militant earnestness and its fondness for definitive declarations and for specious intellectual exercises.

Tzara would sum up this spirit in 1918

in the "Dada Manifesto", in which he said: "To launch a manifesto you have to want: A., B. & C., and fulminate against 1, 2 & 3, work yourself up and sharpen you wings to conquer and circulate lower and upper case As, Bs & Cs, sign, shout, swear, organize prose into a form that is absolutely and irrefutably obvious, prove its *ne plus ultra* and maintain that novelty resembles life in the same way as the latest apparition of a harlot proves the essence of God (…). I am writing a manifesto and there's nothing I want, and yet I'm saying certain things, and in principle I am against manifestos, as I am against principles (quantifying measures of the moral value of every phrase [...]). I'm writing this manifesto to show that you can perform contrary actions at the same time, in one single, fresh breath; I am against action; as for continual contradiction, and affirmation too, I am neither for nor against them, and I won't explain myself because I hate common sense. DADA does not mean anything."

By a curious coincidence of history these proclamations of a grotesque renunciation of all meaning, of all design, of any reasonableness, were made in the setting of the Cabaret

Man Ray
Gift, circa 1958
(replica of 1921 original)
Painted flatiron and tacks,
15.3 × 9 × 11.4 cm
The Museum of Modern
Art, New York
James Thrall Soby Fund

Voltaire at Spiegelgasse 1: just a few houses down the street, at Spiegelgasse 14, another obscure intellectual, Vladimir Ilich Ulyanov called Lenin, was writing *Imperialism: The Latest Stage in the Development of Capitalism* in the peace and quiet of Zurich in those very months and laying the foundations for the Soviet Revolution.

"Today it can be seen that our exhibitions, literary soirées, protests, false news and scandalous events, which looked like anarchy at the time, were a necessity in order for us to get rid of outmoded forms, and to safeguard, against all routine and academicism, the spiritual life", Arp was to write years later. He went on to specify that "Dada is for meaninglessness, which is not the same as nonsense. Dada is as meaningless as nature. Dada is for nature and against art. Dada is as direct as nature. Dada is for infinite meaning and definite means." A few months later these Dada initiatives were joined by a magazine of the same name, conceived as a genuine artistic project even from the viewpoint of its graphics, although only a few issues would be brought out.

To the idea of the "total work of art", one that involved all the media and all the observer's senses, Dada opposed a sort of total rejection, an attitude of life, thought and behaviour of which artistic

"We were seeking an art based
on fundamentals,
to cure the madness of the age.
We aspired to a new order
that might restore the balance
between heaven and hell."

Hans Arp

expression was just one of the exemplary moments. Born as a movement of negation, it devoted itself to promoting methods diametrically opposed to the values of traditional culture: chance against necessity, paradox against the rule, laughter against seriousness, the "raising of public hell" (as Richter called it) against the attempt to persuade, indifference as opposed to intellectual engagement.

While the Galerie Dada, which opened in Zurich in 1917, showed works by the major exponents of the international avant-garde, from Kandinsky to Klee to de Chirico, the founders of Dada chose to express themselves chiefly by exploring the possibilities of purely haphazard practices. "Take a newspaper. Take a pair of scissors. Choose an article as long as you are planning to make your poem. Cut out the article. Then cut out each of the words that make up this article and put them in a bag. Shake it gently. Then take out the scraps one after the other in the order in which they left the bag. Copy conscientiously. The poem will be like you. And here you are a writer, infinitely original and endowed with a sensibility that is charming though beyond the understanding of the vulgar", wrote Tzara in *How to Make a Dadaist Poem*. This is, more or less, the way Arp produced his graphic works: he made the drawings, tore them up and threw the pieces onto a backing in such a way that the random arrangement of the individual elements gave rise, without further intervention, to the final work.

Among the most interesting Dadaist exhibitions in Zurich was the one held in 1918 at the Galerie Wolfsberg, at which the eclectic and prolific artist and cultural organizer Francis Picabia also showed. He had just been through the experience of founding the magazine *391* in Barcelona, where he had got to know Arthur Cravan, founder of the Parisian magazine *Maintenant* in 1912, whose life was an example of total dissipation: his most sensational gesture had been the boxing match he fought in Madrid on 23 April 1916 with the world heavyweight champion Jack Johnson, who knocked him out in the first round. Cravan was an exemplary role model for the Dadaists in the same manner as Jacques Vaché, a nihilist who committed suicide at the age of twenty-three after a youth spent deliberately throwing his talent to the winds. Picabia had also spent time in New York, where he had acted as an intermediary between the European avant-gardes and the new developments in the United States, which had their own coordinator in the photographer Alfred Stieglitz. In 1905 Stieglitz had founded the Little Galleries of the Photo-Secession at 291 Fifth

Avenue, where he had put on exhibitions of Matisse, Toulouse-Lautrec, Rodin, Rousseau and Cézanne and had seen young Americans like Charles Demuth, Arthur Dove, Joseph Stella and John Marin come to maturity. In addition, as editor and publisher of the magazine *Camera Work*, he was doing his best to get photography recognized as an artistic discipline on a par with painting and sculpture: in 1915 the name of the gallery would be changed to 291, after its street number, and it was to this that Picabia, in his choice of *391* as the name for his magazine, paid explicit homage.

It was in this climate that the decision was taken to stage a major exhibition on avant-garde modern art, which opened on 17 February 1913 at an armoury on Lexington Avenue, and thus was called the Armory Show. All the principal exponents of the new European movements took part, but in this panorama the greatest impression was made by Marcel Duchamp's *Nude Descending a Staircase*, the first real attempt on the part of a young artist to go beyond Cubism, which up until that moment had been symbolic of the avant-garde as a whole.

Duchamp, however, went much further. As he recounted: "Already in 1913 I had the happy idea to fasten a bicycle wheel to a kitchen stool and watch it turn. (…) It was around that time that the word ready-made came to mind to designate this form of manifestation. (…) The choice of these 'ready-mades' was never dictated by aesthetic delectation. The choice was based on a reaction of *visual* indifference with at the same time a total absence of good or bad taste (…) in fact a complete anaesthesia (absence of awareness)."

The next stage in the evolution of the ready-made, which made clear that it was not just a provocation, was the annual exhibition of the Society of Independent Artists in 1917. Seeing in the application form that the work to be put on show had to conform to certain dimensions and materials, as well as be signed and dated, Duchamp took a porcelain urinal, dated it and signed it with the name of R. Mutt: the object fulfilled all the requirements of the rules and so, deduced the artist paradoxically, had to be considered a work of art. His initiative caused scandal and controversy, and has now come to be regarded as one of the principal icons of the 20th-century avant-garde. On closer examination, however, Duchamp's subtle intellectual point did not consist in claiming that a urinal is a work of art, but in showing that the customary definitions of what is a work of art can just as well be applied to an object as banal and vulgar as the one

168

"I am against action;
as for continual contradiction,
and affirmation too, I am neither
for nor against them, and
I won't explain myself because
I hate common sense.
DADA does not mean anything."

Tristan Tzara

UN HOMME DANS L'ESPACE !

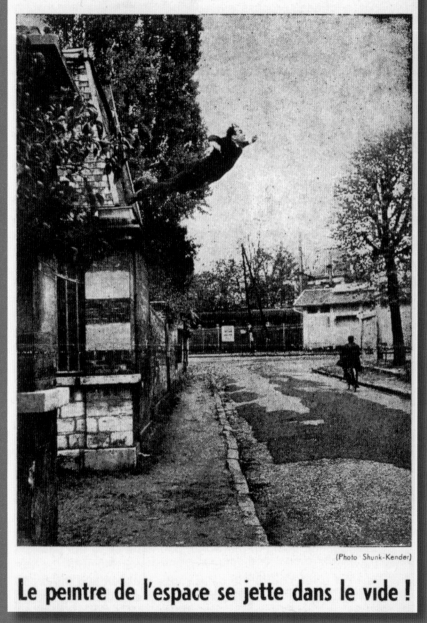

(Photo Shunk-Kender)

Le peintre de l'espace se jette dans le vide !

he chose: thus it was not his work that was incongruous, but the definition of art that everyone accepted as valid. To another objection, the fact that the artist had not made the object with his own hands, he put forward a further defence: the creation of the ready-made, he explained, entailed not making but selecting an object, the intellectual act and not the execution, removing it from its original purpose and assigning it a new significance. Duchamp pointed out that even the great Leonardo had argued that painting was a "mental thing".

As a consequence of the fact that the essence of the work was its intellectual conception, the idea that had generated it, and that its execution and physical nature had been totally devalued, the work was no longer a unique specimen and the criterion of originality no longer applied: Duchamp was to replicate his ready-mades many times over the years, assigning equal legitimacy and value to each reproduction.

A fundamental element of the ready-made was its titling, the operation by which Duchamp, with a sense of verbal as well as intellectual paradox, transfigured the object by projecting it into an estranging dimension of meaning. This was the case with the title *Fountain* chosen for the urinal, and even more so with the apparently cryptic one of another celebrated operation, which entailed drawing a goatee and moustache on a postcard reproduction of Leonardo's *Mona Lisa* that was published in March 1920 on the cover of issue number 12 of *391*: the mocking and irreverent implication of what he called a "ready-made aided", i.e. altered in some way, was accompanied by the allusive title of *L.H.O.O.Q.*, which when pronounced in the French way sounds like a vulgar sexual innuendo.

Duchamp always displayed a sardonic, indifferent and cynically contradictory attitude, through which he systematically undermined any unquestionable fact in the field of art, its techniques, its rules and its conventions. As he was to explain in 1945, "I have forced myself to contradict myself in order to avoid conforming to my own taste", going on to say "an atheist is just as much a religious man as the believer is, and an anti-artist is just as much of an artist as the other artist".

Duchamp's alter-ego in those hectic years in New York was Man Ray, a painter whose friendship with Stieglitz had led to take up photography. His series of collages and graphic works entitled *The Revolving Doors*, 1916-17, was produced alongside monumental

Yves Klein
*Le peintre de l'espace
se jette dans la vide*
(*Leap into the Void*), 1960
Photograph by Harry Shunk
and John Kender
Silver gelatine print,
35 × 27 cm

"Dada is like your hopes: nothing.
Like your paradise: nothing.
Like your idols: nothing.
Like your heroes: nothing.
Like your artists: nothing
Like your religions: nothing."

Hans Arp

paintings like *The Rope Dancer Accompanies Herself with Her Shadows*, 1916, whose title is an explicit allusion to that of Duchamp's cryptic visual operation *La Mariée mise à nu par ses célibataires, même* (*The Bride Stripped Bare by Her Bachelors, Even*, better known as *The Large Glass*), begun in 1915.

Man Ray started to follow in the footsteps of his friend's ready-mades in 1920, when he created *L'énigme d'Isidore Ducasse* (*The Enigma of Isidore Ducasse*), a photograph of an object wrapped up in a blanket and tied up with string, so that it was unrecognizable, and with *Cadeau* (*Gift*), 1921, an iron bristling with nails. It was during his years in Paris, and in the lively encounter between Dada and Surrealism, that Man Ray would produce his most extraordinary work. At the end of the First World War Picabia moved to Paris, where he was joined shortly afterwards by Duchamp and Man Ray. Faithful to his vocation as a cultural agitator, he had founded the magazine *391* in 1917 and published the first issue of *Cannibale* in 1920, shortly after three young poets, André Breton, Philippe Soupault and Louis Aragon, had launched the review *Littérature*, commencing the transition from Dada to Surrealism. In 1920 Picabia published the "Manifeste Cannibale Dada" in issue 7 of Tzara's magazine *Dada*. It had first been declaimed by Breton at a Parisian soirée on 27 March:
"Dada is like your hopes: nothing.
Like your paradise: nothing.
Like your idols: nothing.
Like your heroes: nothing.
Like your artists: nothing
Like your religions: nothing."

Elsewhere he wrote that "art has to become the height of anti-aestheticism, useless and in no way justifiable".

Picabia was forced to become a nomad by the events of the war, and so was Huelsenbeck, who at the beginning of 1917 moved from Zurich to Berlin. Here the cultural climate was characterized by a higher degree of politicization, something that was reflected in two magazines: the openly antimilitaristic *Neue Jugend* and *Freie Strasse*, anarcho-communist in inspiration.

A Dada group formed rapidly around Huelsenbeck. Its principal exponents were the brothers Wieland and Johann Herzfelde (who always signed himself as John Heartfield), George Grosz, Raoul Hausmann, Johannes Baader and Hannah Höch. On 21 January 1918 Huelsenbeck read the "First German Dada Manifesto" at the Galerie Neumann. Two years later the Erste Internationale Dada-Messe (First International Dada Fair) would be held at the shop of the antique dealer

Dr. Otto Burchard. Among the participants were Max Ernst, active in Cologne, and Otto Dix.

In the meantime Kurt Schwitters was working in isolation in Hanover. At the International Dada Fair, Heartfield and Grosz, who had taken part in the Spartacist Revolt and was a member of the Communist Party, hung a grotesque doll with the head of a pig and dressed as a German soldier from the ceiling, causing a scandal and provoking a reaction from the institutions: over the space of a few years his activities earned Grosz a series of indictments and trials for incitement to class hatred, indecent behaviour, defamation of religion and slander of the armed forces. His art was made up of grotesque images that described reality by deforming it to the point where its drama and violence was revealed. Heir to the German visionary tradition inspired by the examples of Goya and Daumier, Grosz believed in the value of the image as a tool of political education. This led him to found two magazines, *Der blutige Ernst*, which he edited with John Höxter and Carl Einstein, bringing out six issues in 1919, and *Die Pleite*, in collaboration with the Herzfelde brothers, which came out

Christo
Le Diable, 1963
Various materials,
122 × 100 × 66 cm
MART – Museo d'Arte
Contemporanea di Trento
e Rovereto, Rovereto
Ileana Sonnabend
Collection (on deposit)

eleven times between 1919 and 1924. He also produced several important series of prints, whose circulation he hoped would serve to awaken a revolutionary consciousness: among the most famous of these are *Gott mit Uns* (*God with Us*), 1920, and *Ecce Homo*, 1922.

Close to him was Dix, although he remained on the periphery of the Dada experience, giving his work a more Expressionist character and then turning to a sort of emphatic realism, filled with symbolic elements and blunt and indignant in its denunciation, almost as if the mere representation of the ills of society with a sharp eye were sufficient to make it an irrevocable condemnation. It is to Heartfield and Höch, as well as Hausmann, that we owe the development of the new artistic technique known as photomontage, a combination of photographic images of various origins assembled in such a way as to produce a fresh vision, or pictures combined with texts that rendered them paradoxical or revealed their meaning. In reality the work of the two artists was largely a form of "photo-collage", i.e. a version of Cubist collage using photographs, and it was not until later, in the mid-twenties, that it became a new technique in its own right, well known among professional photographers and practiced in other areas of research as well by artists like László Moholy-Nagy,

174

who was active in Dada circles in Berlin in 1920 and then a teacher at the Bauhaus in Weimar from 1923, and Alexander Rodchenko, a leading exponent of revolutionary Soviet art.

For Heartfield, Höch and Hausmann too the choice of artistic medium was a question of politics. As Heartfield put it: "New political problems demand new means of propaganda. For this task photography possesses the greatest power of persuasion." Photography was used for propaganda and advertising and had an immediate visual impact, as well as a capacity to influence people's ideas, that painting and drawing perhaps no longer possessed. Amplifying this impact through the use of the element of excess, of satirical parody, that montage brought with it, turned it into a highly effective political tool. Hausmann practiced the technique of a mixture of random and guided montage in sculpture too, and above all in poetry, exploring the possibilities of the arbitrary collation of lines, onomatopoeia and the sound poem. His experiments paved the way for those of Schwitters, who as early as 1919 held an exhibition of collages that he called *Merz* (the term derived from an arbitrary splitting of the word *Kommerz*, "commerce") at the Galerie Der Sturm in Berlin, and the same year created the poem *An Anna Blume*, a free montage of verses that he invented or took from popular songs and banal texts.

Schwitters, who considered himself an artist in the full sense of the word and did not share Dada's nihilistic attitude, was aiming instead at a definitive broadening of the horizon of possible approaches to creativity. For this reason he formed close ties of friendship not only with Arp, but also with members of the De Stijl group like Theo van Doesburg, and in 1923 embarked on the project of a "total work of art" that would demonstrate the true scope of the new practices. While in his *Merzbilden* the techniques of painting and collage were combined in a harmonious way, producing images that aspired to a visual quality as well, in the *Merzbau* he constructed in his house at Waldhausenstraße 5 in Hanover, which transformed the *Merz* montage into a three-dimensional assemblage on an environmental scale, his intention was for the observer to be immersed in the work and assailed by aesthetic perceptions. In parallel, as was common practice at the time, he founded a magazine, *Merz*, and held what he called Merzmatinées, performances for which, among other things, he conceived and executed the *Ursonate*, a full score of phonetic poetry subdivided into movements. He went on working on this, alongside the *Merzbau*, until 1932, the

year in which the rise to power of the Nazi government drove him to move to Norway.

In Cologne Max Ernst was working with Johannes Theodor Baargeld: the two artists also published a magazine, *Die Schammade*, of which only one issue came out in 1920 with contributions from Aragon, Arp, Breton, Éluard, Huelsenbeck, Picabia, Tzara and Soupault, almost heralding the shift to the Surrealist climate that was to take place in Paris.

Less closely tied to the German Dada movement than Schwitters, but like him convinced that the key lay neither in politicization nor in anti-aestheticism at any cost, Ernst in this period created complex assemblages and collages that were characterized by disturbing and cruel, threatening elements, or reworked technical drawings, transforming them into useless or bizarre mechanisms and shifting the provocation of accepted taste onto a more psychological plane, with irrational and unconscious suggestions. Moving to Paris in 1921, he became the driving force behind the evolution towards Surrealism in painting.

In the space of a few years the spirit of Dada was diluted into a series of different movements, ranging from Surrealism to a less intransigent abstract art. It was not until the fifties that a rediscovery of Duchamp, Picabia, Man Ray and their fellow travellers took place.

In the USA this revival of interest was brought about by musicians like John Cage and artists like Robert Rauschenberg and Allan Kaprow.

In Europe an entire generation was fascinated by Dada's caustic spirit and focus on the object. The Nouveau Réalisme theorized by Pierre Restany in 1960, along with Yves Klein, Jean Tinguely, Raymond Hains, Arman, Jacques de La Villeglé, François Dufrêne, Mimmo Rotella, Daniel Spoerri, Martial Raysse, César, Niki de Saint-Phalle, Christo and Gérard Deschamps, as well as experiences like those of Piero Manzoni and the international group Fluxus, with Nam June Paik, Joseph Beuys, Wolf Vostell, Dieter Roth and others, renewed the practice of the alienating manipulation of objects, the provocative happening and the use of the living human body as an artistic element, ushering in the fertile period of the neo-avant-gardes.

177

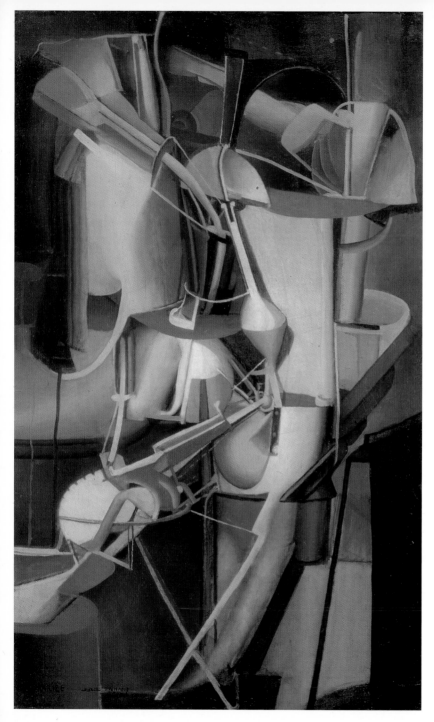

Marcel Duchamp
1. *Mariée (Bride)*

Francis Picabia
2. *I See Again in Memory
My Dear Udnie*

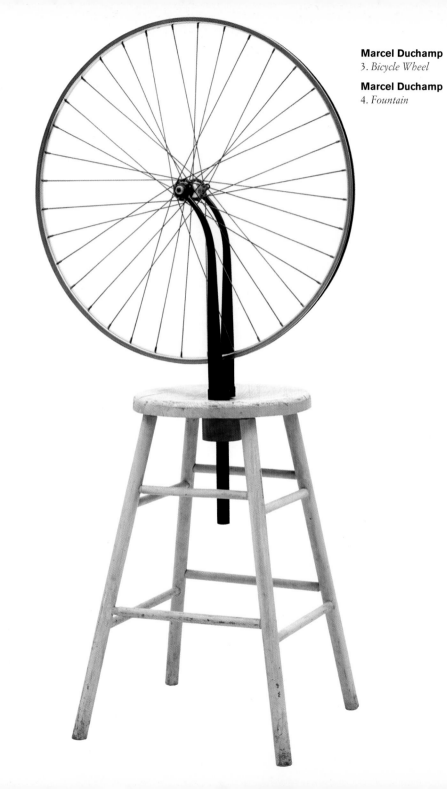

Marcel Duchamp
3. *Bicycle Wheel*

Marcel Duchamp
4. *Fountain*

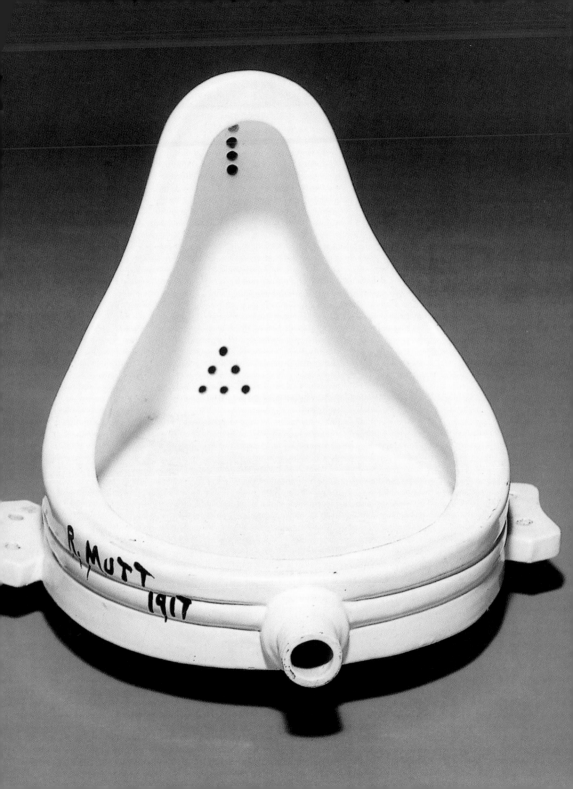

182

Marcel Duchamp
7. *The Bride Stripped Bare
by Her Bachelors, Even*
or *The Large Glass*

Man Ray
8. *The Enigma
of Isidore Ducasse*

185

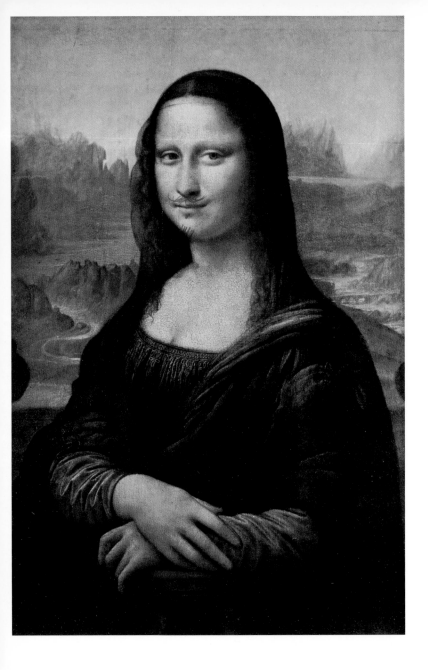

Marcel Duchamp
9. *L.H.O.O.Q.*

Max Ernst
10. *The Pleiades*

La puberté proche n'a pas encore enlevé la grâce ténue de nos pléiades/ Le regard de nos yeux pleins d'ombre est dirigé vers le pavé qui va tomber/ La gravitation des ondulations n'existe pas encore

Hans Arp
11. *Collage with Squares*
Arranged according
to the Laws of Chance

Kurt Schwitters
12. *Rotation*

Following pages
László Moholy-Nagy
13. *25 Pleite Geier*

Raoul Hausmann
14. *P*

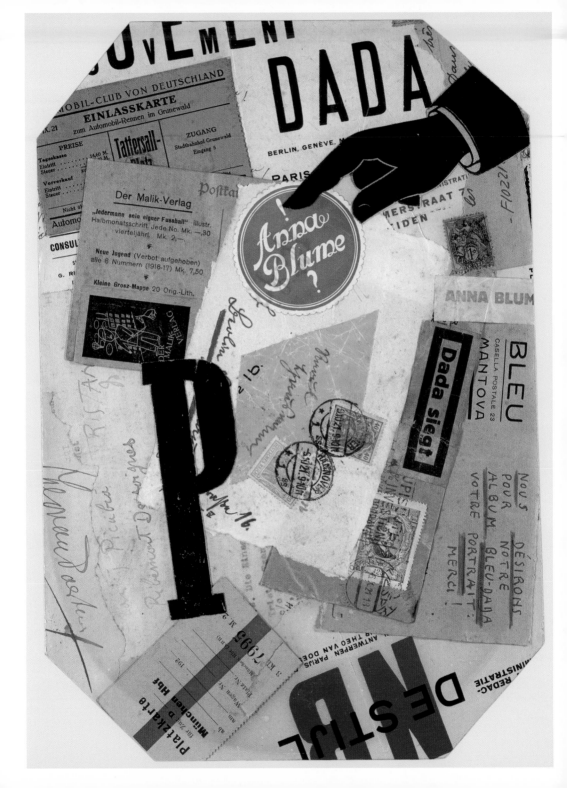

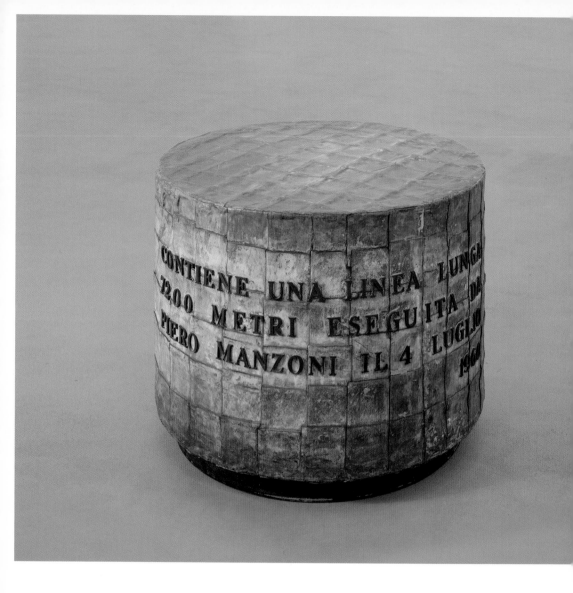

Previous pages
Yves Klein
15. *Anthropometry of the Blue
Period (ANT 82)*

Piero Manzoni
16. *Line m. 7200, 4 July 1960*

Piero Manzoni
17. *Artist's Shit No. 8*

195

Rational Art

In 1916 Theo van Doesburg published a series of articles under the general title *The New Movement in Painting*, which were collected in a volume the following year. The concept of "movement" that he put forward in these writings was used in a symbolic and musical sense because, he argued, in painting as in music the artist acts in accordance with an "inner listening" that the observer in turn puts into effect, in that "he adds something to the plastic work of art, which is born in him, which he reproduces in himself". In this way the Dutch artist, who preached the absolute autonomy of artistic form and content, attempted to condense many of the scattered intuitions that had had been formulated by the avant-gardes which immediately preceded him: in his *Iridescent Interpenetrations* Giacomo Balla had used intersecting geometric elements to produce a visual rhythm, while artists with their roots in Symbolism like Romolo Romani, František Kupka and Mikalojus Čiurlionis—who was also a great composer—had imagined transcendent visions fed by musical ideas; at the beginning of the decade Wassily Kandinsky, August Macke and Paul Klee had sought equivalences between geometry and music ("The tone of colour, the musical tone and human movement in themselves" wrote Kandinsky, "abstracted from their outer meaning, will manifest their inner essence and their own sonority which issues from it"), as had Robert and Sonia Delaunay, whose simultaneous forms were geometric symbologies transformed into visual rhythm.

All these artists saw music as the epitome of abstract art, not dependent on naturalistic references and therefore much better suited to representing a fully spiritual reality, which rose above the sensible one, and to exploring the transcendent. And they regarded geometry as the visual system that came closest to it, as a supernatural world with rules of its own completely susceptible to control by reason and feeling. It was from music, moreover, and to be precise the compositions of Richard Wagner, that the fundamental concept of the *Gesamtkunstwerk* was derived: the "total work of art", capable of bringing all the disciplines together in a single conception, was an idea with which the Futurists, from Depero to Prampolini, were experimenting, as were their Russian emulators, from Kruchenykh, Matyushin and Malevich's *Victory over the Sun*, the "opera" that marked the birth of Suprematism, to Diaghilev's project of getting musicians, painters, choreographers and poets to work together.

In 1917 Van Doesburg founded the journal *De Stijl*, and the group that formed around it included the painters Huszàr, Van der Leck and Mondrian, the

architects Oud, van 't Hoff and Wils and the poet Kok; they were soon joined by Vantongerloo and Rietveld. In the first issue of the magazine Piet Mondrian published the first in a series of articles entitled "De Nieuwe Beelding in de schilderkunst" ("Neo-Plasticism in Painting"), in which he argued that the modern sensibility was growing more and more detached from the simple experience of the natural and becoming abstract, i.e. no longer bound to the subjectivity and the data of the sensible world: what mattered, now, was the feeling of universal beauty, a beauty that transcended its individual incarnations and that induced the artist to "find its expression in the abstraction of form and colour, that is to say, in the straight line and the clearly defined primary colour". Influenced by Cubism, it was in those years that Mondrian moved from the geometric breakdown of forms to canvases in which the vision was reduced to patterns of intersecting vertical and horizontal lines, whose relations and binary patterns were a synthesis of the vital pulsations expressed by nature. He went on to condense the process of painting into a series of rectangles and squares laid

Paul Klee
Main Roads and Minor Roads (detail), 1929
Oil on canvas, 83.7 × 67 cm
Museen der Stadt,
Museum Ludwig, Cologne

on in flat colours that divided up the surface of the picture in a regular way, so that the relations between dimensions and colours provided constantly changing formal cadences. As Mondrian put it: "The determination of the colour entails in the first place the reduction of the natural colour to the primary colour; secondly the reduction of the colour to the plane; and thirdly the delimitation of the colour, so that it appears to us as a unity of rectangular planes." Mondrian's goal was that of an absolute art, the utopia of a beauty that would be the principle of the natural one and not its manifestation, in a sort of mysticism of form and colour. For his part, van Doesburg aimed instead to reflect the multiplicity and the internal dynamics of experience, creating constructions based on contrasting rather than harmonious relations and above all by imagining, in his dream of a total work of art, an integration of the arts through which painting would bring its forms into life in a concrete way, in concert with architecture. As early as 1917 he created stained-glass windows for buildings designed by Jacobus Johannes Pieter Oud and Jan Wils with square elements that held a dialogue with the rectangular structure, corresponding as much to the new architecture, with its plan and elevations based in turn on rectangles and squares, as to the idea of stained glass as heir to the ancient

"In past centuries the 'natural' form has been a crutch on which art relied to move towards the creation of aesthetic harmony. In the 20th century the artist has felt it necessary to destroy that crutch (…). He creates immediately, through the balanced relationship of contrasts, a plastic whole (…)."

Theo van Doesburg

tradition of the luminous image.

"In past centuries", wrote van Doesburg, "the 'natural' form has been a crutch on which art relied to move towards the creation of aesthetic harmony. In the 20th century the artist has felt it necessary to destroy that crutch; he wants to walk by himself. He wants to create a harmony consistent with art, i.e. using its own means of expression. He creates immediately, through the balanced relationship of contrasts, a plastic whole. So this era, which commences today, should be called the 'era of a new plastic art'. It is only by going down this road that art can become independent. Only by going down this road can art attain its own goal: creating a particular expression of unity with the specific means of art: colour for painting, volume for sculpture, space for architecture."

He was more attentive to the functional implications of the new form, which from the early twenties was called neo-plasticism, seeing its most fruitful development in the applied arts and i n architecture, as happened in the buildings of the architects who belonged to the group and in works like Gerrit Rietveld's *Chair*, designed in 1917 and realized in a coloured version in 1923 as a sort of metaphysical piece of furniture in which function and abstract beauty came together. Vantongerloo, on the contrary, placed himself on an even more explicitly mystical plane of understanding than Mondrian: if there is absolute beauty, "the invisible is a perpetual vibration or movement and can become visible to our mind through a point, a line, a plane, a volume, which are the image or the trace of the infinite".

The artists of *De Stijl* did not represent a close-knit group like those of the other avant-gardes. Rather it was a sort of intellectual coterie in which the individuals went their separate ways after the early period in the Netherlands, moving on to numerous other experiences of the time.

The same impulse that was leading the revolutionary Soviet artists towards Constructivism and a functional art—El Lissitzky wrote about his *Prouns* in *De Stijl* in June 1922—had led to the setting up of the Bauhaus, a school of art, architecture and applied arts in Weimar, in 1919, under the direction of Walter Gropius. The intention was clear: robust theoretical teaching and the revival

of manual skills, unity of design due to an evident and shared method and a practical approach: above all, a unity of all the arts under the banner of architecture, in line with what another architect, Bruno Taut, was calling for: "At this point there will be no boundaries between the crafts, sculpture and painting; all will be one: architecture." The syllabus is clearly

illustrated by Gropius's words: "(…) the culminating point of the Bauhaus teaching is a demand for a new and powerful working correlation of all the processes of creation. The gifted student must regain a feeling for the interwoven strands of practical and formal work. The joy of building, in the broadest meaning of that word, must replace the paper work of design. Architecture unites in a collective task all creative workers, from the simple artisan to the supreme artist. "For this reason, the basis of collective education must be sufficiently broad to permit the development of every kind of talent. Since a universally applicable method for the discovery of talent does not exist, the individual in the course of his development must find for himself the field of activity best suited to him within the circle of the community. The majority become interested in production; the few extraordinarily gifted ones will suffer no limits to their activity. After they have completed the course of practical and formal instruction, they undertake independent research and experiment. Modern painting, breaking through old conventions, has released countless suggestions which are still waiting to be used by the practical world. But when, in the future, artists who sense new creative values have had practical training in the industrial world, they will themselves possess the means for realizing those values immediately. They will compel industry to serve their idea and industry will seek out and utilize their comprehensive training."

Not called to teach in Weimar, where Johannes Itten, Lyonel Feininger and Paul Klee were members of the staff, and where they were joined in 1922 by Kandinsky from the Soviet Union, van Doesburg taught an alternative "Stijl-Kursus" in the same city that year, attracting many students from the Bauhaus: he contrasted the rigor of his own method with the Expressionist tendencies that the teachers at the Bauhaus continued to display, and forged ties with El Lissitzky, Gabo and Pevsner, exiled to Germany after the collapse of Soviet revolutionary hopes, and with László Moholy-Nagy, who in 1921 signed the "Appeal for an Elementary Art" in *De Stijl* with Ivan Puni, Hans Arp and Raoul Haussmann, in a lively exchange with the exponents of German Dadaism.

However, Klee and Kandinsky's experience at the Bauhaus was far more important on the level of results. Kandinsky taught courses which he summarized in 1926 in the text *Point and Line to Plane*, in which the basic elements of painting were viewed from a functional point of view, as autonomously capable of constructing autonomously significant configurations, but also and above all in an almost numinous key, as the basis for a far more complex

"The geometric point is an invisible thing.
(…) Considered in terms of substance,
it equals zero. (…) Thus we look upon the
geometric point as the ultimate and
most singular union of silence and speech.
(…) The geometric line is an invisible
thing. It is the track made by the moving
point; that is, its product. It is created
by movement—specifically through
the destruction of the intense
self-contained repose of the point (…)."

Wassily Kandinsky

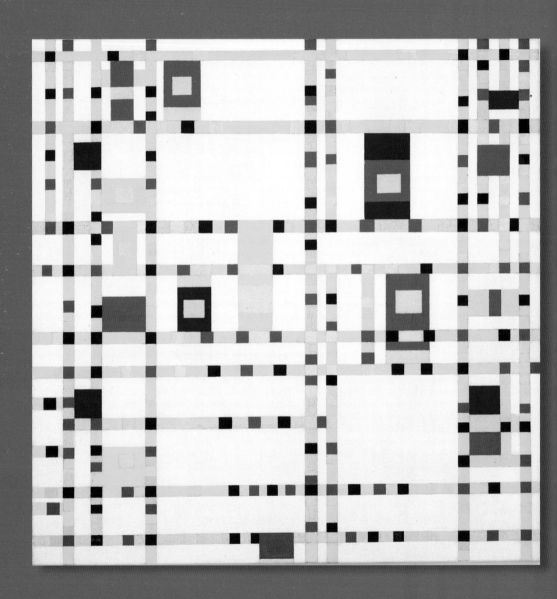

metaphysics of form. He wrote: "The geometric point is an invisible thing. Therefore, it must be defined as an incorporeal thing. Considered in terms of substance, it equals zero. (…) Thus we look upon the geometric point as the ultimate and most *singular union of silence and speech*. (…) The geometric line is an invisible thing. It is the track made by the moving point; that is, its product. It is created by movement—specifically through the destruction of the intense self-contained repose of the point. Here, the leap out of the static to the dynamic occurs." Perceiving these characteristics of the visual elements, as well as the specific characteristics of the colours, allows the observer to "enter into the work, become active in it and live its pulsation with all his senses". From the twenties onwards, in fact, Kandinsky's paintings responded to an invention in which the absolute geometric shapes were continually reflected in biomorphic echoes and symbolic implications. In contrast to the mystical rigor of Mondrian and the methodological severity of van Doesburg, Kandinsky was more interested in the vitality of the form than its absoluteness. Klee, for his part, even

Piet Mondrian
Broadway Boogie-Woogie,
1942-43
Oil on canvas, 127 × 127 cm
The Museum of Modern
Art, New York

defined himself as "abstract with memories", in the sense that for him the imagination, the infinite play of creation, abstract because it was transcendent, was far more important than any artistic theory. If Lothar Schreyer, his colleague at the Bauhaus, wrote of Klee's studio at Weimar that "the whole of our Bauhaus was a laboratory, but here lay the true wizard's kitchen", it was because it was possible to discern in the artist's pictures a tremulous sense of epiphany of form, of silent and gleaming vitality that turned not just nature but also abstract form into places of wonder. As Klee wrote in *The Creative Confession*, published in 1920: "Art is a likeness of the Creation. It is sometimes an example, just as the terrestrial is an example of the cosmic. The shaking free of the elements, their grouping into complex subdivisions, the dismemberment of the object and its reconstruction into a whole, the pictorial polyphony, the achievement of stability through an equilibrium of movement, all these are difficult questions of form, crucial for formal wisdom, but not yet art in the highest circle. In the highest circle an ultimate secret lurks behind the multiplicity of meaning, and the wretched light of the intellect is of no avail."

While the course of the Bauhaus moved towards its conclusion, an end which came in 1933 when it was closed down

"Art is a likeness of the Creation.
It is sometimes an example,
just as the terrestrial is an example
of the cosmic. (…) In the highest
circle an ultimate secret lurks
behind the multiplicity of meaning,
and the wretched light
of the intellect is of no avail."

Paul Klee

by the Nazi regime, it was in the Paris of the late twenties that a new group of exponents of rational art was organized. After the experiences of Le Corbusier and Amédée Ozenfant's journal *L'Esprit Nouveau*, the group Cercle et Carré, founded by Michel Seuphor and Joaquín Torres-García, revived the fortunes of abstractionism in the international field, launching a magazine and staging an exhibition in April 1930 at the Galerie 23 Rue de la Boétie. Much more significant, however, was the influence of Abstraction-Création, a genuinely international congregation of non-objective artists that a year later brought together established masters, from Kupka to Mondrian and from Kandinsky to Arp, and new names with different backgrounds and vocations, including Alexander Calder, Jean Hélion, Max Bill, Ben Nicholson, Auguste Herbin, Willi Baumeister, Lucio Fontana and Mauro Reggiani. The membership of the association eventually reached around four hundred.

In the thirties, Italy was one of the most active countries in the realm of rational art. In 1935 Carlo Belli published *Kn*, an essay in which he set out to demonstrate a continuity of ideas between modern geometric composition and the classical architectural and sculptural canon.

A group of artists formed between Milan and Como whose members included Lucio Fontana, who in that period was practising an abstraction made up of free forms with an echo of the surreal; Osvaldo Licini, with his strong lyrical tendencies and sharp polemical tone (in 1935 he wrote: "The priests say that what I'm doing now is cerebral painting. What are we supposed to do, intestinal painting? Their feeling is a phenomenon of central, cerebral activity as well. And so? They also say—in bad faith—that ours is decorative painting. If ours is decorative painting, their painting is theatrical, photographic or grotesque. And so we're quits. We will show that geometry can become emotion, more interesting poetry than the one expressed by the human face"); Fausto Melotti, with his classical plastic architectures; and Mauro Reggiani, Mario Radice, Manlio Rho, Luigi Veronesi and others. This was the new generation that emerged from Abstraction-Création to carry on with the Rationalist experience after the Second World War. In his essay *Concrete Painting*, published in February 1946, Max Bill wrote: "Abstract painting initially takes its cue from a model drawn from nature, which it then modifies and transforms in such a way that in the end almost no trace is left of the model itself." In *Concrete Art* he declared instead "something that first existed in the world of ideas becomes a reality that can be controlled and observed. Concrete Painting is therefore a representation of the reality of abstract, invisible thoughts".

This was a restatement of the position put forward by van Doesburg in 1930 in the first and only issue of the magazine *Art Concret*, explicitly contrasted with the less uncompromising abstractionism of Cercle et Carré: geometry derived on the one hand from the world, on the other from ideas. Primary geometric shapes, pure colours laid on in a uniform way, research into form and colour that based its aims on the theory of perception, the *Gestalttheorie* of a German tradition that went all the way back to Goethe, and on the theory of colour that Itten had formulated at the Bauhaus, where Bill had received his training. His teachings influenced tendencies embodied by artists like Richard Paul Lohse, Camille Graeser, Jean Dewasne, Antonio Calderara and Dadamaino, all active in the area of concrete art and pure research into colour. Bill's position was the same as the one that another student and then teacher at the Bauhaus, Josef Albers, took to the United States when he emigrated there to escape Nazi persecution, and which was then reflected in the paintings of Rothko, Reinhardt, Kelly and Stella and in the sculpture of David Smith, at the root of Minimalism. From the lesson of the

Alexander Calder
Mobile on Two Levels,
circa 1955
Painted aluminium foil
and iron wire,
200 × 120 × 110 cm
Musée national d'Art
moderne – Centre Georges
Pompidou, Paris
Gift of the artist, 1966

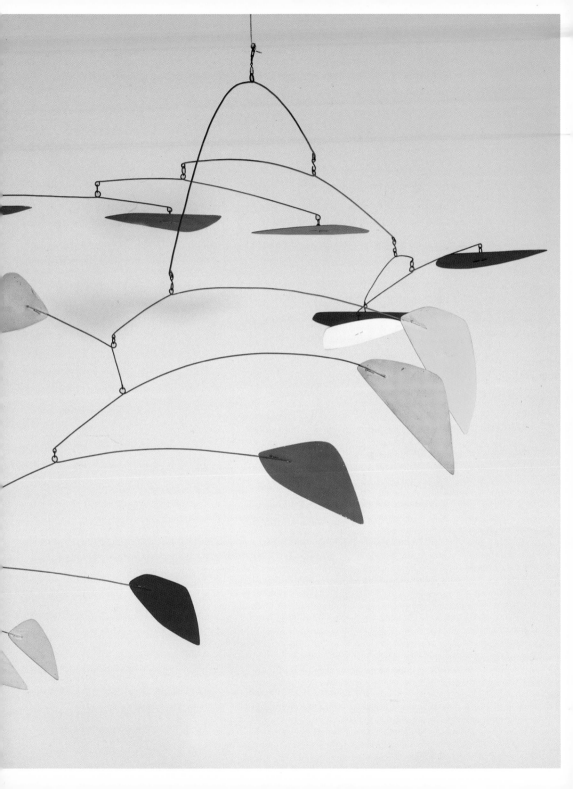

Bauhaus Bill also took the idea of the centrality of education, founding in 1951 the Hochschule für Gestaltung in Ulm, which among other things exercised a decisive influence on the birth of contemporary design.

In 1955 Victor Vasarely organized the exhibition *Le Mouvement* at the Galerie Denise René in Paris, in which he included the pioneering examples of Gabo's *Kinetic Construction*, a sheet of steel made to vibrate by an electric motor that had been presented in 1922 at the *First Exhibition of Russian Artists* in Berlin; Calder's *Mobiles*, sculptures that were free to move in space; and Duchamp's *Rotoreliefs*, rotating disks that produced a range of optical illusions. Art in movement was what Vasarely himself practiced, exploiting all the effects of distortion of geometric figures that generate ambiguous perceptions, an area in which experiments were also conducted by artists like Jesús-Rafael Soto, Yaacov Agam, Julio Le Parc and Bridget Riley. It was also the kind that used actual moving objects, as in the work of Jean Tinguely, and the one that combined light, physical movement and optical illusions, as happened in numerous experiences from the end of the fifties onwards, in group practices that even set out to challenge the individuality of creation and promote its scientific objectivity instead. In 1959 the hothouses for these experiments were the magazine *Azimuth* and the Galleria Azimut founded in Milan by Piero Manzoni and Enrico Castellani. Among the artists who exhibited there were Giovanni Anceschi, Davide Boriani, Gianni Colombo, Gabriele De Vecchi, Dadamaino, Enzo Mari, Manfredo Massironi, Günther Uecker, Otto Piene, Heinz Mack, Almir Mavignier, Oskar Holweck and Kilian Breier, i.e. the founders of the Milanese Gruppo T (who published a programmatic manifesto in 1961 in which they declared: "In view of the fact that the work is a reality made with the same elements that constitute the reality that surrounds us, it is necessary for the work itself to be in continual variation. This does not mean that we reject the validity of means such as colour, form, light, etc., but we put them in a new perspective by introducing them into the work in the actual situation in which we recognize them in reality, i.e. in continual variation, which is the effect of their mutual interaction") and of the Paduan Gruppo N and the German Zero-Gruppe. Alongside these were Nul in the Netherlands, with Schoonhoven, Armando, Henderikse and Peeters, and the GRAV in France, with Morellet, Sobrino, Garcia Rossi, Le Parc, Yvaral, Stein, Ferenc and Vera Molnár, who showed together at a series of events entitled *Nouvelle Tendance*, and the Italian Gruppo 1, with Biggi, Carrino, Frascà, Pace and Uncini.

Quite apart from the greater or lesser conviction of the totally scientific and objective character of this way of practicing art, it is worth pointing out that these experiments intersected closely with those of the European New Dada, in which figures like Klein, Manzoni, Tinguely and Uecker sought in different ways to develop an art that would be totally unemotional and no longer dependent on the classical disciplines of painting and sculpture.

Yet another clue to the interpretation of this lively and contaminated climate is provided by the perspective of *Monochrome Malerei*, an exhibition that the critic Udo Kultermann organized in Leverkusen and that examined the current of New Dada as well as that of concrete and programmed inspiration in the light of the historic tendency of monochrome painting, and therefore not in opposition to the classical concept of art but as an extension of it. The artists included were Bartels, Baumeister, Bellegarde, Bordoni, Castellani, Charchoune, Dorazio, Fischer, Fontana, Geccelli, Geiger, Geitlinger, Grike, Grandjean, van Hoeydonck, Holweck, Ionesco, Klein, Kusama, Leblanc, Leuzinger, Lo Savio, Mack, Manzoni, Mathieu, Mavignier, Megert, Oehm, Piene, Quinte, Rainer, Rothko, Rumney, Scarpitta, Sellung, Tàpies, Uecker, Verheyen, Verstockt and Vorberg:

a spectrum that ranged, therefore, from the exponents of Art Informel to those of the Zero-Gruppe. Outstanding among these artists was the new figure of Piero Dorazio, active in geometric research since the end of the forties (in 1947 he had been one of the founders in Rome, along with Accardi, Attardi, Consagra, Guerrini, Perilli, Sanfilippo and Turcato, of the magazine *Forma*, of abstractionist alignment) and with an international training.

In 1959 he held a solo exhibition at the Galerie Springer in Berlin in which he presented his most recent pictures, created by superimposing meshes of parallel lines painted "straight off" in very thin and luminous colours so as to produce a homogeneous surface, in which the two-dimensional impression went hand in hand with that of a sinking of the gaze through different layers of colour. "I sought the effect of a dominant achromatic light as synthesis of several colours", wrote the artist. If Dorazio was the master of the next Italian generation of artists, of painters like Olivieri, Griffa, Gastini, Battaglia, Aricò and Verna who reacted critically to Minimalism, the *Monochrome Malerei* exhibition as a whole was to influence many of the European artists of the sixties, from Raylich to Erben and from Palermo to Charlton.

Piet Mondrian
1. *Composition with Planes of Colour*

Piet Mondrian
2. *Composition A*

Following pages
Theo van Doesburg
3. *Contra-Composition of Dissonances, XVI*

212

213

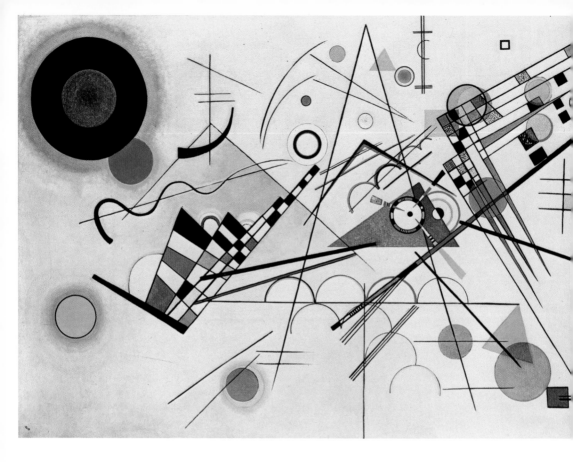

Wassily Kandinsky
4. *Composition VIII*

Wassily Kandinsky
5. *Accent in Pink*

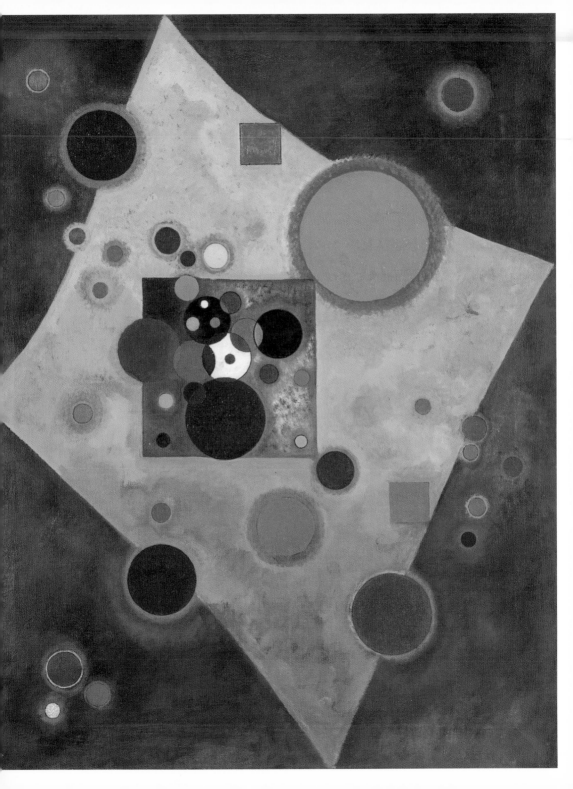

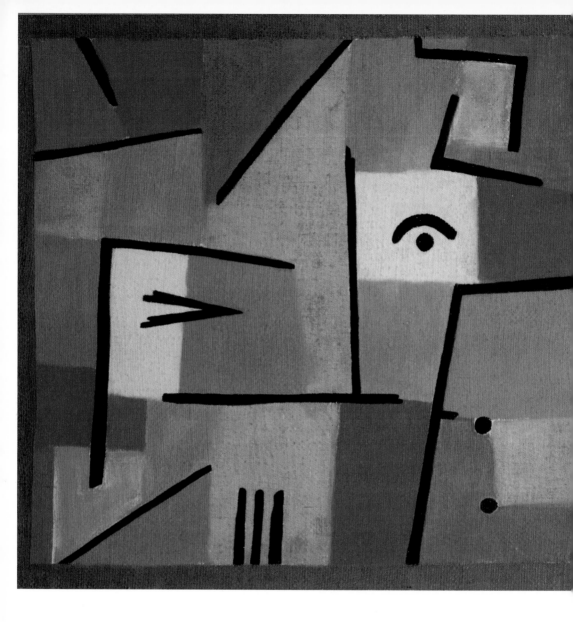

218

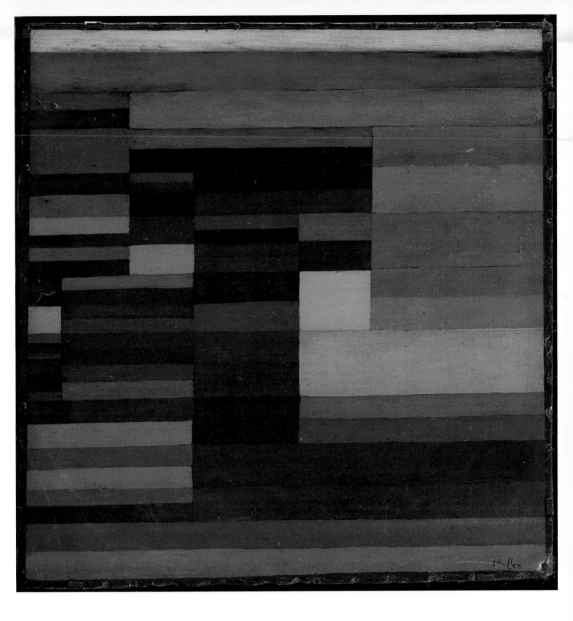

Paul Klee
6. *Gaze from the Red*

Paul Klee
7. *Fire in the Evening*

219

Fausto Melotti
8. *Sculpture*

Lucio Fontana
9. *Sculpture*

220

222

Josef Albers
10. *Study for Homage
to the Square*

Max Bill
11. *Strahlende Orange
(Bright Orange)*

223

Günther Uecker
12. *Quadrat* (*Square*)

Piero Dorazio
13. *Ognuno tesse le sue*
indulgenze II (*Everyone*
Weaves His Indulgences II)

225

Victor Vasarely
14. *Vega-os*

Jesús-Rafael Soto
15. *Cuadrados en el espacio*
(*Squares in Space*)

227

Metaphysical Painting

In the summer of 1915 the painter Giorgio de Chirico and his brother Andrea, a musician and writer who used the pen name of Alberto Savinio, passed their army medicals in Florence and were assigned to the 27th infantry regiment, stationed in Ferrara.

Here they met the poet Corrado Govoni and Filippo Tibertelli de Pisis from the Marche, a man with an eccentric and perceptive mind who was in correspondence with Dadaist circles and active in the fields of painting, creating collages of a Parisian flavour, and literature.

De Chirico was not considered fit for military service in the field and was able to continue with his solitary intellectual ponderings, exchanging letters with his friends Guillaume Apollinaire and Tristan Tzara (who in 1917 gave space to the brothers in his magazine *Dada*), with the dealer Paul Guillaume and with Ardengo Soffici, a writer, painter and above all energetic cultural organizer who shuttled between Florence and Paris and contributed to literary magazines like *La Voce* and *Lacerba*.

These were the prime referents of the period immediately preceding his stay in Ferrara, during which de Chirico's mysterious and disquieting paintings had made their debut in the theatre *par excellence* of the avant-garde, the Paris of the early 1910s. De Chirico had exhibited at the Salon d'Automne in 1912 and 1913 and at the Salon des Indépendants in 1913 and 1914, showing works that the artist himself defined as filled with a "solitary and profound lyricism". The pictures had emblematic titles, from *The Enigma of the Hour*, a theatrical scene rendered disturbing by subtle distortions of perspective, to *The Red Tower*, which the artist described as "a square with porticoes at the sides. In the background, behind a wall, appeared an equestrian statue like the monuments devoted to soldiers and heroes of the Risorgimento that can be seen in many Italian cities, and in Turin especially". This was the first picture that de Chirico sold, in 1913, and a preparatory sketch for it would later be owned by Max Ernst. The picture is painted in a completely academic style, without any technical and stylistic innovation with respect to the historic tradition, so that its entire effect is entrusted to the sense of iconographic alienation that characterizes it, to the atmosphere of subtle hypnotic hallucination that the apparent objectivity of the vision produces.

While the debate raged between avant-garde positions and the destiny of the new art seemed to depend on a profound subversion of the structure of the work, an approach like the one taken by the Italian artist appeared almost reactionary, a throwback to the old current of Symbolism. However, this view was not

shared by Soffici, a thoughtful critic and friend of de Chirico, or by Guillaume Apollinaire, author of *Alcools*, patron of Cubism and the whole of the avant-garde, who devoted an enthusiastic article to the promising new talent in painting in the *Paris-Journal* of 14 July 1914. In the same period his magazine *Les Soirées de Paris* also published Savinio's literary debut, the dramatic poem *Les chants de la mi-mort*.

The interpretation of de Chirico's works was clear from the outset. As Soffici put it: "De Chirico's painting is certainly not painting in the sense that the term is understood today. It could be defined as the transcription of dream. Juxtaposing almost endless vistas of arches and facades, of long straight lines, with immanent masses of simple colour, of almost funereal light and shade, he in fact succeeds in conveying those sensations of vastness, of solitude, of immobility, of ecstasy that the remembered image sometimes produces in our mind when we are drowsy." For his part, Apollinaire noted that he "knows more than one way of seeing and painting" and that he was "the most astonishing of the young generation of painters".

At Apollinaire's home de Chirico met Picasso, Brancusi, Derain, Max Jacob and Jean Paulhan, a writer who immediately hung two works by the artist in his study. The artist himself was to describe these get-togethers in 1918, commemorating his poet friend in the magazine *Ars Nova* following his premature death: "Apollinaire used to pontificate seated at his desk; taciturn and deliberately pensive individuals were seated on the armchairs and sofas; as was the fashion at that time and in those circles, most of them smoked clay pipes, similar to the ones we see in shooting galleries at fairs." On one wall hung, in that year of 1914, the portrait that de Chirico had painted of his friend: in the foreground a bust in the Greek manner evokes Orpheus, musician and poet, whose dark glasses protect him from the dazzling light of truth and induce him to look, like a seer, within himself; the sacred fish suggests the prophetic value of the poet's words; Apollinaire, finally, appears as a dark profile, of the kind found on coins, silhouetted as if in a shadow theatre: a circle is traced on his temple, as if the poet were a target in one of those shooting galleries.

It is curious to note that during the war Apollinaire would be wounded in his temple.

Yet de Chirico stayed aloof from the avant-garde milieu, feeling that he was excluded in too many ways because of his non-experimental style of painting. In the essay *Noi metafisici* ("We Metaphysicals") written a few years later, in 1919, he would recall in a polemic

"De Chirico's painting is certainly
not painting in the sense that the term is
understood today. It could be defined
as the transcription of dream.
Juxtaposing almost endless vistas of
arches and facades, of long straight
lines, with immanent masses
of simple colour (...) he in fact succeeds
in conveying those sensations
of vastness, of solitude, of immobility,
of ecstasy that the remembered image
sometimes produces in our mind
when we are drowsy."

Ardengo Soffici

tone: "Ever since the time when I was working in Paris in the subtle and fertile pre-war years, the word Metaphysical with which I dubbed my painting caused a considerable amount of irritation, resentment and misunderstanding among the would-be intellectuals of the banks of the Seine. The usual jibe, which then degenerated into a cliché, was to say: *c'est de la littérature*. A phrase which matched the one hurled by the Cubists or avant-gardists at the armies of their traditionalist enemies: *c'est pompier*. It is clear that the two accusations amounted to the same thing and in the majority of cases served as a shield for those who spat them out in order to avoid, at least in appearance, being taken for a fool."

Filippo de Pisis
Non c'è la fine
(*There is No End*)
(detail), 1916
Oil and collage on canvas
Private collection

In Ferrara, therefore, the artist carried on with his work, finding in the city itself elements that helped to refine his poetics: "city of geometric lasciviousness" and "beautiful and melancholic Ferrara" were a couple of the epithets that de Chirico gave to the place. Here he reflected on some of the fixed elements of his painting, the sequences of arches that allowed him to create a spatiality somewhere between the perspective and the theatrical, the complex plays of shadows, as solid as the forms, the link between ancient statues—from the casts of *The Uncertainty of the Poet* and *Love Song*, the work that was to dazzle Magritte and show him the way forward, to the Ariadne evoking the labyrinth of *Melancholy* and many other works—and trains suggesting indefinite distances and the theme of the journey.

He painted new pictures, from *The Enemy of the Poet* to *The Disquieting Muses* and from *Hector and Andromache* to compositions of objects in geometrically distorted perspectives. Other elements became crucial, such as the presence of manikins and stage boards, of pictures represented inside other pictures in the 17th-century manner and of geometric solids transformed into objects of normal appearance.

In the spring of 1917 de Chirico, through Soffici, met at the military hospital a no less talented and already famous painter who was serving in the same regiment. This was Carlo Carrà, who had just emerged from the heroic period of Futurism and was at this moment going through a phase of profound reflection on the art of the past as the model for a possible new order of painting: in 1916 he had published the articles "Parlata su Giotto" ("Speaking of Giotto) and "Paolo Uccello costruttore" ("Paolo Uccello the Constructor") in *La*

Voce. Carrà quickly fell into line with de Chirico's position, bringing to Metaphysical painting his character as a rigorous and technically skilled artist, with a partiality for earthy colours and solid and monumental compositions: he too adopted the imagery of manikins and geometric solids transformed into coloured objects and the subtle and theatrical distortion of perspective. Although the two artists planned to hold a joint exhibition in Milan, this did not come off and it was in Rome, in May 1918, that the Metaphysical works of de Chirico and Carrà appeared in an exhibition at which Ferrazzi, Prampolini and Soffici also showed, among others. A great writer of the time, Goffredo Bellonci, wrote about it in *Il Tempo*: "Each object has its outlines clearly marked, has its tone fully extended, has its volume set firmly and solidly in the perspective of the background. The atmosphere with its giddy dance of dipterans has been inflated by a pump; but the space has remained, enormous, dreadful, enclosed by bare walls and the black-and-white checks of the floor of a room, and by houses under construction and the fantastic towers of a square, or by the even, dark, impermeable sky, barely touched on the horizon by a pale glow of light. In the middle stand strange geometric figures and even stranger puppets… all the tools of a toy shop, of the backroom of a tailor, of the study of a surveyor. But these things, and this is the miracle, have life, expression and movement in their steadiness and their materiality: indeed they fill, in their monumental solemnity, the empty spaces. Carrà and de Chirico have created the tragedy of space and volume: they have composed the anatomical tables of the pictorial reality of tomorrow. And I would compare them not so much to the artists of the 14th century, but one, Carrà, to Piero della Francesca and Paolo Uccello, and the other, de Chirico, to some set designer of the late 18th century."

A few months later, on 15 November, the first issue came out of Mario Broglio's magazine *Valori Plastici*, for which de Chirico wrote the article "Zeusi l'esploratore" ("Zeuxis the Explorer"), going on to become a regular contributor. The climate was an international one: writers like Cendrars, Cocteau and Breton alternated with Picasso, Braque, Derain, Grosz, Kandinsky and exponents of De Stijl and L'Esprit Nouveau. But it was also one of progressive disparagement of the watchwords and excesses of the avant-garde in favour of what would come to be called the "return to order", to which de Chirico would also make a fundamental contribution with his the article "Il ritorno al mestiere" ("The Return to the Craft"). Another solitary and isolated painter, who in 1918 had

"And here we have arrived at the metaphysical aspect of things.
By deduction we might conclude that everything has two aspects: the current aspect, which we see nearly always and which ordinary men see, and the ghostly aspect which only rare individuals see in moments of clairvoyance and metaphysical abstraction (…)."

Giorgio de Chirico

discovered Metaphysical art in the pages of the Bolognese magazine *La Raccolta* edited by Giuseppe Raimondi, came to share some of the ideas expressed by *Valori Plastici*. This was Giorgio Morandi, who in his early days had been fascinated by Futurism as well as by the painting of Le Douanier Rousseau and had then moved on to very solid compositions in which the motif of the still life, on which he focused almost exclusively, took on a Metaphysical cast. Into a predominance of shades of brown and grey that evoked the lesson of Cézanne and Cubism, Morandi introduced iconographic elements like the bust of a manikin and geometric solids which alluded explicitly to de Chirico and Carrà. Closer to the latter in his solid construction and cautious composition, the Bolognese artist started down a road that, over the decades, was to make him one of the protagonists of what Soffici called "modernity that harks back to the majesty of the past". It was de Chirico himself, in the presentation of an exhibition by the artist in 1922, who coined for him the expression "metaphysics of everyday things", for Morandi "observes with the gaze of a man who believes, and he reveals the

Le Corbusier
Le bol rouge
(*The Red Bowl*), 1919
Oil on canvas, 81 × 65 cm
Fondation Le Corbusier,
Paris

inner skeleton of those things that for us are dead, because they are motionless, in its most consolatory aspect, in its eternal aspect". The essay *Noi metafisici* was published in 1919 on the occasion of de Chirico's solo exhibition at Anton Giulio Bragaglia's gallery, which was followed by a small monograph brought out by *Valori Plastici*. But while the artist explained that "I see nothing sombre in the word metaphysical; it is the very tranquillity and meaningless beauty of material that appears metaphysical to me and I find all the more metaphysical those objects that for their clarity of colour and correctness of dimensions are poles apart from any confusion and any vagueness", Carrà at the same time offered a more intellectual and mystical, almost sacred version: "Thus the spiritual form is made manifest, revealed to be indivisible, i.e. necessary, n the guise that the concave and the convex appear in the circle. Tragic is the conflict with the image of universal silence. Currents shut in the spirit on every side and hinder its vision; but the freedom that moves them realizes in the end that metaphysical reality which makes things eternal."

When the two artists gradually started to drift apart, André Breton burst into de Chirico's life, speaking of him enthusiastically in his magazine *Littérature* and presenting his major exhibition at Paul Guillaume's gallery in Paris in 1922, the one at which

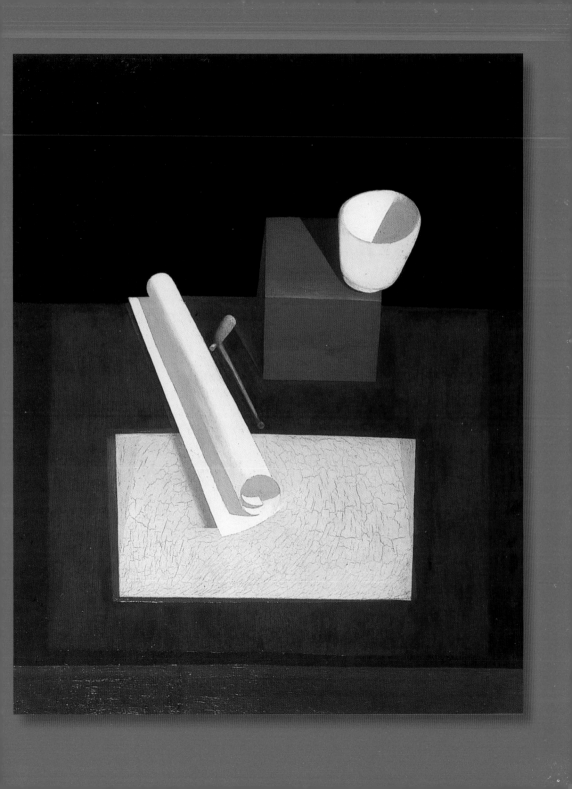

"(…) Finally these objects themselves enter into composition with measuring instruments, and no longer have any obvious relationship with human life except through the symbol of that foodstuff which can easily be preserved for a long time, the dry biscuit; thus de Chirico's great cycle is completed with the period of the metaphysical interiors."

André Breton

Metaphysical art was revealed to an international public. "I believe", wrote Breton, "that a truly modern mythology is being formed". Ernst, Tanguy, Dalí and Magritte (who wrote: "This is a new vision, in which the spectator recovers his own isolation and listens to the silence of the world") were profoundly influenced by the work of the Italian artist, and this proved to be one of the most important cultural foundations of Surrealism. Later on, in his 1941 essay *Genèse et perspectives artistiques du Surréalisme*, Breton summed up the impact of Metaphysical art on the development of Surrealism: "De Chirico's evolution during the four years when inspiration favoured him above all others was just as headlong, had a no less fateful and dramatic aspect, as that of Rimbaud during his equally brief career. This fixing of eternal places, which become spectral (phantoms, horoscopes), where the object can no longer be assessed except in terms of its symbolic and enigmatic value (period of the arches and towers), immediately assigns man a structure that excludes any individual character, reducing him to a framework and a mask (period of the manikins). Then this very framework dissolves: the living being disappears
and is evoked only by inanimate objects that are related to his function (of king, general, sailor, etc.). Finally these objects themselves enter into composition with measuring instruments, and no longer have any obvious relationship with human life except through the symbol of that foodstuff which can easily be preserved for a long time, the dry biscuit; thus de Chirico's great cycle is completed with the period of the metaphysical interiors." Later fierce controversies arose between de Chirico and the Surrealists, with the latter denying the importance of his painting, so clear from Breton's words, from the time of the return to order onwards, and receiving in exchange long tirades of invective, at which the Italian was adept. But at this moment he represented, within the panorama of international painting, one of the most solid intellectual references in a world that saw a crisis of the avant-garde following the Great War.

In fact it was the theorist of the *rappel à l'ordre*, Jean Cocteau, who placed de Chirico alongside Picasso and Stravinsky in the pantheon of models of the new artistic order. In his 1928 book *Le Mystère laïc* ("The Secular Mystery") he wrote: "It is not a question of looking without understanding and taking delight for no reason in a mere decorative charm. It is a matter of paying a high price and understanding with a special sense: the sense of the marvellous." Despite the arguments, there was no Surrealist exhibition at which Metaphysical art was not presented

as a direct and fundamental precedent, and the same thing happened in the German milieu, where artists like Grosz and Schad explicitly admitted the influence of de Chirico and where Carrà had been considered a great master since his Futurist days. In Italy, then, the circle of *Valori Plastici* was enlivened by the theoretical stands taken by de Chirico, Savinio and Carrà. The latter, who since the early twenties had decided "not to keep company with others, just to be myself" and devoted himself to an austere style of painting influenced by primitive art, also took on an important theoretical role, writing regularly not just for Broglio's magazine but also for newspapers like *Il Popolo d'Italia* and *L'Ambrosiano*.

His new painting had "to grasp the relationship that comprehends the need for identification with things and the need for abstraction", and presented itself as brusque and powerful, its composition carefully calculated, in its primary quest for an "elementary plastic order" that harked back, once again, to Cézanne's fundamental lesson, to the rediscovery of the profound sense of universal geometry within the features of nature.

Giorgio de Chirico
The Enigma of the Hour
(detail), 1910-11
Oil on canvas, 55 × 71 cm
Private collection

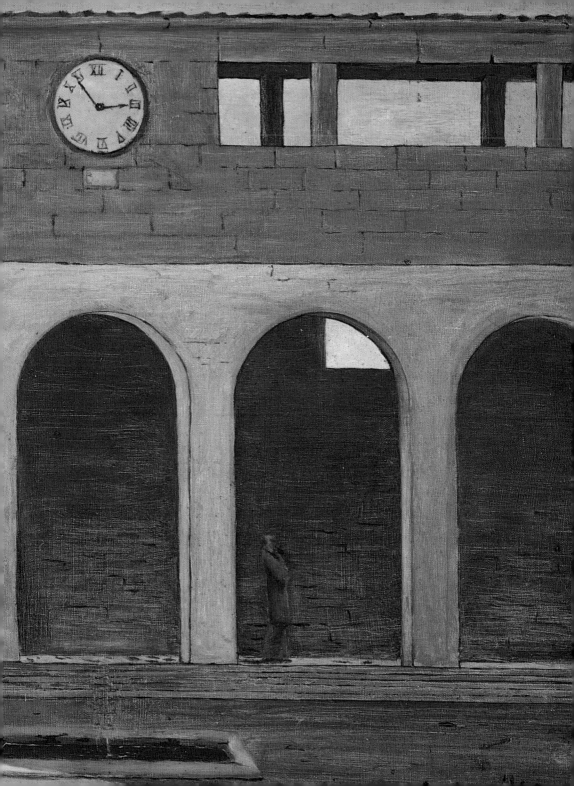

Between Paris and Italy, a broad range of painters took their inspiration in various ways from the Metaphysical model. This was true of Mario Sironi, who like Carrà came from the Futurist ranks and was shortly to become an exponent of the monumentality of the Novecento Italiano, a group that from 1922 embraced, in addition to Sironi, Anselmo Bucci, Leonardo Dudreville, Achille Funi, Gian Emilio Malerba, Piero Marussig and Ubaldo Oppi, all in the name of a "modern classicism". He too went through a brief but crucial Metaphysical period. A thoughtful and melancholy artist, averse to the excessive theorizations of the avant-garde, he introduced manikins and geometric solids into his paintings towards the end of the century's second decade and commenced a series of urban landscapes in which the buildings were schematized into abstract shapes, bathed in a steady and leaden light.

In the years following the war Felice Casorati, who had received a training in the Secessionist milieu, devoted himself to a complex perspective reconstruction of visible reality, steeped in bright and cold light and timeless atmospheres.

Oppi, whose training was also influenced by the Viennese Secession, worked like Casorati on 15th-century painting and its icy imagery, with an almost unreal clarity that differed considerably from the pictures of an artist like Marussig, which were impregnated with a more everyday vein.

From this point of view the richest and most complex figure was Massimo Campigli, who in the Paris of the twenties was one of the most authentic continuators of the Metaphysical current, which he blended with a love of Cubism and Purism. It is no coincidence that, when the association known as Les Italiens de Paris was formed in the French capital in 1928, he would be one of its members, alongside de Chirico, Savinio, Severini, Paresce and Tozzi (influenced no less by the monumental classicism of Picasso than by the Italian Quattrocento) and de Pisis, who at that time was increasingly focusing on painting rather than literature.

It was de Pisis who wrote of Campigli, in 1925: "Yet he did not disdain tradition, indeed he made use of it to the extent that it could serve his purposes. His impasto painting, using the knife alone, gives his canvases a solidity that reminds us of 15th-century frescoes: there is no hint of neoclassicism in our painter, however, and this clearly distinguishes him from de Chirico, Oppi, Casorati and Morandi, to whom, in a certain way, he is related by the search for values that we can call 'Metaphysical' in the shadows, in the solids, in the spaces, in the attitudes of the figures." The echo of Metaphysical

art, therefore, and at the same time a perfect adhesion to the climate of the return to order. Campigli himself said of the works that he showed at his first exhibition at Jeanne-Bucher's gallery in 1929, with "women painted in 1928 who looked like round and resonant amphorae": "There was a bit of Léger, a bit of Metaphysical Carrà, and of Egypt and then the classical. Of Cubism there was very little even though I felt that I fitted perfectly into Post-Cubism." Spaces without perspective, a painting constructed out of dry pastes like a fresco, a sense of primitivism that became the key to an enigmatic and suspended figuration. This was the style of an artist who distilled the essence of Metaphysical art better than any other: "Symmetry fascinated me: the more I practiced it the more mysterious I found it, belonging to the disconcerting order of things that are double or similar or repeated. So these women look like idols, totems or toys turned on the lathe. There is no trace of irony but a wavering between the veneration of supreme things and play, which can be as serious a thing as veneration."

Alongside these positions, perfectly balanced between painting and literature and directly influenced by Metaphysical art, there was the one embodied by Massimo Bontempelli and his Magical Realism.

A friend of Savinio and de Chirico in Italy and Paris and the author of works like *La scacchiera davanti allo specchio* (1922, *The Chess Set in the Mirror*) and *Eva ultima* (1923, *Last Eva*), he described Magical Realism in his journal *900* in 1927 in these words: "The painter of the 16th century was fully and exclusively interested in the real world he painted: the 14th-century painter on the other hand had led us to believe in a disquieting alibi for his more secret concern. The greater the weight and solidity he gave to his subject, the more he wished to suggest to us that his most intense love was for some other thing around and above it." And again: "Rather than for fable we have a thirst for adventure. We want to see the most everyday and ordinary life as an adventurous miracle, as a continual risk." These are, almost to the letter, the ideas of de Chirico: "And here we have arrived at the metaphysical aspect of things. By deduction we might conclude that everything has two aspects: the current aspect, which we see nearly always and which ordinary men see, and the ghostly aspect which only rare individuals see in moments of clairvoyance and metaphysical abstraction, as in the case of certain bodies concealed by substances impenetrable by sunlight yet discernible, for instance, by x-ray or other powerful artificial means."

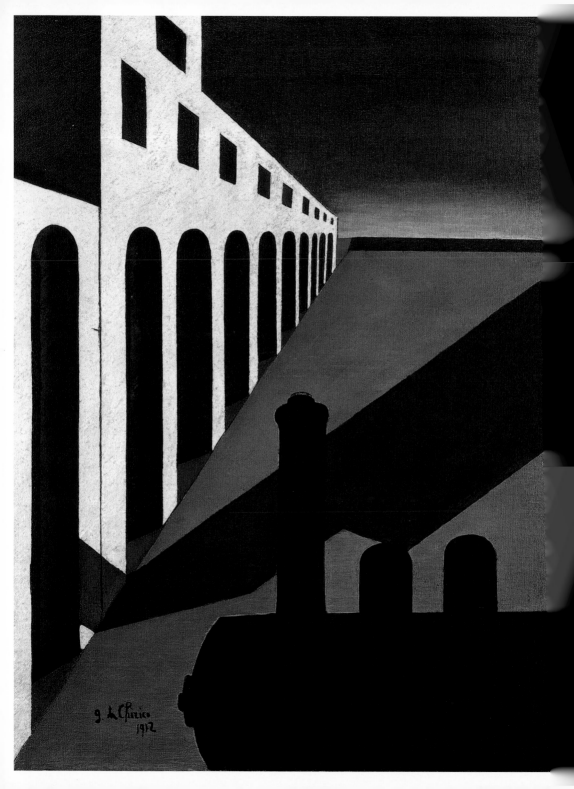

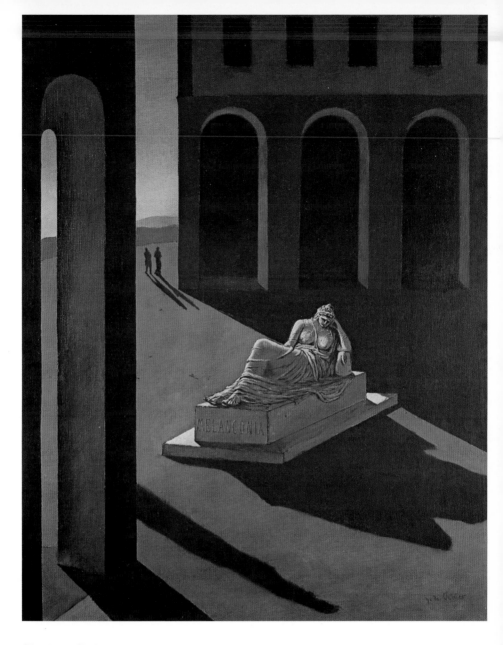

Giorgio de Chirico
1. *La matinée angoissante*
(*The Morning of Anguish*)

Giorgio de Chirico
2. *Melanconia* (*Melancholy*)

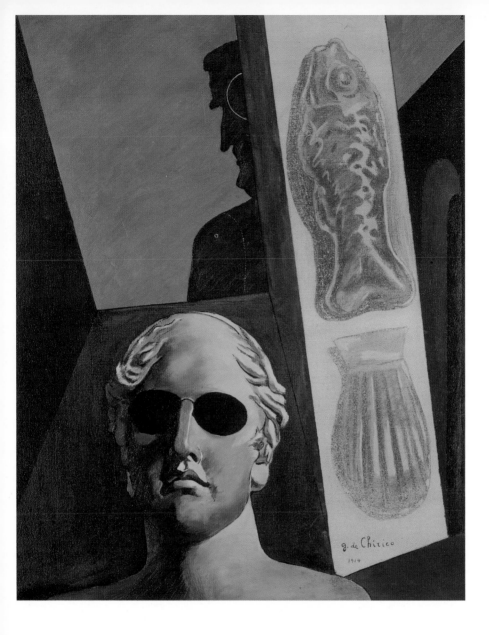

Giorgio de Chirico
3. *Premonitory Portrait*
of Guillaume Apollinaire

Giorgio de Chirico
4. *The Disquieting Muses*

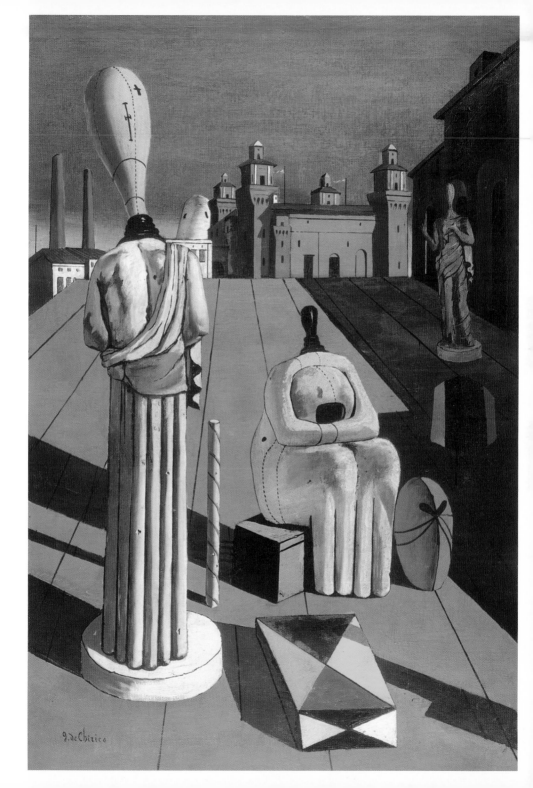

g. de Chirico

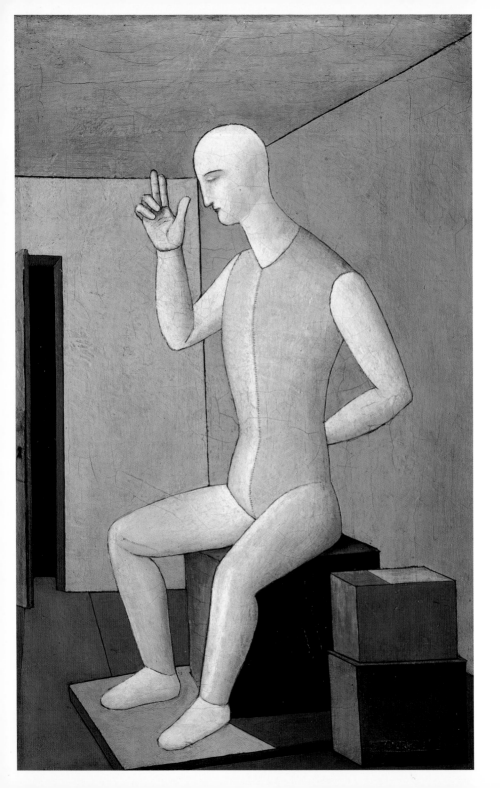

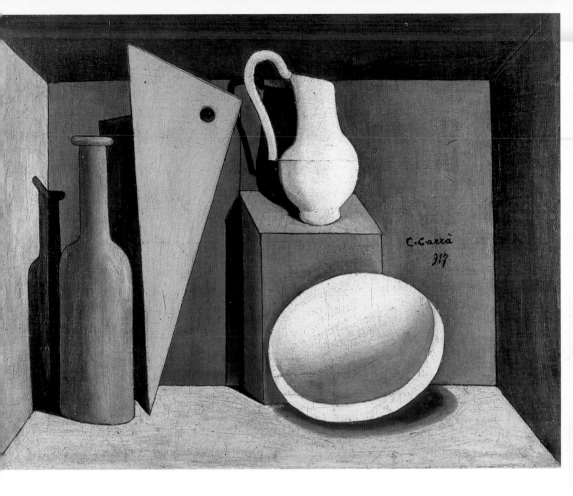

Carlo Carrà
5. *The Hermaphrodite Idol*

Carlo Carrà
6. *Still-Life with Carpenter's Square*

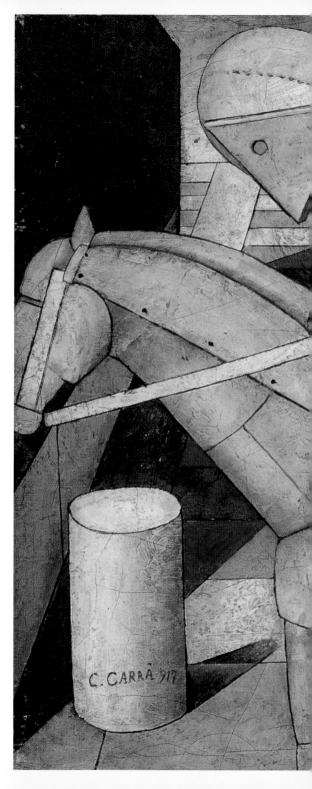

Carlo Carrà
7. Il cavaliere occidentale
(*The Horseman of the West*)

250

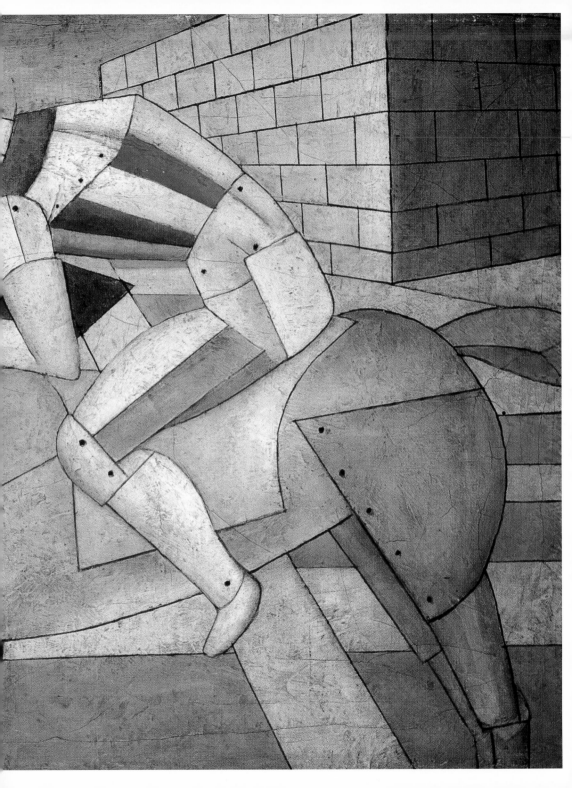

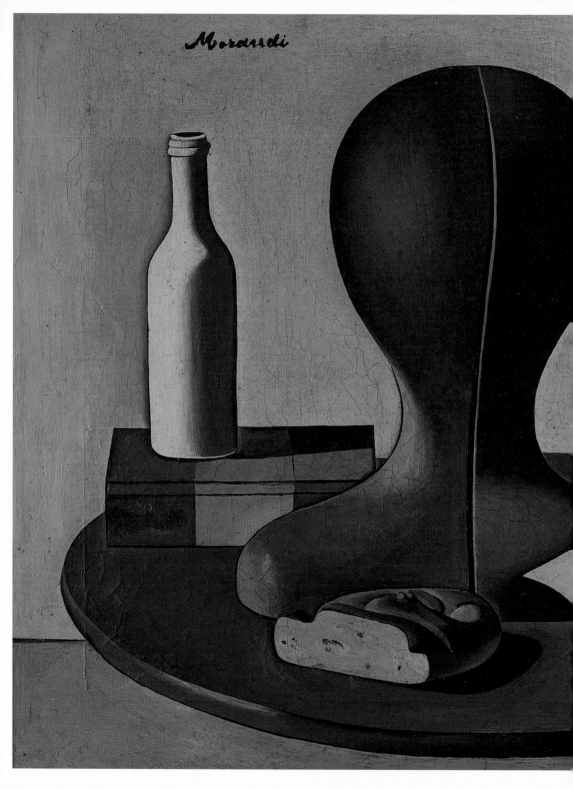

Giorgio Morandi

8. *Metaphysical Still-Life with Manikin*

Felice Casorati
9. *Silvana Cenni*

Massimo Campigli
10. *La carceriera*
(*The Wardress*)

Realism
Hyperrealism

"To show that the new realism as we conceive it has nothing to do with the chameleonic reproduction of life—another ugly thing that has been imported from outside—we assert that it is a spiritual condensation of the aspects of nature, which are born and then turned into artistic unity; realism requires a great attention and a clearer mastery of the aesthetic problem than other doctrines and a very lively sense of modernity and the present: more than any other tendency in contemporary painting." In the essay *A proposito di realtà* ("Speaking of Reality"), written in 1935, at a critical moment between the two wars, Carlo Carrà once again raised one of the crucial questions in 20th-century art. Carrà, who had been one of the fathers of Futurism and an undisputed protagonist of the international avant-garde, now lucidly embodied one of the most nuanced and complex positions in the whole range of new research.

Realism is a term with a long history. The "Pavillon du Réalisme" was the name Gustave Courbet had given to the exhibition of his works that he staged in 1855 after they had been rejected by the Salon; an "art for man" was what many French intellectuals after 1830 had contrasted with "art for art", i.e. the idea of an art unfettered by any historical responsibility and concerned purely with aesthetics. Describing reality and concrete situations, the life of ordinary people, irrespective of any aesthetic consideration; showing things as the senses perceived them and as reason could analyze them; adhering to life through its direct manifestations, not filtered by intellectual schemata: all this had led not only to Impressionism, but also and in the same years to the adoption of genuine ethical stances, along the lines of those taken by the novels of Zola and Verga. An example of this was the sculptor Vincenzo Vela, who in 1882 created his *Monument to the Victims of Labour*, accompanying it with these words: "Now that millions are squandered on raising monuments to kings (…) I felt it was my duty to commemorate to warm-hearted people these humble martyrs, who are our brothers and who work for everyone except themselves." Just as everyday life was the protagonist of Impressionism, Social Realism bequeathed an art with a strong moral bias, which implied making a judgement about reality through its representation. In addition, while some of the avant-gardes of the late 19th and early 20th century openly insisted on a break with tradition ("We want to demolish museums, libraries and academies of all kinds", declared Marinetti in the "Manifesto of Futurism"), it is also true that the majority of artists did not identify either with a stale

traditionalism or with avant-gardist experimentalism at any cost. It was, to mention just the more important artists, typical of figures like Picasso and Braque, de Chirico and Carrà himself and Derain and Severini to see the avant-garde as a superseding of but not necessarily a break with the authoritative past of the history of art, which had to be renewed but whose deepest roots could not be disavowed. Numerous different revivals of Realism emerged in the years immediately after the end of the First World War, essentially inspired either by a renewal of the relationship with the classicism of the past or by an attitude of social and political engagement. In his review of an exhibition of Braque's work held in Paris in 1919 the Cubist painter André Lhote declared that his new painting "constituted along with that of Picasso a sort of *rappel à l'ordre*": an expression, that of the "return to order", which Jean Cocteau was also to use as the title for a collection of writings in 1926. As early as 1914 Pablo Picasso had begun to utilize modes of classical figuration alongside more essentially Cubist ones. And then in 1917 he accompanied Cocteau on a visit to Italy to meet

Grant Wood
American Gothic
(detail), 1930
Oil on wood, 78 × 65.3 cm
The Art Institute,
Chicago

Diaghilev and collaborate on his project for *Parade*, an experimental stage production with music written by Satie. The encounter with Rome, Naples and Pompeii, with antiquity and with Raphael, gave a new sense to the project of "exemplary discipline" in "never infringing the fundamental laws of Art" that Jean Metzinger had recognized in Cubism in a 1911 essay entitled *Cubisme et Tradition*.

While Cubism had based its own theoretical approach on Cézanne's famous declaration that it was necessary to "treat nature by means of the cylinder, the sphere, the cone, everything brought into proper perspective so that each side of an object or a plane is directed towards a central point", it is also true that the master from Aix had never moved away from the representation of nature, of sensible reality, because, as he went on to say, "lines parallel to the horizon give breadth, that is a section of nature, or, if you prefer, of the spectacle which the Pater Omnipotens Aeterne Deus spreads before our eyes". Picasso started out from those assertions and from the teaching of artists like Ingres, creating full, statuary forms, poised between archaic severity and the linear beauties of the Renaissance.

The artist was to recall: "Braque once said to me, 'Basically, you have always loved classical beauty.' It's true. Even today that's true for me. They don't

"(…) I think that you can make,
very much as in abstract painting,
involuntary marks on the canvas which
may suggest much deeper
ways by which you can trap the fact
you are obsessed by.
If anything ever does work in my case,
it works from that moment
when consciously I don't know
what I'm doing."

Francis Bacon

invent a type of beauty every year." Even before the war André Derain, after the intense period of Fauvism, and Gino Severini, always walking a tightrope between Cubism and Futurism, had begun to reconsider the compositional solidity and formal composure of classical art. This was moreover something that an artist like Giorgio de Chirico had never abandoned: in his Metaphysical paintings he explicitly cited images of classical art as well as many elements of Renaissance painting.

The sculpture of the same years came to similar conclusions by other routes. Aristide Maillol even took up ancient themes linked to Mediterranean statuary and in his turn influenced the new Picasso. Charles Despiau, Émile-Antoine Bourdelle and Julio González all took comparable approaches.

The classical was, for these artists, a rational way of reducing the complexity and mutability of sensible experience—which remained supreme—to its necessary and fundamental traits, which could be translated into a system of forms regulated by definite norms. All this was clearly explained by Severini, who in 1921 theorized with lucidity on the then current conception of reality in an essay entitled programmatically *Du Cubisme au Classicisme*: "The aim of art can be defined as follows: to reconstruct the Universe in accordance with the same laws that govern it. If in fact we go back to the earliest manifestations of art, we can see that imitation in general and imitation of the human body in particular were at the root of the artistic sense. Before knowing how he was made, therefore, man began to imitate himself. But the more he has become aware of his construction and of his identity with the Universe, the more he has moved away from imitation and towards internal reconstruction, i.e. towards creation. We must believe that in penetrating the numerical laws that govern the microcosm and the cosmos, man has been struck by the unity and harmony of creation and, transported by admiration, religious faith and the desire for perfection, has wanted to follow the example of God and re-create the Universe in his image.

This explains the undeniable pleasure that man experiences in front of his image, especially if this image has been created and constructed according to his own proportions, his own rhythm."

It is no accident that Severini's reflections had more than one point in common with those of two young artists, Amédée Ozenfant and Charles-Édouard Jeanneret-Gris, who was soon to assume the pseudonym of Le Corbusier: in *Après le Cubisme*, an essay published in 1918, and then in their theories of

261

Purism expounded through the magazine *L'Esprit Nouveau*, first brought out in 1920 (it published "Le Purisme" in 1921), the two painters argued for the need to go beyond Cubism, which had now degenerated into a style, a manner, and to recover the profound sense of formal order inherited from classicism.

The shift in this direction was even more marked in Italian art. Following the death of Boccioni and the orientation of Futurism towards Balla and Depero's *Futurist Reconstruction of the Universe*, the Metaphysical art of Giorgio de Chirico, Carrà and Giorgio Morandi served as a basis for a decided return to classicism. In 1918 Mario Broglio began to bring out the magazine *Valori Plastici*, to which de Chirico, Carrà, Alberto Savinio and Filippo de Pisis contributed and which had many exchanges with *L'Esprit Nouveau*. A crucial moment in the story of the journal was its publication of de Chirico's essay *Il ritorno al mestiere*, in which he wrote: "Just as citizens are invited to go to the polls for elections, we who were the first to set a good example in painting invite reformed or reforming painters to the statues. Yes, gentlemen, to statues; to statues to learn the nobility and religion of drawing, to statues to dehumanize you a little, since despite your puerile tricks, you were still human all too human. If you don't have the time and the means to go and copy them in museums of sculpture, if the system of shutting up the future painter in a room filled with nothing but marbles and plaster casts for at least five years has not yet been adopted in the art schools, if the dawn of laws and canons has not yet broken, be patient, and meanwhile, so as not to lose time, buy yourself some plaster cast or other; it is not necessary for it to be the reproduction of an ancient masterpiece. So buy your cast and then, in the silence of your room copy it ten, twenty, a hundred times; copy it until you succeed in producing a satisfactory work, in drawing once a hand, a foot in such a way that, if by miracle they were to come to life, they would find themselves with the bones, muscles, nerves and tendons in the right place." And he concluded: "For my part I am not worried, and I decorate myself with three words that I wish to be the seal of all my work: *Pictor classicus sum*." De Chirico passed from the Metaphysical enigma to pictures that were increasingly painted in the manner of the ancients, infuriating the exponents of the emerging current of Surrealism but making him the master of the new generation in Italy.

The Novecento italiano, a movement launched in 1922 by Margherita Sarfatti, was modelled on a "modern classicism" that looked

"(…) Buy yourself some plaster cast or other; it is not necessary for it to be the reproduction of an ancient masterpiece (…) then, in the silence of your room copy it ten, twenty, a hundred times; copy it until you succeed in producing a satisfactory work, in drawing once a hand, a foot in such a way that, if by miracle they were to come to life, they would find themselves with the bones, muscles, nerves and tendons in the right place."

Giorgio de Chirico

equally to antiquity and to Cézanne. The members of the group included Mario Sironi, Anselmo Bucci, Leonardo Dudreville, Achille Funi, Gian Emilio Malerba, Piero Marussig and Ubaldo Oppi, and they would be joined over the years by artists who followed independent but not dissimilar paths, such as Felice Casorati, Arturo Martini, Massimo Campigli, Marino Marini, Francesco Messina and others.

Magical Realism, a theory promoted by the writer Massimo Bontempelli, pointed the way instead to a painting with echoes of Metaphysical art in which everyday images would be rendered essential as in the art of the 15th century and charged with an enigmatic ambiguity: "We want to see the most everyday and ordinary life as an adventurous miracle", he wrote in 1927, indicating the course taken by the work of artist like Antonio Donghi, Riccardo Francalancia, Virgilio Guidi, Cagnaccio di San Pietro and others.

Among the Italian artists, Mario Sironi was the most important, both for the rigour with which he geometrically assembled the structure of the image and for the sense of sorrowful solitude which derived from the fact that he

Edward Hopper
Hotel Room (detail), 1931
Oil on canvas,
152.4 × 165.7 cm
Museo Thyssen-Bornemisza,
Madrid

referred not so much to the clarity of the 15th century as to the dramatic force of Caravaggio and 17th-century realism. A case apart, but one linked to Italian culture in many ways, was that of the French artist Balthus, brother of the writer Pierre Klossowski, who drew his inspiration from the geometry and the icy light of Piero della Francesca. In 1926, returning from a visit to Arezzo, he wrote: "The wish to come here and see Piero della Francesca has haunted me for the last five years… But now, what wonder!"

The situation in Germany was very different. The term *Neue Sachlichkeit*, "New Objectivity", coined by Gustav Hartlaub and rendered official by an exhibition in 1925, was applied not just to positions close to Italian Magical Realism like those of Georg Schrimpf, Carlo Mense, Alexander Kanoldt, Franz Radziwill, Carl Grossberg and Christian Schad, who were fascinated by a painting of 15th-century spareness and with Metaphysical echoes, but also to avant-garde figures like George Grosz, John Heartfield, Rudolf Schlichter, Max Beckmann and Otto Dix, whose political militancy was so manifest that in 1924 they formed the Rote Gruppe, openly communist in inspiration and characterized by a highly expressive realism, which they used as a means of social denunciation and appeal.

With the rise to power of Hitler, in 1933, this artistic front was systematically persecuted and broke up. Fleeing to the United States, Grosz was hired as a teacher at the Art Students League in New York by John Sloan, member of a group of left-wing artists that included Ben Shahn and the Mexicans Diego Rivera and Clemente Orozco. They represented a metropolitan variant in a key of social realism, attentive to the life of the poor which had been brought to the forefront by the great economic crisis of 1929, of the movement known as Regionalism, which had a much more closed and anti-modernist attitude. Regionalism was a rough-edged continuation of the 19th-century current in American painting that had attempted to break away from the European model and celebrate instead the rural values of the Midwest and the "new frontier". In the thirties Thomas Hart Benton, Grant Wood, John Steuart Curry and Reginald Marsh depicted the American countryside in the form of a mythical, deliberately provincial epic. As Wood put it in the pamphlet *Revolt Against the City*, written in 1935: "I am building an art of, and for, a specific locality. If I have reached an audience wider than my own region, it is only proof that Iowa is a cross section of the world (…)."
Far more than in the works of these artists, in fact, the social denunciation of the years of the Great Depression is to

"The problem of suffering is an eternal
enigma that can be concealed
under various disguises as well as
revealed in its true nature,
but its reality strikes us at every moment.
I am certain that for some of us
this is a much more deep-rooted feeling
and represents a much heavier personal
burden than for others.
Perhaps I am doing nothing but
attempting, as in primitive art, to exorcize
suffering by painting it."

Ben Shahn

be found in the parallel work of a number of photographers who were engaged by a federal programme, the Farm Security Administration, to document the poverty of the depressed areas of the USA. It was the pictures of Dorothea Lange, Walker Evans, John Vachon, Arthur Rothstein, Gordon Parks and Ben Shahn, photographer as well as painter, that brought a lucid gaze to bear on the crisis in the American dream. As Shahn wrote: "The problem of suffering is an eternal enigma that can be concealed under various disguises as well as revealed in its true nature, but its reality strikes us at every moment. I am certain that for some of us this is a much more deep-rooted feeling and represents a much heavier personal burden than for others. Perhaps I am doing nothing but attempting, as in primitive art, to exorcize suffering by painting it." The eloquent and expressive images of these photographers paved the way for much of the research of the post-war years. The most important of the American artists of the time, Edward Hopper, did not succumb to the charms of photography, but he also rejected the wholly stylistic solutions of the contemporary avant-gardes. His aims

Carlo Carrà
Lot's Daughters
(detail), 1919
Oil on canvas, 110 × 80 cm
MART – Museo d'Arte
Contemporanea di Trento
e Rovereto, Rovereto

were simple and clear: "My goal in painting is to achieve the best possible realization of my most intimate impressions of my surroundings." Having studied in Europe and perfectly abreast of the artistic debate in the Old World, he blended these influences with a literary and highly original vision of America. In his work urban and rural reality became theatres in which isolated figures are crushed by silence and solitude. Hopper created images with clear and orderly compositions and relied on a simple technique that was traditional from every point of view. As early as 1933 an anthological exhibition at the MoMA in New York consecrated him as the greatest American painter of his generation. In 1953 he wrote in an article published by the journal *Reality*: "Great art is the outward expression of an inner life in the artist, and this inner life will result in his personal vision of the world. No amount of skilful invention can replace the essential element of imagination. One of the weaknesses of much abstract painting is the attempt to substitute inventions of the intellect for a pristine imaginative conception. The inner life of a human being is a vast and varied realm and does not concern itself alone with the stimulating arrangements of colour, form and design. The term 'life' as used in art is something not to be held in contempt, for it implies all of existence, and the province of art is to

react to it and not to shun it. Painting will have to deal more fully and less obliquely with life and nature's phenomena before it can again become great."

In post-Second World War Europe it was an unconventional artist, who looked as much to the past as to certain ideas of the Surrealists like the psychological reinvention of the image, who revived the debate over the possibility of a new realism. While, after the sensation caused by Picasso's *Guernica*, a new generation of politically committed artists resorted to tired forms of a rhetorical and sermonizing Realism, or one that was stylized in the manner of a now solely academic Neo-Cubism, Francis Bacon set out to develop another possible form of representation, one that would avoid transcribing appearances but be capable of grasping the inner vital spirit of the figures. As the artist declared in an interview: "(...) I think that you can make, very much as in abstract painting, involuntary marks on the canvas which may suggest much deeper ways by which you can trap the fact you are obsessed by. If anything ever does work in my case, it works from that moment when consciously I don't know what I'm doing. I've often found that, if I have tried to follow the image more exactly, in the sense of its being more illustrational, and it has become extremely banal, and the out of sheer exasperation and hopelessness I've completely destroyed it by not knowing at all the marks I was making within the image—suddenly I have found that the thing comes nearer to the way that my visual instincts feel about the image I am trying to trap. It's really a question in my case of being able to set a trap with which one would be able to catch the fact at its most living point."

Apart from this impressive and high-quality attempt to revitalize an independent approach to painting, however, it was the model of photography, emphasized by the new expansion of the media, that became widely adopted, coinciding with the international domination of American culture.

Chuck Close overcame the Pop stereotype by re-creating in painting the half-tone dots used in printing photographs in an obsessive series of portraits and self-portraits: later he was to use a technical treatment similar to electronic pixels. In the same period, the early seventies, in which Close's work began to attract attention, and while artists like Philip Pearlstein were attempting a still painterly transcription of the image—as artists in Europe such as the followers of Bacon Lucien Freud and Frank Auerbach were also doing—others like Duane Hanson, John De Andrea, Malcolm Morley, Richard

Estes, Ralph Goings, Robert Cottingham and John Kacere started out from the visual or pictorial reconstruction of the photographic image to achieve levels of illusion so striking that the term Hyperrealism was coined for this mode of artistic expression. Among these artists Richard Estes has been the most consistent in pursuing an imagery perfectly balanced between the impersonal visual lucidity of photography and the practice of painting.

The artist has declared: "Degas used photography a lot, Manet… Soon as it was invented they started using it. And Hockney says they always had these instruments for tracing images. There's no way that Bellotto or Canaletto could have done those paintings without the camera lucida because they're too accurate. It's not a matter of just approximating what everything looks like, it's quite nailed down, down to how many windows you can see in the tower and things like that. Once I went to Venice and I had a book of Canaletto's paintings and you can find the sites and you can go there and see how accurate they are (…)." From that moment on, and with the eventual acceptance of the technique of photography as an artistic medium by the public, two generations of artists have operated in various ways in the area of hallucinated contamination between the illusory visual reconstruction of real images, practised by people like Ron Mueck and to some extent Carsten Höller, and the creation of constructed photographic situations, as in the work of Robert Mapplethorpe, Hiroshi Sugimoto and Vanessa Beecroft. The two extreme cases of the use of the iconographic ambiguity of photography are Cindy Sherman, who has made herself the protagonist of an endless series of self-portraits in carefully constructed poses that are citations of other images, and Nan Goldin, who uses photos of violent immediacy to trace a sort of autobiographical live recording, without interventions of an aesthetic or linguistic type.

It is interesting to note how these most recent artificial hypertrophies of real data indicate not the possibility of faithfully re-creating a credible sensible world, but on the contrary the definitive loss of truth on the part of images, in whose universe we are trapped as in a maze without an exit.

271

Pablo Picasso
1. *Two Women Running
on the Beach* (*The Race*)

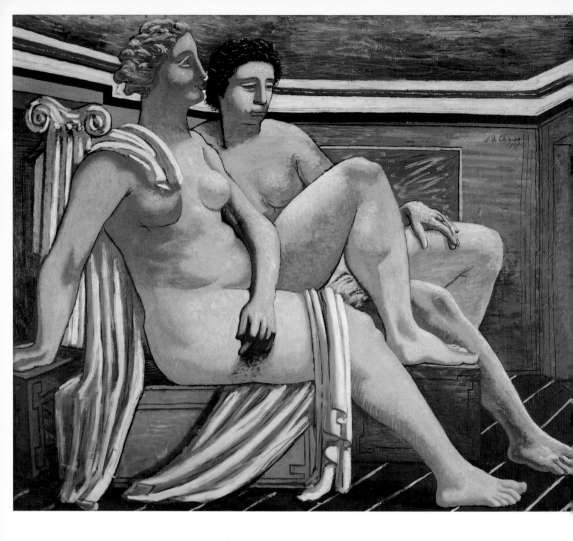

Giorgio de Chirico
2. *Mythological Figures*

Mario Sironi
3. *Solitude*

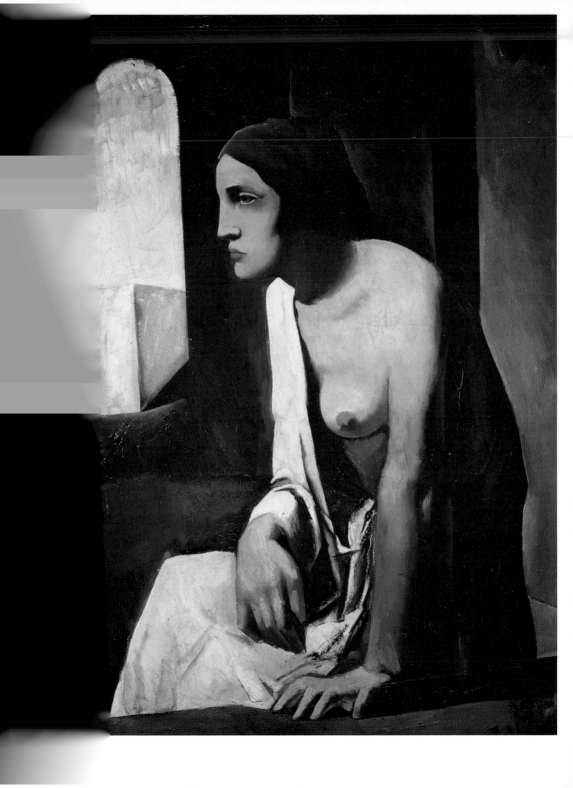

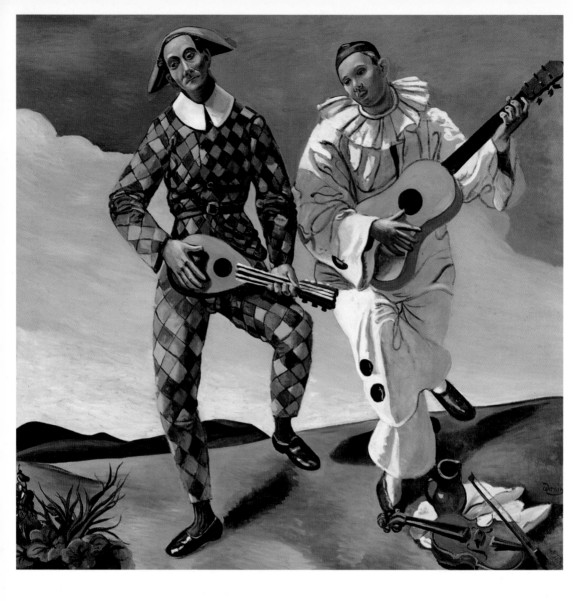

André Derain
4. *Harlequin and Pierrot*

Gino Severini
5. *Motherhood*

276

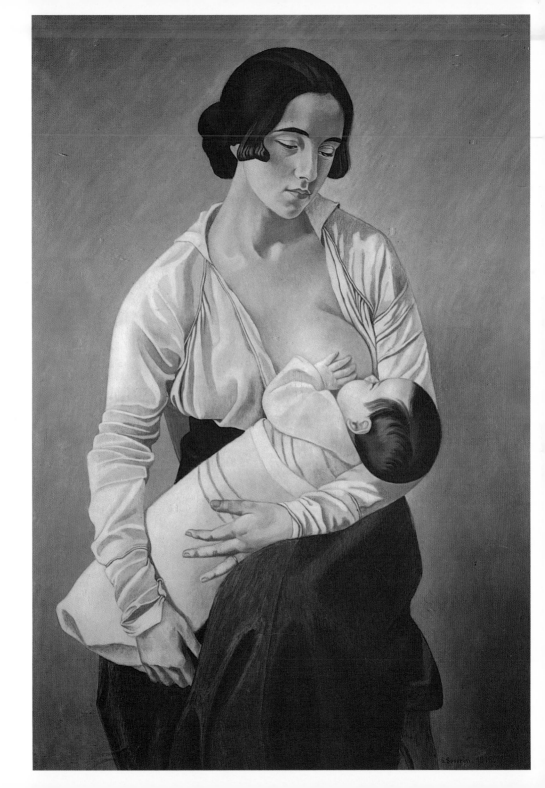

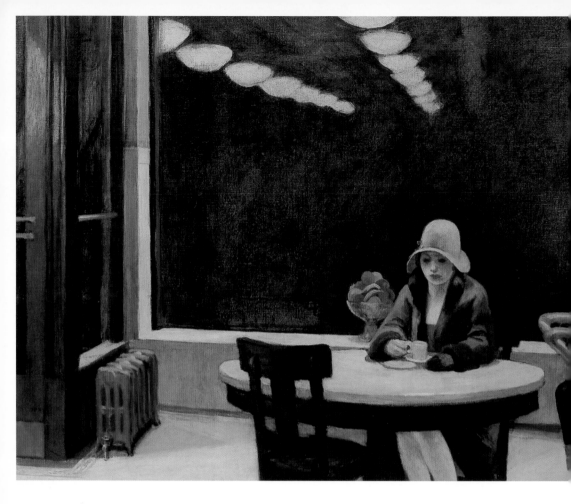

Edward Hopper
6. *Automat*

Francis Bacon
7. *Figure Study II*

278

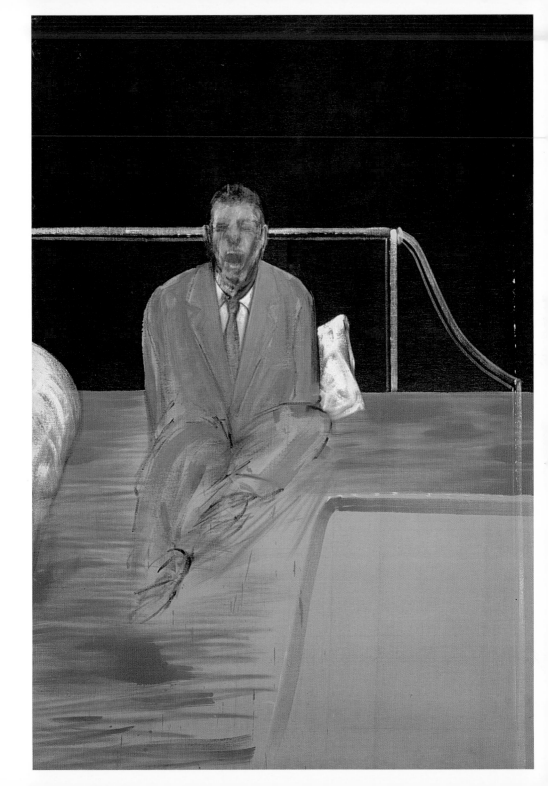

Cindy Sherman
8. *Untitled Film Still No. 49*

Ron Mueck
9. *Untitled (Seated Woman)*

Surrealism

At the end of the First World War many of the protagonists of the most recent developments in the avant-garde, and Dada in particular, gathered in Paris. Francis Picabia, Tristan Tzara, Man Ray, Marcel Duchamp and Max Ernst, the leading figures in the most radically revolutionary movement that art had ever produced, excited the admiration of a number of young and enterprising intellectuals. Outstanding among them were André Breton and Philippe Soupault.

The pair carried out experiments in automatic writing in the Dadaist manner and in 1920 published a book, *Les champs magnétiques* (*The Magnetic Fields*), that offered an ample demonstration of the technique. It was the foundation of a periodical that gave the new artistic climate a centre of gravity. *Littérature*, set up by Breton and Soupault in collaboration with Louis Aragon, was the laboratory in which they conducted the experiments out of which Surrealism would shortly be born. The objective was still that of a total art, i.e. of a wide-ranging artistic attitude that cultivated all means of expression, from poetry to music, from drama to painting, playing down specific techniques and languages in favour of a creativity that was linked entirely to the moods of the individual and that chose, on each occasion, the most

suitable medium with which to work. It is no coincidence that the term originated in connection with a "total" work *par excellence*: Guillaume Apollinaire used the expression *surréalisme* in the programme of *Parade*, a complex performance staged on 17 May 1917 at the Théâtre du Châtelet with a scenario by Jean Cocteau, music by Erik Satie, scenes and costumes by Pablo Picasso and choreography by Léonide Massine.

Littérature promoted and organized soirées that, following the example of the Futurist evenings and the ones staged by the Cabaret Voltaire in Zurich in 1916 from which the Dada movement had sprung, alternated readings and performances by authors with a literary background like Breton, Soupault, Aragon, Ribemont-Dessaignes, Éluard, Dermée, Birot, Radiguet and Cocteau with recitals by musicians like Satie, Auric, Poulenc and Milhaud and the exhibition of works by Gris, de Chirico, Léger, Picabia and Lipchitz.

For Breton Dada was a "state of mind", a mode of being capable of generating creative processes. His young emulators in Paris looked not so much to art as to the happening, to poetry, to the many ways in which that iconoclastic and irreverent attitude could be turned into spectacle. In addition, in keeping with the new

avant-garde tradition ushered in by the Fauves and Cubists, there was a very great temptation to turn everything into an organized movement, something Dada had always rejected.

The crucial moment in the birth of Surrealism was the meeting between Tzara and Breton, both of them many-sided personalities in the manner of Marinetti: writers, performers, cultural organizers and pamphleteers driven by aggressive predicatory and prophetic instincts, they were incarnations of the figure of the tumbler, the mask, which was not just a favourite subject of 20th-century art but the very emblem of the avant-garde man, rootless, deviant and playfully critical of society's system of values.

Between 1920 and 1925 a series of Dada-style soirées were staged, along with lectures, acts of disturbance at official occasions (making news, grabbing the headlines, was a strategy inspired by Futurism), programmatic conferences, the distribution of leaflets, provocative articles in periodicals and attacks on official culture as well as the snobbery of the new progressive culture, carried out with paradoxical arrogance.

Salvador Dalí
Mae West's Face which May be Used as a Surrealist Apartment (detail), 1934-35
Tempera on newspaper, 31 × 17 cm
The Art Institute, Chicago

From Dada the emerging movement of Surrealism inherited the idea of wanting to be a radical way of living and acting rather than a creative tendency in the strict sense. But it rejected, as is apparent from the rupture between Tzara and Breton that took place in 1922 amidst fierce controversy, Dada's opposition to modernity and art, whose vaguely apocalyptic and nihilistic undercurrent it did not share. On the contrary Breton and his friends, fascinated by the Soviet revolution, stressed the risk entailed in Dada's lack of social and cultural commitment.

Until 1925 at least, Breton, who assumed the role of preacher and custodian of a revolutionary rigour and a professed Surrealist orthodoxy (numerous people were to be "excommunicated" over the years, including Soupault, Vitrac, Artaud, de Chirico and Aragon), paid only marginal attention to visual research, which had played a central role in Dada. The prime interest of the collective research carried out by the early exponents of Surrealism was focused on languages in general, as codified systems of communication, regarded as mechanisms in which meaning was not so much revealed as distorted. In this sphere they rediscovered such examples as the poetry of Arthur Rimbaud, *Les Chants de Maldoror* by

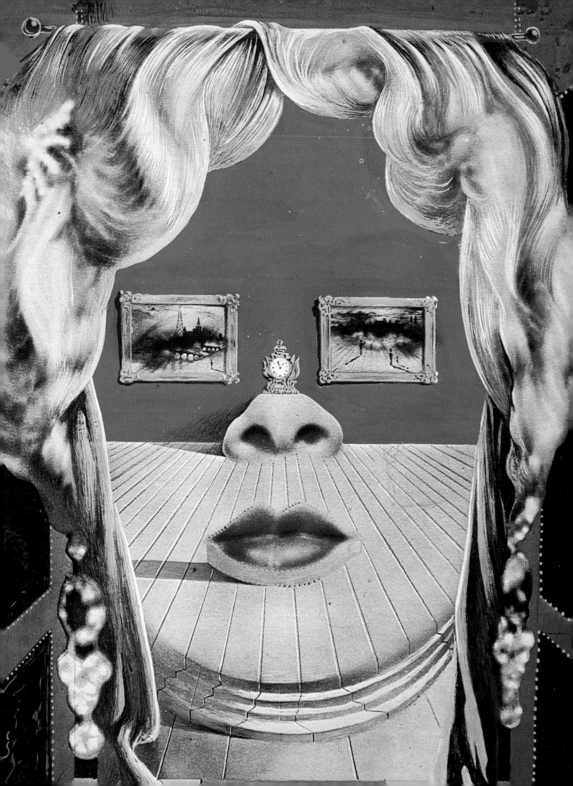

"Psychic automatism in its pure state, by which one proposes to express—verbally, by means of the written word, or in any other manner—the actual functioning of thought. Dictated by the thought, in the absence of any control exercised by reason, exempt from any aesthetic or moral concern."

André Breton

Isidore Ducasse, comte de Lautréamont and Raymond Roussel's *Locus Solus*, literary experiments in which clarity of form gave way to the obscure and ambiguous sound of the word, to the breakdown of the structure of discourse. They ventured into areas like esotericism, psychoanalysis, hypnosis, telepathy and sleep, in other words states of altered consciousness and suspension of rationality in which, it was believed, people expressed their individuality in a way that was not filtered by habits: some, like Artaud and Michaux, took this to the extreme of experimenting with hallucinogens, although this had been a widespread practice among writers and artists since the 19th century. For the same reason they sought stimulation in the mystery of sexuality and the moment, irrational by definition, of erotic desire. Again, on a plane more closely linked to the modalities and techniques of language, great importance was assigned to the pun, the slip of the tongue, the verbal paradox and the joke: indeed Breton provocatively held up as a model to be followed a music hall performer called Dranem, famous for his songs based on risqué double meanings and verbal nonsense.

In the "Manifesto of Surrealism" written by Breton in 1924, he declared: "Psychic automatism in its pure state, by which one proposes to express—verbally, by means of the written word, or in any other manner—the actual functioning of thought. Dictated by the thought, in the absence of any control exercised by reason, exempt from any aesthetic or moral concern."

Typical, in this sphere, was a direct consequence of automatic writing, the *cadavre exquis* ("exquisite corpse"), practiced from 1925 on, which Breton and Éluard would describe as follows in the *Dictionnaire abrégé du surréalisme*: "A folded-paper game in which sentences or pictures are created by several people, none of whom can tell what the contribution of any preceding player may have been. The classic example, which supplied the name of the game, is the first sentence ever obtained in this way: 'The exquisite corpse shall drink the new wine.'" Another product of these experiments was the series of aphorisms and plays on words created in a state of hypnotically induced sleep and transcribed by Robert Desnos, who published them from 1922 on under the name of Rrose Sélavy, the pseudonym previously used by Duchamp.

As far as more strictly artistic research was concerned, the question was less clearly specified and at the outset, it seems evident, considered secondary by

Breton, who limited himself to indicating precedents of the Surrealist attitude in the dreamy atmospheres of "Le Douanier" Rousseau and the Metaphysical painting of de Chirico. In any case, almost no encouragement to investigate a possible iconography of the Surreal came from the artists with a background in Dadaism. For a long time both Picabia, who held a solo exhibition at the Galerie Povolozky in 1920, and Duchamp avoided taking a stand in favour of the new movement. The exhibitions held by Ernst at the bookshop owned by Renée Hilsum and the young Joan Miró at the Galerie la Licorne in 1921 did not cause much comment, and neither did the Salon Dada in the same year, at which Arp and Ernst showed. Nor were de Chirico's small anthological exhibition at the Galerie Guillaume in 1922 and the first appearance of a still post-Cubist André Masson at Kahnweiler's the following year indications of a real tendency. The turning-point came at the end of 1924, with the publication of the first issue of the review *La Révolution surréaliste* and the creation of the Bureau Central de Recherches Surréalistes, opened on 11 October 1924 at no. 15, Rue de Grenelle, as a sort of ideological headquarters for the movement. Alongside writers like Éluard, Desnos, Crevel, Artaud, Péret, Vitrac, Baron, Soupault and Aragon, artists were among the outstanding contributors to the journal: Duchamp, Picabia, Ernst and Masson.

The following year Breton, sensing the changes that had taken place in artistic research, began to theorize about them in *Le Surréalisme et la Peinture*. This led to the staging of an exhibition at the Galerie Pierre with Arp, de Chirico, Ernst, Klee, Masson, Miró, Picasso, Man Ray and Pierre Roy. Breton did nothing but present a picture of something that was emerging independently in the world of art. Even in the artistic field, nevertheless, he established and imposed an orthodoxy. In 1926, as guardian of this orthodoxy, he felt able to brand Ernst and Miró's set designs for the Ballets Russes as a sign of worldly compromise, on the grounds that it was impure work contaminated by its practical and mundane use. On the other hand, with the efforts he had made to proselytize such new names as E.L.T. Mesens, René Magritte, Yves Tanguy, Paul Delvaux, Salvador Dalí and Maurice Henry, he was expecting Surrealism to spread like wildfire, just as Futurism had done and as would in fact happen over the course of the thirties. With this prospect the Galerie Surréaliste, a venue for exhibitions and events, also opened its doors in 1926. From this moment on,

288

"It seemed and still seems to me that the speed of thought is no greater than that of words, and hence does not exceed the flow of either tongue or pen."

André Breton

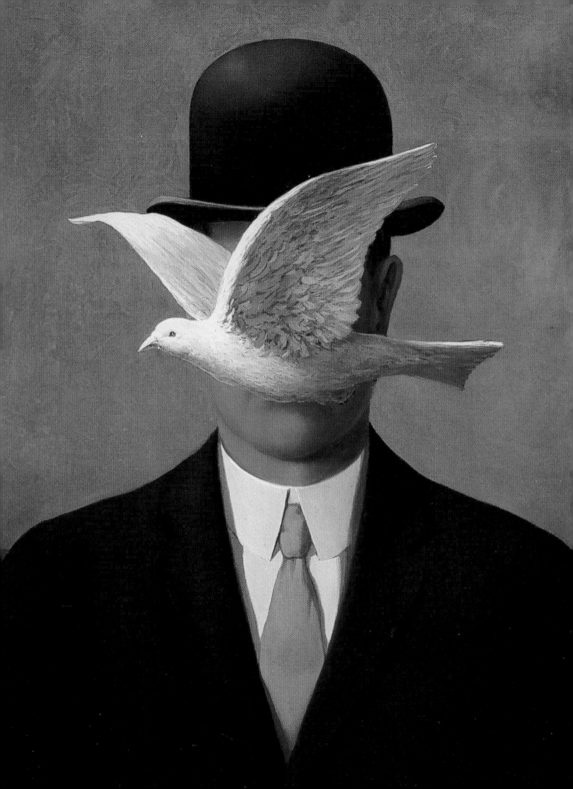

Surrealism was a reality that the world of art recognized and respected. Dream, dark areas of consciousness, psychic automatism, hallucination, and at the same time a continual encounter and clash of sign and word, of word and thing, of sign and thing. In the twenties Surrealism embarked, from the viewpoint of artistic manifestations, on a vast effort to expand the range of expressive possibilities, in a stylistic sense as well as in an anti-stylistic one, but above all on the plane of intellectual goals. Duchamp and de Chirico were the poles chosen and indicated as extremes of these explorations: the former as implacable demolisher of conventions and formulas, capable of imparting new and different energy to every sign of the reality of existence; the latter, for his ability to distil a sense of visual and mental alienation through a masterly use of the most traditional codes of painting: the capacity of painting to represent what is seen analytically was turned by de Chirico into the unrepresentable, the ineffable.

Out of this came, at one and the same time, a mutable series of departures from the accepted rules of art and aesthetics and so slavish and intransigent an application of the same historical rules that it turned into a sort of paradoxical excess, which did not even stop at the borders of the kitsch. They were apparently contradictory approaches, but more than one artist explored the possibilities of both with extraordinary results.

This was the case with two of the early Surrealists, Ernst and Miró. In the early twenties the former, who while still part of German Dada circles had already created extraordinary collages with objects inserted in them, reflected a great deal on the estrangement of the image inaugurated by de Chirico, but applied it to further forms of object-collage, to experimental practices like frottage, which he began to promote in 1926, and, in his more mature years, to assemblage of objects of a sculptural type that would be crucial in the international research of the following decades. Within the group of Surrealists, Ernst's imagery stood out for its Nordic visionary character, inclined to the monstrous, continually breathing an atmosphere of disquiet and anguish and filled with learned references, to everything from literature to Renaissance esotericism.

For his part Miró, while making incursions into the combination of objects and painting, remained for the most part within the limits of a

René Magritte
The Man with
the Bowler Hat, 1964
Oil on canvas, 63.5 × 48 cm
A. Carter Pottash
Collection, New York

technically orthodox painting that was homogeneous on the stylistic plane, relying instead on dense iconographic phantasmagoria. Taking signs from primitive cultures, from biology and from children's stories and fantasy, he assembled visions of potent perceptual richness and limpid wonder, backed up by a sumptuous use of chromatic relationships, a spatiality tending to the two-dimensional mosaic and a sophisticated virtuosity of execution. Miró was always careful to maintain a balance between the autonomous expressive capacity of the elements of the painting and the fascination of the images. As a result he was taken as a model by American Abstract-Surrealist research, and Roberto Matta and Arshile Gorky in particular, a current whose beginnings can be traced to the exhibition *Fantastic Art, Dada, Surrealism* at the MoMA in New York, which opened in December 1936. Another figure with a background in Dada like Ernst was Man Ray, who in these years, in addition to continuing with the practices of painting and the *ready-made*, introduced his "rayographs" in 1922. Based on the technique of contact printing, and used in parallel with photomontage and solarization, these showed that photography could be turned into an independent medium of expression, easier to assimilate to other practices of art. However, Ray's aim was not to win photography the status of an art form in its own right, a question that periodically reared its head in the avant-garde debate, but to demonstrate that the unbounded universe of the surreal image could find expression in technically and stylistically different works, in a world at last liberated from the hierarchy between the arts and the imperative of manual dexterity. In these same years Man Ray was also engaged in a series of cinematographic experiments. After the precedents of Léger's *Ballet mécanique* in 1921 and Hans Richter's first films, he made *Le Retour à la raison* in 1923, took part with Duchamp, Picabia and Satie in René Clair's *Entr'acte* in 1924, and in 1926 made *Anémic cinema*, with Duchamp again and with Marc Allégret, and *Emak Bakia* by himself. In 1929, the same year as Luis Buñuel and Dalí made *Un Chien Andalou*, whose screenplay was published in issue no. 12 of *La Révolution Surréaliste*, he shot *Les Mystères du château de Dé*.

Experiments of this kind had an "anartistic" value in the Duchampian sense, in other words they were not intended to mean or express anything, but simply to pay tribute to chance, to the absurd, to the multiple stumbling blocks of reason and language. The cinema, now the object of mass cultural consumption as a form of

"We do not want to reproduce,
we want to produce, like a plant
which produces a fruit,
directly and not by intermediary.
We want to produce directly,
not indirectly."

Hans Arp

narration by images, was subjected to the same procedures of destructuring of form and meaning that had been applied to the other arts. Joseph Cornell, an American who specialized in the assemblage of highly poetic box/theatres containing found objects arranged to create alienating visions, also devoted himself to the montage of clips from miscellaneous films, obliging viewers to forgo the story and give themselves up to the pure fascination of the flow of images. The exponents of the current that adopted the more classical and recognized forms of painting, starting with the presumption that a figuration of a realistic type completely represented the visible, only to force them to produce paradoxical results, were Masson, Tanguy, Magritte and Delvaux. Masson, whose name is linked to the mixture of sand with paint to obtain effects of irritation and surface texture, and in the following decade to an intense use of automatic drawing, moved on around the middle of the twenties to a sort of evocation of Cubist chromatic and iconographic rigour in which he brought together recognizable forms

Pablo Picasso
Cover of the Minotaure *Magazine*, 1933
published by Albert Skira
Assemblage: cardboard, metal, ribbons, printed paper, artificial plant, drawing pins and pen and ink on paper mounted on wood with charcoal, 48.5 × 41 cm
The Museum of Modern Art, New York

in a way that created absurd effects. More complex is the case of Tanguy who, harking back to the old tradition of "monstrous" painting, organized scenarios of a natural, representative kind in which he introduced apparitions somewhere between the oneiric and the ambiguously biological. The aim, achieved in part through a style that evoked illustration, was to create an effect of wonder induced by the elimination and deviation of what t he observer expected to see. The work of Magritte was at a much higher qualitative and conceptual level. Adopting a polished style very close to—when not actually overlapping with—*trompe l'oeil*, he created images in which the impression of space was always highly arbitrary and misleading: not scenes and situations, but a sort of crystalline hallucination representing the short-circuit between things and the words, or conventions, that designate them, or a metaphysical apparition of elusive and abstruse games of mirrors between what is seen and what it usually signified and came to signify differently in this cryptic and paradoxical figuration. He wrote: "My manner of painting is absolutely banal and academic. What matters in my painting is what it shows." Unlike in the Nordic, cruel and disturbing visions of Ernst, or the fabulous and ironic marvels of Miró, in Magritte's paintings

294

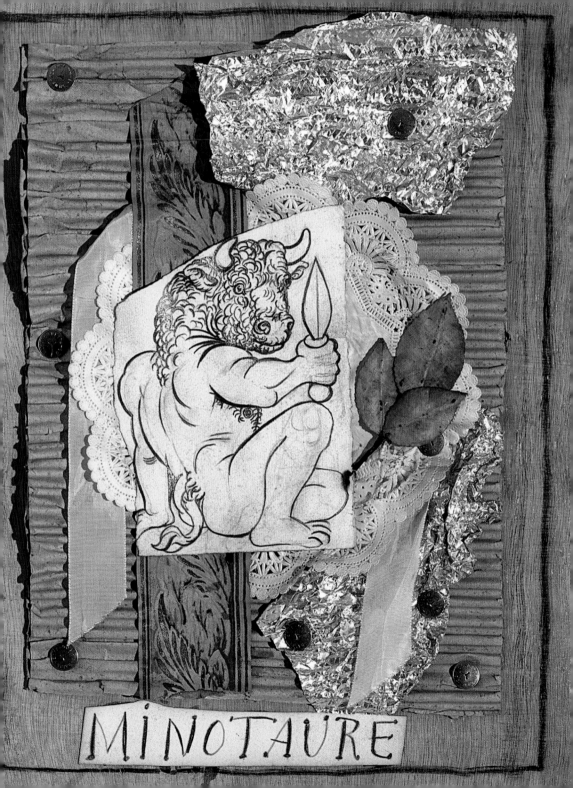

MINOTAURE

the problem is one of truth, of representation, of meaning. In a similar way, Delvaux used a backdrop of apparently clear and illustrative images to introduce subtle and ambiguous atmospheres somewhere between the oneiric and the erotic.

Dalí is a case apart. Disliked by the other exponents of the movement for his exhibitionistic egocentrism and for the way that he sought success by deliberately putting his personal fame before the work itself, he was the theorist of "critical paranoia", which he defined as a "spontaneous method of irrational knowledge based on the critical and systematic objectification of delirious associations and interpretations". The images were phantoms that stirred in the artist's unconscious: he sought to represent them on the canvas, using a procedure akin to that of automatic writing, critically elucidating in the process of painting that which the irrational—what Dalí called paranoia—had brought to the surface. Out of this came the nightmarish climate of his works, and an iconography in which symbolic and allusive figures were combined in a hallucinatory fashion.

It was in the midst of this labyrinth of experiences that the reflection on a new possibility for sculpture, provocatively announced at the beginning of the century by Boccioni and Picasso and taken up in particular by Brancusi, reached a crossroads. From Duchamp's *ready-mades* and Man Ray's "Objects of My Affection", sculpture had derived the certainty that its difference from banal reality lay not in its technical and material constitution, but in the capacity to present itself as a distinct nucleus of meaning, as a concrete anomaly, endowed with a halo of magical or sacred diversity in the panorama of everyday experience.

Again it was Picasso, in the paintings and above all the sculptures of the late twenties that looked to Surrealism, who marked this turning-point. In parallel, the figures of Julio González and Alberto Giacometti attained their maturity. The former, very close to Picasso, worked on a series of masks and totems that oscillated between an anthropological recovery of the idea of face and body, and a process of formation in which the initial geometric elements appeared to obey almost organic rules of growth. His sculptural work, along with that of Picasso, was to serve as a model for the practice of assemblage following the Second World War.

Giacometti, close in these years to the activities of the Surrealists, used

sculpture to construct situations of a theatrical type, or forms of an organic kind in which he emphasized the parts in an anomalous way to produce results that looked like natural paradoxes.

In both artist's work the theme of a sculpture that in some ways emulated biological growth was clearly present, but it was in Arp's sculptures of this period that this was taken to an extreme. "We do not want to reproduce, we want to produce, like a plant which produces a fruit, directly and not by intermediary. We want to produce directly, not indirectly", wrote the artist, going on to say: "Often a detail of one of my sculptures, an outline, a contrast seduces me and becomes the seed of a new sculpture. I accentuate an outline, a contrast and that results in the birth of new forms. Among these, certain of them, two perhaps, grow more quickly and strongly than the others. I let them grow until the original forms become accessory and almost unimportant. Finally, I suppress one of these accessory and unimportant forms to set the others free."

Alongside these experiences there was a more direct revival of the *ready-made* in manipulations of objects, of which the most famous example is Meret Oppenheim's *Objet – Déjeuner en fourrure* (*Object – Lunch in Fur*), which blends evocations of the everyday with hints of subtle eroticism.

At the end of the decade the unruly group of Surrealists broke up definitively. Breton's decision to move on to a more explicit politicization of the movement, which would lead him to cease publication of *La Révolution Surréaliste* and bring out instead, between 1930 and 1933, *Le Surréalisme au service de la Révolution*, estranged authors like Bataille, Leiris, Limbour, Masson and Vitrac, more interested in the exploration of themes like anthropology and the sacred, which they tackled in the journal *Documents*, founded in 1929.

Then, in 1933, the review *Minotaure*, founded by Albert Skira, became a vehicle for the representatives of the more strictly artistic front: Arp, de Chirico, Miró, Duchamp, Man Ray, Masson, Magritte, Tanguy, Dalí and Bellmer.

In January 1938 the *Exposition Internationale du Surréalisme* was held at Georges Wildenstein's Galerie des Beaux-Arts in Paris, a celebration of the movement that took place at the very moment it reached its crisis point.

297

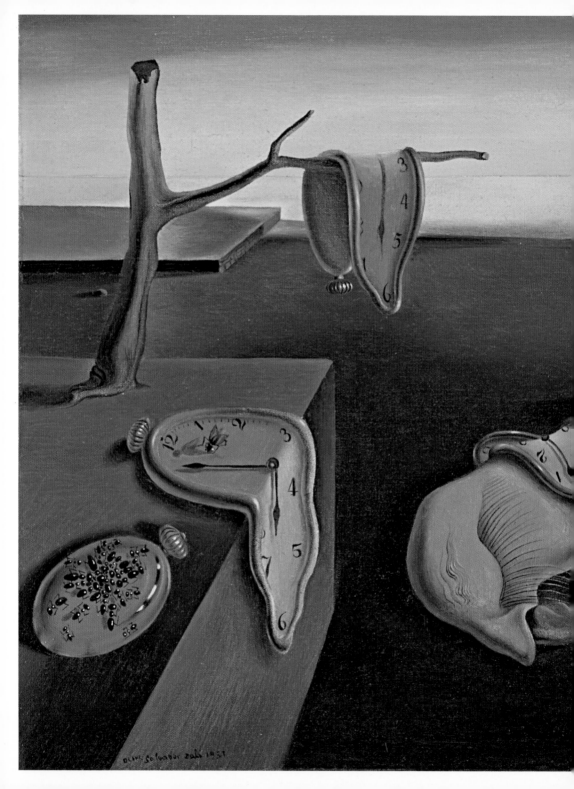

Salvador Dalí
1. *The Persistence of Memory*

Francis Picabia
2. *Transparencies – Head and Horse*

René Magritte
3. *The False Mirror*

Yves Tanguy
4. *Dead Man Watching His Family*

Max Ernst
5. *Attirement of the Bride*

302

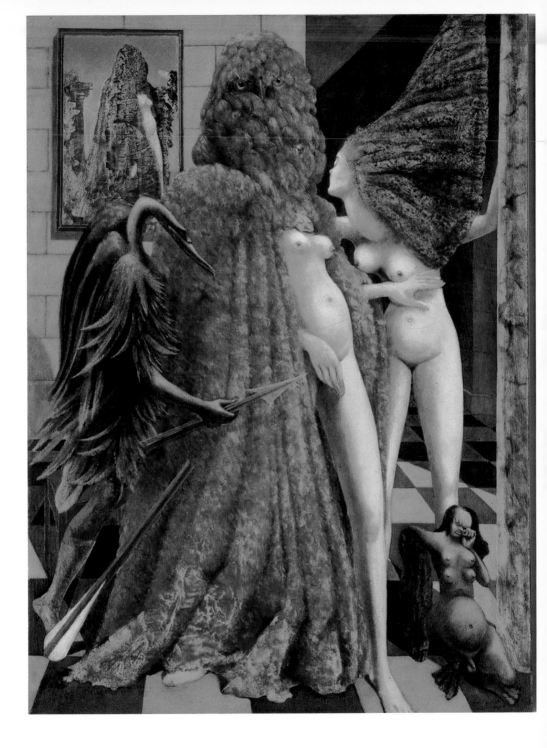

303

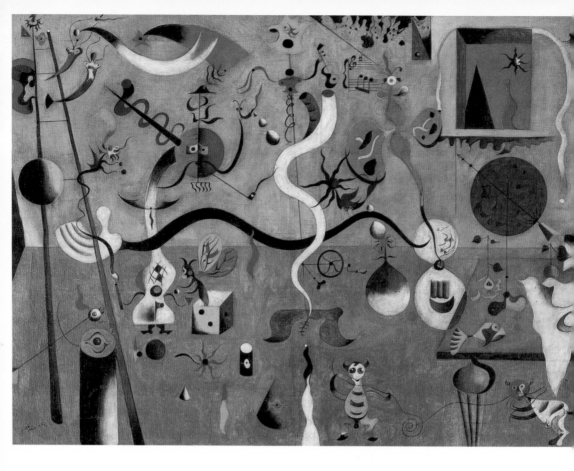

Joan Miró
6. *Carnival of Harlequin*

Joan Miró
7. *Head of Catalan Peasant*

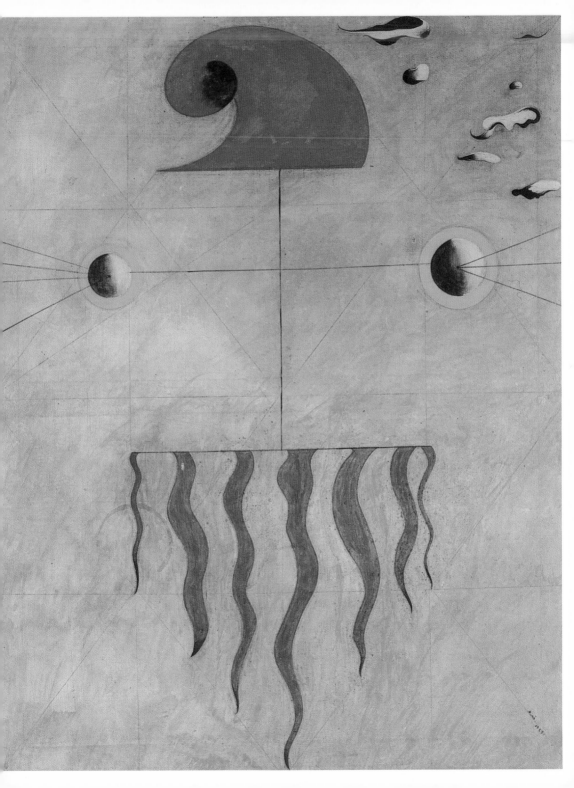

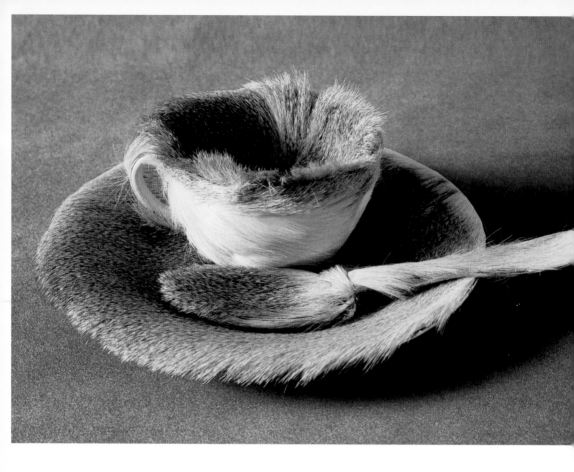

Meret Oppenheim
8. *Objet – Déjeuner en fourrure*
(Object – The lunch in Fur)

Alberto Giacometti
9. *The Nose*

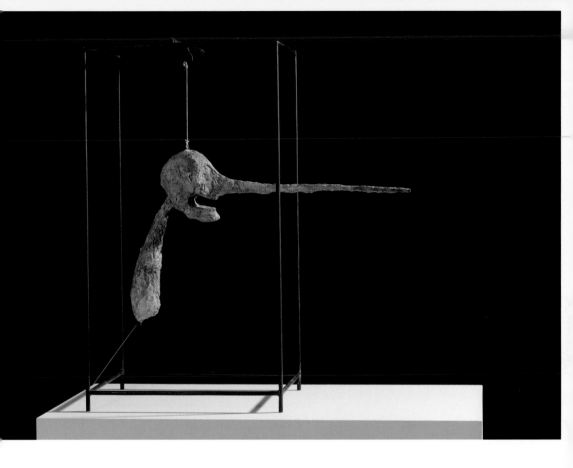

307

Art Informel

In 1952 Michel Tapié, a critic and cultural organizer with a background in Dada and Surrealist circles, published a book in Paris entitled *Un art autre* ("Art of Another Kind"). The publication came a year after the exhibition *Signifiants de l'Informel* at the Galerie Paul Facchetti in Paris, from which the new current of abstract art took its name. Among the artists he indicated as typical of the new approach to painting were Jean Dubuffet, Henri Michaux, Jean Fautrier, Wols, Georges Mathieu, Alfonso Ossorio, Mark Tobey, Hans Hartung, Jackson Pollock, Gianni Dova, Karel Appel, Pierre Soulages, Camille Bryen, Giuseppe Capogrossi and Jean-Paul Riopelle, a cosmopolitan panorama in which he discerned an identical disaffection with the geometric rigour of abstract art and with representative figuration, making them artists "of another kind".

The problem, he wrote, was "to create a work, with or without a theme, in front of which, whatever may be the aggressiveness or banality of the sheer physical contact, one perceives gradually that one's customary hold on the situation has been lost. One is (…) called to enter [either into] ecstasy or madness, for one's traditional criteria, one after the other, have been abandoned. Nevertheless such a work carries with it an invitation to adventure—in the true sense of the word 'adventure'—that is to say something not known, where it is really impossible to predict how things will go (…)".

Thus he recognized the novelty of an art that, in parallel to American Action Painting, did not spring from a concern with style and form, but in which a growth of the image occurred through renunciation of the classical instruments of composition in favour of an unconstrained emotional experience. It was an attitude that, in European art, dated from the forties, and that represented a seamless evolution of both Surrealist automatism and the Expressionist model.

Director of the Galerie Drouin, Tapié made it a meeting point and a showcase for Fautrier, who in 1945 exhibited there his series of *Otages*, the hostages he had seen during the Nazi occupation, figures reduced to clots of thick paint; for Wols, who between 1945 and 1947 showed works in which wandering signs traced phantoms of images floating in a liquid space; and in 1946 for Dubuffet, whose *hautes-pâtes* were brutal layers of paint from which the recognizable body seemed to emerge with dramatic effort. Working alongside them were writers and poets like Pierre Seghers, Paul Éluard, Francis Ponge and Jean Paulhan, exponents of a lyrical attitude that interrogated existence and sought its meaning beyond the obvious aspects of ordinary experience. Other initiatives

were intertwined with these. Hartung took the example of Nolde as his starting point, acting on the pure relationship between strong gestural signs and areas of intense colour in works that he exhibited in Paris in 1947. The same year the Canadian artist Riopelle was in the French capital, practicing an automatic painting that won the support of André Breton, while Mathieu promoted lyrical abstraction, which he presented at the Galerie Montparnasse in an exhibition bringing together the works of Gorky, de Kooning, Pollock, Rothko, Bryen, Hartung, Wols and Picabia, as well as his own.

On 8 November 1948, at the Café Notre Dame, the Dane Asger Jorn, the Dutchman Constant and the Belgian Christian Dotremont founded the group CoBrA, a stimulating name formed from the initials of their respective native cities, Copenhagen, Brussels and Amsterdam.

Nicolas de Staël
The Roofs
(The Sky of Dieppe), 1952
Oil on hardboard,
200 × 150 cm
Musée national d'Art
moderne – Centre
Georges Pompidou, Paris
Gift to the State

Whether they worked, like Fautrier and Dubuffet, with thick layers of paint that were used to convey the sense of an obscure vortex of material, or relied more explicitly on the automatic drawing of the Surrealist and Zen tradition to carry out lyrically distilled operations, as Wols and Mathieu did, all these artists had many traits in common. In fact, they did not plan the complex of forms in advance and then proceed with an execution relying on mastery of technique and style, following a known sequence of operation. The artisan character of the process, one of orderly composition, now gave way to the primary intuition of a formal nucleus of which the artist controlled neither the logic nor the possible developments. Out of this kernel, which had the nature of a creative revelation, came a process in which the artist filtered the choices he felt to be necessary from those that the craft and the figurative tradition suggested as being more plausible on the plane of composition and taste. The outcome of the work, in which each visual element was the fruit of an experienced analysis and at the same time of an effort to discover unknown solutions, was an image that did not meet the traditional parameter of form: on the contrary, it appeared instead to be *informel*, a "formless" organism, not fulfilling ordinary expectations, whose disorder and extraneousness from the usual codes of taste—to the point of ugliness—were capable of stimulating in their turn authentic and unforeseen emotional reactions in the observer. Thus the very idea of the picture changed. No

"(…) I like madness. I am very taken by madness. I feel the need for a work of art to be shrouded in surprise, for it to assume an appearance that has never been seen before, one that is highly disconcerting and takes you into an absolutely unexpected realm. For me, as soon as an art has lost this character of strangeness, it loses all its effectiveness, it's no longer good for anything (…)."

Jean Dubuffet

longer was it seen as an aesthetic object complete in itself, but as the spatially coagulated fragment of an intense psychological process that had a before and an after, on the level of a lucid and cruel delving into a humanity delivered from any rhetoric: from the Expressionist lesson came the idea of putting onto the canvas what the artist experienced subjectively, without concerns of any other kind. It was the disinclination of these practices to any predetermination of form, their rejection of the mere representation of sensible experience, their hostility towards aesthetic gratifications and to an even greater extent towards any decorative reworking of the image, that led to the adoption in continental Europe of the overall definition of Art Informel, which underlined the centrality of the indifference to the finished form with respect to Tapié's more conceptual term Art Autre and expressions more concerned with the mode of execution like Lyrical Abstraction, Tachisme ("painting of blotches") and Action Painting, which following the example of Pollock became the dominant name for similar research in the United States. It was Dubuffet, above all, who brought a disruptive theoretical attitude to the artistic debate. Taking Expressionism's sense of unexpected revelation and Surrealism's experience of loss of rational control and rejection of technical skill as a basis, he started out again from the fascination with children's drawing shown by artists like Klee and set about studying art created by people suffering from mental illness or in situations of total ignorance: this was what he called Art Brut ("Raw Art"), in contrast to the "cultural" arts.

"No I dislike reason. Far from being filled with wonder at human reason, I find it one of the poorest and dullest things there is. (…) It seems to me that man's only hope is to shut up his idiot reason, which makes him the lead arse of the world. This is what gives me my great taste for frenzy. In delirium I see salvation. I like madness. I am very taken by madness. I feel the need for a work of art to be shrouded in surprise, for it to assume an appearance that has never been seen before, one that is highly disconcerting and takes you into an absolutely unexpected realm. For me, as soon as an art has lost this character of strangeness, it loses all its effectiveness, it's no longer good for anything", wrote Dubuffet. He went on to explain that such strangeness was not intended to provoke, but stemmed from the "desire to see the creation of art and its effect exercised completely in the raw, under conditions that exclude any assistance, any pretence, any confusion. It seems to me that the effect of art which has to be produced in conditions so little suited to achieving it will be more

Giulio Turcato
Il deserto che si spacca
(Desert of the Tartars), 1959
Oil on canvas,
160.5 × 220 cm
MART – Museo d'Arte
Contemporanea di Trento
e Rovereto, Rovereto

striking and act with more force". Dubuffet was the master of an extroverted and burgeoning art that would give rise over the years to large sculptural forms and to true environments. His model inspired above all the members of the CoBrA group, who sought the barbaric force of Northern European imaginings, somewhere between legend and magic, transferring it into paintings developed out of brusque and incoherent gestures that strained the representation to the point where it was swallowed up in dripping flows of paint in discordant and always strident colours. Karel Appel and Asger Jorn were the principal exponents of this position, which was also taken by Carl-Henning Pedersen, Pierre Alechinsky, Corneille, Jean-Michel Atlan and Bengt Lindström. Godson of a Scandinavian shaman and initiated into his secrets, Lindström wrote: "I believe that the idea of the professional painter is to surprise his entourage, to perturb them so as to show (…) that there are other men who image unknown worlds, and it is these very worlds which are fabricated, which are necessary to a man to escape from this sad, material life that he himself has created."

Alongside these extreme positions we can set others that were more cautiously interested in pushing the figurative tradition in the direction of an explicit emotional participation of the artist in the vision. The world that they aimed to represent was not an alternative to the natural one, but probed instead into nature's internal mechanism of germination, of formation. This was the case, in France, with Nicolas de Staël, who translated the landscape and the figure at first into broad structured patches of thick and gleaming paint and then, spurred on by the reflection that "painting should not just be a wall on a wall. Painting should figure in space"—in other words, those rough textures could not be justified except as a move towards a possible new figuration—began to explore more complex spatial organizations, and more explicit references to the visible.

This was also the position of many of the new generation of Italian painters, whom the art historian Lionello Venturi grouped together in his book *Otto pittori italiani* ("Eight Italian Painters") in that same fateful year of 1952. In an Italian art polarized between Realism of an ideological and political stamp on the one hand, and the return to orthodox geometric abstraction on the part of the Movimento Arte Concreta on the other, he identified a third way represented by Afro, Renato Birolli, Antonio Corpora, Mattia Moreni, Ennio Morlotti, Giuseppe Santomaso, Giulio Turcato and Emilio Vedova. The following year an exhibition

entitled *Dodici pittori italiani* ("Twelve Italian Painters") at the Galleria del Milione proposed a similar grouping, with Afro, Ajmone, Birolli, Carmassi, Cassinari, Meloni, Moreni, Morlotti, Romiti, Santomaso, Vacchi and Vedova. The painting of these artists, while attaining extremes of lyrical abstraction in Turcato and Santomaso and explicit gestural accents in Vedova, was based on a non-descriptive idea of naturalism, in which the artist's relationship with sensible experience was one of strong emotional participation. On the canvas this translated into the creation of a world of lines and colours that evoked the inner vitality of nature, the sense of birth, death and transformation, the incessant generation and regeneration of which what we call form is nothing but a transitory passage. Exemplary, from this point of view, were the works of Afro, who transcribed the natural in the key of subtle exchanges of tones and fluid graphic veining, and of Morlotti, who declared unequivocally: "I feel that it is a question of embodying this perception, of rendering it vital and not deathly, and not pornographic. And nature will still be sap, germ, shiver and sex, and not just light and shadow and sentiment, not just Cézanne, Corot and Fontanesi."

Vedova was not only lucid in rehabilitating the Futurist lesson of the vital energy of matter expressed by taut lines of force, but also the most open to exchange with what was going on abroad, in particular the Action Painting of American artists like Franz Kline and German ones like Emil Schumacher and Karl Otto Götz. His tendency to entwine the space with dramatic and agitated black lines that stood out against pure yellows and reds, and to go beyond the canonical form of painting towards more complex spatial aggregations, as powerful stage machineries of a space rendered wholly pictorial, led him in 1964 to the series of *Plurimi* ("Multiples"), in perfect equilibrium between painterly experience and an architectural structure that, without turning into sculpture, erupted into physical space. This attitude of extreme physical and emotional immediacy of the gesture was rooted in a primarily moral tension: "Our need will be to deliver lines and colours from all forms of indolence, from all vices, for the great adventure: for the expressive birth of a new human condition. It is out of the need to come up with the equivalents of this new feeling that stems the search for, the insertion of new means of expression. Living in awareness signifies living in tension, in order to touch moments of truth."

Sculpture—which at the international level saw the use of strong materials like iron and bronze, lacerated to the point where

the idea of statue was dissolved, in the work of such artists as Lynn Chadwick and Kenneth Armitage—in Italy saw Leoncillo reach his maturity after a long period of oscillation between Neo-Cubism and baroque influences and make ceramic the "formless" material *par excellence*. The figure became a vertical agglomeration of clay wounded by furrows because, as Leoncillo wrote in 1957, "clay is like my flesh, a process of total identification". And he sought "not a reality described and turned into style, but form, colour, material to give directly the emotion, the feeling of nature", through "acts that stem from a reaction of our being, that grow out of fury, out of gentleness, out of desperation motivated by our being alive, by what we feel and see". A similar identification of expressive freedom and human freedom could be found in the whole new generation of Spanish artists, from Antonio Saura to Antoni Tàpies, who had been forced into exile by the illiberal Francoist regime and were thus driven by explicit motivations of political engagement. Tàpies used hard and thick layers of paint in strong tones of colour, which he made reverberate by inserting actual physical objects and carving deep lines that cut through the paste like wounds.

For him too art was experimentation and adventure, and, just as for Vedova, the purification from all rhetorical devices was a form of liberation that was not just metaphorical: "I can't picture the artist to myself if not wholly given up to adventure, in a complete state of trance, in the act of throwing himself into empty space."

One of the models for Tàpies and a broad range of artists from the generation of Art Informel to the successive one of New Dada was undoubtedly the isolated figure of Alberto Burri, whose personality stands alongside that of Fontana as a mark of this whole period of research. At the end of the forties Burri abandoned the orthodox technique of painting under the influence of Prampolini's experiments with the use of unusual materials and, through him, of Schwitters. At first he combined on the support such heterogeneous elements as tar, sand, pumice, rags and enamel, and then went on to use sacking, which he either painted or simply sewed on and left in view. Burri's idea was to utilize materials in an objective way, but in a process of composition that was still specifically pictorial in nature: in this way his works became at one and the same time "things" of the world and materials of art.

Leoncillo
Saint Sebastian, 1962
Stoneware and enamels,
54 × 16 × 15 cm
Alessia Calarota Collection,
Bologna

In the second half of the fifties he started to produce his *Combustions*, created by burning portions of the materials used for the composition, his "irons" and then his "woods", material surfaces that were shaped and fused into compositions on the boundary between two dimensions and three dimensions.

This recourse to the brutal appearance of materials reached its peak, in the following decade, with the *Plastics*, sheets of plastic marked by burnings and strong manipulations of the surface. The expressive value of these works is a highly dramatic one, owing to the immediate force of the material configuration and to Burri's predilection for colours like black and dark red, relieved only by raw whites. From the compositional viewpoint, on the other hand, he left unaltered the values of essential equilibrium, clear articulation of the spaces and structural order typical of the grand tradition, showing that the historical identity of art could be amplified without any need to deny its roots.

A fervent relationship with the artistic heritage of the past at its intersection with the most lively experimentation characterized Lucio Fontana, whose sculptural training in the years between the two wars had made conscious of the fragility of the concept of style and discipline, and above all of the fact that the moment of invention, of conception of the work is the crucial one of revelation of an authentically different reality. As in the great baroque period, and as the Futurists and other avant-gardes had begun to realize, the artistic experience could not be limited, in Fontana's view, to the canonical forms of the picture and the sculpture, but had to become to all intents and purposes the total work of art. This is what happened in the Spatial Environment he created at the Galleria del Naviglio in Milan in 1949, a dark room illuminated by ultraviolet light from a Wood's lamp in which phosphorescent forms floated and music echoed, and in the ceiling of curved whorls of neon for the Milan Triennale of 1951, a pure design of light in space. The picture itself was, from this point of view, a concrete form that existed in space, whose surface was not the anointed place of images, but the point of intersection between the physical space of our experience and infinite space. Out of this insight came, in 1949, his first monochrome works punctured with sequences of holes ("I make a hole, infinity passes through it, light passes through it, there is no need to paint (...) everyone thought I wanted to destroy; but it is not true, I have constructed, not destroyed, that's the thing (...)"). This marked the beginning of a long period of

"I make a hole, infinity passes through it, light passes through it, there is no need to paint (…) everyone thought I wanted to destroy; but it is not true, I have constructed, not destroyed, that's the thing (…)."

Lucio Fontana

experimentation in which his canvases housed fissures, biomorphic images made out of thick, dull or shiny materials, insertions of glass gems and eventually long cracks whose meaning lay in their being signs conceived with such a degree of purity that they became immaterial. Not provocation and not destruction, Fontana's holes and cuts were, in the highest degree, signs that did not define the circumscribed area of the canvas, but opened it up to infinity, of which the space of our experience is nothing but an extremely limited portion. As the artist put it: "I'm not interested in the type of space you're talking about. I think in another dimension."

From 1948 on a group of artists gathered around the charismatic and visionary figure of Fontana. Starting out from the example of Surrealist automatism, they set out to find a sort of abstract imagery with a strong non-representational component, giving rise to the Movimento spaziale ("Spatial Movement").

In the fifties Fontana carried on with his quest for a total space in which matter would rediscover its primeval state of substance that manifests its inner energy in space: "Existence, nature, and matter come together in a perfect unity. They develop in time and space. Movement, the property of evolution and development, is the basic condition of matter. This now exists in movement and in no other form; its development is eternal. Matter, colour and sound in motion are the phenomena whose simultaneous development makes up the new art", he wrote in 1951. Alongside him, in the exhibition *Arte spaziale* ("Spatial Art") held at the Galleria del Naviglio in 1952, showed Anton Giulio Ambrosini, Giancarlo Carozzi, Roberto Crippa, Mario Deluigi, Gianni Dova, Virgilio Guidi, Beniamino Joppolo, Milena Milani, Berto Morucchio, Cesare Peverelli and Vinicio Vianello. Over time they were joined by other painters, including Tancredi and Emilio Scanavino: the former was the author of airy compositions in which the strongly coloured sign opened up lyrical spaces, while the latter devoted himself to a dramatic, dark and vaguely 17th-century understanding of the non-figurative image. Their entry onto the scene marked the emergence of a new generation of non-representational artists, who in the second half of the fifties tended to move away from the existential emphasis of the masters of Art Informel and, taking Fontana's lesson on board, focus on creative processes with an intense mental and poetic component. Cy Twombly, the author of pure graphic sequences that echoed those of calligraphy in a renewed primary automatism, moved from the USA to Rome. Alongside him worked Achille

Perilli and Gastone Novelli, who in their turn started out from Surrealist automatic writing and transformed the surface of the painting into a field of complex psychological experiences. As Novelli wrote: "An image is born in some place of a common memory resulting from the sum of a chaotic and initial truth, of an immediate necessity and of an accumulation of facts from the past. An individual can pick this up through an intimate analysis, a cancellation and an intense and continual action tending to make itself a 'means' of expression. Out of this comes a collaboration between the work that demands its material, its complements, and the artist who eliminates every superfluous fact and every digression, and enriches and concentrates it."

In 1957 Perilli and Novelli founded the magazine *L'Esperienza moderna*, similar in its outlook to Enrico Baj's *Gesto*, created two years earlier, whose pages provided the forum for a true genetic mutation of the Informel, turning it into an art of a highly lyrical stamp, increasingly cosmopolitan in character and more and more attentive to developments elsewhere, but lucidly analytical and free of sentimental dross, and therefore of the new forms of rhetoric that mediocre popularizations of action and material painting were putting about.

Klee, Schwitters, Wols, Fontana and Arp were the avowed historical references, while new figures emerged alongside Twombly, including Carla Accardi, Mimmo Rotella, Arnaldo and Giò Pomodoro, César, Winfred Gaul and Serge Vandercam.
In fact the Pomodoro brothers were, along with Francesco Somaini and the older Umberto Milani and Pietro Consagra, responsible for the evolution from Art Informel to sculpture: they did not act brutally on the form but attempted instead to find the point of psychological and conceptual contradiction between the form that we recognize as complete—exemplary of this is Arnaldo Pomodoro's work on the sphere—and its obscure formation and disappearance, the inner activity of growth and dissolution of matter. With other members of this generation, such as Enrico Castellani, Piero Manzoni, Agostino Bonalumi, Dadamaino, Enrico Baj and Gianni Colombo in Italy, and elsewhere in Europe Yves Klein, Jan Schoonhoven, Günther Uecker, Jean Tinguely and Henk Peeters, i.e. the initiators of New Dada art and the "new exact art", the experience of the Informel was left behind.

Jean Fautrier
1. *Sarah*

Jean Dubuffet
2. *Noble port de tête*
(*Noble Carriage of Head*)

324

Wols
3. *The Blue Phantom*

Nicolas de Staël
4. *Figure by the Sea*

Following pages
Lucio Fontana
5. *Spatial Concept*

Alberto Burri
6. *Sacco IV (Sack IV)*

326

Emilio Scanavino
7. *Personaggio* (*Figure*)

Antoni Tàpies
8. *Crossed Lines*

331

Hans Hartung
9. *T1962-R18*

Gastone Novelli
10. *Telegram*

333

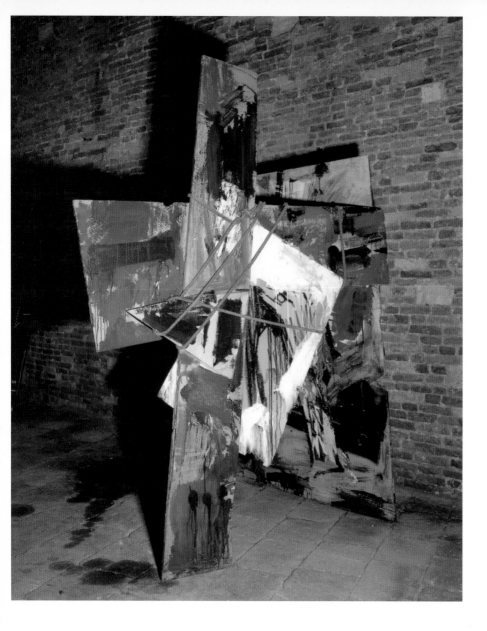

Emilio Vedova
11. *Plurimo n. 6*
(*Multiple No. 6*)

Georges Mathieu
12. *Mathieu from Alsace
Goes to Ramsey Abbey*

334

The New
York School

When, on 8 August 1949, the prestigious magazine *Life* asked provocatively "Is Jackson Pollock the greatest living American painter?", this did not just confirm the artist's reputation at the popular level. It also and above all showed that it was now possible to speak of an American art in its own right, no longer obsessed with emulating European art and in some ways overawed by the latter's pre-eminence. The capital of the art world, from this time on, would no longer be Paris, but New York. In fact this shift had already begun to take place in the thirties. A number of collections had been formed, including those of Albert Barnes, a lover of Impressionism and Post-Impressionism who in 1922 had set up a museum at Merion in Pennsylvania, and Solomon Guggenheim, who exhibited dozens of works by Kandinsky, Klee and Chagall in his apartment in New York's Plaza Hotel. And then there was Katherine Dreier, the founder in 1920 with Man Ray and Duchamp of the Société Anonyme, an institution that acquired and promoted the avant-garde. These had been accompanied by ambitious initiatives like the MoMA, the Museum of Modern Art in New York directed by Alfred H. Barr Jr., which was set up in 1929 at the behest of three women from wealthy New York families, Lillie P. Bliss, Abby Aldrich Rockefeller and Mary Queen Sullivan, and the Whitney Museum of American Art, devoted expressly to American art, which was founded two years later by Gertrude Vanderbilt Whitney.

It was at the MoMA that several exhibitions were staged which acted as a basis and model for the art of the new generations. *The International Style* in 1932, *Cubist and Abstract Art* and *Fantastic Art, Dada and Surrealism* in 1936 and a major exhibition of Picasso's work in 1939. Alongside these exhibitions, which documented the cream of the European avant-garde, presenting it as an example to be followed, others were devoted to the promotion of local experiences, in an evident attempt at freeing the country's art from its provincialism. In 1935 *Abstract Painting in America* was held at the Whitney, while in 1947 the Chicago Art Institute would organize *Abstract and Surrealist American Art*.

In addition the crisis in Europe, with the rise of Nazism and the first signs of war, had brought many protagonists of the avant-garde to the United States: Gropius, Breuer, van der Rohe, Albers, Feininger, Gabo, Moholy-Nagy, Mondrian, Grosz, Beckmann, Chagall, Matta, Dalí, Ernst, Seligmann, Masson, Breton, Léger, Man Ray and Duchamp. In 1942, an exhibition at Pierre Matisse's gallery in New York was significantly entitled *Artists in Exile*. Respected as masters

of the new languages and often taking up teaching posts, they contributed indirectly and directly to training a new American generation that felt itself to be the legitimate heir of the historical avant-gardes. This generation coagulated around gallery owners who championed the continuity between the avant-garde movements of Europe and new American art, such as Betty Parsons, Sam Kootz, Charles Egan and Sidney Janis, and above all the collector Peggy Guggenheim, muse of the Paris of the thirties, who in 1942 opened the Art of This Century gallery in New York: it was here that Hans Hofmann, Jackson Pollock, William Baziotes, Mark Rothko, Clyfford Still, Robert Motherwell and Adolph Gottlieb all exhibited for the first time.

The young New York artists reproduced in their behaviour the fringe heroism and intellectual intransigence that had characterized the Parisian model. They stood outside official culture, contradicting its values in polemical fashion and trying to create a cultural milieu totally extraneous to the dominant one. This explains the close ties of solidarity established with a group of avant-garde poets who defined

themselves as the New York School and who, just as in France at the end of the 19th century and in the early decades of the 20th, practiced militant criticism alongside literature: from Frank O'Hara, who among other things was an assistant curator at the MoMA, to John Ashbery and from James Schuyler to Kenneth Koch. The artists gathered around schools of painting like the Art Students League of New York, where people like Thomas Hart Benton and George Grosz taught and where Hofmann began to give lectures immediately after his arrival from Germany: Pollock, who moved to New York from Wyoming in 1930, studied under Benton there. Independent schools were set up on the initiative of the artists themselves, from Hofmann to the Mexican David Siqueiros, an exponent of public mural art in an epic style, much in vogue at that time in New York.

The most fashionable district was Greenwich Village, like the Parisian quarters of Montmartre and Montparnasse a meeting place for intellectuals and *engagé* youth: shortly afterwards the artistic community would choose as its own haunt the nearby neighbourhood of SoHo, an area of industrial buildings to the south of Houston Street whose ample spaces were turned into studios, homes and,

"(…) Pictures must be miraculous:
the instant one is completed,
the intimacy between the creation
and the creator is ended.
He is an outsider. The picture must
be for him, as for anyone
experiencing it later, a revelation,
an unexpected and
unprecedented resolution of an
eternally familiar need."

Mark Rothko

in the case of The Club, a venue for free encounters and debates. Between Eighth and Tenth Street a number of cooperative galleries were set up where the first shows were held in polemical opposition to the official circuit: one major exhibition, the *Ninth Street Show*, would be organized in 1951 in a building that was about to be demolished. And then of course there were the bars, emulating the best French tradition: the Cedar Tavern was, like the Deux Magots or the Café de Flore in Paris had been for Picasso and company, the most popular hangout. In the early forties all the artists of what, on the model of the associated group of poets, was defined as the New York School (the name would be made official in 1951 with the exhibition *The School of New York* at the Perls Gallery in Beverly Hills, California, organized by Motherwell and including works by Baziotes, de Kooning, Gatch, Gottlieb, Graves, Hofmann, Matta, Motherwell, Pollock, Pousette-Dart, Reinhardt, Rothko, Stamos, Sterne, Still, Tobey and Tomlin) held their first exhibitions, for the most part under the dual influence of Abstractionism and Surrealism.

Baziotes, Gottlieb, Still and even Rothko and Reinhardt—who were among the founders of the group known as American Abstract Artists, active from 1936 and polemically committed—ranged between biomorphic images and totemic echoes, some taking an explicitly figurative approach in an Expressionist key, while others were more interested in using decorative elements drawn from Native American art, which was rediscovered in those very years. The keystone of their action was the fact that they felt and proclaimed themselves to be "abstract", in contrast with the rhetorical figuration that was in vogue, assuming forms of avowed traditionalism in such exponents of Regionalism as Grant Wood and Reginald Marsh. Rothko, Newman and Motherwell were also gifted critics and argued forcefully in support of their own positions in the pages of magazines like *The Partisan Review*, to which the critics Clement Greenberg and James Johnson Sweeney, very close to these artists, also contributed, and *Possibilities*, whose one and only issue came out in 1947, edited by Motherwell and the critic Harold Rosenberg: among those who wrote articles for it was the composer John Cage.

Rothko wrote in *Possibilities*: "The most important tool the artist fashions through constant practice is faith in his ability to produce miracles when they are needed. Pictures must be miraculous: the instant one is completed, the intimacy between the creation and the creator is ended. He is an outsider. The picture must be for him, as for anyone experiencing it

later, a revelation, an unexpected and unprecedented resolution of an eternally familiar need." This mystical vision of abstract creation was matched, in the same publication, by the momentous statement in which Pollock described his technique of "dripping", used to produce works in which the relationship with the canvas was a physical, pragmatic one; in which action prevailed over intention in the Surrealist manner, in a sort of expressive trance in which the artist himself was not capable of calculating or predicting what would come out, but only of experiencing the intensity of the process: "My painting does not come from the easel. I hardly ever stretch my canvas before painting. I prefer to tack the unstretched canvas to the hard wall or floor. I need the resistance of a hard surface. On the floor I am more at ease. I feel nearer, more a part of the painting, since this way I can walk round it, work from the four sides and literally be in the painting. This is akin to the methods of the Indian sand painters of the West. I continue to get further away from the usual painter's tools such as easel, palette, brushes, etc. I prefer sticks, trowels, knives and dripping fluid paint or a heavy impasto with sand,

Robert Motherwell
Wall Painting No. III, 1953
Oil on canvas,
137.1 × 184.5 cm
MACBA – Museu d'Art
Contemporani de Barcelona,
Barcelona
On deposit from
the Onnasch Collection

343

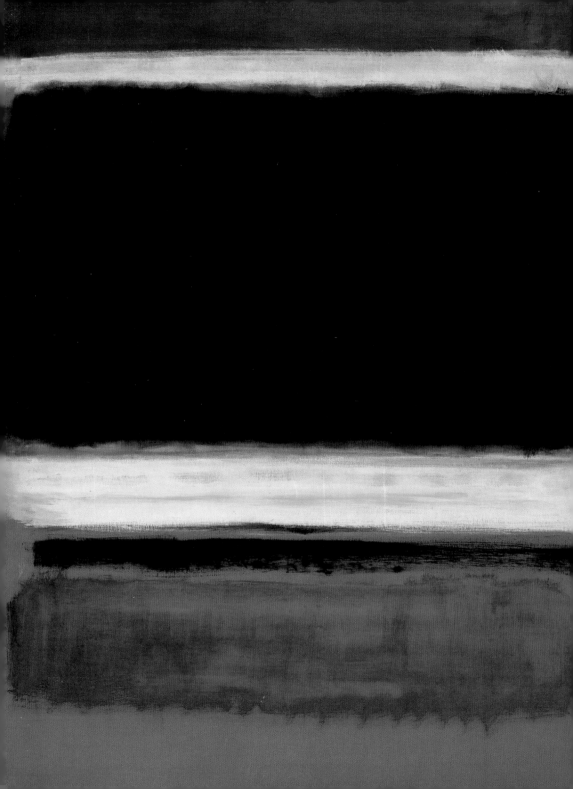

broken glass and other foreign matter added. When I am in my painting, I'm not aware of what I'm doing. It is only after a sort of 'get acquainted' period that I see what I have been about. I have no fears about making changes, destroying the image, etc., because the painting has a life of its own. I try to let it come through. It is only when I lose contact with the painting that the result is a mess. Otherwise there is pure harmony, an easy give and take, and the painting comes out well." These two attitudes, Rothko's metaphysical spirit and Pollock's approach based entirely on the physical dynamics of action, were the two extremes between which the experiences of this fervent moment moved. In 1946 the critic of the *New Yorker* Robert Coates had coined the term Abstract Expressionism as a description of the American art of the time, but the name that would eventually prevail, after an article by Rosenberg entitled "American Action Painters" was published in *Art News* in 1952, was that of Action Painting. This became a synonym for what a year earlier Sidney Janis and his young assistant Leo Castelli had more generically dubbed the "American Vanguard" in an exhibition at his gallery,

emphasizing the American character of the new current. In similar fashion Dorothy C. Miller, setting an official seal on the movement at the MoMA in 1952, chose the neutral title *Fifteen Americans*. Between the two poles were located the extreme abstractions of artists like Newman and Reinhardt, forerunners of what would shortly come to be known as Minimal Art, de Kooning and Guston's work on the verge of the figurative, Kline's blunt gestural painting and Still's subtle use of colour. So the term Action Painting can only be applied to some of these artists, while far more interesting is the fact that, above and beyond their individual and often contrasting approaches to expression, they operated with a profound unity of intents in a city, New York, that in the space of a few years became the centre of the international artistic avant-garde. The most mature of these artists was the eclectic and dynamic Hofmann, who reflected on the symbolic power of colour by trying out forms of expression that ranged from "dripping" to a chaotic and energetic style of painting, with echoes of Kandinsky and rhythmic-geometric patterns inspired by the "American" Mondrian of pictures like *Broadway Boogie-Woogie*.

Arshile Gorky (born to Armenian parents in Turkey) carried an extensive baggage of European influences, from the Cézannian ones of his early works, at the

end of the twenties, to his subsequent long involvement with Cubism and adoption of the emotionally charged signs of Miró and the strident colouring of the Expressionist Kandinsky. On these foundations he developed his strongly biomorphic abstraction, made up of fluid spaces that served as screens for a sort of psychological projection he regarded as far more crucial than any evocation of nature. As he put it: "Art is more than a mere chronicle. It must mirror the intellect and the emotion, for anyone, even a commercial artist or illustrator, can portray realism." The work, for him, was a total experience of the psyche, which started out from the lesson of Surrealist automatism and turned into an urgent and blind transcription of flows of consciousness, setting aside any preoccupation of a formal or stylistic character.

The same indifference to questions of style was shown by de Kooning, who started out instead from the sensible phenomenon, from the model of representation, in order to investigate pictorially the corporeal vitality of the figure rather than limiting himself to fixing its external features. In his *Women* of the early fifties as well as in later compositions in which the figural pretext was less evident, colour played a quantitative rather than qualitative role, identified with the physical substance of the image. The artist seemed to focus on the dramatic process of its development, of its growth to a completeness that was however only provisional, subject as it was to a continual motion of formation/disintegration.

Yet it was around Pollock that the new mythology of the emerging American art quickly jelled, partly because of the sensational nature of his Action Painting and partly because he, unlike the European immigrants Hofmann, Gorky and de Kooning, was American by birth. His early work reflects a variety of influences, from Matisse's wholly superficial treatment of the image to the coagulation of form through the gesture of Surrealist origin. For him, however, the surface took on the significance of a concrete and physically resistant portion of space, remote from any projective and atmospheric mediation: it was a physical value in which the action of the artist did not mediate and contributed nothing but his own energy, at once physiological and mental, emotional; a place that came into existence precisely because it was saturated by the quivering course of the material splashes of colour. From the *Mural* executed in 1943 for Peggy Guggenheim's apartment, a precocious experiment with painting on a very large scale that constituted a surmounting of the murals of Hart Benton and Ben Shahn and at the same time a foretaste

"(…) When I am in my painting,
I'm not aware of what I'm doing.
It is only after a sort of 'get
acquainted' period that I see what
I have been about. I have no fears
about making changes,
destroying the image, etc., because
the painting has a life of its own.
I try to let it come through."

Jackson Pollock

of the huge canvases of the years to come, to the "drippings" that he created from 1947 onwards, Pollock succeeded, by eliminating the brushstroke as a mark of gestural energy, in getting his labyrinth of colours to emerge in a more or less autonomous way on the canvas, making its marked two-dimensionality and lack of pre-arranged formal structures even more explicit, given the absence of direct intervention.

A new element was introduced into the wholly physical two-dimensionality of the canvas with the concept of "all-over" painting, i.e. of a visual uniformity in which the entire surface was treated indistinctly without any hierarchies between different portions of the image and without the borders representing the boundaries of the historically "other" vision of painting, but only a physical limit with respect to the surrounding space.

A similar energy and surface tension, but one entrusted to the urgent intensity of the gesture, lay at the root of Kline's work. With his taut lines streaking the surface, with his reduction of chromatic relationships to a predominance of black on white and with his simplified and distorted geometries that contradicted

Franz Kline
Untitled, 1952 circa
Ink on page from
a telephone directory,
27.5 × 23 cm
Private collection
Courtesy McKee Gallery,
New York

any expectation of balanced composition, the artist created a crude two-dimensionality in which the sign took on an abstract character as in calligraphy and in Japanese paintings, which caught the interest of many other American and European artists, from Tobey to Mathieu, at this moment. Superficial concreteness and markedly abstract essentiality of sign were also the underlying values of the work of Motherwell, a student of aesthetics and essay writer as well as painter. His role in the New York of the forties was on the one hand one of study and documentation of the historical notions of Abstractionism and Surrealism (from his *Notes on Mondrian and de Chirico* of 1942 to the conception, in 1944-45, of the *Documents of Modern Art*, fourteen volumes devoted to a range of subjects, including Mondrian, Arp, Ernst, Cubism and Dada, and in 1951 of *Modern Artists in America*, edited in collaboration with Ad Reinhardt), and on the other of experimentation with a painting in which the structure of the composition and colouring was determined in a very objective way, concentrating the emotional and conceptual tension in the actions and procedures rather than in the final image. Instead of the dramatization and physical participation—being totally inside the painting—attempted by de Kooning and Pollock, he sought an intensity based on

conscious perceptions of action, on an expressive concentration endowed with an optical evidence as concrete as that of Pollock, but handled in a different way, closer to the Matissian idea of the inlay and to Klee's use of signs and based on an emphasizing of the relationships between strong and elementary colours—red/yellow, white/black, yellow/black—produced by full, rapid and determined brushstrokes.

Philip Guston turned to a more lyrical abstraction veined with echoes of Surrealism, before moving on a few years later to a cartoonish form of representation in acid and impure colours. As Guston would write: "There is something ridiculous and miserly in the myth we inherit from abstract art. That painting is autonomous, pure and for itself, therefore we habitually analyze its ingredients and define its limits. But painting is 'impure'. It is the adjustment of 'impurities' which forces its continuity (…)."

Baziotes, for his part, drew on a surreal and biomorphic type of inspiration, remaining essentially faithful to it right to the end and increasingly relying on the transparencies and sensible qualities of the colour, following the example of Miró. In a letter to the *New York Times* in 1943 Newman, Rothko and Gottlieb declared: "We favour the simple expression of the complex thought. We are for the large shape because it has the impact of the unequivocal. We wish to reassert the picture plane. We are for flat forms because they destroy illusion and reveal truth."

While Barnett Newman soon turned, like Reinhardt, to a sublime understanding of geometric form and colour, Gottlieb and Rothko, and with them Still, set their sights on an idea of abstraction based on fluid structures, on a dimension of the non-objective image somewhere between the oneiric and the metaphysical which assumed very different forms but was unified by a high degree of poetic intent. Gottlieb asked himself: "If the models we use are the apparitions seen in a dream, or the recollection of our prehistoric past, is this less part of nature or realism than a cow in a field? I think not. The role of the artist, of course, has always been that of image-maker. Different times require different images. Today when our aspirations have been reduced to a desperate attempt to escape from evil, and times are out of joint, our obsessive, subterranean and pictographic images are the expression of the neurosis which is reality. To my mind, so-called abstraction is not abstraction at all. On the contrary, it is the realism of our time."

For his part Rothko declared: "I quarrel with surrealists and abstract art only as one quarrels with his father and mother; recognizing the inevitability and function of my roots, but insistent upon my

dissent; I, being both they, and an integral completely independent of them. The surrealist has uncovered the glossary of the myth and has established a congruity between the phantasmagoria of the unconscious and the objects of everyday life. This congruity constitutes the exhilarated tragic experience which for me is the only source book for art. But I love both the objects and the dream far too much to have them effervesced into the insubstantiality of memory and hallucination."

The abstract front of the American painting of the time saw the maturation of other figures, like the younger Cy Twombly, a pupil of Kline and Motherwell, who kept faith with a painting based on a dense mesh of signs belonging to a sort of script on the limits of the comprehensible that retraced the whole of the tradition from the prehistoric graffito to Oriental calligraphy, and Sam Francis, of predominantly European formation, who adopted a liquid colouring with a myriad transparencies used to create infinite layers in the image, in accordance with his motto "depth is all".

A separate group consisted of Morris Louis, Kenneth Noland and Helen Frankenthaler, for whom the expression Colour Field Painting has been coined to reflect their predilection for an abstraction based on clean and bright colours laid on in fields that hold a dialogue with the surface of the canvas, in a manner that can be traced back to the mature works of Matisse.

Quite apart from the specific solutions adopted by each of these figures, these experiences throw light on some fundamental questions. In the first place the effort to finally construct a real pictorial space, expanded physically beyond the controllable dimension and at the same time emotionally indefinable, capable of substituting its own truth for the traditional but now impracticable idea of nature and reality: a space that rendered meaningless the problem of the imitation of the perceptual world and that affirmed a completely new quality of the image and vision. Secondly, the idea of the artist as an inseparable whole of body and mind, existence and thought, unconscious and reason, who put his own identity and existence to the test in the experience of painting. As a consequence, the value of the work was no longer that of a finished and perfect product, but the precipitate of a single moment of that experience which was renewed from work to work, no longer aspiring to universality but attempting to concentrate in an image an intense, unique moment of life and expression.

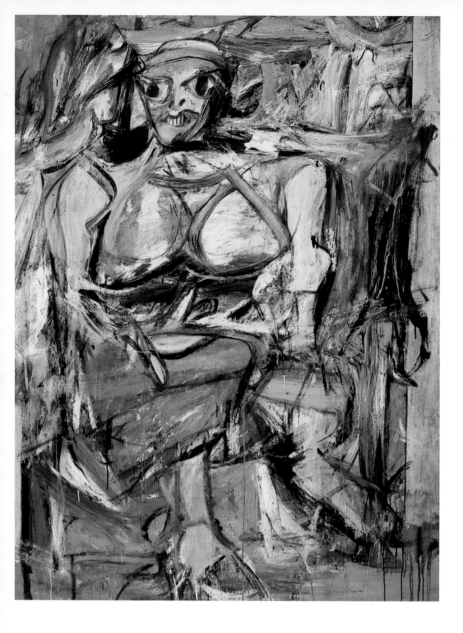

Willem de Kooning
1. *Woman I*

Jackson Pollock
2. *Composition 16*

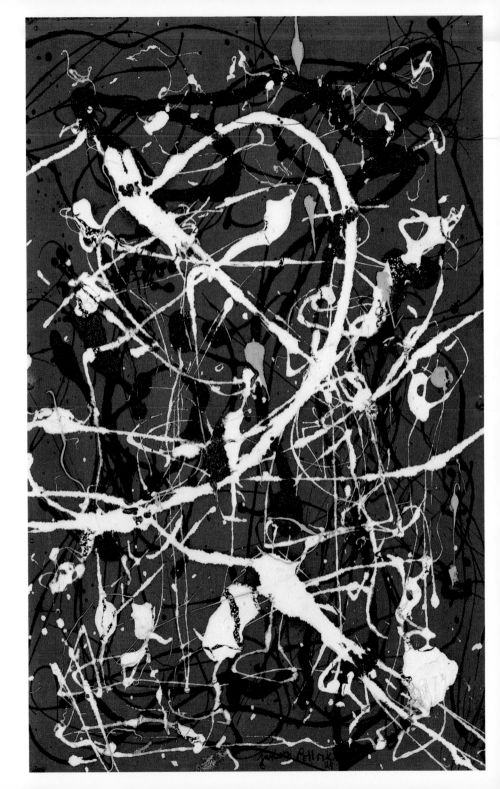

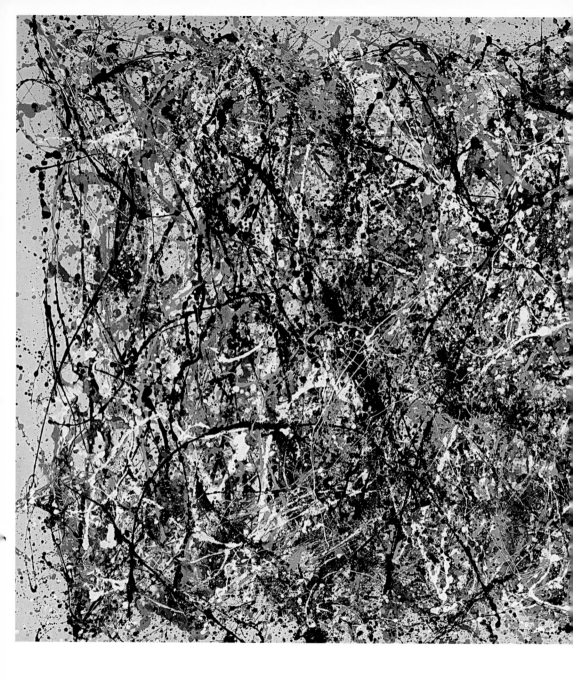

354

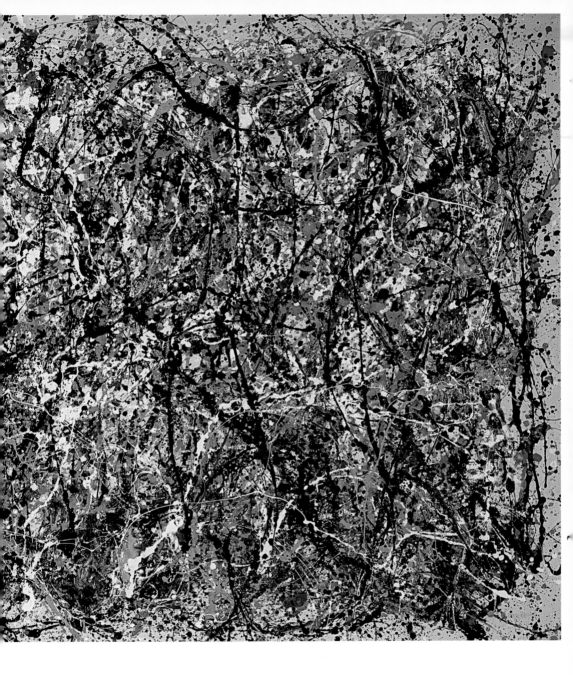

Jackson Pollock
3. *One (Number 31, 1950)*

Followings pages
Franz Kline
4. *Andrus*

355

Clyfford Still
5. *Untitled*

Helen Frankenthaler
6. *Walnut Hedge*

Morris Louis
7. *Beta Lambda*

Sam Francis
8. *Untitled – SF 57-265*

360

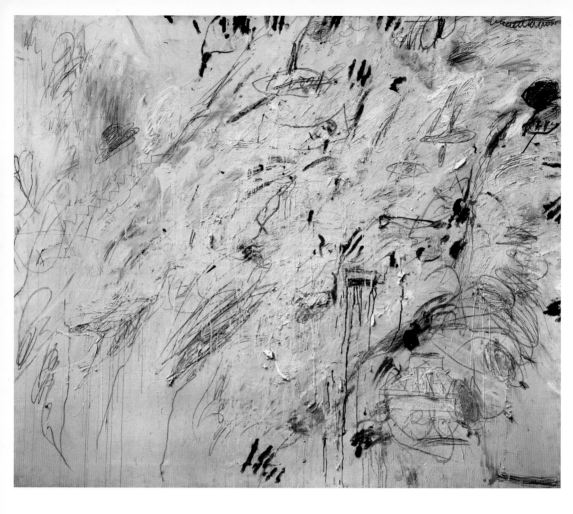

Cy Twombly
9. *Rome (The Wall)*

Mark Rothko
10. *No. 22*

363

Pop Art

January 1958. A solo exhibition by Jasper Johns opened at Leo Castelli's gallery in New York, followed, in February, by an exhibition of Robert Rauschenberg. Pollock had died dramatically just over a year earlier, and the international art scene had changed drastically. Many sought to identify the character of the new artistic climate as a revival of Dadaism, resulting in the coining of the term New Dada, but it was an English critic, Lawrence Alloway, who first sensed the underlying reality of the new form of art.

In an article that came out in *Architectural Design* in that same February of 1958, significantly entitled "The Arts and the Mass Media", he spoke of a culture made up of banal images linked to mass consumption, stereotypes and simplifications, in which merchandise had more importance than objects of art and comic strips communicated more effectively than novels: this was "mass popular art", which had assumed a far more dominant role than "high" and official culture. Pop Art was the art that was born out of this situation, it was popular culture constructing its own monuments. Rauschenberg exhibited his "combine-paintings", works to which he applied photographs, fragments of advertising images and above all actual objects taken from ordinary life, such as an umbrella or a car tyre, a bottle of Coca-Cola or a stuffed animal. These objects were introduced into works dripping with paint in bright colours, executed with a cursive and brusque technique that in some ways recalled that of the immediately preceding current of Action Painting. So they were still pictures, but at the same time three-dimensional assemblages in which the banal object was presented for what it was, a scrap of everyday life inserted into a work of art. The result was in some ways shocking, because it was the first time that things and images taken from daily reality had been included within a pictorial procedure with such indifferent brutality, but it was an act that brought the pictures to life. It had some paradoxical effects: the MoMA, the Museum of Modern Art in New York, temple of the historical avant-garde, initially turned down donations of works from the artist because they were made out of perishable materials whose conservation it was unable to guarantee. In other ways Rauschenberg's works fell within a tradition that was familiar to the avant-garde of the 20th century: from the Cubist collage, which entailed the insertion of existing images into the fabric of the painting, to the Dadaist ready-made, which manipulated concrete objects; from the creations of Kurt Schwitters, which turned things drawn from reality into pictures, to those of the Surrealists, from Max Ernst to Joseph Cornell, in which objects were

transformed into elements of complex and paradoxical visual situations; from the work of Francis Picabia, who reutilized popular images in his iconographic montages, to that of the Americans Stuart Davis and William Copley, the former author since the twenties of pictures representing commercial packages and advertising images, the latter a follower of Surrealism who was influenced by the comic strip in the fifties and chose themes like State emblems and flags. Rauschenberg was considered the great synthesizer of these precedents, and the assignment of the Grand Prize to him at the Venice Biennale in 1964 would proclaim him, to all intents and purposes, as the father of Pop Art. The case of Jasper Johns is very different. He painted in slow, detached, precise strokes, with great accuracy, resorting to long-established techniques like encaustics, used by the ancient Romans, and glazing to produce pictures of a traditional size. But his subjects were the American flag, shooting gallery targets and numerals, i.e. schematic and stereotyped images that had no other significance than their vividness. Instead of contaminating and dissolving the common idea of painting from the technical point of view, he chose to ennoble banal icons through the use of the most sophisticated techniques of painting, in a sort of metaphysics of the commonplace. Perhaps partly as a consequence of the ease of identification of his works, which did not present any problems from the perspective of execution, he was considered from the outset the "new Pollock" of American art: his obvious technical skill, and the fact that his forerunners were artists like Davis and Charles Demuth (who had also devoted a series of paintings to numbers), which meant that unlike Rauschenberg he drew his inspiration from the indigenous tradition rather than from the European one, made him the perfect "100% American" artist: something which at that moment, when the USA wanted to add cultural pre-eminence to its political and economic dominance, was considered a fundamental factor. It is no coincidence that the MoMA acquired four works by Johns on the very day his exhibition opened at Castelli's gallery, and that it was one of his works, now in the Whitney Museum in New York, that was first sold at the symbolically significant price of a million dollars. Johns had tackled the subject of the flag in 1954, and in the first half of the fifties Rauschenberg was already evolving from his own roots in Dada and Surrealism.

Tom Wesselmann
Stil- Life #30 (detail), 1963
Oil, enamel and synthetic polymer paint on composition board with collage of printed advertisements, plastic flowers, refrigerator door, plastic replicas of 7-Up bottles, glazed and framed colour reproduction and stamped metal,
$122 \times 167.5 \times 10$ cm
The Museum of Modern Art, New York
Gift of Philip Johnson

366

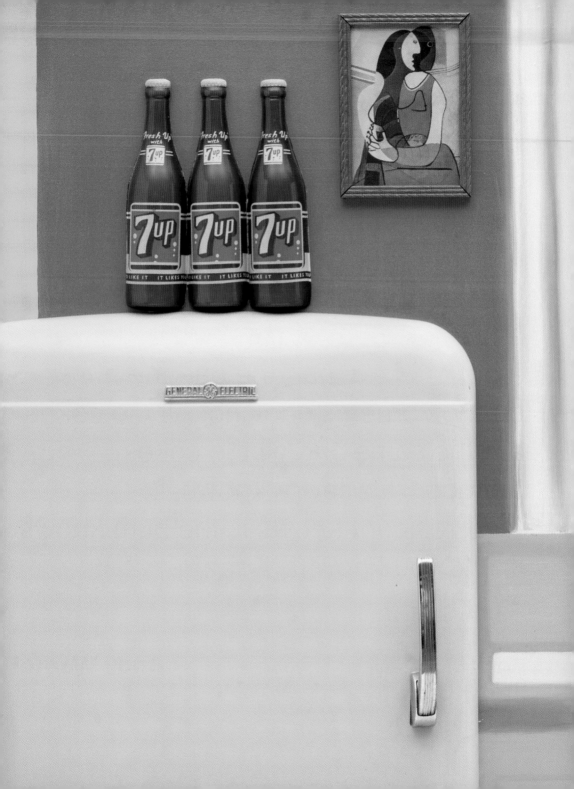

"(…) You can be watching TV and see Coca Cola, and you know that the President drinks Coca Cola, Liz Taylor drinks Coca Cola, and just think, you can drink Coca Cola, too. A coke is a coke and no amount of money can get you a better coke than the one the bum on the corner is drinking. All the cokes are the same and all the cokes are good. Liz Taylor knows it, the President knows it, the bum knows it, and you know it."

Andy Warhol

The fact is that, even before the boom of the sixties, Pop Art had had, like all avant-garde movements, a series of harbingers and germinal experiences. These occurred not just in the USA, acknowledged home of the movement, but also, and in a far from marginal way, in Europe. It is no accident that an exhibition by the brilliant Italian set designer and illustrator Domenico Gnoli in New York in 1956 is considered an important stage in the development of Pop Art.

In the early fifties the Independent Group, an association of intellectuals who reflected on modernity and its images in various ways, was active at the Institute of Contemporary Art in London. The artists Eduardo Paolozzi and Richard Hamilton, the architects Alison and Peter Smithson and the critic Lawrence Alloway staged exhibitions at the ICA like *Parallel of Life and Art*, 1953, and *Man, Machine and Motion*, 1955, followed the year after by *This Is Tomorrow* at the Whitechapel Gallery. They were made up of photographs, montages and installations that examined the grand themes of the contemporary imagination: photography, technology, advertising, merchandise, machinery. The new British painting, announced by the exhibition *Young Contemporaries* at the RBA Galleries in London in 1961, was born in this milieu,

with the emergence of an authentic Pop generation that included such outstanding artists as Paolozzi, Hamilton, Richard Smith, Peter Blake (who was to design the legendary sleeve for the Beatles' album *Sgt. Pepper's Lonely Hearts Club Band* in 1967), Ronald B. Kitaj, Peter Phillips, David Hockney, Joe Tilson, Bernard Cohen, Allen Jones and Patrick Caulfield. Phillips was to write in 1964: "My awareness of machines, advertising and mass communications is not probably in the same sense of an older generation that's been without these factors... I've lived with them ever since I can remember and so it's natural to use them without thinking." In the same years something similar was going on in Parisian circles. On show at the first Paris Biennale, in 1959, were a monochrome by Yves Klein, one of Jean Tinguely's "painting machines" and a hoarding with torn posters by Raymond Hains. It was the beginning of what was to be dubbed Nouveau Réalisme ("New Realism") by the critic Pierre Restany a year later, presenting the movement in an exhibition at the Galleria Apollinaire in Milan and, in 1961, in the Parisian exhibition *A 40° au-dessus de Dada* ("40° above Dada"). While Klein's monochromes explored a sort of metaphysics of colour, Tinguely's noisy and useless machines, like the works of Hains, Arman, Jacques de La Villeglé, François Dufrêne, Mimmo Rotella, Daniel

Spoerri, Martial Raysse, César, Niki de Saint Phalle, Christo and Gérard Deschamps, brought about what Restany defined as a "poetic recycling of urban, industrial and advertising reality", i.e. the reutilization of mechanisms, objects and shreds of images drawn from everyday life and their reinvention in different ways.

The expression Pop Art had not yet caught on and the definition coined by the French critic appeared at first to prevail, since interpretations of the time were inclined ed to view these artists more in terms of their tendency to reuse the materials of the civilization of merchandise in an inventive fashion than in those of the celebration of mass imagery. In the exhibition *Le Nouveau Réalisme à Paris et à New York* staged at the Galerie Rive Droite in Paris in 1961, American artists showed alongside the French group. Among them were Rauschenberg, Johns, Chryssa, Richard Stankiewicz and John Chamberlain, whose sculptures made from crushed automobile parts were very close to the works of César: a sign, this, that the new creative climate was by now international in character. The developments in Paris had a strong influence, at this moment, on the New York milieu: in the same year the exhibition *The Art of Assemblage* at the MoMA presented the French Nouveaux

Réalistes alongside artists from the United States like Edward Kienholz, Robert Moskowitz, George Brecht and Lucas Samaras, while the following year *The New Realists* exhibition at the Sidney Janis Gallery in New York seemed to have set a definitive seal on the name and destiny of the movement. The most innovative research conducted in New York appeared at that time to have characteristics linked more closely to the birth of the happening, the installation and the performance than to the ones that Pop Art was to emphasize. Allan Kaprow had already set an example with his *18 Happenings in 6 Parts* at the Reuben Gallery in 1959, ushering in the art of performance which physically involved author and public. At other "off" venues like the Judson Gallery, Claes Oldenburg, Jim Dine and their fellow experimenters created three-dimensional settings they called environments: *Environments, Situations, Spaces* was the title given to a major exhibition staged at the Martha Jackson Gallery in 1961, with artists come Brecht, Dine, Kaprow and Oldenburg. Among the more sensational events of the period was Oldenburg's *The Store*, which in 1961 presented mock products in a real abandoned shop on the Lower East Side, filled by the artist with 120 sculptures representing objects for sale along with their prices. Oldenburg wrote: "I am for the art of

"I am for the art of (...) red and white gasoline pumps. I am for the art of bright blue factory columns and blinking biscuit signs. (...) I am for Kool-art, 7-UP art, Pepsi-art, (...) 39 cents art, (...) 9.99 art (...)."

Claes Oldenburg

(…) red and white gasoline pumps. I am for the art of bright blue factory columns and blinking biscuit signs. (…) I am for Kool-art, 7-UP art, Pepsi-art, (…) 39 cents art, (…) 9.99 art (…)."

A year later the scenario had completely changed, through the work of artists who bore the names of Roy Lichtenstein, Tom Wesselmann, James Rosenquist, George Segal, Claes Oldenburg, Robert Indiana and Andy Warhol. After Johns and Rauschenberg, Leo Castelli launched Lichtenstein, who chose the iconography of the cartoon strip and commercial art and blew it up out of all proportion, transferring it onto canvas without aesthetic interventions and handling the paint in a dry, uniform manner, as similar as possible to the inking used in popular publishing and even reproducing the half-tone dots.

In 1962 the Green Gallery staged exhibitions by James Rosenquist, George Segal, Oldenburg and Tom Wesselmann. Rosenquist, a sign painter and illustrator (Lichtenstein and Warhol also came from the world of commercial art), adapted a gluey medium used for billboards to represent fragments of images drawn from advertising and daily life on a giant scale, often on transparent supports. Segal, closer to the world of happenings and New Dada, placed plaster casts of real people in settings resembling the ones they lived in, or that were created out of physical objects, in a sort of ambiguous and disquieting theatre in which the roles of reality and representation were deliberately exchanged.

His figures inhabited situations that had much in common, in their silent anonymity, with contemporary avant-garde theatre and the world of happenings, which had abandoned traditional performance venues to blend in with real life. Oldenburg, who had started out with happenings of a markedly theatrical and ornate character, moved on from the reconstruction of objects and food in *The Store* to their reproduction on an exaggerated scale and in shiny, vulgar colours drawn from the best tradition of the kitsch, in soft or bleakly stiff materials: from slices of cake to cigarette butts, from typewriters to sanitary appliances, from work tools to cosmetics. Wesselmann inserted images in settings made up of objects, always on a plane of extreme banalization. Painting among things, things in painting: his work was always located on the boundary between what the observer was accustomed to consider art and what he called "ordinary life". At another innovative venue, the Stable

Claes Oldenburg and Coosje van Bruggen
Balancing Tools
(detail), 1984
Steel painted with polyurethane enamel,
8 × 9 × 6,05 m
Vitra International AG, Weil am Rhein, Germany

373

"Business art is the step that comes after Art.
(…) After I did the thing called 'art' or whatever it's called, I went into business art."

Andy Warhol

Gallery, which shared the role of talent-scout with the Green Gallery, Robert Indiana showed large paintings conceived as signs, with harsh verbal inserts (*Eat*, *Die*), represented with a slickness of colour not unlike that of contemporary abstract painters like Ellsworth Kelly. After a solo exhibition at the Ferus in Los Angeles with faithful reproductions of Campbell soup cans, Andy Warhol made his New York debut at the same gallery, presenting enlargements and serial repetitions of common articles, such as Coca-Cola bottles, or silk-screened portraits of celebrities like Marilyn Monroe.

Towards the end of 1962, in the exhibition *New Realists*, Sidney Janis turned the relationship between Europe and the USA established by the earlier exhibition in Paris, based on an emphasis of the experimentalism and Dada implications of the new lines of research, on its head by showing a group of European artists like Arman, Christo (who not long before had presented a heap of cans at the Galerie J in Paris), Hains, Klein, Raysse, Spoerri, Tinguely, Enrico Baj, Rotella, Gianfranco Baruchello, the young Tano Festa and Mario Schifano, Peter Blake, John Latham, Peter Phillips and Öyvind Fahlström alongside Dine, Indiana, Lichtenstein, Oldenburg, Rosenquist,

Segal, Warhol, Wesselmann, Moskowitz, Wayne Thiebaud and others.

It was an exhibition that did not set out to establish affinities, but differences. European art tended to take an intellectual and critical approach. American Pop Art on the other hand worked on the plane of a monumental and detached emphasizing of the object and the imagery used by advertising, of a deliberate and extreme vulgarization of the practice, once considered noble, of art. The new works icily took icons of banality, representing them on a gigantic scale and assigning them commonsense values, without alienating them. They did not just use the image of mass communications, but even adopted its standards, indifferent to the effect of cold mortality that derived from this, under the gleaming and eye-catching appearance of the object, in painting. From the moment American Pop Art was given official status, with the exhibition *Pop Art USA* at the Oakland Art Museum in September 1963, it was clear that the aspect of parody and criticism typical of the European avant-garde had been transformed into a sort of impersonal recording of images, without emotions and without alterations of quality: they were what they were, they had nothing to communicate but their own existence, and the artist reproduced them while keeping the contribution of technical

skill, the "artistic" aspect, to a minimum, or even reducing it to the point of irrelevance. Whereas Dine and Segal, like Johns and Rauschenberg, still displayed a concern for a lucid redefinition of the creative attitude, what prevailed in the others was the strategy of utilizing the artistic context as a vehicle for the purely promotional amplification of a practice that fed on the same humus of stereotypes and language with a high degree of immediate comprehensibility as did the advertising industry. It is no coincidence that many critics have pointed out that Pop Art is the only one of the historic avant-garde movements to have been a success with the public and the media before being accepted by the experts and the world of art, and it was Lichtenstein who made it clear that "the things that I have apparently parodied I actually admire". Pop Art was the perfect art for pop culture, and pop culture, the straightforward one of the numerically dominant masses, can be recognized immediately. They loved these pictures because they loved their subjects, because they loved advertising and merchandise, or as Oldenburg would put it, "39 cents and 9.99 dollars".

Martial Raysse
Yellow Nude
(detail), 1964
Acrylic and oil on plywood,
96.5 × 130 cm
Luigi and Peppino Agrati
Collection

Pop artists brought to the rigours and purities of the art world a vitality that was vulgar and domineering but devoid of snobbism, and one which lucidly substituted for the "highbrow" American identity sought in Action Painting the mediocrity of the middle class, the slovenly pride of recognizing one's own cultural roots in a panorama of images of consumer goods. The genius who proved capable of grasping the more profound implications of pop culture was without question Warhol. His talent lay in not seeking to put any talent into the creation of works, but adapting the mechanisms of the star system, which dominated the culture of the masses, allowing them to dream, to the world of art. If Picasso, in the first half of the century, had succeeded in becoming the symbol of the historic avant-garde by virtue of his incomparable gifts, an unfailing cultural lucidity and a tireless prolificacy, Warhol deployed equal talent, equal lucidity and equal tenacity in becoming the most famous artist of the second half: in short he understood that, in the new culture, it was not a question of being regarded as the new Leonardo, but of becoming the new Marilyn Monroe, a living Coca-Cola. These had become the subjects of art because they were the new myths, of which the artist could make himself high priest, to the point of becoming a myth himself. Warhol's strategy, therefore, was to be recognized as an artist irrespective of the recognition of his artistic value and not as a consequence of it. If, he reasoned, a long and demanding apprenticeship with uncertain results in the end did nothing but admit the artist into the realm of the star system, as had happened to people like Picasso, Dalí and Miró, then why not adopt directly the methods of the marketing of image that governed that star system? And if the destiny of the works of great artists was to be turned into icons of an advertising type reproduced in millions of copies, as had happened to Leonardo's *Mona Lisa* or Picasso's *Guernica*, then you might as well make sure from the outset that this could take place as smoothly as possible, by choosing as subjects images that were already part of that world. It was Warhol who argued, with the genius of a copywriter, that the artist did not have to possess any technical ability, that he was wholly indifferent to the images he created, and that the only units of measurement of the value of art were the fame that it bestowed on its author, so that he was treated on a par with the stars of rock music or the movies, and its economic value, capable of guaranteeing the respect and appreciation of all. "Business art is the step that comes after Art", wrote Warhol. "After I did the thing called 'art' or whatever it's called, I went into business art." And if art had also been assigned an ethical value, that

of teaching or example or testimony, the new watchword would be amorality, indifference to any expectation that the work ought to carry a message. The artist gathered images from glossy magazines and articles from the supermarket in order to become a glossy image himself, a mass product whose trademark was the philosophy of the trademark itself. In this way the concept of a specific and autonomous value implicit in the practice of art was completely overturned. Everything was disvalue, in itself, and acquired quality only when it was capable of winning attention and publicity by worldly mechanisms. So the world of art was in turn a convention established and accepted from a purely sociological and media viewpoint: the difference between a Campbell soup can bought in a shop and a Campbell soup can signed by Warhol was a value assigned on the basis of parameters that took no account of its objective and conceptual nature, but only its social and conventional recognition. In fact that is exactly what happened. The MoMA straightaway bought works by Indiana, Warhol, Oldenburg, Wesselmann, Thiebaud and Marisol, and so did major collectors. Their prices rose quickly from a few hundred dollars to the 7,500 paid for a Rosenquist in 1963 (causing a stir in the press) and the 60,000 for a Warhol in 1970. This made news, making the art

of merchandise the perfect cultural commodity.

Other exponents of Pop Art, from Allan D'Arcangelo to Red Grooms, from Richard Lindner to Robert Watts, from Richard Artschwager to Alex Katz and from Chuck Close to Mel Ramos, achieved no less success and international fame than those of the early members of the movement. Naturally all this made American Pop Art very different from the otherwise similar experiences on the other side of the Atlantic. On the whole the great European Pop artists, from Hamilton to Jones and from Hockney to Schifano (the outstanding Italian talent of a generation that also included figures like Franco Angeli, Pino Pascali, Valerio Adami and Lucio Del Pezzo), did not renounce a quest for quality and above all for the specific value of the work of art. Pop, for them, was not an elimination of all qualitative and intellectual aspects from painting. Rather it was an evolution, and one that in any case did not want to turn its back on the history of art, and on the idea itself of art that tradition had handed down. Moreover in Europe it would be more the Neo-Dadaist current identified in Nouveau Réalisme, and the evolution of the work of the earlier Surrealists, that acted as a guiding thread for the new experiences.

379

Jasper Johns
1. *Flag*

Robert Rauschenberg
2. *Bed*

Following pages
Richard Hamilton
3. *Pin-up*

Roy Lichtenstein
4. *Girl with ball*

380

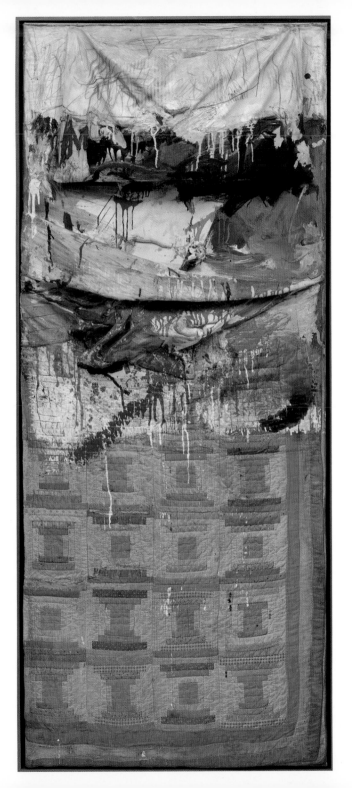

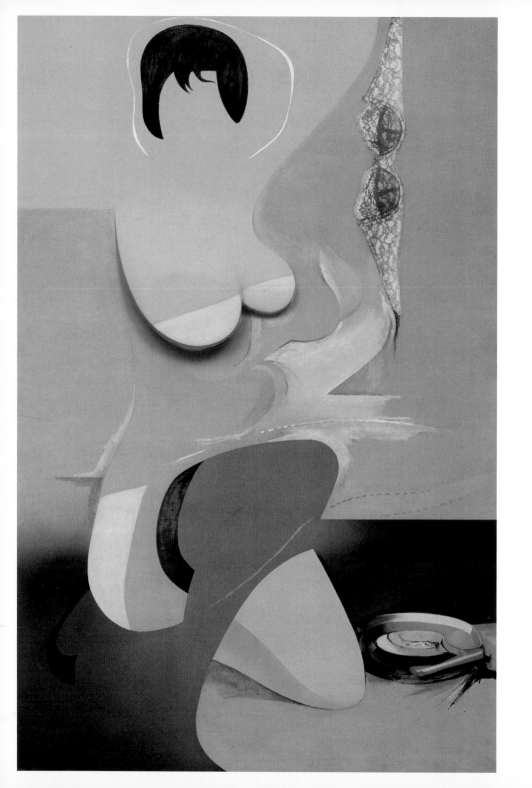

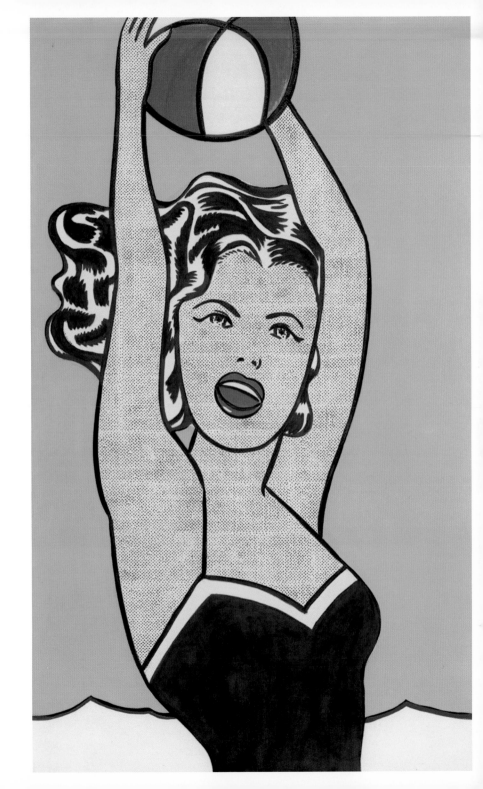

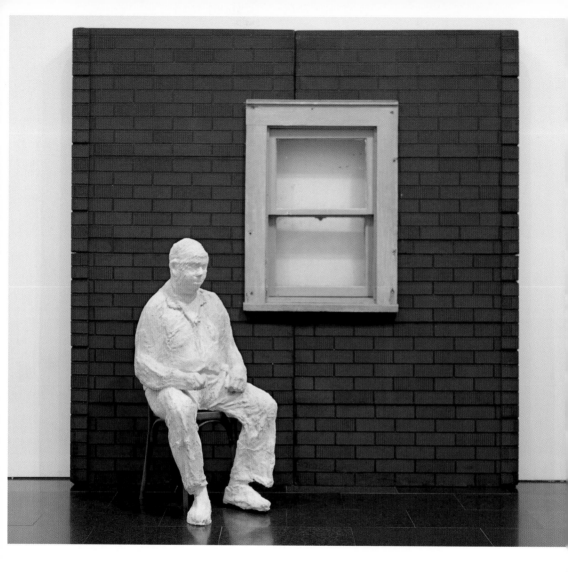

George Segal
5. *The Farm Worker*

Andy Warhol
6. *Four Marilyns*

Following pages
Robert Indiana
7. *Eat*

Robert Indiana
8. *Die*

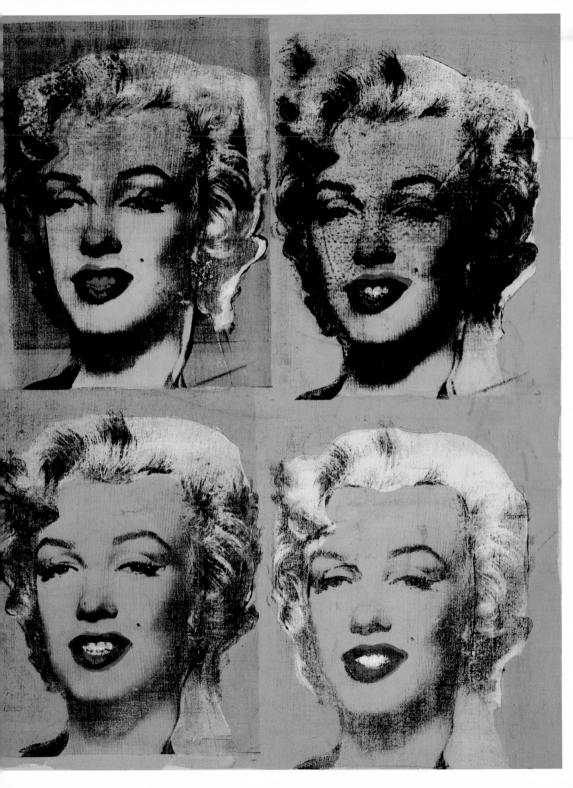

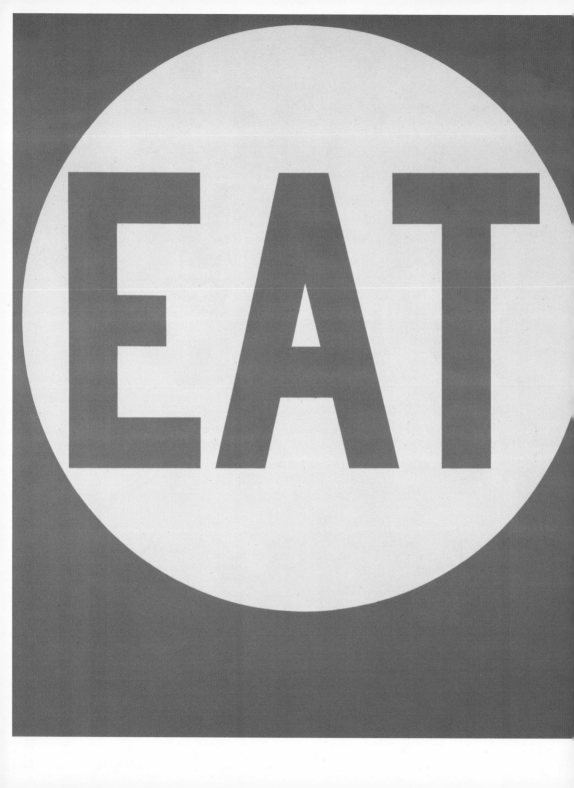

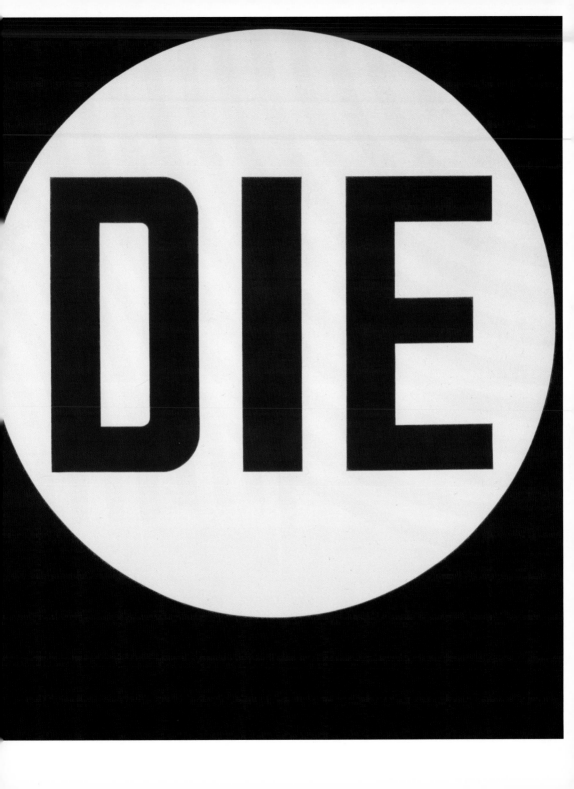

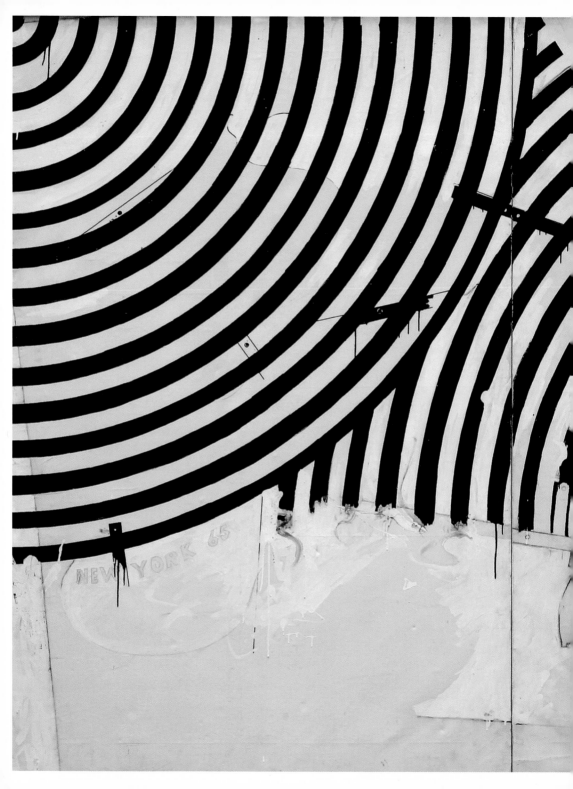

Mario Schifano
9. *L'inverno attraverso il museo*
(Winter through the Museum)

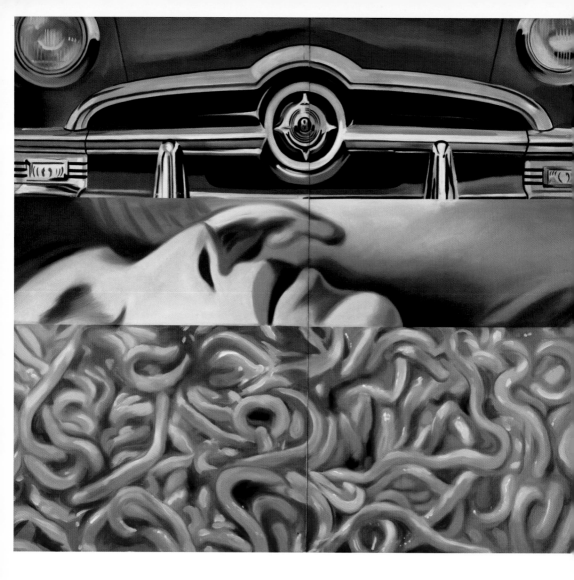

James Rosenquist
10. *I Love You with My Ford*

Pino Pascali
11. *Reconstruction of Whale*

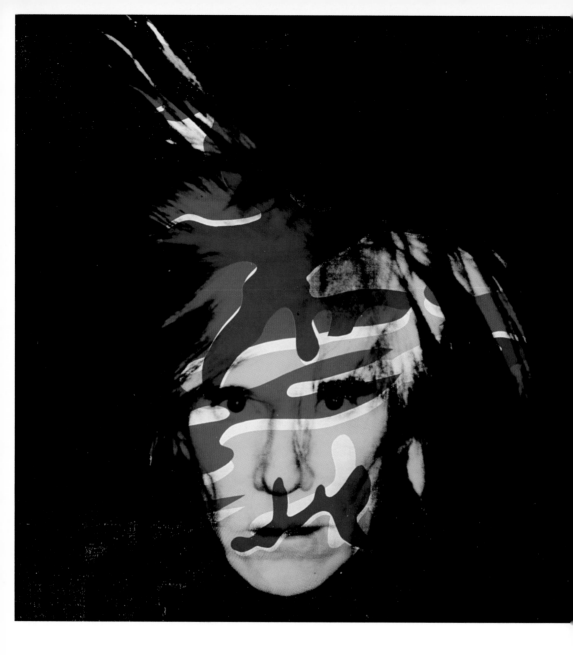

392

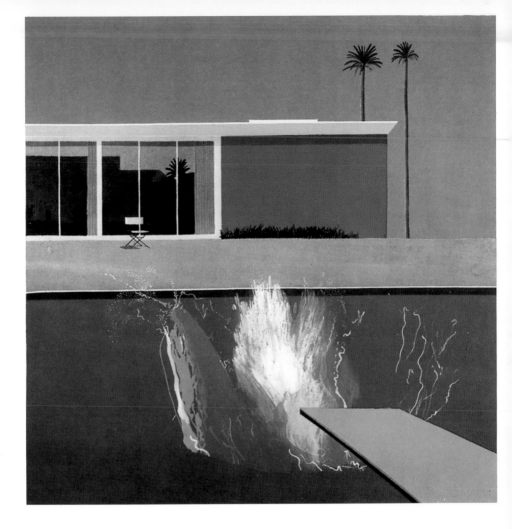

Andy Warhol
12. *Self-portrait*

David Hockney
13. *A Bigger Splash*

393

Minimalism

"What you see is what you see." This is how Frank Stella, in 1964, summed up the significance of his work, with the intention of stressing its profound difference from the intellectual implications of the European geometric and monochrome tradition. From the end of the fifties onwards he produced a series of pictures of large size in which a black ground was streaked by regular bands of uniform and inexpressive colour, almost emulating Jasper Johns' contemporary works representing flags and targets, on which he soon bestowed a shape that turned them into actual physical bodies holding a dialogue with the concrete setting in which they were displayed. Thus the separation between the illusionistic space within the work and the external one in which the observer is located was abolished for good, and any remaining expectation of representation overcome: the work was now a complete spatial object, whose prime quality lay in the fact that it established a set of relationships with the surrounding space and produced modifications of it.

Stella's painting was elementary, executed with indifference to technique, but above all it did not set out to represent anything but itself, its own, evident objectivity. It was a radical way of proposing a superseding of the European abstraction of the past, which through artists like Mondrian and Albers had profoundly influenced earlier generations in the United States, avoiding any implication of a mystical and philosophical type, any intention of producing a meaning that the observer would perceive as different from the pure physical and psychological experience of looking.

From the formal point of view Stella's paintings had direct precedents in those of the great masters of the previous generation, in particular Barnett Newman and Ad Reinhardt. Stella shared some of their other positions as well, commencing with a rejection of the intellectual complexity of the historical avant-garde and the conception of the work as an aesthetic object in its own right, whose values come from nothing but itself.

In a famous essay written in 1948 Newman had gone so far as to speak of the "sublime". In *Sublime is Now* he said: "We are reasserting man's natural desire for the exalted, for a concern with our relationship to the absolute emotions. (…) We are creating images whose reality is self evident and which are devoid of the props and crutches that evoke associations with outmoded images, both sublime and beautiful. We are freeing ourselves of the impediments of memory, association, nostalgia, legend, myth, or what have

"The one object of fifty years of abstract art is to present art-as-art and as nothing else, to make it into the one thing it is only, separating it and defining it more and more, making it purer and emptier, more absolute and more exclusive-non-objective, non-representational, non-figurative, non-imagist, non-expressionist, non-subjective."

Ad Reinhardt

you, that have been the devices of Western European painting. Instead of making cathedrals out of Christ, man, or 'life', we are making it out of ourselves, out of our own feelings. The image we produce is the self-evident one of revelation, real and concrete, that can be understood by anyone who will look at it without the nostalgic glasses of history."

For his part Reinhardt declared: "The one thing to say about art is that it is one thing. Art is art-as-art and everything else is everything else. Art-as-art is nothing but art. Art is not what is not art. (…) The one object of fifty years of abstract art is to present art-as-art and as nothing else, to make it into the one thing it is only, separating it and defining it more and more, making it purer and emptier, more absolute and more exclusive—non-objective, non-representational, non-figurative, non-imagist, non-expressionist, non-subjective."

In fact other artists, in parallel to Stella, were at that moment developing forms of painting in which the old abstract tradition was giving way to something that was described by Newman again in the following words: "I don't manipulate space. I declare it."

In 1953 Robert Rauschenberg had held an exhibition at the Stable Gallery in New York that consisted of completely white canvases in various groupings. John Cage, intellectual guru of the younger generations, had written a text for the show that alluded to the Dada origins of such works: "No subject/No image/No taste/No object/No beauty/No message/No talent/No technique (no why)/No idea/No intention/No art."

Agnes Martin held a solo exhibition at the Betty Parsons Gallery in New York in 1958 that was made up of pictures characterized by a minimal use of colour, traced in simple, repetitive, regular bands, without further subdivisions of space. At that time Martin was living in Coenties Slip, an area in Lower Manhattan, along with Robert Indiana, who was to become one of the leading exponents of a Pop Art with highly abstract connotations, and with Ellsworth Kelly and Jack Youngerman, geometric artists who had both spent time in Paris. Kelly in particular, influenced by Vantongerloo and Arp, had been working since the early fifties on essential geometric forms, assembling panels painted in a single flat and uniform colour into a theoretically unlimited combination of pictorial shapes. He started out by composing monochrome squares into images with a strong alternation of colours and then moved on to different geometries—rectangles, triangles, ovals

and portions of a circle, mostly painted in primary colours, in a variety of situations, because, as he put it, "the form of my painting is the content".

With Stella and Kelly the concept of the "shaped canvas", of a picture in which the colour did not represent anything but itself and which, as Newman put it, declared space, finally came to maturity. Between the late fifties and early sixties the paths of Robert Ryman, who was painting all white canvases with elementary and iterative brushstrokes, totally lacking in intention, and who soon began to use metal surfaces as a support, and his wife the scholar Lucy Lippard crossed with those of Dan Flavin, Eva Hesse, Sol LeWitt and Robert Mangold in the Bowery, another marginal district of New York where numerous artists had their studios: at that time some of them were employed at the MoMA. In 1963 the younger Brice Marden moved to New York too, coming into contact with the artistic milieu first as a guard at the Jewish Museum and then as Rauschenberg's assistant. It was out of the exchanges between the legacy

Dan Flavin
Untitled (To Don Judd, Colorist), 1987
30 coloured fluorescent lights,
137.2 × 121.92 × 10.2 cm (each; 5 elements)
Panza di Biumo Collection, Varese

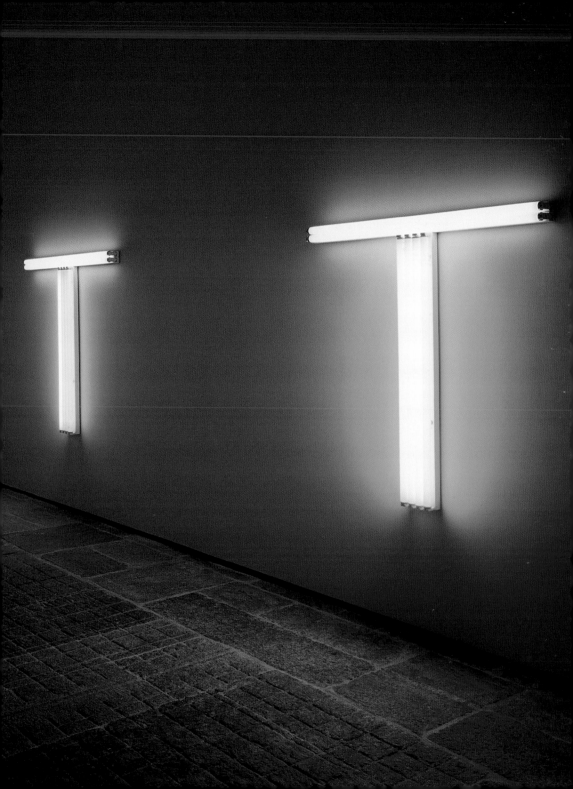

of geometric art and the post-Dadaist and Pop attitude, indifferent to any content and basically opposed to any aesthetic intent, that a climate emerged which soon came to be represented in exhibitions. The primary intellectual reference was, once again, the detached action of Duchamp, his conception of the artistic process as something wholly unexceptional, as an accident that started out from life and ordinary experience only to return to it, charged with lucid critical energy.

In 1964 the Los Angeles County Museum staged an exhibition of the works of Francis, Frankenthaler, Held, Kelly, Louis, Noland, Olitski, Stella and others, defined by the curator Clement Greenberg as "Post-Painterly Abstraction", a term in which the concept of "post-painterly" was a reference to its difference from the previous tradition of expression. More radical in his outlook, Lawrence Alloway used the term "Systemic Painting" for an exhibition at the Guggenheim in New York in 1966 that comprised works by Newman, Reinhardt, Held, Kelly, Martin, Baer, Stella, Ryman and Mangold, among others. The expression Minimal Art, which was later to predominate, made its appearance in January 1965 and in a quite different context: an article by the philosopher Richard Wollheim in *Arts Magazine* in

which he drew attention to the extreme reduction of artistic content in the works of artists like Reinhardt, Rauschenberg, Duchamp and Warhol. Thus it much more a reference to the artistic intent than to the technical form.

In 1966 another crucial exhibition was held, *Primary Structures* at the Jewish Museum. The same concept of elementary form without aesthetic and emotional implications had emerged in the field of the new American and British sculpture, in the works of artists like Andre, Bell, Caro, De Maria, Flavin, Judd, Kelly, King, LeWitt, Morris, Smithson and Tucker. Perhaps the most outstanding personality in this area was Donald Judd, who since the early sixties had been exploring the possibilities of plastic creations conceived as "specific objects", i.e. as spatial forms that did away with the difference between object and sculpture in the name of its own, elementary force. In his 1965 treatise *Specific Objects* Judd explained: "Actual space is intrinsically more powerful and specific than paint on a flat surface. Obviously, anything in three dimensions can be any shape, regular or irregular, and can have any relation to the wall, floor, ceiling, room, rooms or exterior or none at all. Any material can be used, as is or painted. A work needs only to be interesting. Most

400

works finally have one quality. In earlier art the complexity was displayed and built the quality. In recent painting the complexity was in the format and the few main shapes, which had been made according to various interests and problems. A painting by Newman is finally no simpler than one by Cézanne. In the three-dimensional work the whole thing is made according to complex purposes, and these are not scattered but asserted by one form. It isn't necessary for a work to have a lot of things to look at, to compare, to analyze one by one, to contemplate. The thing as a whole, its quality as a whole, is what is interesting."

Between 1963 and 1968, the year in which the movement was finally consecrated by the exhibition *Minimal Art*, organized by Lucy Lippard and Enno Develing at the Gemeentemuseum in The Hague, the research conducted by these artists reached its culmination. Donald Judd used materials like steel, aluminium, iron, Formica, Perspex and wood without any processing, and non-artistic technical procedures like industrial colouring: he did not intervene manually in the work, but designed it and had it made as if it were a mass-produced article, one that had to appear aesthetically indifferent, alienated, without offering the observer any kind of sensual gratification. He chose ordinary geometric structures like parallelepipeds and cubes, which he placed individually in the setting—on the floor, or on the wall—or arranged in regular rows or in progression, so as to turn the whole space into the location for a sort of highly distilled aesthetic experience, an experience of absoluteness that was moreover devoid of philosophical or metaphysical implications.

At *Primary Structures* he presented two rows of four cubes of polished steel set at regular distances, one running horizontally on the wall and the other on the floor. At the same exhibition Carl Andre showed a continuous rectilinear series of 183 bricks placed on edge on the floor, a line of physically ready-made modules that was heir to the constructions with industrial wooden elements he had been producing since the end of the fifties and forerunner of the flooring of square metal plates, treated in various ways, that was to characterize much of his later work. His position lay at an extreme of reduction in execution and form: "I believe that all ideas are the same up until the moment of execution. My executions are tests of my ideas rather than attempts at plastic virtuosity."

In many ways very similar to Andre's, the works of Sol LeWitt were primary structures *par excellence*. In this period

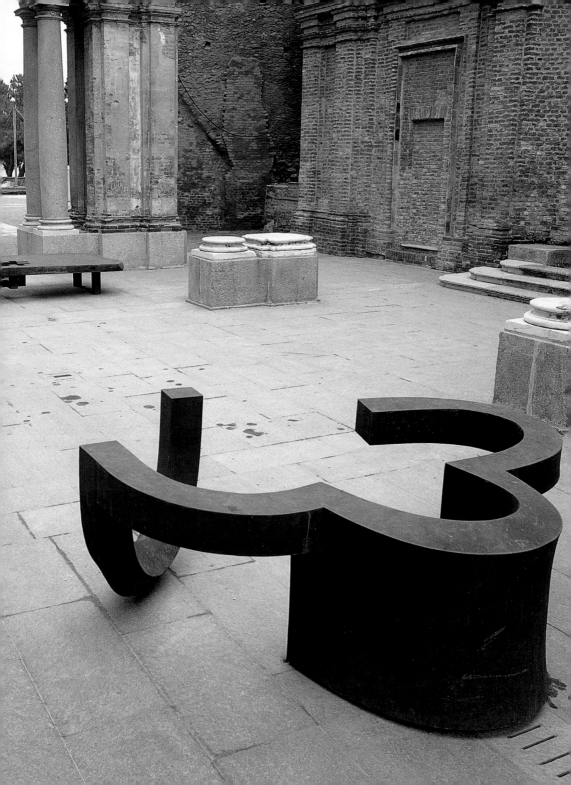

he explored all the possibilities of construction—by seriation, assembly and separation into parts, modularity, sequence, through drawings, murals, plastic structures—around the figure of the cube ("The idea of flatness of a plane evolves naturally in the three-dimensionality of the form which turns into mural structures, initially created with colour that advances and retreats, later just with black and white, and finally as independent pieces"), and in his 1967 article "Paragraphs on Conceptual Art" theorized a primacy of the concept that rendered the execution "a perfunctory affair". In his mature years LeWitt would progressively enunciate a richer repertory of geometric analyses, even echoing the lesson of the great frescoes of the 15th-century in his "wall-paintings".

Eduardo Chillida
Tolerance I
(in foreground), 1985-86
Luca Pacioli's Table
(in background), 1985-86
Installation
Courtesy Castello di Rivoli,
Rivoli

A stimulating relationship between immateriality of structure and capacity for aesthetic metamorphosis of space was attained by Dan Flavin, who concentrated his own activity on the use of fluorescent tubes in different colours.

While the pioneering works of an artist like Lucio Fontana, who in 1951 had set a huge whorl of shaped neon tubes on the ceiling of the Triennale in Milan, were aimed at realizing the utopian idea of "drawing without material", in pure light, dear to many of the avant-gardes and the subject of experiments like those of the photographer Gjon Mili, who among other things created images of Picasso painting with light, Flavin took the industrial fluorescent tube as a given form, a primary module whose implicitly geometric configuration could be organized in the physical setting in theoretically infinite ways. Starting with the homage to Constructivism implicit in the series of works, commenced in 1964, inspired by Tatlin's *Monument to the Third International*, Flavin created works that could be arranged in their setting in various ways, as well as installations that established a critical relationship with a specific physical space, in the sense of a structural comment, a contradiction, even a poetic metamorphosis through light. More complex, with respect to these artists, was the position of Robert Morris. For *Primary Structures* he created L-shaped structures made out of plywood and arranged in various ways in space, but on other occasions he conceived simple geometric shapes, again made of plywood and painted a

403

nondescript grey, that were characterized by very slight but decisive imperfections, such as a non-precise orthogonality, or mirrored cubes with an ambiguous physical presence. For him the question of the physical setting was crucial. In *Notes on Sculpture*, 1966, he wrote: "The object is but one of the terms in the newer aesthetic. It is in some way more reflexive because one's awareness of oneself existing in the same space as the work is stronger than in previous work, with its many internal relationships. One is more aware than before that he himself is establishing relationships as he apprehends the object from various positions and under varying conditions of light and spatial context. But the concerns now are for more control of and/or cooperation of the entire situation. The control is necessary if the variables of object, light, space, and body are to function. The object itself has not become less important. It has merely become less self-important."

Shortly afterwards, in a fundamental text written in 1968, Morris would move on to even more complex reflections on what he called anti-form, in which the attention was focused on the materials and on their autonomous ability to organize themselves into form. "But it is the a priori evaluation of the well constructed that determines the materials. The well-constructed form of the objects has preceded any consideration of the means. The materials themselves have been limited to those that realize the general object form in an efficient way": according to Morris, therefore, a new duality had been established between form and material.

It could be resolved if "a direct manipulation of a given material without the use of any tool is made. In these cases considerations of gravity become as important as those of space. Random piling, loose stacking, hanging, give passing form to the material. (…) Disengagement with preconceived enduring forms and orders for things is a positive assertion." So if the question was to seek a sort of absolute objectivity without relations, it should be explored in the physiology and the properties of the materials far more than in the concept of geometric form, in any case of rational and philosophical derivation: in the end it too, Morris understood, could be considered a way of imposing a pre-established value on the work from the outside.

This was the basis for his experiments with materials like felt, which were carried out alongside those of artists like Eva Hesse and Keith Sonnier, who in his light installations gave a physical interpretation of neon itself ("In actual

"(…) But the concerns now are for more control of and/or cooperation of the entire situation. The control is necessary if the variables of object, light, space, and body are to function. The object itself has not become less important. It has merely become less self-important."

Robert Morris

fact I'm attracted by neon because this is, literally, a trapped gas, a real colour not applied to a surface in the sense of paint, but a colour that bathes or fills its immediate surroundings in a natural way"), and above all Richard Serra. Starting out from experiments with anti-form, the latter evolved towards forms of macroscopic environmental intervention in which the opaque and threatening gravity of the material, predominantly untreated lead, steel and iron, became the prime constituent factor of the work. The sensation of exceptional weight, the lack of proportion with respect to the setting and the non-aesthetic roughness of the material, which was therefore used with a minimum of manipulation and without any metaphorical intent, were crucial characteristics of Serra's approach. "I think sculpture, if it has any potential at all, has the potential to create its own space, and to work in contradiction to the places and spaces where it is created. I am interested in work where the artist is a maker of 'anti-environment'": this how Serra explicitly disclaimed one of the risks that Minimal Art ran from the outset, that of turning into mere decoration.

Carl Andre
Untitled, 1984
Installation (on the floor)
Courtesy Castello di Rivoli, Rivoli

Marisa Merz
Untitled, 1984
Installation (on the walls)
Courtesy Castello di Rivoli, Rivoli

f Flavin could argue that "art is shedding its vaunted mystery for a common sense of keenly realized decoration", because "we are pressing downward toward no art—a mutual sense of psychologically indifferent decoration—a neutral pleasure of seeing known to everyone", with artists like Serra the work if anything rediscovered an antagonistic relationship with space, a form of aesthetic apprehension that, far from gratifying, placed itself at the opposite extreme of indifference. However, numerous other artists, in the United States and in Europe, profited from the rigorism of Minimal Art without accepting its aesthetic and theoretical indifference, making it the basis for further expressive experiences instead. This was the case, in the United States, with Mark di Suvero, whose large geometric structures in metal and wood were derived instead from the tradition of Constructivism and the example of David Smith, or with Joel Shapiro, who mediated the primary form with elementary figural evocations, or again with Fred Sandback, who experimented with geometric constructions that took the form of pure drawings in space, and Richard Nonas, author of remarkable environmental interventions based on archetypal forms, with anthropological implications.

In Europe the British school of sculpture represented by Philip King and William Tucker, who both showed at *Primary Structures*, offered a less rigid relationship with geometry and a dialogue with physical space open to explicitly aesthetic interventions: this was also characteristic of the work of Anthony Caro, the most important of the British artists of this generation. Since the end of the fifties there had been artists in Italy who were more tightly focused on an exploration of the premises of Minimalism, and above all on developments linked to a deeply physical understanding of materials and their characteristics and to the critical relationship with architecture. These included Francesco Lo Savio, Giuseppe Uncini and, in painting, Rodolfo Aricò, precocious in his use of the shaped canvas. And there were younger ones like Giuseppe Spagnulo and Mauro Staccioli: Spagnulo created large forms out of solid iron whose final form stemmed from a violent modification of the initial geometry; Staccioli worked systematically on the dimension of the environment, with large-scale geometric insertions that radically altered its perception. Not very distant from these lines of research, but concentrating more on the purity of the geometric definition of space, were the early works of Giulio Paolini and Luciano Fabro. In the German-speaking world it was above all artists like Ulrich Rückriem

and Reiner Ruthenbeck who, along with the Korean Lee Ufan, operated on a primary and quantitative understanding of materials. Positions strongly influenced by the American painting of artists like Newman and Ryman formed the basis for a line of research that, between the sixties and seventies, acted on a concept of simplified painting and elementary gestures and areas of colour.

The French artists Daniel Buren, Olivier Mosset and Michel Parmentier and the Swiss Niele Toroni started out from a purely conceptual attitude, creating "painted objects" from 1967 onwards that were characterized by iterative touches of colour, parallel monochrome bands and neutral cells of paint repeated *ad infinitum*, with a marked environmental component. In 1970 an exhibition was held at the ARC in Paris by another French group, Supports-Surfaces, which argued that painting was a completely real phenomenon, and that it was nothing but the *mise-en-scène* of the artist's physical work in time and space: the members of the group were Vincent Bioulès, Marc Devade, Daniel Dezeuze, Patrick Saytour, André Valensi and Claude Viallat, who were later joined by Noël Dolla, Louis Cane and others.

In Italy the related research carried out at the end of the sixties by figures like Giorgio Griffa, Claudio Olivieri and Marco Gastini led to the emergence of a situation which influenced Carlo Battaglia, Claudio Verna, Gianfranco Zappettini, Carmengloria Morales, Pino Pinelli and Diego Esposito, among others. Exhibitions like *Geplante Malerei* ("Planned Painting") at the Westfälischer Kunstverein in Münster, 1974, and *Documenta 6* at Kassel, 1977, marked out the boundaries of a research, defined as analytic or fundamental painting, that, in exchange with Minimalism and Conceptualism, overcame the expressive tradition of abstraction and involved, in addition to the artists cited, figures like Raimund Girke, Thomas Rajlich, Ulrich Erben, Imi Knoebel, Blinky Palermo, Winfried Gaul, Alan Charlton, Gotthard Graubner and Edda Renouf.

Barnett Newman
1. *Vir Heroicus Sublimis*

410

411

Barnett Newman
2. *Untitled*

Ad Reinhardt
3. *Abstract Painting*

Following pages
Frank Stella
4. *The Marriage of Reason
and Squalor, II*

413

416

Robert Ryman
5. *Winsor 6*

Ellsworth Kelly
6. *Colors for a Large Wall*

Sol LeWitt
7. Incomplete Open Cubes

418

Robert Morris
8. *Untitled*

Donald Judd
9. *Untitled*

420

421

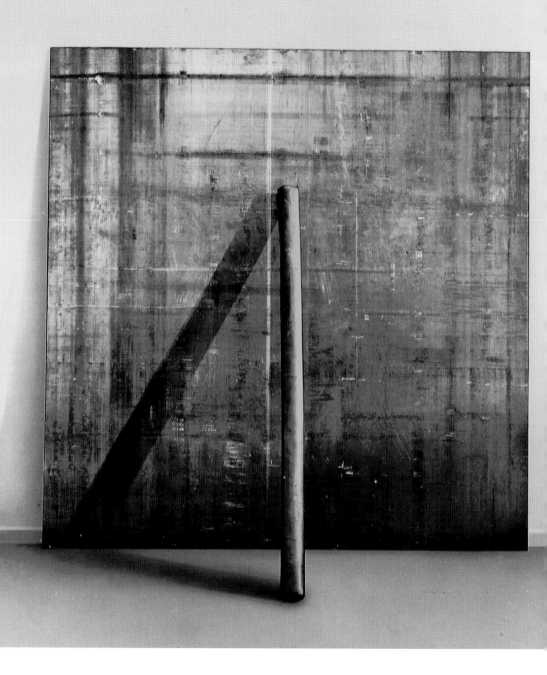

422

Richard Serra
10. *Floor Pole Prop*

Richard Serra
11. *House of Cards 1*

423

Brice Marden
12. *Tour III*

Robert Mangold
13. *1/4 V Series*

425

Conceptual Art
Arte Povera
Land Art

The middle years of the 1960s were characterized by two elements. The first was an increasingly marked intellectualization of the artistic process, in the wake of a reinterpretation of Duchamp in terms that were no longer paradoxical and playful, and of the work of John Cage, who had moved from his primary musical inspiration to the happening and to visual practice proper.

The second was a distinct political radicalization of the work, with an unequivocal rejection of the commercial trappings of art.

Among the artists working within this horizon were Joseph Beuys, author of performances and installations in which the political nature of the artistic action became paramount; Sigmar Polke, who in 1963 began his series of works *Kapitalistischen Realismus* ("Capitalistic Realism"); and Hans Haacke, who carried out uncompromising operations bordering on sociology. Beuys provided a link with the Fluxus network, which also expressed itself in openly political forms and in which artists like Nam June Paik and George Maciunas imparted a strong ideological value to their work.

It should be remembered that it was under the auspices of Fluxus that Jackson Mac Low and La Monte Young had published in 1963 their book entitled *An anthology of chance operations, concept art, anti-art, indeterminacy, improvisation, meaningless works, natural disasters, plans of action, stories, diagrams, music, poetry, essays, dance, constructions, compositions, mathematics*, precursor of many of the experiences to come.

In 1966 the exhibition *Eccentric Abstraction* in New York focused attention on an area of deviation from Minimalist rigorism embodied by Bourgeois, Hesse, Sonnier, Nauman and others.

But it was in 1967 that many signals came together to indicate a major shift. Publishing his "Paragraphs on Conceptual Art" in the magazine *Artforum*, Sol LeWitt took the implications of his reflection on art to an extreme, looking at art independently of the mechanisms of objectification that made it a physical expression. He wrote: "In conceptual art the idea or concept is the most important aspect of the work. When an artist uses a conceptual form of art, it means that all of the planning and decisions are made beforehand and the execution is a perfunctory affair. The idea becomes a machine that makes the art. This kind of art is not theoretical or illustrative of theories; it is intuitive, it is involved with all types of mental processes and it is purposeless. It is usually free from the dependence on the skill of the artist as a craftsman.

It is the objective of the artist who is concerned with conceptual art to make his work mentally interesting to the spectator, and therefore usually he would want it to become emotionally dry."

In this text the term conceptual was used for the first time to indicate a conscious artistic attitude, and exhibitions like *Art in Series* at Finch College in New York and *Serielle Formationen* ("Serial Formations") at Goethe University in Frankfurt documented the highly analytical character (an organization into series and a methodicalness which evoked that of the exact sciences were the most evident features) of the work of artists like Bochner, Darboven, Graham, LeWitt, Dibbets, Girke, Judd and Flavin, with perceptive references to Castellani and Manzoni.

In the same year exhibitions in Italy like *Contempl'azione* ("Contempl'action") in Turin, *Fuoco, immagine, terra, acqua* ("Fire, Image, Earth, Water") in Rome and *Arte Povera – Im spazio* ("Poor Art – Im Space") in Genoa presented the results of the research carried out by artists like Pascali, Kounellis, Pistoletto, Ceroli, Gilardi, Anselmo,

Michelangelo Pistoletto
Venus of the Rags, 1967
Photograph by Paolo
Pellion, Turin
Cement copy of classical
statue of Venus covered with
mica, rags, 130 × 40 × 45 cm
Castello di Rivoli, Rivoli
Giuliana and Tommaso
Setari Collection, Paris

Fabro, Boetti, Paolini, Zorio, Mattiacci, Icaro and others: the definition given to this area from the outset was that of Arte Povera.

At the *Salon de la Jeune Peinture* ("Exhibition of Young Artists") in Paris, Buren, Mosset, Parmentier and Toroni took a stance of radical rejection of painting as a profession and as an activity that involved manual skill and aesthetics, in favour of political interventions in the structures of art.

This was the beginning of a long period of promotion and proselytising in which the critical and organizational activity of the artists themselves, alongside that of critics, gallery owners and museum curators (who saw their own role as one of radical intellectual militancy), resulted in a long series of events that were extended from institutional venues to deliberately unusual settings in order to underline the congenital and vocational extraneousness of these attitudes to the institutional and commercial art system. Such actions were not, initially, aimed at the mass market and the public at large.

The new positions were antagonistic not so much to the taste and beliefs of the public, as had been the case with the historic avant-gardes, as to the institutional and economic machinery of the art world, unwilling

428

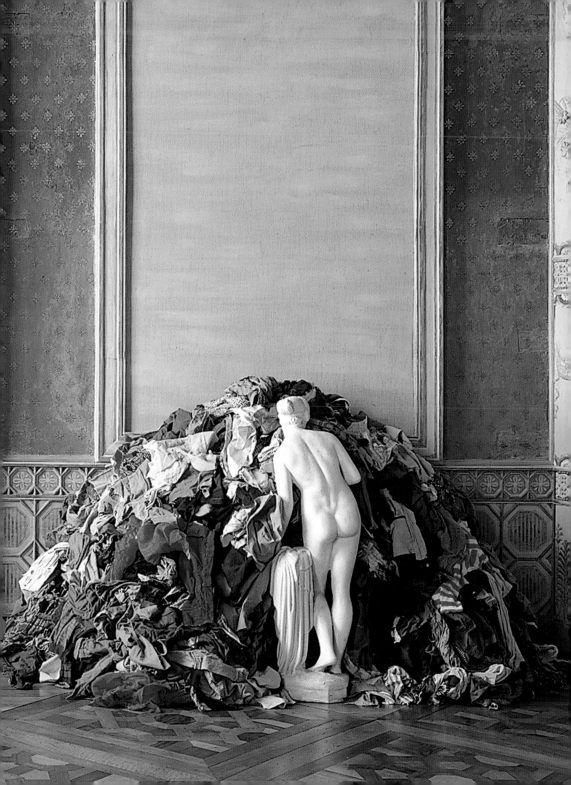

"Intuitions, inventions of instruments, explorations and revelations, questioning functions and systems, fixing
and inventing points, organizing signs, reinvigorating the faculties of perception, using the image to indicate other images, indicating yourself by images
through images, making images by exploiting potential intentions
and exploring the use of pre-existing, existing, imagined, imaginary instruments, made in the moment of making."

Gilberto Zorio

as they were to recognize its power to make decisions about questions of artistic quality, which inevitably translated into market values. For its part the public was bewildered by the fact that these operations could not be made to fit into the historic parameters of art forms, and at the same time by the impossibility of judging them in terms of taste and aesthetic harmony. On close examination, what Duchamp had provocatively achieved with his urinal (*Fountain*) in 1917, a thwarting of any attempt to judge the work of art on the basis of conventional criteria, was taken to an extreme here, although with the no less pertinent contraindication that an art based on purely intellectual notions was continually exposed to the risk of not being distinguishable from related operations on the plane of language, but based on extemporary ideas.

However, a number of other major public exhibitions guaranteed Conceptual Art the role of an authoritative interlocutor in the artistic debate. These included *557.087* at the Seattle Art Museum, *Op Losse Schroeven* at the Stedelijk in Amsterdam, *When Attitudes Become Form* at the Kunsthalle in Bern, *New Media: New Methods* at the MoMA of New York, all in 1969, and above all the gigantic *Documenta* show at Kassel in 1972, and marked the rapid acceptance of the new avant-gardes at the institutional level.

Attitude, method, process, concept and art-idea were recurrent terms in the approach to the variegated spectrum of experiences underway: however, it was an approach that, in view of the tendency of the critics and the artistic milieu to schematize things by drawing permanent circles around groups of authors and defining every movement in terms of a technical superseding of the previous ones, generated considerable ambiguity.

While such distant figures as Judd and LeWitt had been lumped under Minimal Art on the basis of similarities that were after all quite superficial, even cruder categorizations were now being made in a field in which each individual artist followed an intellectual path all of his own, and resorted to means of expression that differed greatly from one another. To the area more properly called conceptual on the basis of LeWitt's essay were ascribed figures that took the full and ostentatious mental experimentation of the original Fluxus movement, modelled in part on the work of artists like Klein and Manzoni, in the direction of a pure analysis of the structure and conventions of the notion of art. An example was Joseph Kosuth, who

had been investigating the relationship between visual phenomena and their verbal definition since the mid-sixties, making use of techniques of exemplification in which meaninglessness, randomness and tautology played a dominant part.

In his most typical works an object, its photograph and its dictionary definition were juxtaposed to indicate different moments of codification of the same visual and verbal experience. Mel Bochner, an artist-critic very close to LeWitt, worked on such logical models as measurements, numerical series and geometrical proportions. Hanne Darboven also adopted a coded model, that of the numeration of the written page, of the idea of writing or enumerating as physical measurement of time and space.

The infinite numerical series lay at the base of the work of Roman Opalka, who in 1965 began to fill large canvases and small sheets of paper with the numbers from one to infinity, starting each time from where the last one had left off in a process that will come to an end at the time of his death, and the in some ways similar project of On Kawara, who summed up the conventional reckoning of time and space in the mammoth work *One Million Years* and in a series of works in which he reproduced dates, times and geographical locations in the same cold manner.

The group Art & Language, set up in 1968 on the initiative of Terry Atkinson, Michael Baldwin and others, operated on a plane more typically attentive to language, and close to Kosuth. It assumed a theoretical-philosophical attitude with interventions that mostly used the medium of publishing, commencing with the magazine of the same name. Written declarations and documentary photos were the preferred material of a large number of Conceptual artists, from Barry to Weiner and from Graham to Ramsden, following a model whose precedents lay in Fluxus publishing, in isolated figures like Jiří Kolář, who had reinvented the collage in terms of a critical exercise on the image, and in the books of Ruscha and Rot. An extreme case was that of Bernd and Hilla Becher, among the few authentic interpreters of a Conceptual Art based solely on photography: their aseptic and unemotional pictures of industrial buildings paved the way for new generations of artists who concentrated on the medium of photography.

In Italy, it was artists like Giulio Paolini, Luciano Fabro and Vincenzo Agnetti who in different ways marked out the at once analytical and inventive approach to conventional codes of meaning.

The insubstantiality and unknowability of the image outside the complex web of cultural mediations and their related

"One's mind and the earth are in a constant state of erosion (…). The entire body is pulled into the cerebral sediment, where particles and fragments make themselves known as solid consciousness. A bleached and fractured world surrounds the artist. To organize this mess of corrosion into patterns, grids, and subdivisions is an aesthetic process that has scarcely been touched."

Robert Smithson

stereotypes were at the root of the whole of the research carried out by Paolini, who at the same time used codes of graphic representation like perspective, original or reproduced photographic images and plaster casts of ancient works in a critical manner, all in a continual play of mirrors between authenticity and artificiality of the image.

In the middle of the sixties Fabro embarked on a long work of reinstatement of symbolic values to stereotyped images, through complex processes of estrangement, commencing with the outline of Italy as it has been fixed in our imagination by geography books.

Eva Hesse
C-Clamp Blues, 1965
Mixed media on canvas,
65 × 55 cm
The Estate of Eva Hesse
Courtesy Robert Miller
Gallery, New York

Originally a critic, Agnetti's work was characterized by a paradoxical and poetic invention rooted in an extreme interpretation of literary and visual codes: in 1968 he created the *Macchina drogata* (*Drugged machine*), a calculator with letters instead of numbers; in 1969 he created the *Libro dimenticato a memoria* (*Book Forgotten by Heart*), a book with an empty space in the part intended for the text, and published *Ciclostile 1* (*Cyclostyle 1*), the project for an exhibition solely of ideas.

Valid for all these practices is the synthesis put forward by two militant critics, Lucy Lippard and John Chandler, in their fundamental essay "The Dematerialization of Art", published in 1968 in the magazine *Art International*: "The artist-thinker, not subject to any of the limitations of the artist-faber, can plan an imaginary and utopian art that is no less art than concrete works. There are many precedents for this kind of dematerialized art in architecture: Wright's mile-high skyscraper is no less art for not having had a concrete expression. Moreover, since art—as idea—cannot be sold, this denies economic materialism along with physical materialism."

Paolini and Fabro were among the protagonists of the exhibition *Arte Povera – Im spazio*, which formed the basis for the more wide-ranging book *Arte Povera* edited by Germano Celant in 1969, in which Italian artists were associated with others working in the conceptual and environmental field, like Beuys, De Maria, Dibbets, Haacke, Heizer, Hesse, Huebler, Kosuth, Long, Morris, Nauman, Oppenheim, Serra, Smithson, Sonnier, van Elk and Weiner. Mental energy, along with the assumption of materials, objects, forms and their transfiguration in a subjective sense, in accordance with a complex web of references that included

Fontana, Klein and Manzoni and even extended to the intriguing stagecraft of experimenters like Jerzy Grotowski (who published *Towards a Poor Theatre* in 1968), was at the base of these practices, which differed greatly from one another. Piero Gilardi worked on the plane of the absolute mediacy of the artificial with respect to presumptions of naturalness in his *Nature Carpets*, illusionistic reproductions of natural phenomena in foam rubber.

Also operating on a level of fervid iconographic ambiguity were artists like Alighiero Boetti, who developed processes of invention in which the conception and formalization of the work was also located on a plane of paradoxical straining of codes; Pino Pascali, who relied more on the iconographic estrangement of Pop Art; Michelangelo Pistoletto, the creator of photographic reproductions on mirrored surfaces that functioned on the boundary between representation and illusion, and who in the *Venus of the Rags* contrasted the classical idea of beauty with a heap of rags; and above all Kounellis, the most attentive to the theatricalization of experience and to a subjective and vaguely mythical use of materials, focusing on their symbolic implications and on those of forms.

Bernd and Hilla Becher
Ryhope Colliery, Sunderland, England, 1968
Courtesy Castello di Rivoli, Rivoli

Mario Merz, who had already been active in the second generation of the Italian Informel, brought about an extraordinary synthesis between structural and spatial archetypes, such as the igloo and the spiral, logical codes, like the Fibonacci series and the geometric progression, and a wholly creative, never didactic, use of objects and conditions characteristic of the materials adopted, from glass to fat, from fruit to newspapers. He wrote: "Arte Povera (they say) has lifted materials from commerce and from their manufacturing and technological destiny to that of representing an artistic idea, has destroyed or simply obscured a certain small quantity of supports in order to give the support back the pregnant value of destiny in the broad sense. For example it has removed the frame as a support so as to give value to the more elementary, but also more complex support of the statics of the floor, the statics of the field or the vertical statics of the brick, stone or concrete wall. It has been hung from beams or from trees. These alternative destinies-supports have allowed art to be freed from fixed programmes, not in order to create new

436

"The artist-thinker, not subject to any of the limitations of the artist-faber, can plan an imaginary and utopian art that is no less art than concrete works. There are many precedents for this kind of dematerialized art in architecture: Wright's mile-high skyscraper is no less art for not having had a concrete expression. Moreover, since art—as idea—cannot be sold, this denies economic materialism along with physical materialism."

Lucy Lippard and John Chandler

iconographies, but to liberate the sentiment of the art as a probe into different and contrasting realities rather than to enclose art or nail it down to traditional supports, and thus retrieving for art the values of relationships with iconographies or between iconographies. One cannot speak of relations between Expressionisms, Goya, pre-Raphaelite and Fauvist iconographies, etc. etc.

This would-be sense of novelty does not safeguard art, does not make it fan out, but gives it the capacity to become every now and then a sounding of reality, objects and languages intended for other values, or other types of interpretation. For example Conceptual Art is a probing into printed words, luminous scripts or notes written in rapid, instinctive, nervous calligraphy. Objects or natures very far from being art, or supports for art, find acceptance in the new art."

Working on a plane of greater attention to an abstraction of space and the physical properties of matter, in its processes of manifestation and formation, were artists like Eliseo Mattiacci, who constructed plastic structures in a sort of visionary mechanics, and Gilberto Zorio, who configured explicit processes of mutation of energy into the form of physico-chemical processes and who concentrated on conventional forms with a high symbolic value like the star, the javelin and the crucible. "Intuitions, inventions of instruments, explorations and revelations, questioning functions and systems, fixing and inventing points, organizing signs, reinvigorating the faculties of perception, using the image to indicate other images, indicating yourself by images through images, making images by exploiting potential intentions and exploring the use of pre-existing, existing, imagined, imaginary instruments, made in the moment of making" is how Zorio put it.

Alongside them acted a group that was no less experienced on the plane of inventive lucidity and which included Giovanni Anselmo, who worked on natural elements like chips of stone to bring out their inner energy on the practical and symbolic level; Giuseppe Penone, who intervened with thought-provoking modifications of our idea of nature; and Pier Paolo Calzolari, who used dull and non-aesthetic materials, especially lead, in installations of sombre allusiveness.

The characteristic feature of many of these experiences was that they were not limited to a detached and controlled, demonstrative practice, but triggered subtle phenomena of non-definable creative depth, with heavy accents of subjective mythology, of introverted individual narrative.

439

While the background to these developments, which were predominantly European, was the philosophical heritage of art and its relationship with the world, in the United States the pragmatism that had characterized the approach to art since the fifties persisted. If the concepts of reality, nature, mimesis, form, structure, material and process were all part of the analytical game played by Europeans, the post-Minimalist generation in America started out from the values of the daily nature of experience. It is in this sense that we can interpret such macroscopic and spectacular manifestations as those of Land Art.

The disproportionate size of the artistic sign and its force within a web of interpretation not guaranteed by the artistic code but fully involved with reality and nature had already been characteristic of happenings and certain aspects of Pop Art. The extension of the artistic field to the physical panorama itself, with the purity of its accidental being and with the only parameter represented by the horizon, was nothing but the consequence of an attitude that was intended to be a direct intersection between art and life, without reductive mediations. The *Earthworks* exhibition that was held in New York in 1968 presented arbitrary modifications of natural locations carried out by Andre, Bayer, Heizer, Kaltenbach, De Maria, Morris, Oldenburg, Oppenheim, Smithson and LeWitt, documented photographically but theoretically visitable *in situ*. It was the *Land Art* exhibition of 1969, in Cologne, that gave this area of research its name. Among the works symbolic of this current are Dennis Oppenheim's *Annual Rings* (1968), traced in the snow; Michael Heizer's violent alterations of the landscape, such as *Double Negative*, a trench cut into the Nevada desert in 1969-70; Robert Smithson's *Spiral Jetty*, a huge spiral of earth constructed in the Great Salt Lake, Utah, in 1970; and Walter De Maria's *The Lightning Field*, a grid of lightning conductors built in New Mexico in 1977. The mental aspect of these operations is clearly explained by Smithson, the most theoretical member of the group. In 1968 he wrote: "The earth's surface and the figments of the mind have a way of disintegrating into discrete regions of art. Various agents, both fictional and real, somehow trade places with each other—one cannot avoid muddy thinking when it comes to earth projects, or what I will call 'abstract geology'. One's mind and the earth are in a constant state of erosion, mental rivers wear away abstract banks,

brain waves undermine cliffs of thought, ideas decompose into stones of unknowing, and conceptual crystallizations break apart into deposits of gritty reason. Vast moving faculties occur in this geological miasma, and they move in the most physical way. This movement seems motionless, yet it crushes the landscape of logic under glacial reveries. This slow flowage makes one conscious of the turbidity of thinking. Slump, debris slides, avalanches all take place within the cracking limits of the brain. The entire body is pulled into the cerebral sediment, where particles and fragments make themselves known as solid consciousness. A bleached and fractured world surrounds the artist. To organize this mess of corrosion into patterns, grids, and subdivisions is an aesthetic process that has scarcely been touched."

These operations should be seen in association with those of European artists like Richard Long or Hamish Fulton, for whom the relationship with the territory was more of an autobiographical projection of the journey, of a space-time-place experienced subjectively, or Jan Dibbets, who took the horizon as parameter of an analytical investigation of physical space. But it was Christo, a protagonist of the earlier adventure of Nouveau Réalisme, who passed from macroscopic undertakings of temporary aesthetic intervention in the territory (an example is *Running Fence*, 1972-76, a long line of cloth stretching for about thirty miles through California, as far as the sea), to dimensions so large that each operation became a true epic that lasted for years. Moving from the wrapping of objects to that of natural features and above all urban buildings, he created a contradiction between the vast scale of each of his operations and its immediate perishability: "Is art immortal? Is art forever? Is building things in gold and silver and stones to be remembered forever? It is a kind of naiveté and arrogance to think that this thing stays forever, for eternity. It probably takes greater courage to go away than to stay. All these projects have this strong dimension of missing, of self-effacement, that they will go away, like our childhood. Our life. They create a tremendous intensity when they are there for a few days." These are different but not inconsistent examples of the expanded understanding of art, of its manifestation as continual definition and phenomenal experimentation, that was, above and beyond any reductive and laboured categorization, the authentic and vital aspect of that moment.

Joseph Beuys
1. *Eurasia Siberian Symphony*
1963

Giovanni Anselmo
2. *Torsion*

442

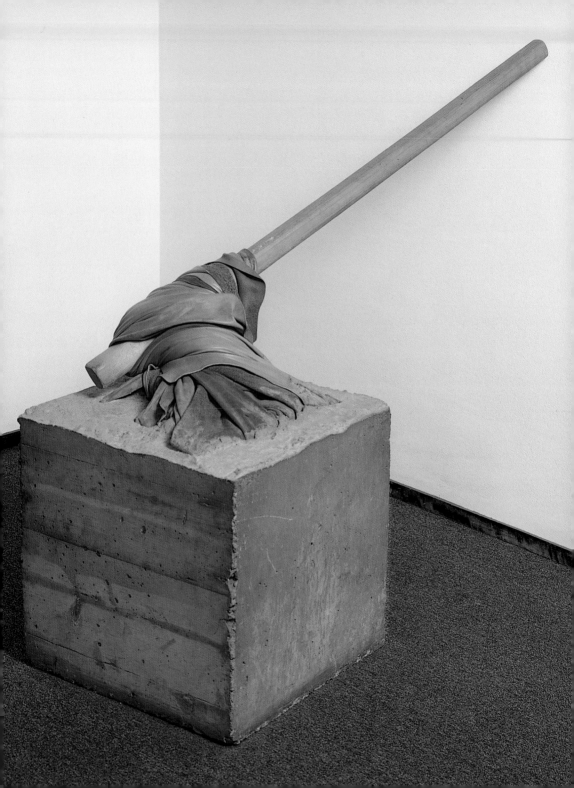

U.S.A. SURPASSES ALL THE GENOCIDE RECORDS

KUBLAI KHAN MASSACRES 10% IN NEAR EAS

SPAIN MASSACRES 10% OF AMERICAN INDIAN

JOSEPH STALIN MASSACRES 5% OF RUSSIAN

NAZIS MASSACRE 5% OF OCCUPIED EUROPEANS AND 75% OF EUROPEAN JEW

U.S.A. MASSACRES 6.5% OF SOUTH VIETNAMESE & 75% OF AMERICAN INDIAN

FOR CALCULATIONS & REFERENCES WRITE TO: P.O. BOX 180, NEW YORK, N.Y. 1001

George Maciunas
3. *USA Surpasses
All the Genocide Records!*

Joseph Kosuth
4. *Art as Idea: Nothing*

444

noth-ing (nuth′ing). [Orig. two words, *no thing*.] **I.** *n.* No thing, not anything, or naught (as, to see, do, or say *nothing*; "I opened wide the door: Darkness there, and *nothing* more!" Poe's "Raven"); no part, share, or trace (*of*: as, the place shows *nothing* of its former magnificence; there is *nothing* of his father about him); also, that which is non-existent (as, to create a world out of *nothing*; to reduce something to *nothing*, as by a process of extinction or annihilation); also, something of no importance or significance (as, "Gratiano speaks an infinite deal of *nothing*," Shakspere's "Merchant of Venice," i. 1. 114; "The defeat itself was *nothing* . . . but the death of the Prince was a blow," Besant's "Coligny," ix.); a trifling action, matter, circumstance, or thing; a trivial remark (as, "In pompous *nothings* on his side, and civil assents on that of his cousins, their time passed": Jane Austen's "Pride and Prejudice," xv.); a person of no importance, or a nobody or nonentity; in *arith.*, that which is without quantity or magnitude; also, a cipher or naught (0).

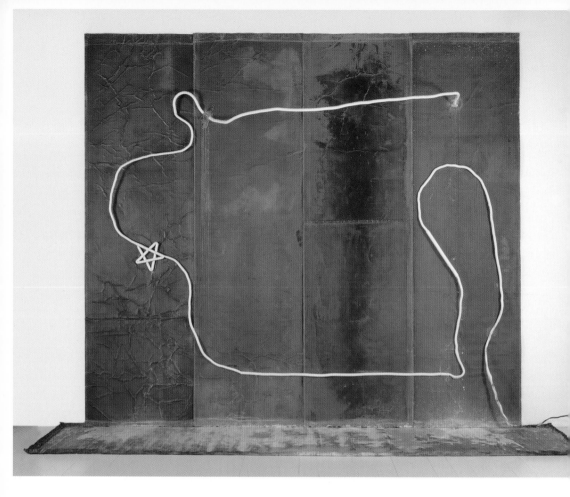

Pier Paolo Calzolari
5. *Horoscope
as Plan of My Life*

Bruce Nauman
6. *Light Trap for Henry Moore,
No. 1*

Mario Merz
7. *Objet cache-toi*
(*Object, Hide Yourself*)

Jannis Kounellis
8. *Untitled*

448

Giuseppe Penone
9. *Breath of Clay H*
Respirare l'ombra
(*Breathing the Shadow*)

Alighiero Boetti
10. *Map*

Following pages
Gilberto Zorio
11. *Macchia III* (*Stain III*)

Luciano Fabro
12. *L'Italia d'oro*
(*Golden Italy*)

450

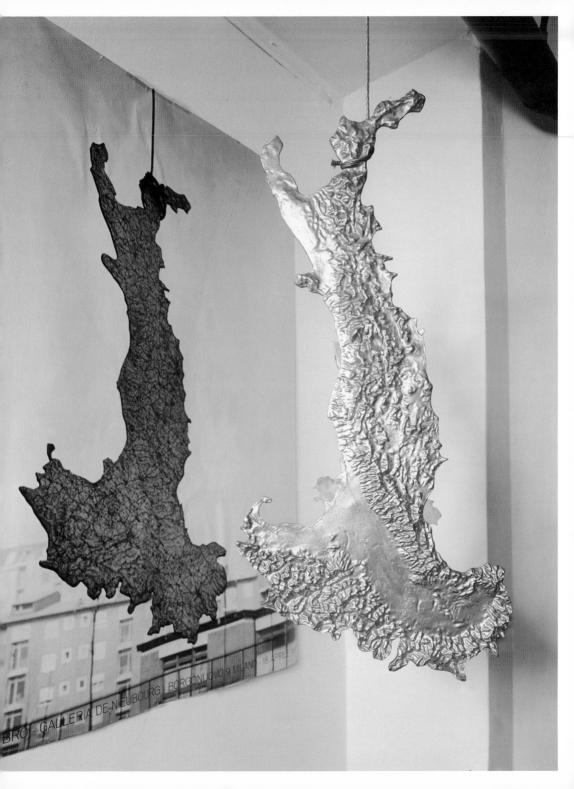

Walter De Maria
13. *The Lightning Field*

Christo e Jeanne-Claude
14. *Running Fence. Sonoma
and Marin Counties, California*

Performance
Body Art

During his time in Paris Filippo Tommaso Marinetti not only published the "Manifesto of Futurism" but also, a couple of months later, in April 1909, staged the play *Roi Bombance* at the Théâtre de l'Œuvre: this was the same theatre where Alfred Jarry's *Ubu Roi* had first been performed, in 1896. Both were provocative forms of drama, drawing on models that ranged from the variety show to children's and puppet theatre, and marked the first stage in the incubation of a lively relationship between visual art and performing arts. A few months later, on 12 January 1910, the first in a long series of Futurist soirées was held at the Politeama Rossetti in Trieste. These were public spectacles in which those on stage explicitly set out to provoke the audience, in name of the notoriety that the Futurists were constantly seeking through scandal. This is how Alberto Viviani described the Futurist soirée held at the Teatro Verdi in Florence in 1913, in which Marinetti, Cangiullo, Boccioni, Carrà, Soffici, Papini, Tavolato and Scarpelli took part: "Now I will say for once and for all that as soon as our friends were on stage and the lights were lit the noise turned into a truly savage and frightening roar that did not slacken its passion and its intensity for a moment. In short something like the boric-acid fumaroles of Larderello accompanied by trumpets and cymbals.

At the same time an abundant and well-aimed barrage of potatoes, carrots, enormous onions, asafoetida, anchovies, eggs, apples, pasta, electric light bulbs, chickpeas and other things began to rain from the stalls, boxes and gallery. Halfway through the evening Marinetti was struck by a potato that gave him a large and painful black eye. Cangiullo on the other hand, who until then had maintained his sly air of a placid Neapolitan, had a wonderful outburst: he ran to the edge of the stage and with great passion started to throw the vegetable projectiles back into the stalls, accompanying them with a string of words that were anything but flattering and modest, in pure Neapolitan dialect." Music, declamations of poems, reading of manifestos, pantomimes, dances. An antagonistic relationship with the audience, that was drawn in and played an active part, whether it was aware of it or not, in the performance. Futurism, with the works of Anton Giulio Bragaglia, also paved the way for the use of photographs as a dynamic record of actions, in the same way as pioneers like Eadweard Muybridge and Étienne-Jules Marey had done, and for a theatre that was profoundly renewed from the experimental point of view, as in Fortunato Depero's *Balli Plastici*, performed with puppets. In 1917 Marinetti published his "Manifesto of Futurist Dance", in which

he cited models like Isadora Duncan, Loie Fuller and Diaghilev. The latter was one of the bridges between Futurism and the Russian avant-garde: his Ballets Russes, long active in Paris and elsewhere in Europe, attempted an extreme synthesis between scenery, costumes and choreography in the service of the new music, while back in Russia experiments like Alexei Kruchenykh's "opera" *Victory over the Sun*, staged in collaboration with Matyushin and Malevich in 1913 and, after the revolution, the choreographies of Nikolai Foregger and the theatre of Vladimir Mayakovsky and Vsevolod Meyerhold aimed to create a sort of pure aesthetic experience of the human body and its movements as such.

Anton Giulio Bragaglia
Thais, 1916
Black-and-white photograph, 17.8 × 23.1 cm
Galleria Civica, Modena
Fondo Franco Fontana

"Our age", wrote Aleksei Sidorov in 1923, "is the time of movement. In the tempestuous rhythm of city life, of the culture of machines, of all the spiritual watersheds and social changes, there is a continual call to dance, to practise sport, to go to the cinema. Dance in its essence is the artistic organization of physical culture."

From Dadaism onwards many of these models were adopted in the practices of the avant-garde. At the Cabaret Voltaire,

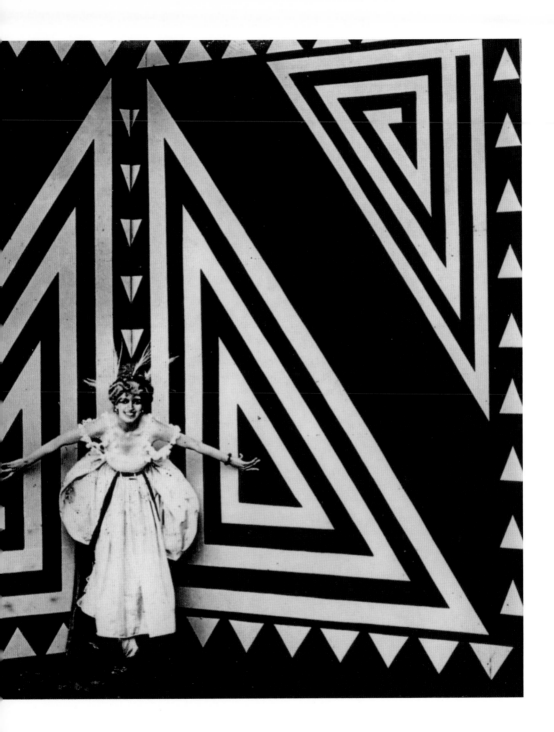

459

"The idea of performances in the early seventies, especially my own, was that they should not be repeated. In those times, you had to stick rigidly to the concept: no repetition, no rehearsal and no pre-arranged ending."

Marina Abramović

where Sophie Taeuber and Mary Wigman made the most of their gifts as choreographers, the soirées echoed those of the Futurists. In the words of Hans Arp: "On the stage of a gaudy, motley, overcrowded tavern there are several weird and peculiar figures representing Tzara, Janco, Ball, Huelsenbeck, Madame Hennings, and your humble servant. Total pandemonium. The people around us are shouting, laughing, and gesticulating. Our replies are sighs of love, volleys of hiccups, poems, moos and miaowing of medieval *Bruitists*. Tzara is wiggling his behind like the belly of an oriental dancer. Janco is playing an invisible violin and bowing and scraping. Madame Hennings, with a Madonna face, is doing the splits. Huelsenbeck is banging away non-stop on the great drum, with Ball accompanying him on the piano, pale as a chalky ghost. We are given the honorary title of Nihilists."

These events alternated with a series of experiments with the body. In 1919 Duchamp had a star shaved on his head and dressed up as Rrose Sélavy for Man Ray's photos: from the photomontages of Hannah Höch, John Heartfield and Max Ernst to multiple exposures, and from carefully staged poses to an obsessive investigation of the portrait and the self-portrait, the relationship between body and identity was subjected to an intense exploration within the horizon of Dada and Surrealism, with the latter carrying out extensive experiments in the area of the cinema as well. On the musical plane, then, a crucial development was Kurt Schwitters' *Ursonate*, which the artist began to work on in 1923. Emulating the phonetic poems of Raoul Hausmann, he composed a genuine sonata for solo voice using meaningless words, which he performed himself. The goal of a total performance was attained in 1924 with *Relâche*, a ballet/pantomime by Francis Picabia that was staged in Paris by the Ballets Suédois on 28 November 1924, with music by Erik Satie. The intermezzo between the two acts consisted of a screening of René Clair's film *Entr'acte*, which Picabia summed up in a note as follows: "Boxing attack by white gloves, on a black screen. Game of chess between Duchamp and Man Ray. Jet of water handled by Picabia sweeping away the game. Juggler and Father Lacolique. Huntsman firing at an ostrich egg on a fountain; a dove comes out of the egg and lands on the huntsman's head; a second huntsman, firing at it, kills the first huntsman: he falls, the bird flies away. Twenty-one people lying on their backs, showing the soles of their feet. Dancer on a transparent mirror, filmed from beneath. Blowing-up of rubber balloons and screens, on which figures will be drawn, accompanied by inscriptions.

461

A funeral hearse drawn by a camel, etc."
In the same years Oskar Schlemmer, a
protagonist of the German avant-garde
who was associated with the Bauhaus,
worked on an "abstract" theatre in which
the movements of the body were
replaced by the mechanical ones of
paradoxical body-puppets. While Sophie
Taeuber had used actual marionettes in
Carlo Gozzi's *Re Cervo*, 1918, in his
Triadische Ballet, staged in 1922,
Schlemmer focused
on the study of human
movement: standing,
walking, jumping,
following a path: the body,
once again, was the hub
of a possible aesthetics.
The Bauhaus served as
the link between
European and American
experiences. In 1933 the
Black Mountain College
was founded in North
Carolina by John A. Rice as a model
educational establishment based on the
principles of John Dewey. Josef Albers
and his wife Anni, fleeing Nazi Germany,
brought to the school their experience
of integration of the arts at Bauhaus.
In 1936 they were joined by Xanti
Schawinsky, one of the principal authors
of the Bauhaus's new "Visual Theatre".
In 1948 John Cage, the most authentic
exponent of Dadaist music, came to
Black Mountain College: with the

Merce Cunningham
Summerspace, 1958
Scenery and costumes
by Robert Rauschenberg
Cunningham Dance
Foundation, New York

collaboration of Willem de Kooning, the
architect Buckminster Fuller and above
all the dancer and choreographer Merce
Cunningham, with whom he embarked
on a long association, he put on Satie's
The Ruse of the Medusa. Four years later
Cage and Cunningham found other
collaborators at Black Mountain College.
The event that was staged in 1952 was,
in Cage's words, "anarchic", "purposeless
in that we didn't know what was going
to happen": Cage read a text on Zen
Buddhism and performed music with a
radio, Robert Rauschenberg played old
records and David Tudor a prepared
piano, while Charles Olson and Mary
Caroline Richards read poems, Jay Watt
played exotic instruments and
Cunningham improvised dance steps; on
the ceiling and backdrop Rauschenberg
projected abstract slides made with
coloured gelatin and clips from films. This
marked the beginning of Rauschenberg's
collaboration with Cunningham,
designing scenes and costumes for his
company's productions of *Minutiæ*, 1954,
and *Summerspace*, 1958. In 1956 Cage
was called to teach at the New School
for Social Research in New York, where
his students included Allan Kaprow,
Jackson Mac Low, George Brecht, Al
Hansen and Dick Higgins. In New York
another group influenced by Cage's
concept of a random and undetermined
happening was already operating in a
basement on Wooster Street. The Living

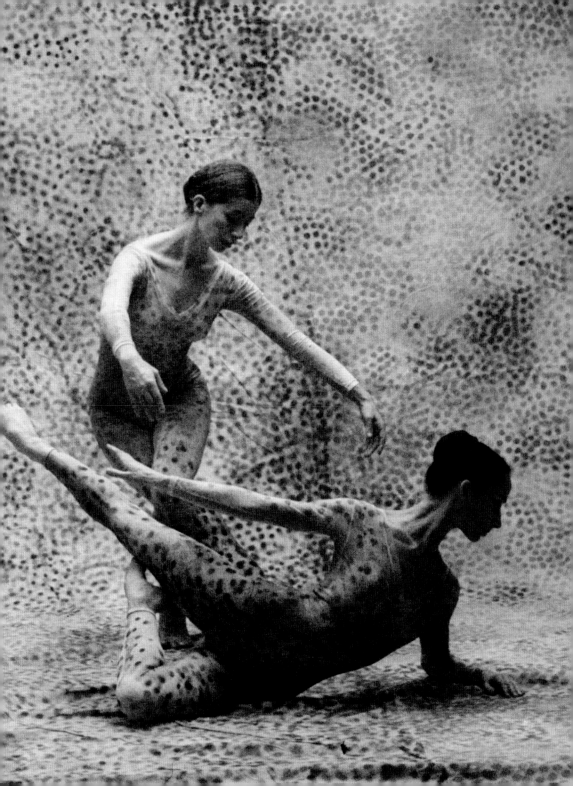

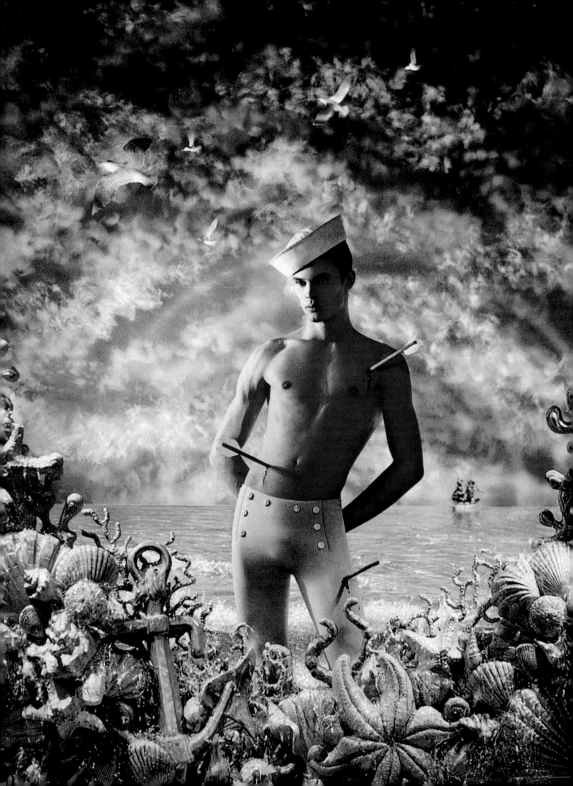

Theatre had been founded in 1947 on the initiative of Julian Beck, a painter of Pollock's circle, and the actress Judith Malina. Inspired by Cocteau and Artaud as well as by Pirandello's "theatre under construction", the Living Theatre worked on improvisation and the drama-event, moving out of the restricted space of the stage. The year 1959 was a turning point for the group, which carried out a true deconstruction of theatrical rules with *The Connection*. This was the same year that Kaprow presented *18 Happenings in 6 Parts* at the Reuben Gallery of New York. The invitation declared "you will become part of the happenings; you will simultaneously experience them". In three spaces characterized by different lighting, the participants had to move around to the sound of a bell that marked the beginning and end of each happening. They could take part in the events only once, for a total duration of an hour and a half: projection of slides, improvised music, a naked woman sinking into a sofa, another squeezing oranges, a group of artists painting canvases hung on partitions, others reciting texts or playing instruments. It was the start of a series of happenings and events staged by Robert Whitman,

Pierre et Gilles
Sébastien de la mer – Laurent, 1994

Red Grooms and Al Hansen. In February 1960 they collaborated with Kaprow, Claes Oldenburg, Dick Higgins and Jim Dine on *Ray Gun Spex*, a sequence of performances at the Judson Memorial Church in New York. In the same period a number of European artists were reviving the Dada-Surrealist tradition of direct action and a relationship without distinctions between ordinary life and artistic experience. In 1959 Wolf Vostell staged the televised happening *TV dé-coll/age. Ereignisse und Handlungen für Millionen* ("TV Dé-coll/age. Events and Acts for Millions"), in which viewers were given instructions like "sit close to the screen and clean your teeth" or "run or crawl in your room and repeat everything that is said on television". They could also kiss a face on the screen, drink a Coca-Cola while thinking about a Pepsi ad and lie in bed with the television set under the blankets. On 21 July 1960, in Milan, Piero Manzoni invited the public to *Consumazione dell'arte dinamica del pubblico, divorare l'arte* ("Consumption of Dynamic Art by the Public, Devouring Art"), a performance at which the visitors could eat boiled eggs signed by the artist, in a sort of paradoxical liturgy. In the same year Yves Klein staged his *Anthropometries*, events at which he painted the bodies of women and imprinted them on canvas. On 27 November he brought out *Le journal d'un seul jour – Dimanche*, a newspaper

465

"By gradually eliminating whatever proved superfluous, we found that theatre can exist without make-up, without autonomic costume and scenography, without a separate performance area (stage), without lighting and sound effects, etc. It cannot exist without the spectator relationship of perceptual, direct, communion."

Jerzy Grotowski

devoted to a single day with a photograph of him leaping from a building on the front page. On 22 April 1961 Manzoni signed the bodies of naked women, calling them *Living Sculptures*, in a perfect short-circuit between the historical anthropomorphic model of art and the living truth of the human body.

While the explicit use of the body as material and artistic icon, with values linked to the sacred and to social customs and with strong political implications—a leading current of feminism would choose Body Art as a specific field of action—remained a prerogative of certain European experiences, the aspects more closely connected with the total unification of performative practices, from painting to music to drama, characterized the Fluxus movement, whose origins, as in the case of Cage, lay in the realm of music. Following the Music Antiqua et Nova festival organized by Cage at the AG Gallery in New York in 1961, the Fluxus Internationale Festspiele Neuester Musik opened at the Städtisches Museum in Wiesbaden on 1 September 1962. Among those who took part were George Brecht, Philip Corner, Robert Filliou, Dick Higgins, Alison Knowles, La Monte Young, Nam June Paik, Emmett Williams, Wolf Vostell, George Maciunas

and Benjamin Patterson. Maciunas became the coordinator and ideological referent of a movement that immediately spread like wildfire, reflecting a climate in which all the arts were interacting in a lively fashion around the idea of the centrality of the artist's body, in real life as in staged events, and of the body used in itself as an artistic subject: visual arts, music, poetry, dance, drama. What counted, at this moment, was the mounting political orientation of almost all the exponents of these tendencies, who also saw in the new practices the possibility of no longer producing works that could be handled by the system of the market, the galleries and the museums, but existed only for the fleeting moment of their creation. Another factor was the awareness that the evolution of the techniques of mechanical reproduction, from photography to the magnetic tape, from video to film, permitted recording of the events, to the point where the recordings themselves, films and photographs, would come to be seen as works of art in their own right, in a close interaction with the development of new media. Marina Abramović has explained lucidly: "The idea of performances in the early seventies, especially my own, was that they should not be repeated. In those times, you had to stick rigidly to the concept: no repetition, no rehearsal and no pre-arranged ending. The

performances were done in such a way that it was almost impossible to repeat them, owing to the physical and mental risks. It was very important for performers and the audience to experience the work without any prospect of its repetition." On the other hand "the video camera should be positioned in such a way as to film the audience and the action, without worrying about making the film a work in itself. I've done performances just for the video camera, after a number of live performances, framed so that the viewer could see them from the same point of view as the real audience."

Figures like Yoko Ono, Charlotte Moorman, Walter De Maria, Ben Vautier, Daniel Spoerri, Joseph Beuys, Robert Morris, Giuseppe Chiari, Gianni Emilio Simonetti and Walter Marchetti took part in the activities of Fluxus, while in Japan the Guta'i group experimented along not dissimilar lines. Vautier in particular anticipated in many ways the habit, later to become typical of Conceptualism, of expressing himself through simple declarations, in his case handwritten: "Gesture: sitting in front of a mirror and looking at yourself for four hours"; "Ben will live as he is accustomed to every day. He will write down the insignificant details of his day in a Fluxus notebook"; "I, Ben, have lived for fifteen nights and days entirely in the window of Gallery One in London"; "Given that every possible form is accepted as part of the game in advance, the artist will try to get out of the game"; "I take possession of the whole visible and invisible, audible or inaudible universe". In parallel to Fluxus experimental genres emerged that were more closely linked to the individual disciplines of the performing arts. From the Dancers Workshop Company founded by Ann Halprin in San Francisco in 1955 and the Judson Dance Group in New York, set up in 1962, came figures like Simone Forti, Trisha Brown, Yvonne Rainer, Steve Paxton, Lucinda Childs and Carolee Schneemann, who made corporeality the heart of the new dance. Alongside them worked musicians with various links to Fluxus like Terry Riley, Philip Glass, La Monte Young, Charlemagne Palestine, Meredith Monk and Laurie Anderson. Schneemann's performances, in which the female body was at the centre of practices evoking archaic liturgies connected with sexuality, had something in common with the *Aktionsveranstaltung*, "Material Actions", of the Austrians Otto Muehl, Adolf Frohner, Hermann Nitsch and Rudolf Schwarzkogler, who were later joined by Günther Brus, Arnulf Rainer and Valie Export, that had been carried out in Vienna in the sixties on the basis of the

Matthew Barney
Drawing Restraint 7, 1993
Photograph by Michael James O'Brien, taken from one of the films in the *Drawing Restraint* project

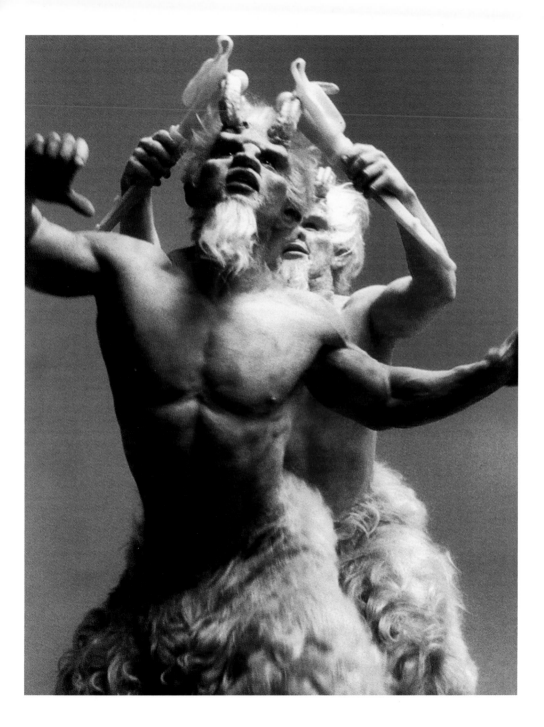

crude representation of acts of sex and violence, or of extreme situations on the physical plane. In the world of drama, in addition to the Living Theatre, people like Bob Wilson, Jerzy Grotowski and Eugenio Barba, and then groups like La Gaia Scienza, Magazzini Criminali and Falso Movimento and the younger Jan Fabre, Societas Raffaello Sanzio and Fura dels Baus were working to liberate the theatre from its historical conventions. As Grotowski put it: "By gradually eliminating whatever proved superfluous, we found that theatre can exist without make-up, without autonomic costume and scenography, without a separate performance area (stage), without lighting and sound effects, etc. It cannot exist without the spectator relationship of perceptual, direct, communion."

The second half of the sixties saw corporeal practices flower in every field, from the world of the neo-avant-gardes with Bruce Nauman, Vito Acconci, Giuseppe Penone, Gilberto Zorio, Jannis Kounellis, Fabio Mauri, Gino De Dominicis, Rebecca Horn and Klaus Rinke, to more clear-cut experiences in which the artist displayed his or her own body or that of others in constructed and aesthetically intentioned situations. From the early seventies onwards Urs Lüthi created performances and photographs in which, dressed in men's or women's clothing, he placed himself in deliberately ambiguous situations: "Perhaps the most significant and creative aspect of my work is its ambivalence as such. The result of this image of mine is the portrait. A portrait that has an existence of its own and that lives outside me. Whoever looks at it compares it with his own to the point of modifying himself, and splitting himself in two." Michele Zaza also worked on the image of himself, making it the subject of metaphysical and esoteric reflections on time and place. Gilbert & George created genuine *tableaux vivants* in which they were represented as statues of themselves; Following in their footsteps, Pierre et Gilles portrayed themselves in kitsch imagery ranging from the sacred to pornography, while Catherine Opie documented the ambiguous metamorphosis of bodies between transgender, tattoo and body-building. Luigi Ontani used his own body to stage photographically celebrated works from the history of art: in similar fashion Dara Birnbaum parodied the public's passive identification with the personalities of popular television in her videos. A genius of photography, Helmut Newton, cited the icy world of avant-garde actions in a parodistic way, projecting it ambiguously onto that of the fashion parade in the double photograph *Sie Kommen (Naked and Dressed)*, 1981, setting a trend that would be followed later by artists like Vanessa Beecroft. Robert Longo, an American who later devoted himself to

the cinema as well, staged actions like *Sound Distance of a Good Man*, 1978, and in the series *Men in the Cities* made drawings from photographs of bodies in atypical poses, as if they were dancing and looking almost like stills from films. And Larry Clark shifted entirely to the cinema after documenting the crude reality of violence, sex and drugs among the young in his book of photographs entitled *Tulsa*. The work of Matthew Barney consisted of a series of five films with the overall title *Cremaster*, 1994-2002. The title derived from the name of a small muscle, the cremaster, associated with the gonads and involved in the definition of sexual identity, and the works investigated the relations between male and female identity and the metamorphosis between animal and human being, in a sort of visionary and deranged physiology. Hard, and carrying a powerful message of social and aesthetic criticism, were also the images of artists like Andrés Serrano, in which the triumphant representation of the body gave way to visions of imperfection, decay and death; those of Nan Goldin, who documented the life that surrounded her, in a crude and desolate setting; those of Shirin Neshat, who in her photos and videos focused on questions of identity and corporeity through the filter of culture. "In the beginning", says Neshat, "when I started to take photographs of myself it was simply a question of convenience, it was like living my own life. After the first series it was as if I had located my image in the past and I chose other women to photograph. The body is very important in my works, because there are so many things that have passed into Islamic culture through the woman's body." The vision of reality as a sort of formless and senseless theatre has characterized more recent generations of Body artists. The work of Olafur Eliasson is based on a sort of dreamy situational ambiguity; Gary Hill makes extensive use of video, through which he investigates the movement of the body in space, the breakdown of gesture, language and the estranging sense of labial sound. While narrative and deconstructive interests are becoming increasingly predominant in this sort of renewed Story Art, some aspects of which date back to the work of artists like John Baldessari, Didier Bay, Victor Burgin, Jochen Gerz and Duane Michals in the seventies, it is a member of the historic generation of Performance Art, Marina Abramović, who is now taking a more complex approach, resorting to conventions of a theatrical nature and a non-banal use of technological means to trace a kind of pitiless autobiography in which fears and rituals, sexuality and citations of artistic iconography are jumbled together. Abramović's most authentic performance is, now, her entire history.

471

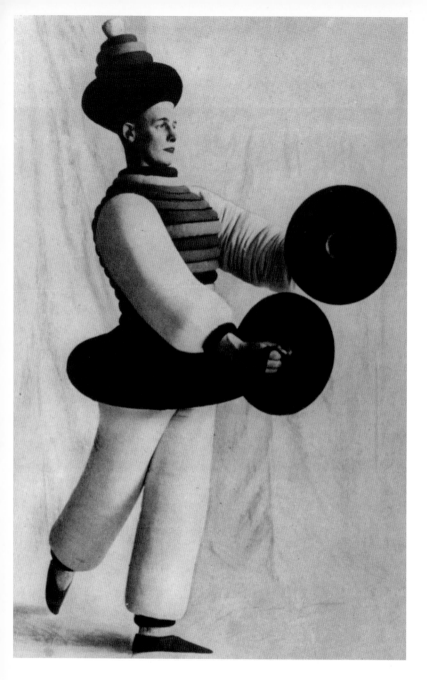

Anonymous
1. *Oskar Schlemmer
in the Costume of the 'Turk'
in* Triadische Ballet

Man Ray
2. *Marcel Duchamp
as Rrose Sélavy*

472

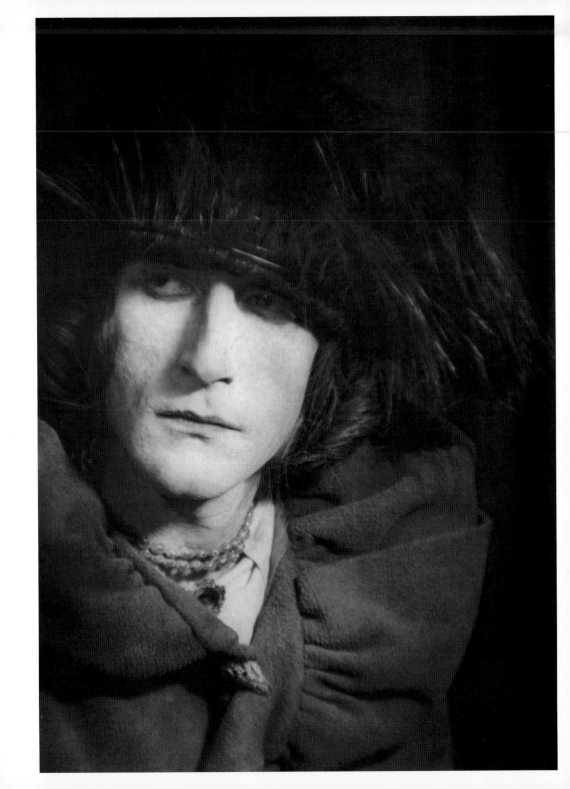

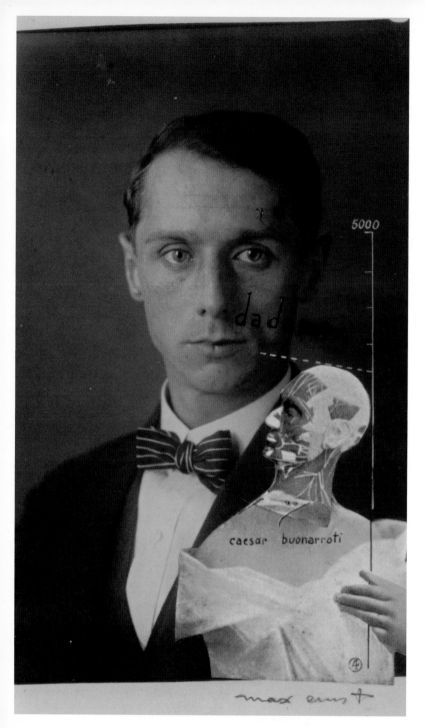

Max Ernst
3. *The Punching Ball ou L'immortalité de Buonarroti*

Lazar Markovich Lisitsky (El Lissitzky)
4. *Kurt Schwitters*

Following pages
Robert Wilson
5. *Dreamplay*

474

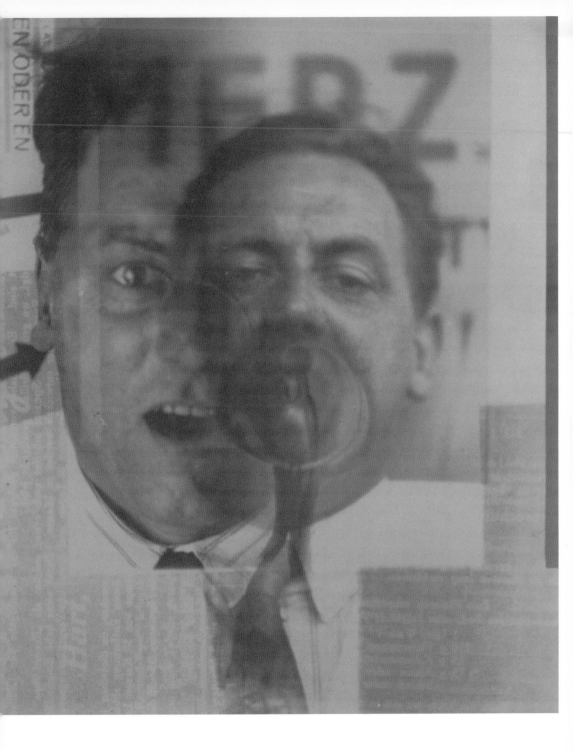

475

Gilbert & George
6. *The Singing Sculpture*

Dick Higgins
7. *Wiesbaden*

479

Andrés Serrano
8. *A History of Sex (Giada)*

Shirin Neshat
9. *Identified*

Nan Goldin
10. *Berlin*

Ulay & Marina Abramović
11. *Gold found by the artists*
(*Anima Mundi: tango*)

482

483

Sam Taylor-Wood
12. *Travesty of a Mockery*

Transavanguardia
Street Art

"It was completely wild. And we controlled it ourselves. There was the group of artists called COLAB, Collaborative Projects, doing exhibitions in abandoned buildings. And there was the club scene, the Mudd Club and Club 57, at St. Mark's Place, in the basement of a Polish church, which became our hangout, a clubhouse, where we could do whatever we wanted. (…) I organized a show at Club 57 for Frank Holliday and me. I bought a roll of oak-tag paper and cut it up and put it all over the floor and worked on this whole group of drawings. The first few were abstracts, but then these images started coming. They were humans and animals in different combinations."

Arriving in New York in 1978, the young Keith Haring enrolled in the School of Visual Arts, but at the same time he got involved in the alternative art scene of the East Village, with its musicians, performers and "writers", authors of the graffiti in which a few people were beginning to recognize expressive qualities that could no longer be found in the tired official milieu. One-night shows, exhibitions as short as happenings, were held at the Pyramid Club on Avenue A of Alphabet City, an area that was regarded as a slum. The Fun Gallery staged a "Minifestival of the various forms of Slum Art in its space on the Tenth Street East, with rap music and break-dancing along with graffiti exhibited on the walls".

Alongside these there were alternative spaces like Gallery 51X, Nature Morte, Civilian Warfare and Gracie Mansion's and haunts like the Red Bar. The predominance of unemotional attitudes and intellectualistic theories derived from Conceptual Art led more than one critic to write, on the occasion of *Documenta 6* in Kassel, 1977, that the history of painting—represented there by Analytical Painting—was coming to its end, and was about to give way to the dominion of technological media. In reality the new generation was reacting in a different way. Instead of coming up with a new avant-garde attitude in opposition to the previous ones, instead of developing a new intellectual scheme, it turned its back on such excesses of cultural sophistication. This was a symptom picked up early in the area of experimental art by the exhibition *Bad Painting*, organized by the critic Marcia Tucker at the New Museum of Contemporary Art of New York in 1978 and including the work of Albertson, Joan Brown, Garabedian, Jenney, Linhares, Staley and Wegman.

But if there was an art that was at home in the comfortable conservatory of museums, successful galleries and the houses of the great collectors, and thus an art that considered itself aristocratic, then the clearest contrast with it was provided by an art that was literally of the street, freely expressed on factory walls

and hoardings, on railway and subway carriages, which staged its own events in abandoned buildings and other unconventional locations. The real innovation came from the world of Hip Hop culture and Street Art, which invaded New York in the mid-seventies with its vernacular manifestations somewhere between Pop and the primitive, a pure, energetic and often anonymous expression of a creativity that had no intention of placing limits on itself, and that above all rejected, at this moment, any validation on the part of highbrow culture.

"I was becoming more and more involved in the underground art scene", declared Haring, "doing graffiti, and then I would use people's studios and do paintings. It was one of the first times graffiti was being considered art, and there were shows. In the summer of 1980, COLAB organized an exhibition of a lot of these artists in the Times Square Show. It was the first time the art world really paid attention to graffiti and to these other outsider artists." The *Times Square Show* was the exhibition that revealed Haring to a wider public, and with him Kenny Scharf (who in 1979 had held one-night show at Club 57) and Jean-Michel Basquiat, the triad

at the cutting edge of a generation which included a mutable galaxy of figures. Some of these, like Ronnie Cutrone and John Ahern, immediately found their way onto the circuit of the art galleries, but others remained linked to the art of the street and to their AKAs ("Also Known As"), the names with which they signed their interventions, from A-One to Futura 2000, from Rammellzee to Crash, from Toxic to Daze. The publication of the book *Subway Art*, in 1984, with photos by Henry Chalfant and Martha Cooper, bestowed an aura that was a blend of the heroic and the menacing on the illegal actions of those people who continued to act outside the official settings, popularizing a model that would be imitated all over the world. At the same time, however, Haring's succinct and gleaming figures ("I was thinking about these images as symbols, as a vocabulary of things", said the artist, who in 1986 opened the Pop Shop in SoHo, a true retail outlet for objects decorated with his images) and the primordial brutality of Basquiat's work began to be associated with the experiences of other artists, in exhibitions and by collectors. Stimulated by the examples of Haring and Basquiat, they had devoted themselves to a deliberately schematic art without intellectual pretensions, moving between irony and irrepressible immediacy and drawing on unsystematic and often perfunctory cultural references that

"It more and more appears
to me that art is not an elite activity
destined exclusively to be
appreciated by a limited number
of art lovers, but is meant for
everyone, and it is in this spirit that
I shall continue to work."

Keith Haring

ranged from the primitive arts to the historic avant-gardes, especially Expressionism: prominent among them were Susan Rothenberg, James Brown, Donald Baechler, David Salle, Jonathan Borofsky, Nicholas Africano, Ronnie Cutrone, Erich Fischl and above all Julian Schnabel. Schnabel, who made his debut in 1979 at the Mary Boone Gallery—along with the Shafrazi Gallery, the principal showcase for the new tendency in New York—was the author of an explicit and violent kind of painting that shunned all rules of good taste and skilful execution in favour of a direct and powerful grandeur, in which objects and materials were mixed up, and in which there was no question of figuration or abstraction but everything was centrifuged and flaunted in the name of an immediacy that could be disconcerting. "I thought that if painting is dead, then it's a nice time to start painting. People have been talking about the death of painting for so many years that most of those people are dead now", declared Schnabel, who on the subject of the often immense size of his pictures went on to say: "They are large because that's a necessary part of the content of the paintings. The scale and size of the painting has a physical reality that affects its meaning (…). When the paintings are large, the interior of the painting seems to deconstruct itself (…)." The American artist was among those invited to show at

Aperto '80, the section of the 1980 Venice Biennale devoted to young artists. The same exhibition included the work of German artists like Georg Baselitz and Anselm Kiefer, exponents of a current that was defined as the Neuen Wilden, the "New Fauves", in explicit reference to the historic movement of Expressionism, and Italians like Sandro Chia, Francesco Clemente, Enzo Cucchi, Nicola De Maria and Mimmo Paladino. At the time of the exhibition *Arte cifra* ("Cipher Art") at the Galerie Paul Maenz in Cologne in 1979, the critic Achille Bonito Oliva had written an article in which he defined the work of Chia, Clemente, De Maria, Longobardi, Paladino and Tatafiore as "La transavanguardia italiana" ("The Italian Trans-avant-garde"). He then went on to present the protagonists of this current in the exhibition *Opere fatte ad arte* ("Artfully Made Works") at Acireale.

The situation in Europe, where Street Art did not catch on until later, and then only as an imitative phenomenon, was no less lively than in the United States, and above all similar in many ways. The major event *Europa '79* in Stuttgart had assembled a range of artists whose common characteristic was a cursive painting, indifferent to quality of execution, which identified with a rhetorically emphatic approach to the discipline and a figuration so explicit that it bordered on illustrative naivety and

kitsch. The exhibition included numerous German, Swiss and Austrian artists, all exponents in various ways of a particular climate in the new German culture of which the Neuen Wilden were the most evident aspect.

After years of crisis following defeat in the war, the culture of the German-speaking world had spent several decades in a sort of cultural subjection to the United States, accentuated by an explicit policy of promotion of American models that the US government had pursued in Europe since the sixties. At the same time, the division of Germany into two separate States, the Westernized West and the East under Soviet control, had kept the question of national identity at the forefront of people's consciousness. It was at the end of the seventies, at the moment when Germany fully recovered its role as a world economic power, that the theme of a truly German art became a burning issue, and not just in the cultural world. With its international success, the generation of Joseph Beuys, Wolf Vostell and Günther Uecker in the Neo-Dada milieu, and of Gerhard Richter and Sigmar Polke, who from 1963 worked on the theme of *Kapitalistischen Realismus*, "Capitalist Realism", as a politicized and polemical variant of Pop Art that pilloried the new German economic miracle, created the conditions

for the emergence of an art with a strong ethical predisposition that recognized its own models in the committed Expressionism of the early decades of the century. The Expressionist legacy, it now became apparent, had never really been lost. Exhibitions like *Die Neuen Wilden* in Aachen and *Der Gekrümmte Horizont* ("The Curved Horizon") in Berlin, in 1980, turned the spotlight back onto the work of figures like Georg Baselitz, Jörg Immendorff, Anselm Kiefer, Markus Lüpertz and the isolated East German A.R. Penck. For some time these artists had been operating in the area of a formally and expressively intense painting, an agitated and ungraceful figuration that, like its historical reference, focused on the emotionally fired subjectivity of the artist and on a sensual and violent eclecticism, with traits of primitivism. As Penck put it: "Everything I paint is like a diary, open to criticism certainly, but with many ideas. Beauty has gone away, it no longer exists, and with it perhaps thought as well. We have to construct ourselves new bases, like the Pyramids or Stonehenge, new criteria for the future." For his part Baselitz, notorious for his decision to hang his pictures upside down, declared: "The fact of the upside-down object is proof that a painting dependent on representation does not exist. The reality is the picture, it is most certainly not in the picture. There are no longer programmatic contexts,

"When your heart catches fire and starts to pump hard, the first thing you must do is discipline it. A method is needed to govern it, to control it. Talent pushes too hard, it's like an animal, so you have to know how to hold the reins in order to harmonize everything. Otherwise, when the sign diminishes, you run the risk of slipping into decoration."

Enzo Cucchi

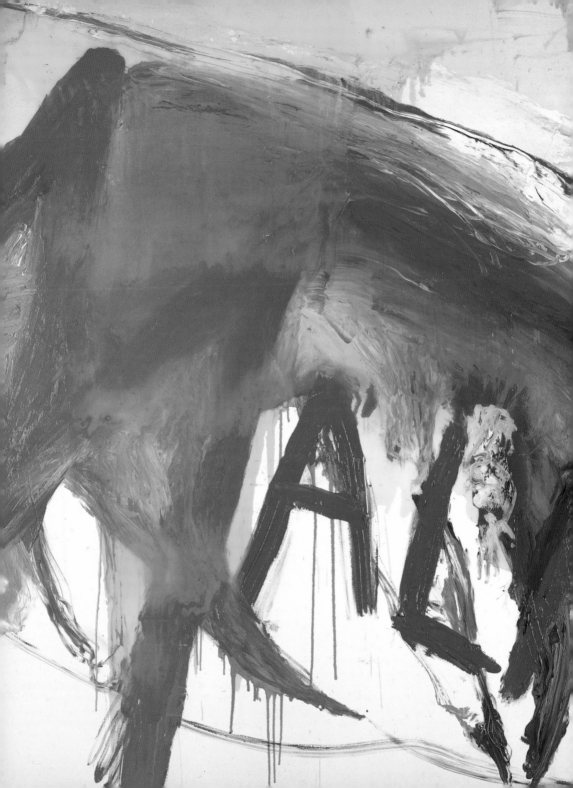

there are no longer any manifestos. Now there is just pure painting. Where can anything else exist?" With the analysis of formal language and the conception of art as an intellectual process now pushed into the background, it was on the biographical reality of the artist, on his alienation and marginality, that this primitive and exhilarated aesthetic tended to concentrate, in the name of what was defined the "sovereignty of the archaic narcissistic ego". In Berlin artists identified with the *Heftige Malerei*, the "Violent Painting" that was the title of an exhibition in 1980, with Elvira Bach, Luciano Castelli, Rainer Fetting, Helmut Middendorf, Salomé and Bernd Zimmer. The artists were pupils of Bernd Koberling and Karl Horst Hödicke, whose work in the previous decades had never moved away from a figuration filled with pathos, somewhere between Expressionism and evocations of German Dada. Cologne saw the formation of the Mülheimer Freiheit group, named after the address of the joint studios in which they worked, which adopted a position of self-inflicted marginalization that was also social, in the name of an aesthetic nihilism which found expression in works devoid of style, with explicit citations and deep forays into

kitsch: its members were Hans Peter Adamski, Peter Bömmels, Walter Dahn, Jiří Georg Dokoupil and Gerd Naschberger, later joined by Leiko Ikemura, Gerard Kever, Stefan Szczesny and Volker Tannert. Artists active in Hamburg, like Werner Büttner, Martin Kippenberger and the brothers Albert and Markus Oehlen, the Swiss Martin Disler and the Austrians Siegfried Anzinger, Erwin Bohatsch, Gunter Damisch, Hubert Scheibl and Hubert Schmalix, operated along similar lines. If developments in the United States can be seen as a further irruption of lowbrow culture into the world of artistic practices, and thus as a form of Post-Pop, and in Germany as a revival of the socially critical and Neo-Expressionist attitude, the Transavanguardia in Italy worked in a wholly formal area, focusing chiefly on a rejection of the primacy of ideology in art and of the myth of the new image techniques. As Bonito Oliva explained: "The Transavanguardia has responded in contextual terms to the general catastrophe of history and culture, moving beyond the pure materialism of techniques and new materials and arriving at a reclamation of the lack of relevance of painting to the present, understood as a capacity to restore to the creative process the character of an intense eroticism, the depth of an image that does not relinquish the pleasure of representation and narration."

Julian Schnabel
Malfi (detail), 2000
Oil and enamel on canvas,
273 × 225 cm
Private collection

495

"(…) Today there is such a proliferation of works, music, messages, there are no boundaries to break. I don't mean to say that Duchamp was wrong to show his urinal in an art gallery. The first time he did it, it was extraordinary, but by the second time it was not. Maybe the second time it still had some meaning, but by the third showing the urinal was just a urinal. Art and life are two very different things."

Anselm Kiefer

So what the experiences of Chia, Clemente, Cucchi, De Maria and Paladino had in common above all was the refusal to bow to the mechanism of the avant-gardes, which had by now turned into a frantic quest for the new, the original, and the provocative, and a return to painting—a painting that was intense and at times excessively pleased with itself, but in any case handled in masterly fashion and endowed with aesthetic intents—in the place of dispassionate techniques like photography and video, which these artists had also used since the early seventies, with remarkable results in Paladino's case. They were, on the other hand, a clearly recognizable nucleus within a much broader horizon, in which an entire generation rediscovered in various ways the pleasure of manual work and the expression of emotion. At the outset Ernesto Tatafiore and Nino Longobardi showed at the group's exhibitions, while artists like Giuseppe Maraniello, Davide Benati and Omar Galliani started out from a sumptuous Post-Conceptualism and concentrated on seeking a powerful stylistic as well as lyrical charge. Mimmo Germanà, Salvo, Luigi Mainolfi, Piero Manai and Bruno Ceccobelli displayed a more marked taste for citation and an exaggerated iconography. Close to them was located the work of younger artists, from Arcangelo to Piero Pizzi Cannella, from Nunzio to Marco Tirelli and from Domenico Bianchi to Gianni Dessì and Giuseppe Gallo, who acted within the same expressive area while eliminating the formal excesses of their older colleagues. Chia has written: "There is a lot of talk about the space of the work or the work in the environment, but I believe that all this talk is a consequence of the loss of the force and image of the work (…) the space of the work is the area of intensity that the work is capable of bearing." Even more controversially, Clemente asserted that the new art was "a reaction to the weight of the ideology that belonged to the previous generation", and that it was simply a matter of "introducing an object into the world without it being a response to something". Cucchi, finally, has explained: "Between the realm of chaos and the decorative order extends a new zone, and a key to understanding this mutability is the inclination to form piles: of history, of feelings, of artistic expressions; living simultaneously with moments of dream, then there is no longer history but piles of history." And again: "When your heart catches fire and starts to pump hard, the first thing you must do is discipline it. A method is needed to govern it, to control it. Talent pushes too hard, it's like an animal, so you have to know how to hold the reins in order to harmonize everything. Otherwise, when the sign diminishes, you run the risk of slipping into decoration."

Mimmo Paladino
Stones, 1998
Vicenza stone,
200 × 70 × 50 cm
(20 elements)
Installation for the square
of the new MART
Collection of the artist

The French milieu rapidly adapted to this new climate too. In fact it was a French philosopher, Jean-François Lyotard, and his book *The Post-modern Condition*, published in 1979, that inspired many critics to celebrate artistic attitudes freed from the obligation of a marked ideological and stylistic rigour. Lyotard himself, a few years later, was to place the accent on the fact that avoiding the confrontation with technology and with a limpidly rational attitude presented other risks of which the world of painting, cinema, literature and music had not shown themselves to be sufficiently aware: "The System [of production], even if unconsciously, attempts to invade everything, penetrating laboratories, newspaper editorial offices, and even the writer's workspace, in order to obtain the kind of product it knows how to market. The crisis of the avant-garde derives from the System's weariness with painters and writers whose works are incomprehensible or unreadable. The System wants readable products! An editor once told me: 'Look, we'll publish you, but give us something readable'. He meant: 'give us something that can be put on the cultural market.'" In any case French art fell into line with the international tendency with the group Figuration Libre, made up of Robert Combas, Hervé Di Rosa, Richard Di Rosa, Rémi Blanchard, François Boisrond and Louis Jammes, while artists like Gérard Garouste, Jean-Michel Alberola and Jean-Charles Blais operated on the plane of a more explicit recourse to citation and evocation of the tradition of painting. Spanish art, which had only begun to forge permanent international ties after the death of the dictator Francisco Franco in 1975, was represented by members of the younger generation like Miquel Barceló, Ferrán García Sevilla, José Manuel Broto, Chema Cobo and José María Sicilia.

By this time, between 1981 and 1982, it was possible to speak of a general international trend, with no characteristics in common apart from a massive and programmatic return to the ostentation of practices of painting and sculpture and to a figuration now delivered from any ambiguous sense of dependence on representation, in favour of a sort of "Popism" in which the 20th-century artistic tradition was, like the world of mass media, treated with uninhibited detachment. Three exhibitions, in 1981 and 1982, set the seal on the new climate. The first, *A New Spirit in Painting* at the Royal Academy in London in 1981, attempted to interpret the new artistic personalities from the historical perspective of a link with members of previous generations who had in one way or another made painting the privileged medium of their experience: Auerbach, Bacon, Balthus,

Baselitz, Calzolari, Charlton, Chia, Fetting, Freud, Graubner, Guston, Hacker, Hélion, Hockney, Hodgkin, Hoedicke, Kiefer, Kirkeby, Kitaj, Koberling, De Kooning, Kounellis, Lüpertz, Marden, Matta, McLean, Merz, Morley, Paladino, Penck, Picasso, Polke, Richter, Ryman, Schnabel, Stella, Twombly and Warhol, covering a period from the historic avant-garde to that time. The second, *Zeitgeist* at the Martin-Gropius-Bau in Berlin, in 1982, looked at the "Spirit of the Time" and thus offered an interpretation centred wholly on the present, with Anzinger, Baselitz, Beuys, Bömmels, Bonatsch, Borofsky, Büttner, Byars, Calzolari, Clemente, Chia, Cucchi, Dahn, Daniels, Dokoupil, Fetting, Flanagan, Garouste, Gilbert & George, Hacker, Höckelmann, Hödicke, Immendorff, Kiefer, Kirkeby, Koberling, Kounellis, Le Brun, Lüpertz, McLean, Merz, Middendorf, Morley, Morris, Paladino, Penck, Polke, Rothenberg, Salle, Salomé, Schnabel, Stella, Tannert, Twombly and Warhol. Finally *Transavanguardia Italia/America*, staged at the Galleria Civica in Modena, again in 1982, focused on the relationship between the new Italian art of Chia, Clemente, Cucchi, De Maria and Paladino and the generation of American artists represented by Basquiat, Haring, Salle and Schnabel. The figure that stood out clearly within this motley company was Anselm Kiefer, the most representative and qualitatively gifted of this generation.

Active since the early seventies, he produced large pictures in which the paint was mixed with different materials and which expanded to the point of becoming installations. They were animated by a severe and potent figuration, veined with a deep sense of tragedy, that reflected on the great myths and on symbols, on history and its meaning, on memory and on the human values that history often dramatically contradicted. In contrast to the facility and vagueness typical of much of the painting of the eighties, Kiefer set out to restore art to its central role as a place where humanity reflects on its prime values, to be considered inescapable. In Kiefer's words: "In the 1970s, when I was a student, we used to organise happenings and try to break the boundaries between art and life. Today there is such a proliferation of works, music, messages, there are no boundaries to break. I don't mean to say that Duchamp was wrong to show his urinal in an art gallery. The first time he did it, it was extraordinary, but by the second time it was not. Maybe the second time it still had some meaning, but by the third showing the urinal was just a urinal. Art and life are two very different things."

Keith Haring
1. *Untitled*

503

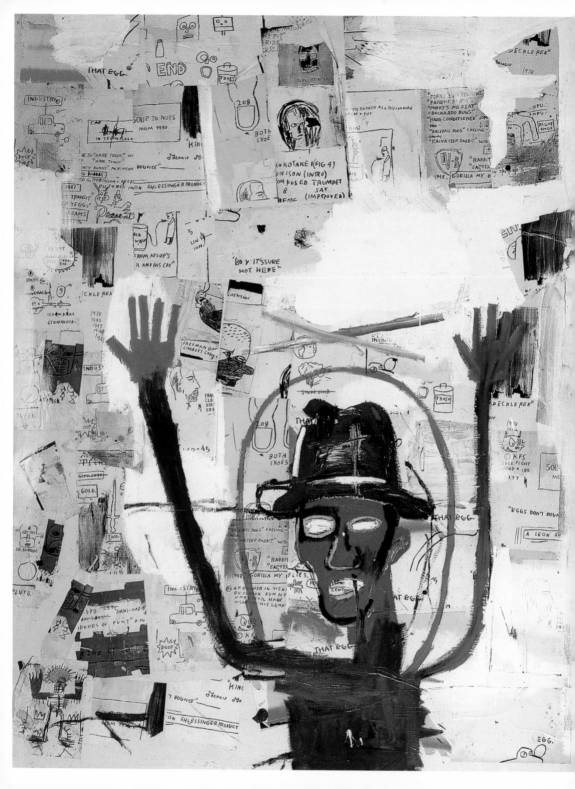

Jean-Michel Basquiat
2. *Toxic*

Keith Haring
3. *Untitled*

505

Sandro Chia
4. *Sull'onda e bastone*
(*On the Wave and Club*)

Francesco Clemente
5. *Arlecchino da vicino*
(*Harlequin Close-up*)

Enzo Cucchi
6. *Un quadro che sfiora il mare*
(*A Painting Skimming the Sea*)

Nicola De Maria
*7. Mattino soave del Regno
dei Fiori nell'aria scintillante
(Mild Morning of the Kingdom
of Flowers in the Sparkling Air)*

511

Georg Baselitz
8. *Strandbild 7. Blick*
aus dem Fenster nach draussen
(Beach Picture 7. Glance
out of the Window)

Following pages

Markus Lüpertz
9. *Cupid and Psyche I*

Anselm Kiefer
10. *Althanor*

513

New Media

ince the early sixties, when artistic practices openly took the road of an extensive interaction with the performing arts and the staging of events and situations that could not be turned into fixed and lasting works, the contemporary evolution of the technology used for recording images has entered a new dimension.

Once utilized strictly for documentary purposes, the medium has grown increasingly conscious of the possibility of becoming a language in its own right and a means of expression, of creation, rather than just of recording. The illustrious precedent for this, and one that in the same years was going through an intense phase of redefinition in artistic circles, was photography. After the pioneering experiments of the historic avant-gardes, it was exhibitions like *The Painter and the Photograph* at the University of New Mexico in Albuquerque, in 1965, and *The Photographic Image* at the Guggenheim in New York, in 1966, that presented photography to the public as a now mature medium which could be accepted as "art" in the full sense of the word.

At the same time, and ever since the fifties, the power of television as a means of communication and medium was perceived as the new technological frontier of expression and began to attract the attention of artists too. In 1952 the group of Italian Spatialists centring on Lucio Fontana launched the "Television Manifesto of the Spatial Movement", in which they declared: "For the first time anywhere in the world, we Spatialists are using television to transmit our new forms of art based on the concepts of space, to be understood from two points of view: the first concerns spaces that were once considered mysterious but that are now known and explored, and that we therefore use as plastic material: the second concerns the still unknown spaces of the cosmos—spaces to which we address ourselves as data of intuition and mystery, the typical data of art as divination. (…) We Spatialists feel ourselves to be the artists of today, since the conquests of technology are now at the service of the art we profess."

At the end of the decade Wolf Vostell carried out his operations of TV dé-coll/age, in which television broadcasts were not only subjected to criticism from the political and sociological viewpoint (*Deutscher Ausblick*, "German View", 1959, associated the medium with memories of Nazism), but also treated as the source of an indistinct flow and therefore devoid of meaning in itself, as in the film *Sun in Your Head*, 1963, an indefinite

collection of distorted TV images. The same year Andy Warhol inaugurated a completely new use of the cinematographic medium in films like *Sleep*, where the camera was trained for six hours without a break on a sleeping person. In doing so he was drawing on and extending the experiments of the American underground cinema, which promoted a solely creative use of the medium without regard for technical quality of execution ("It is fantasy and play against the commercial order of the others. But that is not all. It is the painters' and poets' revenge", is how Fernand Léger had described experimental cinema as fare back as the twenties), conducted by directors like Robert Breer, Stanley Brakhage, Marie Menken, Pat O'Neill, John Schofill, Ronald Nameth, Michael Snow and Jonas Mekas. In 1964, in fact, Mekas collaborated with Warhol on *Empire*, an eight-hour-long film of the Empire State Building. In the same period the Italians Gianfranco Baruchello and Alberto Grifi began to make *La verifica incerta*, a montage of discarded sequences from films made in the fifties and sixties. In 1965, after presenting *13 TVs: 13*

Jan Fabre
Sarcofago conditus
(detail), 2003
Drawing pins, nails, mannequin, fabric and wood, 203 × 117 × 78 cm
Courtesy Certosa di San Lorenzo, Padula

Distorted TV Sets at the Galerie Parnass in Wuppertal in 1963, a performance in which pianos were mixed up with a variety of objects, including a disjointed female mannequin in a bath tub, a bull's head dripping with blood and thirteen television sets that reproduced distorted and deformed fixed images, Nam June Paik began to use the Sony Portapak, the first portable video camera, to film events on location, commencing with the traffic snarls in New York on the day of Paul VI's visit to the city, shown the same day at the Cafe au Go Go in Greenwich Village. "Someday artists will work with capacitors, resistors, and semiconductors as they work today with brushes, violins, and junk", argued Paik, for "in the same way that collage has replaced oil painting, cathode ray tubes will replace canvas". Moreover, "TV tortured the intellectuals for a long time (…) it is about time that the intellectuals torture TV".

On the opposite front to the dematerialization and detached conceptualization represented by experiences like Conceptual and Minimal Art, these developments paved the way for the expansion of artistic practices into the world of new media and for the definitive conception of the artistic

518

event as a complex phenomenon from both the linguistic viewpoint—involving the most diverse techniques, from the installation to electronics, from sound to the performance—and the spatial one, with settings that ranged from the closed room to the urban landscape as a whole, and that implicated more and more directly a relationship between artistic operation and active participation of the public.

In 1966 Robert Rauschenberg and the engineer Billy Klüver—who also collaborated with Jean Tinguely, John Cage and Andy Warhol—founded the group Experiments in Art and Technology (EAT) in Los Angeles, along with the artist Bob Whitman and Fred Waldhauer of Bell Labs, establishing links with the emerging world of electronics. In 1968 the first attempts at Computer Art were shown in the exhibition *Cybernetic Serendipity* at the Institute of Contemporary Art in London.

In 1969 the Museum of Contemporary Art in Chicago staged the exhibition *Art by Telephone* in which the participants, who included John Baldessari, George Brecht, John Day, Hans Haacke, Dick Higgins, Joseph Kosuth, Sol LeWitt,

Andy Warhol
Andy Warhol's Fifteen Minutes, pilot episode, 1985
Videotape, colour, sound.
Duration: 30 seconds
Courtesy of the Andy
Warhol Museum, Pittsburgh

Bruce Nauman and Wolf Vostell, either gave instructions for the installation of their works over the telephone or made the telephone the subject of their intervention: the recording of these conversations on disc was an integral part of the event.

Photography and cinema remained the media most easily appropriated by artists, who recognized their status as a new tradition by virtue of the pioneering work of the historic avant-gardes. In Italy film attracted the interest of artists like Ugo Nespolo (*Grazie Mamma Kodak*, 1967) and Mario Schifano (*Anna Carini vista in agosto dalle farfalle*, 1967). Schifano even declared: "Painting, at least mine, with its limitations, has no prospects. The cinema offers greater possibilities for the creation of images." In the US as charismatic a figure as Warhol was able to say in 1975 that "I like photography and cinematography more than painting now. It's because you can show more in it. There are more images, more pictures that can be created. No-one can show anything in a picture anymore, at least not as much as in a film. I knew I should have given up painting. I knew I ought to have found new and different things".

But it was in television and the evolving electronic media that the most

noticeable innovations were to be found. Active in San Francisco since 1954, the KQED channel (the three final letters were an acronym for *quod erat demonstrandum*) collaborated with the Dilexi Gallery directed by Jim Newman, soon transformed into a foundation, on the production of the *Dilexi Series*, 12 original TV programmes by artists like Terry Riley, Ann Halprin, Yvonne Rainer, Frank Zappa, Walter De Maria and the Living Theatre that were broadcast from 1969 onwards. At the same time the WGBH channel in Boston broadcast the programme *The Medium is the Medium*, with works by artists like Otto Piene and Nam June Paik: Allan Kaprow used it for the first happening to be broadcast live, *Hallo*. In New York Howard Wise organized the exhibition *TV as a Creative Medium* at his own gallery, where he presented works by Paul Ryan, Eric Siegel and Frank Gillette, along with Paik's celebrated *TV Bra for Living Sculpture*, in which two TV screens served as the cups of a brassiere for the cello player Charlotte Moorman, displaying images modulated by the sound of the instrument. "The real implied issue in 'Art and Technology' is not to make another scientific toy, but how to *humanize* the technology and the electronic medium, which is progressing rapidly—too rapidly", wrote Paik on the occasion.

Shortly afterwards, in 1971, Wise founded Electronic Arts Intermix, an association devoted specifically to the creative development of new media. In Italy the slower spread of television made artists less aware, after the pioneering experiment of Fontana and company, of the medium's potential. In 1965 Baruchello created *Television Limiter*, a device for limiting or blocking the view of the TV screen. In 1968 Franco Vaccari's *Immagine televisiva* was recorded, and in 1970 Gianni Colombo and Vincenzo Agnetti's *Vobulazione e Bieloquenza Neg.*

The situation in Europe evolved in a significant way thanks to Gerry Schum, who founded the Fernsehgalerie (Television Gallery) in 1969, staging televised exhibitions like *Land Art*, 1968-69, with Richard Long, Barry Flanagan, Dennis Oppenheim, Robert Smithson, Marinus Boezem, Jan Dibbets, Walter De Maria and Michael Heizer, broadcast on 15 April 1969 by the WDR channel (which had already experimented with the transmission of videos by Paik, Vostell, Piene and Ulrike Rosenbach), and *Identifications*, broadcast by the SWF/ARD canal on 30 November 1970, a montage of the actions of twenty artists: Joseph Beuys, Reiner Ruthenbeck, Klaus Rinke, Ulrich Rückriem, Daniel Buren, Hamish Fulton, Gilbert & George, Stanley Brown, Ger

"(…) In the same way that collage has replaced oil painting, cathode ray tubes will replace canvas. (…) TV tortured the intellectuals for a long time (…) it is about time that the intellectuals torture TV."

Nam June Paik

van Elk, Giovanni Anselmo, Alighiero Boetti, Pier Paolo Calzolari, Gino De Dominicis, Mario Merz, Gilberto Zorio, Gary Kuehn, Keith Sonnier, Richard Serra, Lawrence Weiner and Franz Erhard Walther.

Schum's aims were clear. He understood that video, with the possibilities of filming, manipulation and editing that it presented, was much more than a simple means of recording happenings and events and could become a specific medium of expression with great potentialities that had yet to be explored. He declared: "Art should no longer be made for the private or exclusive world of dealers or collectors. (...) Until now artists have not succeeded in finding a modern system of communication. The only chance I see for the visual arts is the conscious deployment of television." And again:

"In the TV object the artist can reduce his object to the attitude, to the mere gesture, as a reference to his conception. The art object displays itself as the union of idea, visualization and the artist as demonstrator."

The shift from film to video was a decisive factor at this moment, and cleared the way for what, in the seventies, was known as Video Art and practiced at centres like The Kitchen, set up in New York in 1971, with a focus on multimedia, and in Italy at the Centro di Videoarte in Ferrara, founded by Lola Bonora at the Palazzo dei Diamanti, and Art/Tapes/22, founded in Florence the same year by Maria Gloria Bicocchi, with the collaboration, for a while, of Bill Viola, later to emerge as a true genius of video. It is clear that the main stimuli to the evolution of the language of the new media came from the performing arts. The musician and performer Laurie Anderson wrote: "For the past thirty years my work has basically consisted of music and performances, in which I have always combined several art forms. A typical large-scale work will include film or video, animation, digital processing, music, electronics and stories." The exhibition *Projekt '74*, organized at the Kunstverein and Kunsthalle in Cologne, even decided to produce a video catalogue to document the six video installations by Nam June Paik, Peter Campus, Dan Graham, Michael Hayden, Frank Gillette and Douglas Davis and the ninety-five videos presented by performers like Vito Acconci, Joan Jonas, Reiner Ruthenbeck, Ulrike Rosenbach and Valie Export.

By contrast, when the Whitney Museum in New York staged *A Special Videotape Show* in 1971, the organizers declared that "it was decided instead to limit the program to tapes

which focus on the ability of videotape to create and generate its own intrinsic imagery, rather than its ability to record reality. This is done with special video synthesizers, colourizers, and by utilizing many of the unique electronic properties of the medium."

Bill Viola summed up these developments as follows: "It was only at the end of the sixties that this attempt to emulate the cinema ended, when artists began to look with curiosity beneath the surface, in order to discover the fundamental characteristics of the medium and liberate the visual potentials of the electronic image unique in the genre, potentials which are taken for granted today, with a yawn and often a grimace, like the daily meal that the TV offers us. The video switch was designed as part of the first video synthesizer. Its principles were acoustic and musical, a further evolution of early electronic musical systems like the 'Moog'. The video did not just begin to resemble and act like the cinema, but it began to resemble and act just like anything else: fashion, conversation, politics, visual art, music."

From the eighties onwards the awareness of the linguistic and evocative possibilities of the new media intersected on the one hand with an ever more marked spectacularization of art, and on the other with a typically post-modern attitude that consisted in the total right, on the artist's part, to create works and events of very different types from the viewpoint of both their objective nature and their spatial situation.

One line of research pursued by recent generations has exploited the tradition of photography in a new way. In the light of the additional possibilities of shooting and printing, the medium has assumed connotations of great impact, interacting with the tradition of "constructed situations" and a highly stylized narrative. Among the artists who have gone down this road are Andreas Gursky, Thomas Ruff, Candida Höfer, Thomas Struth and James Casebere, with a lucidly documentary vision in the tradition of Bernd and Hilla Becher; or Jeanne Dunning, Georgina Starr, Wolfgang Tillmans, Sharon Lockhart, Philip- Lorca DiCorcia and Jeff Wall, whose approach has been based on a sort of alienated narrativity. For others, such as Sarah Lucas, Sam Taylor-Wood, Olafur Eliasson, Vik Muniz, Fischli & Weiss and Pierre Huyghe, the photograph is just one of many linguistic possibilities, which they combined and often alternated with the making of films, videos, sculptures, installations and actions. In these cases it is interesting to observe how among the younger generations the hiatus

"It was only at the end of the sixties
that this attempt to emulate
the cinema ended, when artists began
to look with curiosity beneath
the surface, in order to discover the
fundamental characteristics
of the medium and liberate the unique
visual potentials of the electronic
image in their genre, potentials
which are taken for granted today, with
a yawn and often a grimace, like
the daily meal that the TV offers us."

Bill Viola

between primary operation (the event, the action, the situation) and its translation into media, as it had been perceived and probed by the avant-gardes of the sixties and seventies, has gradually become a matter of total indifference. Between reflections of a philosophical nature and pure expansion of existential frequencies, what the artist now concentrates on is an intellectual and expressive project, whose modes of manifestation are manifold, without this entailing the preoccupation with linguistic or technical or stylistic coherence that had played such a great part in the story of the historic avant-gardes.

Following pages
Damien Hirst
Some Comfort Gained from the Acceptance of the Inherent Lies in Everything, 1996
Glass, steel, formaldehyde and two cows in twelve tanks, 200 × 90.2 × 30.5 cm (each; 12 elements)
François Pinault Collection

Emblematic of this are two of today's major artists, William Kentridge and Jan Fabre. The former conceives his own operations as a passage from the historic technique of drawing to the animated film, from the theatre—including that of puppets—to sculpture in bronze, from the installation to projections in space. His themes have a strong political significance, stemming from his birth in apartheid South Africa, but also going all the way back to the origins of the avant-garde, reflecting on figures like Alfred Jarry and the pioneer filmmaker Georges Méliès. Fabre, a visual artist, theatre director and writer, passes from the plastic arts to video and from drama to choreography, creating complex situations characterized by an exploration of biological metamorphosis, in a lucid and disquieting vision.

Metamorphosis and situational ambiguity are also characteristic of Matthew Barney, while an artist like Doug Aitken prefers to use video and video installations to sound out situations of a physical and spatial kind, investigating a sort of grey zone between art and architecture. According to Aitken: "Much of my work is invested in the theory of finding a kind of idea-architecture that is immediate and ephemeral. Where the ideas of content, perception and viewing collide. Creating ideas as something that can be walked through instead of just thought about, or that there can be a physicality to a concept. I think seeing these as a definition of a new form of architecture is kind of important."

Douglas Gordon works on images drawn from the history of cinema, straining the monumentality attributed to them by the psychology of the viewer. Tony Oursler—who also moves between the video and photography, between sound atmospheres and installations with objects—creates

527

situations obsessively centred on the body and its dissolution. Others, especially in the last few years, have tended to hypertrophy the presence of the technical means and the complexity of the installation, giving rise to a not always satisfying kind of media spectacle.

The new technologies, along with evocations of the techniques used by the avant-garde, have been resorted to by some artists in whom the critical component, somewhere between sociology and politics, is predominant. Krzysztof Wodiczko works with a strong political message on the scale of the urban space, and argues: "Public space is where we often explore or enact democracy. In the 1970s, there was a growing interest in public art, public space, site-specific art because of the rapid transformation of cities. Eventually, site specificity was replaced by other concerns, but it was an important stage when artists began to focus on context. Art could be geographically specific, formally and visually specific, or socially specific. Artists began to consider the implications of an intervention in one area when similar events were happening at the same time in other places. In the 1980s, there emerged influences from critical urban geography and the ideas of uneven development, urban struggle, and cultural resistance. Artists began to think critically about art—the position of their practice—in relation to development in a city and the lives of its people. Questions of representation also emerged. How should a particular social group or stratum be represented? More artists became directly involved in the lives of the inhabitants of cities." Jenny Holzer has taken an analogous approach in her work, utilizing projections in communal spaces and technological devices to present statements of a critical and political character or provocatively banal phrases, in a sort of reversal of the conception of social communication predominant in the advertising world. A similar degree of ethical tension and political interventionism, inherited from the historic generation of artists like Hans Haacke, characterizes works like those of Barbara Kruger, who uses the Minimalist technique of collage in accordance with the German Dada tradition: a parallel to this can be seen in a work of crude criticism like that of Reinhard Mucha, whose strong physical interventions of environmental interpretation straddle the installation and the sculpture, following a current that has its precedents in artists like Gordon Matta-Clark and Michael Asher. The work of a number of very famous

artists, from Jeff Koons to Maurizio Cattelan, from Mona Hatoum to Damien Hirst and from Heim Steinbach to Bertrand Lavier, borders on the installation, photography and an uninhibited use of media in which the spectacular dimension and a scenographic use of visual materials seem to prevail over any intellectual tendency, but it appears fairly fragile and occasional, in the key of a Neo-Pop and Post-Conceptual provocation. Instead it is from a renewed relationship, at once lucidly critical and creative, with a technological medium like the computer and the contiguous world of the Web that experiences of quite another significance are coming.

Some artists are investigating the language of software itself, while others are exploring the communicative possibilities of the Web and the psychological effects that such innovations have on the public, commencing with the fear of figures like the hacker. In both cases we are seeing the return of another device that had been used by the Dada avant-garde, the parody of its own earnestness and obsession with theory, with tendencies toward self-mythologization that are typical of the art world. "We at plagiarist.org know that it's very important for artists to have a manifesto. It shows passion! It shows conviction!",

proclaimed Amy Alexander in 1998. Since this is a plagiarist manifesto, however, it is different every time you connect to the site, mixing up at random fragments taken from existing manifestos and programmes (ranging from the Futurist ones to the proclamations of the Unabomber), so that no two versions of the text are ever the same. Vuk Cosic, Alexei Shulgin, 0100101110101101.ORG, EpidemiC, Jaromil and Florian Cramer act on the structure of the software itself, while others, like etoy, The Yes Men, Surveillance Camera Players, Cornelia Sollfrank, ®TMark and Patrick Lichty use the power of persuasion and the fragile boundaries between true and false typical of the Web to produce authentic media and social hoaxes, as well as alienated situations: from the invention of a fake artist, Darko Maver, on the part of 0100101110101101.ORG to Biennale.py, a computer virus developed by the same group with EpidemiC for the 2001 Venice Biennale, which filled the mass media and public with worries about potential infection, and to Vote Auction, created by Ubermorgen in 2000: an apparently perfectly normal site on which American citizens could put their vote for the presidential elections up for sale.

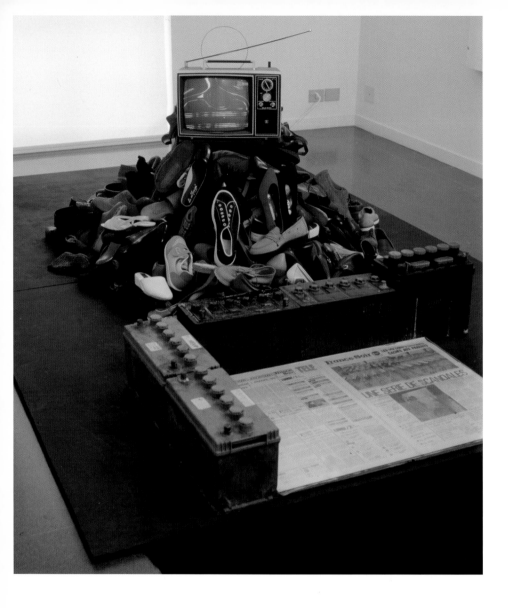

Wolf Vostell
1. *TV – Shoes*

Nam June Paik
2. *Family of Robot, Aunt*

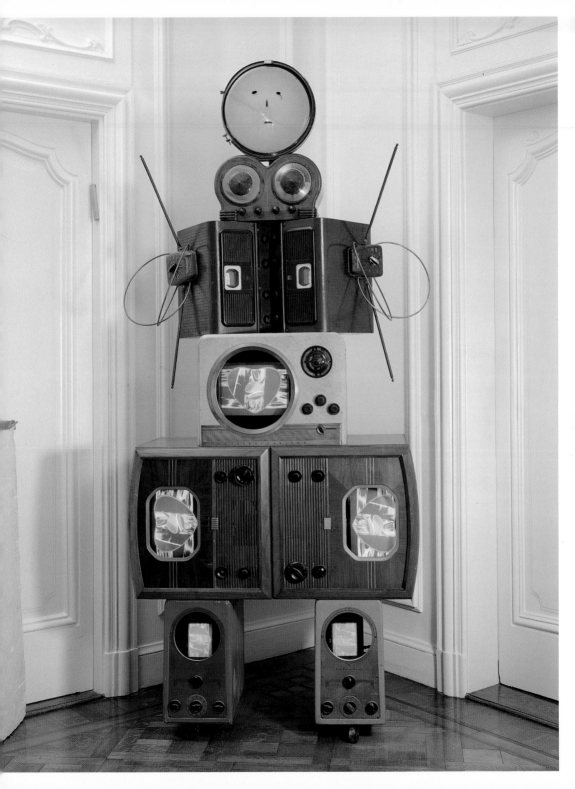

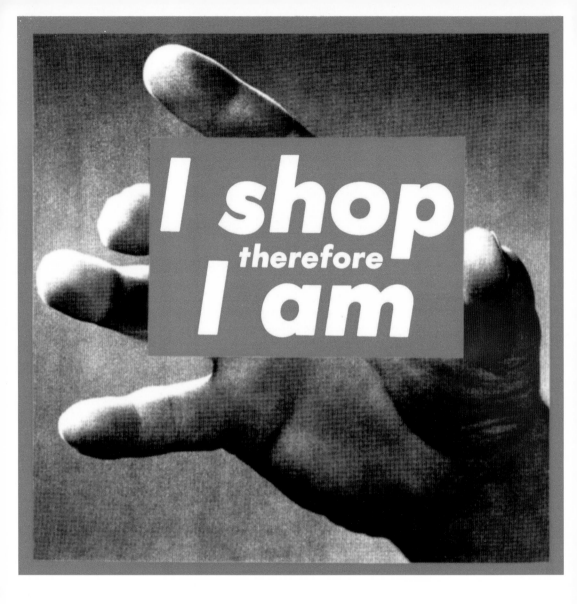

Barbara Kruger
3. *Untitled*
(I shop therefore I am)

Jenny Holzer
4. *Red and Yellow Looming*

Following pages
William Kentridge
5. *Journey to the Moon*
and Seven Fragments
for Georges Méliès

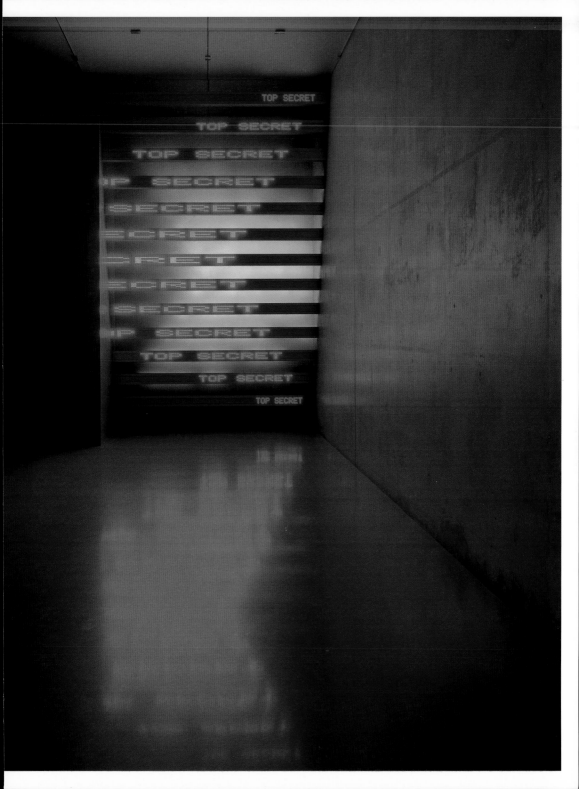

Andreas Gursky
6. *Athens* (diptych)

538

539

Jeff Wall
7. *The Thinker*

Bill Viola
8. *Study for Emergence*

541

Technical Entries
on the Works

Henri Matisse
5. *The Red Studio*, 1911
Oil on canvas, 181 x 219.1 cm
The Museum of Modern Art,
New York
Mrs. Simon Guggenheim Fund

Henri Matisse
6. *Harmony in Red*, 1908
Oil on canvas, 120 x 180 cm
State Hermitage Museum,
St. Petersburg

Erich Heckel
7. *Path in the Wood*, 1914
Oil on canvas, 87 x 44 cm
Sprengel Museum, Hanover

Ernst Ludwig Kirchner
8. *Five Women in the Street*, 1913
Oil on canvas, 120.5 x 75.5 cm
Wallraf-Richartz-Museum, Cologne

Egon Schiele
9. *The Artist's Room
at Neulengbach*, 1911
Oil on canvas, 80 x 53 cm
Historisches Museum der Stadt
Wien, Vienna

Egon Schiele
10. *The Family*, 1917
Oil on canvas, 191.8 x 152.5 cm
Österreichische Galerie Belvedere,
Vienna

George Grosz
11. *Street Scene*, 1925
Oil on canvas, 81 x 61 cm
Museo Thyssen-Bornemisza,
Madrid

George Grosz
12. *Metropolis*, 1917
Oil on wood, 68 x 47.6 cm
The Museum of Modern Art,
New York

Max Beckmann
13. *The Night*, 1918-19
Oil on canvas, 133 x 154 cm
Kunstsammlungen, Düsseldorf

Christian Schad
14. *Self-portrait with Model*, 1927
Oil on canvas, 76 x 71 cm
Private collection

FUTURISM

Umberto Boccioni
1. *The Laugh*, 1911
Oil on canvas, 110.2 x 145.4 cm
The Museum of Modern Art,
New York
Gift of Herbert and Hannette
Rothschild

Giacomo Balla
2. *Dynamism of a Dog on a Leash*,
1912
Oil on canvas, 90.8 x 110.2 cm
Albright-Knox Art Gallery, Buffalo
Gift of G. F. Goodyear

Giacomo Balla
3. *Little Girl Running
on the Balcony*, 1912
Oil on canvas, 125 x 125 cm
Civiche Raccolte d'Arte, Milan
Grassi Collection

Carlo Carrà
4. *Rhythms of Objects*, 1911
Oil on canvas, 53 x 67 cm
Pinacoteca di Brera, Milan
Emilio and Maria Jesi donation

Luigi Russolo
5. *Music*, 1911
Oil on canvas, 225 x 140 cm
Estorick Collection, London

Umberto Boccioni
6. *Dynamism of a Human Body*,
1913-14
Oil on canvas, 100 x 100 cm
Civiche Raccolte d'Arte, Milan

Gino Severini
7. *Sea=Dancer*, 1913
Oil on canvas, 105.3 x 85.9 cm
Peggy Guggenheim Collection,
Venice

Umberto Boccioni
8. *Development of a Bottle
in Space*, 1912
(bronze cast of 1935)
Bronze, 38 x 59.5 x 32 cm
Civiche Raccolte d'Arte, Milan

Umberto Boccioni
9. *Unique Forms of Continuity
in Space*, 1913
(bronze cast of 1931)
Bronze, 112 x 40 x 90 cm
Civiche Raccolte d'Arte, Milan

Fortunato Depero
10. *Figure Seated at a Café Table
(Portrait of Gilbert Clavel)*, 1918
Oil on canvas, 59 x 59 cm
Civiche Raccolte d'Arte, Milan

Enrico Prampolini
11. *F. T. Marinetti, Free-word Poet*,
1929
Oil on canvas, 176 x 91 cm
Galleria Nazionale d'Arte Moderna
– Arte Contemporanea, Rome

CUBISM

Pablo Picasso
1. *Gertrude Stein*, 1906
Oil on canvas, 99 x 81 cm
The Metropolitan Museum of Art,
New York
Bequest of Gertrude Stein

Pablo Picasso
2. *Les Demoiselles d'Avignon*,
1907
Oil on canvas, 243 x 233 cm
The Museum of Modern Art,
New York
Acquired through the Lillie P. Bliss
Bequest

Pablo Picasso
3. *Man with a Guitar*, 1912
Oil on canvas, 131.6 x 89.1 cm
Philadelphia Museum of Art,
Philadelphia
The Louise and Walter Arensberg
Collection

Georges Braque
4. *Viaduct at L'Estaque*, 1908
Oil on canvas, 70 x 57 cm
Musée national d'Art moderne –
Centre Georges Pompidou, Paris

Robert Delaunay
5. *The City No. 2*, 1910
watercolour on cardboard,
70 x 55.5 cm
Musée national d'Art moderne –
Centre Georges Pompidou, Paris

Georges Braque
6. *Man with a Guitar*, 1911-12
Oil on canvas, 116.2 x 80.9 cm
The Museum of Modern Art,
New York
Acquired through the Lillie P. Bliss
Bequest

Sonia Delaunay
7. *Electric Prisms*, 1914
Oil on canvas, 250 x 250 cm
Musée national d'Art moderne –
Centre Georges Pompidou, Paris

Fernand Léger
8. *Mechanical Elements*, 1924
Oil on canvas, 146 x 97 cm
Musée national d'Art moderne –
Centre Georges Pompidou, Paris

Francis Picabia
9. *Impétuosité Française*,
1913-14
Tempera on paper,
50 x 70 cm
Private collection

Pablo Picasso
10. *Guernica*, 1937
Oil on canvas, 349.3 x 776.6 cm
Museo Nacional Centro de Art
Reina Sofía, Madrid

ART OF THE REVOLUTIONS

Alexandra Exter
1. *Abstract Composition*, 1917-18
Oil on canvas, 88 x 79 cm
Russian State Museum,
St. Petersburg

Lyubov Popova
2. *Still-Life*, 1915-16
Oil on canvas, 54 x 36 cm
Museum of Fine Arts, Gorky

Kasimir Malevich
3. *Drawing for the Opera Victory
over the Sun by M. Matyushin
and A.E. Kruchenykh*, 1913
Pencil on paper, 21.5 x 27.5 cm
State Museum of Theatre
and Music, St. Petersburg

Kasimir Malevich
4. *[Black] Cross*, 1915
Oil on canvas, 80 x 79.5 cm
Musée national d'Art moderne –
Centre Georges Pompidou, Paris
Gift of the Scaler Foundation and
the Beaubourg Foundation, 1980

Kasimir Malevich
5. *Suprematist Composition:
Airplane Flying*, 1914
Oil on canvas, 58.1 x 48.3 cm
The Museum of Modern Art,
New York
Acquisition confirmed in 1999
by agreement with the Estate
of Kazimir Malevich and made
possible with funds from the
Mrs. John Hay Whitney Bequest
(by exchange)

Kasimir Malevich
6. *Suprematism*, 1915
Oil on canvas, 87.5 x 72 cm
Russian State Museum,
St. Petersburg

**Lazar Markovich Lisitsky
(El Lissitzky)**
7. *Proun 1 D*, 1919
Oil on canvas mounted on wood,
96 x 71.5 cm
Kunstmuseum, Basel

Alexander Rodchenko
8. *Yellow Composition*, 1920
Oil on canvas, 183 x 183 cm
Rodchenko Archives, Moscow

Alexander Rodchenko
9. *Poster for the Propaganda
of the Book*, 1924
Rodchenko Archives, Moscow

Alexander Gerasimov
10. *Lenin on the Tribune*, 1930
Oil on canvas, 281 x 208.5 cm
State Museum of History, Moscow

Isaac Brodsky
11. *Lenin at the Smolny*
Oil on canvas, 190 x 287 cm
Tretyakov Gallery, Moscow

DADA

Marcel Duchamp
1. *Mariée* (*Bride*), 1912
Oil on canvas, 89.5 x 55 cm
Philadelphia Museum of Art,
Philadelphia
The Louise and Walter Arensberg
Collection

Francis Picabia
2. *I See Again in Memory My Dear
Udnie*, 1914
Oil on canvas, 250.2 x 198.8 cm
The Museum of Modern Art,
New York
Hillman Periodicals Fund

Marcel Duchamp
3. *Bicycle Wheel*, 1951
(third version, after lost
original of 1913)
Metal wheel mounted
on painted wood stool,
129.5 x 63.5 x 41.9 cm
The Museum of Modern Art,
New York
The Sidney and Harriet Janis
Collection

Marcel Duchamp
4. *Fountain*, 1917
Original lost; replica
Ready-made: white porcelain
urinal, 62.5 cm (height)
Arturo Schwarz Collection, Milan

Man Ray
5. *Metronome*, 1965
Metronome, 22.5 x 10.7 cm
E.G. Bonamini Collection, Verona

Francis Picabia
6. *L'œil cacodylate*
(*The Cacodylic Eye*), 1921
Oil with collage of photographs,
postcards and cuttings on canvas,
148.6 x 117.4 cm
Musée national d'Art moderne –
Centre Georges Pompidou, Paris
Purchase in homage to the days
of Le Bœuf sur le Toit

Marcel Duchamp
7. *The Bride Stripped Bare by Her
Bachelors, Even* or *The Large
Glass*, 1915-23
Oil paint, varnish, lead foil, lead
wire, 278 x 176.5 cm
Philadelphia Museum of Art,
Philadelphia
Katherine S. Dreier Bequest

Man Ray
8. *The Enigma of Isidore Ducasse*,
1920
Sewing machine wrapped in a
blanket, 40 x 57 x 21 cm
Private collection, Milan

Marcel Duchamp
9. *L.H.O.O.Q.*, 1919
Ready-made: pencil on a
reproduction of Leonardo da
Vinci's Mona Lisa, 19.7 x 12.4 cm
Private collection, Rome

Max Ernst
10. *The Pleiades*, 1921
Collage on cardboard,
25.5 x 16.6 cm
Private collection

Hans Arp
11. *Collage with Squares
Arranged according to the Laws
of Chance*, 1916-17
Torn-and-pasted paper on blue-
grey paper, 48.5 x 34.6 cm
The Museum of Modern Art,
New York

Kurt Schwitters
12. *Rotation*, 1919
Oil on canvas and assemblage,
122.7 x 88.7 cm
The Museum of Modern Art,
New York
Advisory Committee Fund

László Moholy-Nagy
13. *25 Pleite Geier*, 1922-23
Collage, 60 x 40 cm
Arturo Schwarz Collection, Milan
Courtesy Fondazione Mudima

Raoul Hausmann
14. *P*, 1921
Collage on paper, 30 x 21 cm
Hamburger Kunsthalle, Hamburg

Yves Klein
15. *Anthropometry of the Blue
Period (ANT 82)*, 1960
Pure pigment in resin on paper
mounted on canvas,
156.5 x 282.5 cm
Musée national d'Art moderne –
Centre Georges Pompidou, Paris

Piero Manzoni
16. *Line m. 7200, 4 July 1960*, 1960
Ink, paper, zinc and lead, 66 x 96 cm
Buried in the gardens of the Herning Kunstmuseum, Herning

Piero Manzoni
17. *Artist's Shit No. 8*, 1961
"Content 30 gr., freshly preserved, produced and tinned in May 1961"
Metal tin, excrement, 4.8 x 6.5 cm
Archivio Opera Piero Manzoni ONLUS, Milan

RATIONAL ART

Piet Mondrian
1. *Composition with Planes of Colour*, 1917
Oil on canvas, 48 x 61 cm
Museum Boijmans van Beuningen, Rotterdam

Piet Mondrian
2. *Composition A*, 1919
Oil on canvas, 130 x 130 cm
Galleria Nazionale d'Arte Moderna – Arte Contemporanea, Rome

Theo van Doesburg
3. *Contra-Composition of Dissonances, XVI*, 1925
Oil on canvas, 100 x 180 cm
Haags Gemeentemuseum, The Hague

Wassily Kandinsky
4. *Composition VIII*, 1923
Oil on canvas, 140 x 201 cm
Solomon R. Guggenheim Museum, New York

Wassily Kandinsky
5. *Accent in Pink*, 1926
Oil on canvas, 100.5 x 80.5 cm
Musée national d'Art moderne – Centre Georges Pompidou, Paris
Gift of Nina Kandinsky, 1976

Paul Klee
6. *Gaze from the Red*, 1937
Pastels on white cotton mounted on jute, 47 x 59 cm
Klee-Museum, Bern
Gift of LK

Paul Klee
7. *Fire in the Evening*, 1929
Oil on board, 33.8 x 33.3 cm
The Museum of Modern Art, New York
Mr. and Mrs. Joachim Jean Aberbach Fund

Fausto Melotti
8. *Sculpture*, 1935
Stainless steel, 150 x 100 x 100 cm
MART – Museo d'Arte Contemporanea di Trento e Rovereto, Rovereto

Lucio Fontana
9. *Sculpture*, 1934
Coloured cement and iron, 59 x 50 cm
Panicali Collection, Rome

Josef Albers
10. *Study for Homage to the Square*, 1956
Oil on cardboard, 45 x 45 cm
Calderara Collection, Vacciago

Max Bill
11. *Strahlende Orange (Bright Orange)*, 1959-67
Oil on canvas, 34 x 34 cm
Calderara Collection, Vacciago

Günther Uecker
12. *Quadrat (Square)*, 1971
Nails on wood, 25 x 25 cm
Calderara Collection, Vacciago

Piero Dorazio
13. *Ognuno tesse le sue indulgenze II (Everyone Weaves His Indulgences II)*, 1960
Oil on canvas, 197 x 210 cm
Galleria Nazionale d'Arte Moderna – Arte Contemporanea, Rome

Victor Vasarely
14. *Vega-os*, 1956
Ink on paper, 49.5 x 35.5 cm
Calderara Collection, Vacciago

Jesús-Rafael Soto
15. *Cuadrados en el espacio (Squares in Space)*, 1971
Wood, 54 x 54 x 14 cm
Calderara Collection, Vacciago

METAPHYSICAL PAINTING

Giorgio de Chirico
1. *La matinée angoissante (The Morning of Anguish)*, 1912
Oil on canvas, 81 x 65 cm
MART – Museo d'Arte Contemporanea di Trento e Rovereto, Rovereto

Giorgio de Chirico
2. *Melanconia (Melancholy)*, 1912
Oil on canvas, 79 x 63.5 cm
Estorick Collection of Modern Italian Art, London

Giorgio de Chirico
3. *Premonitory Portrait of Guillaume Apollinaire*, 1914
Oil on canvas, 81 x 65 cm
Musée national d'Art noderne – Centre Georges Pompidou, Paris

Giorgio de Chirico
4. *The Disquieting Muses*, 1918
Oil on canvas, 97 x 66 cm
Private collection

Carlo Carrà
5. *The Hermaphrodite Idol*, 1917
Oil on canvas, 80 x 60 cm
Private collection

Carlo Carrà
6. *Still-Life with Carpenter's Square*, 1917
Oil on canvas, 45 x 60 cm
Civico Museo d'Arte Contemporanea, Milan

Carlo Carrà
7. *Il cavaliere occidentale (The Horseman of the West)*, 1917
Oil on canvas, 52 x 67 cm
Private collection

Giorgio Morandi
8. *Metaphysical Still-Life with Manikin*, circa 1918
Oil on canvas, 68.5 x 72 cm
Pinacoteca di Brera, Milan
Jesi Collection

Felice Casorati
9. *Silvana Cenni*, 1922
Tempera on canvas, 205 x 105 cm
Private collection

Massimo Campigli
10. *La carceriera (The Wardress)*, 1929
Oil on canvas, 94 x 61 cm
Private collection

REALISM – HYPERREALISM

Pablo Picasso
1. *Two Women Running on the Beach (The Race)*, 1922
Oil on plywood, 32.5 x 41.5 cm
Musée national Picasso, Paris

Giorgio de Chirico
2. *Mythological Figures*, 1927
Oil on canvas, 130 x 162 cm
Private collection

Mario Sironi
3. *Solitude*, 1926
Oil on canvas, 103 x 85 cm
Galleria Nazionale d'Arte Moderna - Arte Contemporanea, Rome

545

André Derain
4. *Harlequin and Pierrot*, 1924
Oil on canvas, 175 x 175 cm
Musée de l'Orangerie, Paris
Collection Jean Walter
and Paul Guillaume

Gino Severini
5. *Motherhood*, 1916
Oil on canvas, 92 x 65 cm
Museo dell'Accademia Etrusca
e della Città di Cortona, Cortona

Edward Hopper
6. *Automat*, 1927
Oil on canvas, 71.4 x 91.4 cm
Des Moines Art Center,
Des Moines
Permanent Collection

Francis Bacon
7. *Figure Study II*, 1953-55
Oil on canvas, 198 x 137 cm
Collection of Mr. and Mrs.
J. Tomilson Hill, New York

Cindy Sherman
8. *Untitled Film Still No. 49*, 1979
Black-and-white photographic
print, 20 x 25.5 cm
Sandretto Re Rebaudengo
Collection, Turin

Ron Mueck
9. *Untitled* (*Seated Woman*), 1999
Silicone, acrylic, polyurethane,
foam rubber and fabric,
72 x 62 x 56 cm
Courtesy of the James Cohan
Gallery, New York

SURREALISM

Salvador Dalí
1. *The Persistence of Memory*,
1931
Oil on canvas, 24 x 33 cm
The Museum of Modern Art,
New York

Francis Picabia
2. *Transparencies – Head
and Horse*, 1930
Brush and ink, gouache
and watercolour on paper,
77 x 59 cm
The Museum of Modern Art,
New York

René Magritte
3. *The False Mirror*, 1929
Oil on canvas, 54 x 81 cm
The Museum of Modern Art,
New York

Yves Tanguy
4. *Dead Man Watching
His Family*, 1927
Oil on canvas, 100 x 73 cm
Museo Thyssen-Bornemisza,
Madrid

Max Ernst
5. *Attirement of the Bride*,
1939-40
Oil on canvas, 130 x 96 cm
Peggy Guggenheim Collection,
Venice

Joan Miró
6. *Carnival of Harlequin*, 1924-25
Oil on canvas, 66 x 93 cm
Albright-Knox Art Gallery, Buffalo

Joan Miró
7. *Head of Catalan Peasant*, 1925
Oil on canvas, 91 x 73 cm
Roland Penrose Collection, London

Meret Oppenheim
8. *Objet – Déjeuner en fourrure*
(*Object – The lunch in Fur*), 1936
Cup, saucer and spoon covered
with fur, 10.9 cm (diameter cup),
23.7 cm (diameter saucer),
20.2 cm (spoon) 7.3 cm (overall
height)
The Museum of Modern Art,
New York

Alberto Giacometti
9. *The Nose*, 1947
Painted plaster, string and metal,
82.6 x 77.5 x 36.7 cm
Musée national d'Art moderne –
Centre Georges Pompidou, Paris
Gift of the Aimé Maeght Bequest,
1992

ART INFORMEL

Jean Fautrier
1. *Sarah*, 1942
Oil on paper and canvas,
116 x 89 cm
Private collection, Paris

Jean Dubuffet
2. *Noble port de tête* (*Noble
Carriage of Head*), 1954
Oil on canvas, 81 x 53.5 cm
Anthony Denney Collection

Wols
3. *The Blue Phantom*, 1951
Oil on canvas, 73 x 50 cm
Private collection

Nicolas de Staël
4. *Figure by the Sea*, 1952
Oil on canvas, 161.5 x 129.5 cm
Kunstsammlung Nordrhein-
Westfalen, Düsseldorf

Lucio Fontana
5. *Spatial Concept*, 1964
Oil on canvas, 73 x 60 cm
Private collection

Alberto Burri
6. *Sacco IV* (*Sack IV*), 1954
Painting and sacking (jute cloth)
sewn onto cotton cloth,
114 x 76 cm
Purchase of the Ville de Toulouse
Anthony Denney Collection

Emilio Scanavino
7. *Personaggio* (*Figure*), 1957
Oil on canvas, 80 x 100 cm
Private collection

Antoni Tàpies
8. *Crossed Lines*, 1968
Mixed media on canvas,
81 x 100 cm
Beldì Collection, Oleggio

Hans Hartung
9. *T1962-R18*, 1962
Vinyl on canvas, 92 x 73 cm
Private collection

Gastone Novelli
10. *Telegram*, 1960
Mixed media on canvas,
135 x 135 cm
Ivan Novelli Collection

Emilio Vedova
11. *Plurimo n. 6* (*Multiple No. 6*),
from the cycle "Absurdes Berliner
Tagebuch '64"
Mixed media on wood, 272 cm
(height)
Courtesy of the artist

Georges Mathieu
12. *Mathieu from Alsace Goes
to Ramsey Abbey*, 1956
Oil on canvas, 198 x 147 cm
Anthony Denney Collection

THE NEW YORK SCHOOL

Willem de Kooning
1. *Woman I*, 1950-52
Oil on canvas, 192.7 x 147.3 cm
The Museum of Modern Art,
New York
Purchase

Jackson Pollock
2. *Composition 16*, 1948
Oil on canvas, 56.5 x 39.5 cm
Museum Frieder Burda,
Baden-Baden

Jackson Pollock
3. *One (Number 31, 1950)*, 1950
Oil and enamel on unprimed
canvas, 269.5 x 530.8 cm
The Museum of Modern Art,
New York
Sidney and Harriet Janis Collection
Fund

Franz Kline
4. *Andrus*, 1961
Oil on canvas, 200.6 x 337.8 cm
Private collection

Clyfford Still
5. *Untitled*, 1964
Oil on canvas, 289.6 x 190.3 cm
Museum Frieder Burda,
Baden-Baden

Helen Frankenthaler
6. *Walnut Hedge*, 1971
Acrylic on canvas, 305 x 195 cm
Collection of the Pennsylvania
Academy of Art
Courtesy Knoedler & Company,
New York

Morris Louis
7. *Beta Lambda*, 1961
Synthetic polymer paint
on canvas, 262.6 x 407 cm
The Museum of Modern Art,
New York
Gift of Mrs. Abner Brenner

Sam Francis
8. *Untitled – SF 57-265*, 1957
Watercolour and gouache
on paper, 106 x 77.5 cm
Private collection, Starnberg

Cy Twombly
9. *Rome (The Wall)*, 1962
Oil, enamels, graffiti and charcoal
on canvas, 240.7 x 200 cm
Galleria Civica d'Arte Moderna,
Turin

Mark Rothko
10. *No. 22*, 1949
Oil on canvas, 297 x 272 cm
The Museum of Modern Art,
New York
Gift of Mark Rothko

POP ART

Jasper Johns
1. *Flag*, 1954-55
Encaustic, oil and collage
on fabric mounted on plywood,
107.3 x 154 cm
The Museum of Modern Art,
New York
Gift of Philip Johnson in honour
of Alfred H. Barr Jr.

Robert Rauschenberg
2. *Bed*, 1955
Oil and pencil on pillow, quilt
and sheet on wooden supports,
191.1 x 80 x 20.3 cm
The Museum of Modern Art,
New York
Gift of Leo Castelli in honour
of Alfred H. Barr Jr.

Richard Hamilton
3. *Pin-up*, 1961
Oil, cellulose, and collage on panel,
121.9 x 81.3 x 7.6 cm
The Museum of Modern Art,
New York
Enid A. Haupt Fund and
an anonymous fund

Roy Lichtenstein
4. *Girl with Ball*, 1961
Oil and synthetic polymer paint
on canvas, 153 x 91.9 cm
The Museum of Modern Art,
New York
Gift of Philip Johnson

George Segal
5. *The Farm Worker*, 1963
Mixed materials,
243 x 243 x 107 cm
MACBA – Museu d'Art
Contemporani de Barcelona,
Barcelona
On deposit from the Onnasch
Collection

Andy Warhol
6. *Four Marilyns*, 1962
Silkscreen ink on synthetic polymer
paint on canvas, 76.2 x 61 cm
Private collection

Robert Indiana
7-8. *Eat/Die*, 1962
Oil on canvas, diptych,
182.8 x 152.3 cm
Private collection
Courtesy Simon Salama-Caro

Mario Schifano
9. *L'inverno attraverso il museo
(Winter through the Museum)*,
1965
Enamel paint on paper mounted
on canvas, 220 x 300 cm
Private collection

James Rosenquist
10. *I Love You with My Ford*, 1961
Oil on canvas, 210.2 x 237.5 cm
Moderna Museet, Stockholm

Pino Pascali
11. *Reconstruction of Whale*,
1966
Canvas stretched over wooden
ribs, 366 cm (8 elements)
Luigi and Peppino Agrati Collection

Andy Warhol
12. *Self-portrait*, 1986
Acrylic and silkscreen ink on
canvas, 101.6 x 101.6 cm
Andy Warhol Museum, Pittsburgh

David Hockney
13. *A Bigger Splash*, 1967
Acrylic on canvas,
242.5 x 243.9 cm
Tate Gallery, London

MINIMALISM

Barnett Newman
1. *Vir Heroicus Sublimis*, 1950-51
Oil on canvas, 242.2 x 541.7 cm
The Museum of Modern Art,
New York
Gift of Mr. and Mrs. Ben Heller

Barnett Newman
2. *Untitled*, 1948
Oil on paper mounted on canvas,
46 x 50.8 cm
Private collection
Courtesy Art Focus AG, Zurich

Ad Reinhardt
3. *Abstract Painting*, 1963
Oil on canvas,
152.4 x 152.4 cm
The Museum of Modern Art,
New York
Gift of Mrs. Morton J. Hornick

Frank Stella
4. *The Marriage of Reason
and Squalor, II*, 1959
Enamel on canvas,
230.5 x 337.2 cm
The Museum of Modern Art,
New York
Larry Aldrich Foundation Fund

Robert Ryman
5. *Winsor 6*, 1965
Oil on canvas,
192.4 x 192.4 cm
François Pinault Collection

Ellsworth Kelly
6. *Colors for a Large Wall*, 1951
Oil on canvas mounted on wooden
panels, 240 x 240cm
(each; 64 elements)
The Museum of Modern Art,
New York
Gift of the artist

547

Sol LeWitt
7. *Incomple Open Cubes*, 1974
Installation
Courtesy Castello di Rivoli, Rivoli

Robert Morris
8. *Untitled*, 1968
Aluminium, 91.5 x 93 x 93 cm
(each; 9 elements)
MART – Museo d'Arte
Contemporanea di Trento e
Rovereto, Rovereto
Ileana Sonnabend Collection

Donald Judd
9. *Untitled*, 1966-67
Stainless steel and yellow
Perspex, 86.4 x 86.4 x 86.4 cm
(each; 6 elements)
François Pinault Collection

Richard Serra
10. *Floor Pole Prop*, 1969
Lead, antimony, 250 x 250 x 95 cm
François Pinault Collection

Richard Serra
11. *House of Cards 1*, 1968-98
Steel plates, 138 x 138 x 2.5 cm
(each; 4 elements)
Galerie M. Bochum,
Bochum-Weitmar

Brice Marden
12. *Tour III*, 1972
Oil and beeswax on canvas,
244 x 91 cm
François Pinault Collection

Robert Mangold
13. *1/4 V Series*, 1968
Acrylic on masonite, 122 x 122 cm
Luigi and Peppino Agrati
Collection

CONCEPTUAL ART –
ARTE POVERA – LAND ART

Joseph Beuys
1. *Eurasia Siberian Symphony
1963*, 1966
Panel with chalk drawing, felt, fat,
hare and painted poles,
183 x 230 x 50 cm
The Museum of Modern Art,
New York
Gift of Frederic Clay Bartlett
(by exchange)

Giovanni Anselmo
2. *Torsion*, 1968
Photograph by Paolo Vandrash,
Milan
Cement, leather and wood,
100 x 60 x 110 cm
Private collection

George Maciunas
3. *USA Surpasses All the
Genocide Records!*, 1966-73
Silkscreen print in colour,
54.8 x 87.8 cm
Bonotto Collection, Bassano
del Grappa

Joseph Kosuth
4. *Art as Idea: Nothing*, 1967
Photostat on paper mounted
on wood, 98 x 98 cm
Courtesy Archivio Celant, Genoa

Pier Paolo Calzolari
5. *Horoscope as Plan of My Life*,
1968
Structure in ice, lead and
refrigerator, 325 x 386 cm
François Pinault Collection

Bruce Nauman
6. *Light Trap for Henry Moore,
No. 1*, 1967
Black-and-white photographic
print, 162.6 x 101.6 cm
François Pinault Collection

Mario Merz
7. *Objet cache-toi*
(*Object, Hide Yourself*), 1977
Aluminium, c-clamps, mesh, glass,
neon and transformer,
185 x 365 cm
François Pinault Collection

Jannis Kounellis
8. *Untitled*, 1969
Photograph by Paolo Pellion, Turin
Structure in iron, plates, lit
metaldehyde, 190 x 164 x 10 cm
Margherita Stein Collection
Property of the Fondazione CRT
on permanent loan
Castello di Rivoli, Rivoli
GAM – Galleria Civica d'Arte
Moderna e Contemporanea, Turin

Giuseppe Penone
9. *Breath of Clay H*, 1978
Terra-cotta, 160 x 80 x 80 cm
Castello di Rivoli, Rivoli
Fondo Rivetti per l'Arte Collection,
Turin

Respirare l'ombra
(*Breathing the Shadow*), 1999
199 pieces of wire netting,
bay leaves and gold element
Castello di Rivoli, Rivoli, variable
dimensions on long-term loan
Fondazione CRT Progetto Arte
Moderna and Contemporanea,
2005

Alighiero Boetti
10. *Map*, 1974
Embroidery on linen,
120 x 180 cm
Luigi and Peppino Agrati
Collection

Gilberto Zorio
11. *Macchia III* (*Stain III*), 1968
Rope and rubber,
120 x 126 x 7 cm
Collection Margherita Stein
Property of the Fondazione CRT
on permanent loan
Castello di Rivoli, Rivoli
GAM – Galleria Civica d'Arte
Moderna e Contemporanea, Turin

Luciano Fabro
12. *L'Italia d'oro*
(*Golden Italy*), 1971
Gilt bronze, 92 x 45 cm
François Pinault Collection
Former collection of Mrs.
Margherita Stein

Walter De Maria
13. *The Lightning Field*, 1977
Grid of lightning conductors,
colour photograph
New Mexico

Christo and Jeanne-Claude
14. *Running Fence. Sonoma
and Marin Counties, California*,
1972-76
Photograph by Wolfgang Volz,
46.4 x 72 cm
Musée national d'Art moderne –
Centre Georges Pompidou, Paris
Gift of the artists, 1999

PERFORMANCE – BODY ART

Anonymous
1. *Oskar Schlemmer
in the Costume of the 'Turk'
in Triadische Ballet*, 1922
Black-and-white photograph from
the catalogue Die Maler und das
Theater im 20 Jahrhundert
Schirn Kunsthalle, Frankfurt

Man Ray
2. *Marcel Duchamp as Rrose
Sélavy*, 1921
Black-and-white photograph
Man Ray Trust, Paris

Max Ernst
3. *The Punching Ball ou
L'immortalité de Buonarroti*, 1920
Photomontage, gouache, ink,
17.6 x 11.4 cm
Arnold Crane Collection, Chicago

**Lazar Markovich Lisitsky
(El Lissitzky)**
4. *Kurt Schwitters*, 1924
Gelatin silver printing-out-paper
print 10.6 x 9.4 cm
The Museum of Modern Art,
New York
Thomas Walther Collection

Robert Wilson
5. *Dreamplay*, 1998
Photograph by Lesley
Leslie-Spinks
Stadsteater, Stockholm

Gilbert & George
6. *The Singing Sculpture*, 1991
Colour photograph of a
performance staged at the
Sonnabend Gallery in New York

Dick Higgins
7. *Wiesbaden*, 1962
Photograph by Hartmut Rekort
Archiv Sohm, Staatsgalerie,
Stuttgart

Andrés Serrano
8. *A History of Sex (Giada)*, 1996
Cibachrome, silicone, Perspex
and wooden frame, 165 x 139 cm
Courtesy the artist and Paula
Cooper Gallery, New York

Shirin Neshat
9. *Identified*, 1995
Silver gelatine print,
35.5 x 28 cm
Kunstmuseum, Linz

Nan Goldin
10. *Berlin*, 1992
Photographic print,
70 x 100 cm
Sandretto Re Rebaudengo
Collection, Turin

Ulay & Marina Abramović
11. *Gold found by the artists
(Anima Mundi: tango)*,1981
Performance
Courtesy Castello di Rivoli, Rivoli

Sam Taylor-Wood
12. *Travesty of a Mockery*, 1995
Video installation
Sandretto Re Rebaudengo
Collection, Turin

TRANSAVANGUARDIA – STREET ART

Keith Haring
1. *Untitled*, 1983
Acrylic on canvas, 290 x 590 cm
Palazzo Reale, Caserta
Terrae Motus Collection

Jean-Michel Basquiat
2. *Toxic*, 1984
Acrylic, oil pastel and coloured
Xerox collage on canvas,
218 x 172.5 cm
Private collection, Paris

Keith Haring
3. *Untitled*, 1982
Vinyl paint on vinyl tarpaulin,
299.7 x 304.8 cm
Courtesy Meir Teper, Malibu

Sandro Chia
4. *Sull'onda e bastone*
(*On the Wave and Club*), 1977
Oil on canvas, 24 x 24 cm
(first of 3 elements)
Luigi and Peppino Agrati Collection

Francesco Clemente
5. *Arlecchino da vicino*
(*Harlequin Close-up*), 1978
Gouache on paper transferred
onto canvas, 114.5 x 61.5 cm
Private collection

Enzo Cucchi
6. *Un quadro che sfiora il mare*
(*A Painting Skimming the Sea*),
1983
Oil and mixed media on canvas,
199 x 290 cm
Private collection
Courtesy Galerie Bruno
Bischofberger, Zurich

Nicola De Maria
7. *Mattino soave del Regno
dei Fiori nell'aria scintillante*
(*Mild Morning of the Kingdom
of Flowers in the Sparkling Air*),
2004
Photograph by Paolo Pellion, Turin
Pigment on linen, 200 x 385 cm
Private collection

Georg Baselitz
8. *Strandbild 7. Blick aus
dem Fenster nach draussen*
(*Beach Picture 7. Glance out
of the Window*), 1981
Oil and tempera on canvas,
250 x 200 cm
Ackermeier Collection, Berlin

Markus Lüpertz
9. *Cupid and Psyche I*, 1978
Oil and mixed media on canvas,
285 x 285 cm
Onnasch Collection, Berlin

Anselm Kiefer
10. *Althanor*, 1983-84
Oil, acrylic, emulsion, shellac
and straw on photograph mounted
on canvas; scorch marks,
225 x 380 cm
Amsterdam, Sanders Collection

NEW MEDIA

Wolf Vostell
1. *TV – Shoes*, 1970
TV set, two lorry batteries, heap
of shoes and newspapers,
150 x 300 x 450 cm
Fondazione Mudima, Milan

Nam June Paik
2. *Family of Robots, Aunt*, 1986
Mixed media, 220 x 130 x 60 cm
Simone Leiser Collection

Barbara Kruger
3. *Untitled (I shop therefore I am)*,
1987
Photographic screen-print on vinyl,
281.9 x 287 cm
François Pinault Collection

Jenny Holzer
4. *Red and Yellow Looming*, 2004
Double-sided electronic signs
with red and amber diodes,
276.86 x 13.34 x 10.16 cm
(each; 13 elements)
Courtesy Monika Sprüth and
Philomene Magers, Cologne,
Munich

William Kentridge
5. *Journey to the Moon and Seven
Fragments for Georges Méliès*,
2003
About 40 drawings and fragments,
charcoal on paper, drawing and
photograph, variable dimensions
Director: William Kentridge
Editing: Catherine Meyburgh
Castello di Rivoli, Rivoli

Andreas Gursky
6. *Athens* (diptych), 1995
Photographic print
Courtesy Castello di Rivoli, Rivoli

Jeff Wall
7. *The Thinker*, 1986
Light-box, 239 x 216 cm
Courtesy the artist and Galleria
Lorcan O'Neill, Rome

Bill Viola
8. *Study for Emergence*, 2002
Video installation: colour video
on LCD panel, 28 x 36 cm
Giovanni and Patrizia Aldobrandini
Collection

Index of Names

554

556

558

Photo Credits